Plains Indian
Sculpture

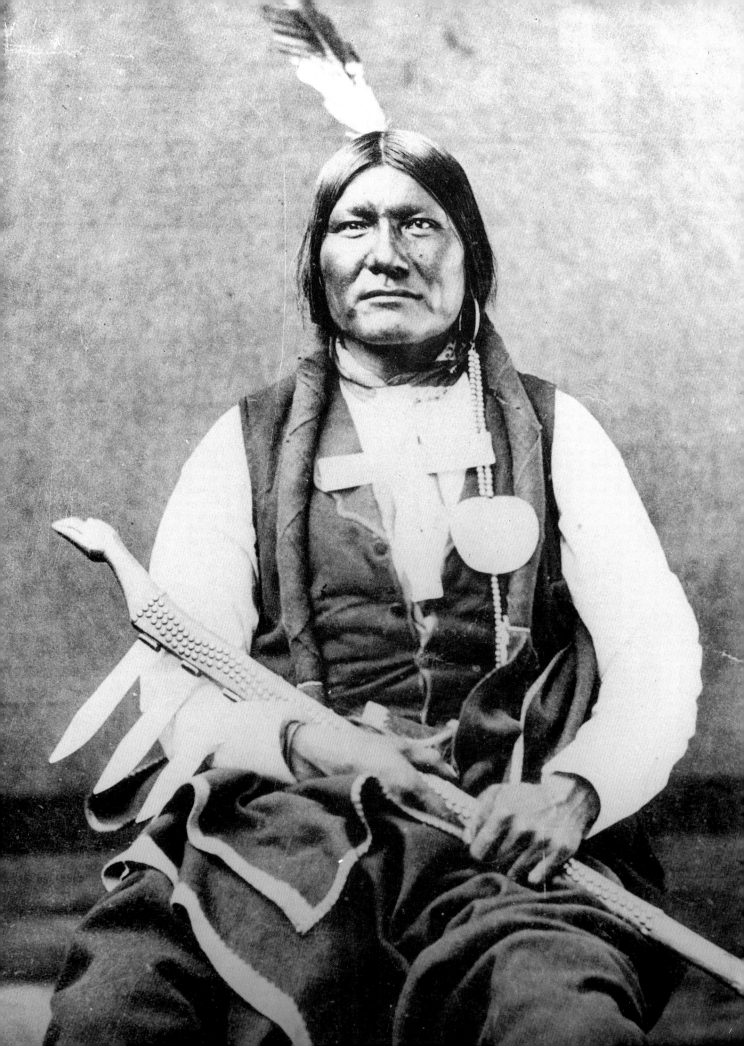

Plains Indian Sculpture

A Traditional Art from America's Heartland

John C. Ewers

SMITHSONIAN INSTITUTION PRESS
Washington, D.C.

To my wife, Margaret, whose assistance in research and constant encouragement have made this book possible

FRONT COVER: Seated human figure; Caddo, probably quite old: painted wood, hair mustache and wig, holds cloth packet of medicine between legs; 6¾″ high. [Colorplate 3]
Smithsonian Institution, cat. no. 378,577.

FRONTISPIECE: Snake effigy war club, carried by He Dog, Oglala Sioux warrior, probably 1870s. Club is of wood, with three inserted knife blades, brass tacks. [FIGURE 121]
Photograph by D. S. Mitchell.

© 1986 by Smithsonian Institution. All rights reserved.

Library of Congress Cataloging-in-Publication Data
Ewers, John Canfield.
　Plains Indian sculpture.
　Bibliography: p.
　1. Indians of North America—Great Plains—Sculpture.
I. Title.
E78.G73E935　1986　　730′.08997　　85-600247
ISBN 0-87474-422-9 (alk. paper)
ISBN 0-87474-423-7 (pbk. : alk. paper)

Printed in Japan

∞ The paper in this book meets the guidelines for permanence and durability of the Committee on Production Guidelines for Book Longevity of the Council on Library Resources.

Book design by Christopher Jones

Contents

Preface

I have written this book for three reasons. First, to show that the art of the Plains Indians, who lived in the very heart of the North American continent, had an important third dimension. Second, to illustrate the ingenuity and the skill of those Indians in creating miniature carvings of human and animal forms in stone, wood, and other materials. Third, to demonstrate how these carvings served many useful functions in their religious and secular life.

My awareness of the importance of carved effigies in Plains Indian culture developed gradually out of a variety of experiences during the 1940s and 1950s. Under the guidance of Clark Wissler in graduate school during the early 1930s, I had written my master's thesis on the subject of Plains Indian painting on robes and skins, based largely on the study of examples in the larger museums of eastern United States and Canada. I later developed this into the first book on that subject, published in 1939. During the early forties, I began to learn about Plains Indian sculpture at first hand when I had two gifted Piegan sculptors helping me with the development of exhibits for the Museum of the Plains Indian on the Blackfeet Reservation in Montana. They were John Clarke and Albert Racine.

Upon my return from service in World War II, I joined the staff of the Smithsonian Institution's Department of Anthropology as associate curator of ethnology. Given opportunities to continue my studies of Plains Indian art and material culture, I found the collections of the U.S. National Museum to contain quite a number of examples of Plains Indian miniature sculpture in stone, wood, and horn, some of them well documented. As I was able to extend my studies to other large museums in Philadelphia, New York, New Haven, Boston, Pittsburgh, and Chicago, I examined the carvings in their collections. Furthermore, I was becoming impressed with the quality and variety of these works.

Then for nine years beginning in 1956 my opportunities for research in other museums virtually ceased, while I was involved in the planning and development of the Smithsonian's great new Museum of History and Technology (now the Museum of American History) to be built on the Mall in Washington.

In 1965, after that museum was established, I returned to the Department of Anthropology and began that fall to renew and to expand my studies of Plains Indian sculpture collections to other

museums in this country and abroad. I hoped to find as many as 1,000 examples of effigy carvings. I have not been disappointed, for I have seen nearly twice that many carvings in some 150 museums and private collections in this country and in Canada, England, and six nations on the continent of Europe. Of course, many of these examples were poorly documented, but one of the advantages of examining such a large sampling has been to make possible the better identification of those carvings through comparison with similar, more fully-documented ones. It has been especially satisfying to find examples of the same sculptor's works preserved in widely separated museums—even though the names of the artists who created them remain unknown. A special effort has been made to record in this book the names of the creators of specific works when they could be found.

I have also searched the vast and largely unindexed literature on the Plains Indians from the time of Coronado in 1541 for references to effigy carvings in the writings of early explorers, later travelers, traders, government officials, and, yes, even in the technical papers written by some of the early twentieth-century ethnologists who tended to decry the quality of the carvings in their more general statements about Plains Indian art. In addition, I have examined many technical reports of archeological explorations in the Great Plains, which have become much more numerous since World War II. At the same time I have looked for drawings and photographs that illustrate the appearance and/or uses of objects carved by Plains Indians. The written and pictorial records have helped to reveal the functions of some types of carvings that were poorly documented in museum records and to assess the relative commonness of certain kinds of carvings among the various tribes.

In my study of Plains Indian carving, I have tried to do more than select and picture examples and trace the history of this long-neglected, three-dimensional art. I have sought also to show how this art reflected Indian values and attitudes toward women, toward members of enemy tribes, and toward non-Indians, especially whites who came to be fairly common subjects for portrayal in Plains Indian carving during the nineteenth century. The carvings range from the sacred to the profane—from the sublime to the ridiculous, if you will—and in so doing they reveal the essential humanity of the Indians who conceived and executed them.

I hope that this study will help members of Indian tribes to understand and appreciate the fact that the creation of carved effigies was a traditional Plains Indian art of which they should be proud. Although miniature in size, some of these carvings are monumental in their artistry. I also hope that this study will encourage present and future generations of Plains Indians to find expression for their own creative talents in their traditional art of sculpture.

Introduction

It is unfortunate that leading students of American Indian art and of Plains Indian history and culture who were active during the first half of this century tended to ignore or to belittle Plains Indian sculpture. William H. Holmes, a talented artist as well as a prominent student of prehistoric Indian art, who wrote the short article *Sculpture and Carving* in the Smithsonian Institution's *Handbook of American Indians North of Mexico*, praised the stone effigy pipes created by the ancient mound builders of the Eastern Woodlands, the wood and slate carvings executed by the historic tribes of the North Pacific Coast, and the clever little bone and ivory carvings made by the Eskimos of the American Arctic. But he did not mention Plains Indian carvings in any medium (Holmes, in Hodge 1910, pt. 2., pp. 490–92).

Leading ethnological field workers among the tribes of the Great Plains during the first quarter of this century—men who were the teachers of my generation of graduate students—collected some examples of sculpture by Plains Indians for the museums that employed them. But they tended to deprecate the artistic value of these works. Clark Wissler, who supervised the most intensive program of field research and collecting among the Plains Indians, that of the American Museum of Natural History in New York, defined Plains Indian culture in terms that called attention to these Indians' "weak development of work in wood, stone and bone. Their art is strongly geometric, but as a whole not symbolic." (Wissler 1922, p. 220.) Diamond Jenness, who had field-work experience among tribes of the Canadian Plains, stated in *The Indians of Canada*: "On the Plains there is no sculpture worthy of mention." (Jenness 1932, p. 209.) And Robert H. Lowie, who had been the American Museum's most active field worker among several Plains Indian tribes during the second decade of this century, began the chapter on art in his popular handbook, *Indians of the Plains*, with the words, "Stone sculpture was absent and wood carving as a craft too little developed to foster artistry." (Lowie 1954, p. 130.)

In view of the short shrift given the three-dimensional art of the Plains Indians by the anthropologists who had studied the culture of these Indians more intensively, it is not surprising that Harold E. Driver, in his comprehensive survey of all North Ameri-

can Indian cultures, *Indians of North America*, should have written in 1961: "Almost all Plains artwork was applied to hide, which was the most common material in this hunting culture where the buffalo was the principal animal taken." (Driver 1961, p. 192.)

As I look back on the status of Plains Indian studies before mid-century, I am impressed by the probability that one reason why carving received so little recognition was that most of the anthropologists who studied the Plains tribes most closely had little understanding and appreciation of sculpture as an art form. They tended to judge sculpture by naturalistic standards, that is, if the objects were not exact replicas or idealized representations of human and animal forms—like the equestrian statues of military heroes on horseback that decorate our public parks—they were not worthy of consideration as works of art.

Another reason why students may have neglected this subject may have been quantitative—examples of sculpture were not as common as articles of decorated clothing, or porcupine-quilled or beaded containers, or paintings and drawings on hides, cloth, and paper among the Plains Indians in the early years of this century. They were not as readily available for collection, and to this day few among even the larger museums in this country and abroad possess more than twenty-five or thirty examples of Plains Indian sculpture. And during the first half of this century most students tended to confine their studies of art and material culture to the collections of a single museum—the one in which they were employed.

In any event, abundant evidence exists in the form of sculpture in museum collections, literary references, and representations in drawings and photographs to prove beyond doubt that the Plains Indian tribes created carvings that are deserving of full recognition as works of art.

How then does their sculpture differ from that created by the native peoples of other North American cultures whose works are better known—the Eskimo of the Arctic, the Indians of the North Pacific Coast, and the Indians of the Eastern Woodlands?

We should recognize at the outset that unlike the sculptors of those three other culture areas, the Plains Indians did not carve life-size masks, nor did they create the tall, imposing totem poles so typical of the Indians of the Northwest Coast. Nearly all of their three-dimensional life forms were rendered in miniature and at a very small scale, so that even the largest animals or human figures rarely exceed six to eight inches in greatest dimension. In scale these carvings are more comparable to the life forms appearing on Eskimo ivory carvings, on Haida argillite ones, and on the stone effigy pipes executed by the prehistoric mound builders of the Ohio Valley.

Like the miniature sculptors of those other areas, the Plains Indians chose as their subjects the forms of life that were familiar to them in their locality. Instead of the large sea mammals of the Arctic or the Northwest Coast, they portrayed the wildlife of their plains environment in the interior of the continent. Their favorite animal subjects were the buffalo, the bighorn, the elk, and the grizzly bear. But the domesticated horse became very popular as a subject for sculpture in the nineteenth century. Among the birds, the eagle and owl were especially favored. Turtles and rattlesnakes appear in both stone and wood carvings. The snake was often chosen for decorating long, tubular forms, such as the barrels of canes, some pipestems, and the shanks of pipes.

No subject was more common in Plains Indian sculpture than the human being—whether in the form of the head alone, the single entire figure, or the human head or full figure in confrontation with an animal or another human. Plains Indians took pains to distinguish men from women, enemy tribesmen from friendly Indians, and whites from Indians. A few even executed portraits of individuals on tobacco pipes. Many of their most innovative and carefully detailed works reveal their attitudes toward women, toward enemy Indians, toward the liquor trade, or toward whites. Some illustrate myths. A few portray mythical creatures such as the thunderbird or the whirlwind worm.

There is no doubt that Plains Indian sculpture most closely resembles that of the tribes of the Eastern Woodlands, with whom they shared many cultural traits and religious beliefs. These ties were especially close between the Sioux—the most active Plains Indian sculptors of the nineteenth century—and their neighbors to the east in the Great Lakes region.

Unfortunately, we have no really comprehensive survey of the sculpture of the historic tribes of the Great Lakes region. The best effort in that direction to date appears to be the illustrated article *Woodland Sculpture* by the late Robert E. Ritzenthaler that appeared in *American Indian Art* magazine in August 1976 (pp. 34–41). Brief as it was, that article mentioned certain attributes of the sculpture of the tribes of the Great Lakes region that I have found to have been characteristic of Plains Indian sculpture also. These include:

• Realistic portrayal of human, bird, and animal forms;
• Stone pipes with human and animal figures carved on bowl or shank;
• Wooden pipestems occasionally carved;
• Use of crooked knife in wood carving (historically);
• Use of European paints, brass tacks, beads, and ribbon to decorate wood carvings;
• Wooden bowls with carved effigies above rims;

• Wooden ladles (or spoons) with bird or animal figures at ends of handles;

• Cedar flutes with bird or animal carved stops;

• Clubs with animals carved on them;

• Religious carvings — including puppets, love medicines, figures included in medicine bundles, and human figures used by shamans.

Let us remember, however, that when Dr. Ritzenthaler was writing his article he was seeking to define Eastern Woodlands sculpture and did not have a comparison of Great Lakes Indian and Plains Indian sculpture in mind. So that even this impressive list of similarities between the two, based on my comparison of his definition of the sculpture of those woodland people with that of Plains Indians, is not a complete coverage of their likenesses. Even so, readers should not jump to the conclusion that Plains Indian sculpture was simply a westward extension of that of the Indians of the Eastern Woodlands, or that the sculpture of all Indian tribes from the Rocky Mountains eastward to the Atlantic Seaboard should be lumped together into one artistic region. On the contrary, the history of Plains Indian sculpture is only partly related to that of the Eastern Woodlands—most closely in its earlier stages when several Woodlands tribes were themselves moving westward onto the open plains, carrying with them their background of woodland culture, which became modified in their new environment.

More recent developments have been quite different in the two areas. Dr. Ritzenthaler concluded his article on Woodland sculpture (in which he really was considering *only* that of Indians of the Great Lakes region) with the gloomy observations that there is little demand for this sculpture on the part of the present-day Indians themselves, and little sculpture was produced for sale, so that it had become "almost a lost art." (Ritzenthaler 1975, pp. 40–41.) By contrast, Plains Indian sculpture since World War II has experienced a new wave of creativity and seems to offer promise of continued vitality in the future.

IN MY OWN QUEST for information on the antiquity of effigy carving among the Plains Indians, I have found archeological evidence of the existence before Columbus discovered America of effigy pipes of the handsome red stone that has come to be known as catlinite. Even so, effigy pipe carvings became more numerous in early historic sites, which strongly suggests that the acquisition of metal tools from whites stimulated the creation of effigies by Plains Indians. By the 1830s there was a virtual florescence of carving as a result of the establishment of a non-Indian market for pipes at frontier posts.

There is no evidence that anyone sought to gather information systematically about any aspect of Plains Indian sculpture be-

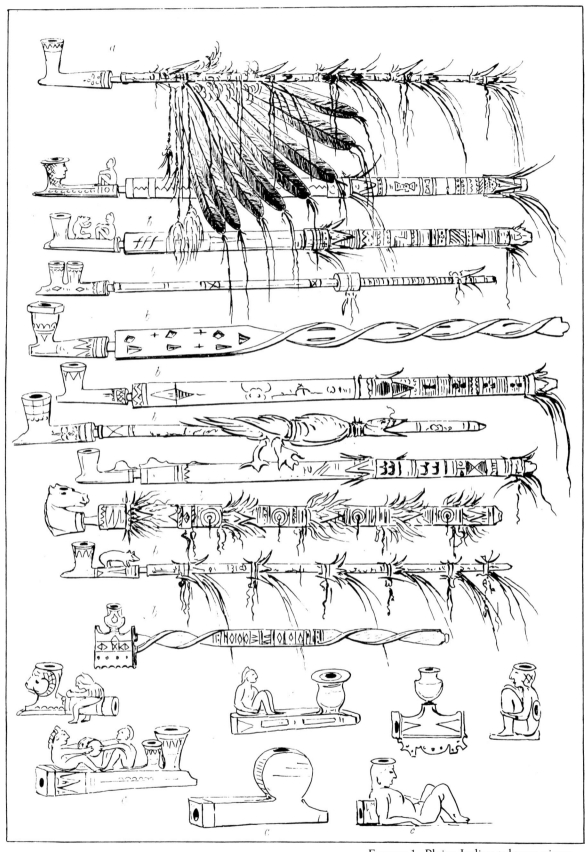

FIGURE 1. Plains Indian tobacco pipes;
outline drawings by George Catlin.
From Catlin's Letters and Notes, *1841, pl. 98.*

fore the early and middle 1830s, when the American artist George Catlin traveled widely among the tribes of the Upper Missouri and Upper Mississippi valleys. Catlin pictured a few prominent Indians holding effigy pipes as they sat for their portraits. He made a special trip westward to visit the famed pipestone quarry near present-day Pipestone, Minnesota, where Indians obtained the stone from which the great majority of Plains Indian effigy pipes were fashioned. He submitted samples of this stone to a Boston geologist, who found it to be a previously undescribed substance, described it, and named it "catlinite" in honor of the artist.

Figure 1 is the full-page plate 98 of George Catlin's classic *Letters and Notes on the Manners, Customs and Condition of the North American Indians*, published in London at his own expense in 1841. This plate shows some eighteen tobacco pipes in outline, half of them effigy pipes bearing carved representations of Indians and/or animals found in Plains Indian territory. In his book, Catlin referred briefly to tobacco pipes:

> As smoking is a luxury so highly valued by the Indians, they have bestowed much pains, and not a little ingenuity to the construction of their pipes. Of these I have procured a collection of several hundreds, and in Plate 98, have given facsimile outlines of a number of the most curious. The bowls of these are generally made of red steatite, or "pipe-stone" (as it is most familiarly called in this country), and many of them designed and carved with much taste and skill, with figures and groups in *alto relievo*, standing or reclining upon them. (Catlin 1841, vol. 1, p. 234.)

So George Catlin, himself an artist and the first student of any aspect of Plains Indian sculpture, was prepared to accept these effigy pipes as works of art "designed and carved with much taste and skill."

Not content with this brief reference to effigy pipes, Catlin some years later prepared for William Bragge, a noted English collector of objects and information from all parts of the world relating to uses of tobacco, a monograph entitled *North American Tobacco Pipes*, with illustrations of more than 100 differently executed tobacco pipes. The great majority of these Catlin identified by tribe of origin as creations of Plains Indians. In this monograph he illustrated again the ones he had pictured in 1841, but with their tribal identifications added.

I saw this illustrated manuscript in the collections of the British Museum, recognized its importance as the pioneer work in its field, and obtained permission to edit it for joint publication with my own Smithsonian Institution. It appeared in 1979 under the title *Indian Art in Pipestone, George Catlin's Portfolio in the British Museum* (Ewers 1979). In this work I added photographic reproductions of a number of effigy pipes I had seen in various museums

in this country and abroad that were very like some of those Catlin pictured. These comparisons showed that "Catlin the graphic artist, tended to render life forms a bit more freely and fluidly than did Indian carvers working within the confines of their more rigid medium." (Idem, p. 19.)

Catlin's monograph aided my studies in several ways. It revealed that as early as the 1830s, some Plains Indian sculptors had achieved a high degree of skill in carving effigy pipes, and that they offered a wide variety of styles and subjects. Compared with the achievements of Plains Indians in the graphic arts, the sculptors created more realistically proportioned and detailed human and animal figures in a greater variety of poses. Most graphic artists of that early period were content to show men and animals as stick figures lacking in lifelike proportions or anatomical details. Not so the sculptors.

Catlin further revealed that by the mid-1830s a goodly number of the finely carved effigy pipes were already in the possession of white men, some of them government officials highly respected by the Indians. One of them was William Clark, famous coleader of the first United States exploring expedition overland to the shores of the Pacific and back in 1804–1806. In 1816 Clark established an Indian Museum in a large hall attached to his residence in Saint Louis, which served a second function as a conference room where he met with important Indian delegations in his official capacity as superintendent for the western tribes.

Another white owner of the effigy pipes was Toussaint Charbonneau, interpreter for Lewis and Clark and husband of the better known Sacajawea. In Catlin's time, Charbonneau still served as official interpreter among the Hidatsa Indians on the Missouri. He seemed to prefer pipes that portrayed erotic themes. A third collector was Lawrence Taliaferro, who had been a successful agent to the Sioux and Ojibwa tribes on the Upper Mississippi for many years. Some traders on the Missouri also had effigy pipes made by Indians, as did Major James Harvey Hook, an army officer stationed in Washington, D.C., who obtained artifacts for his Indian collection through fellow officers stationed in the West. It is an interesting question to what extent Plains Indian sculptors may have been attempting certain themes in their effigy pipes especially to please their white patrons, even as early as the 1830s.

Plains Indian wood carving had a quite different history. Effigy carving in wood may have been an older art than stone carving among those Indians because wood could have been worked more easily than stone with the tools available to them before they obtained metal from whites. However, because wood deteriorates rapidly when imbedded in the ground, no wooden effigies of prehistoric or early historic times have been found in archeological sites on the Great Plains.

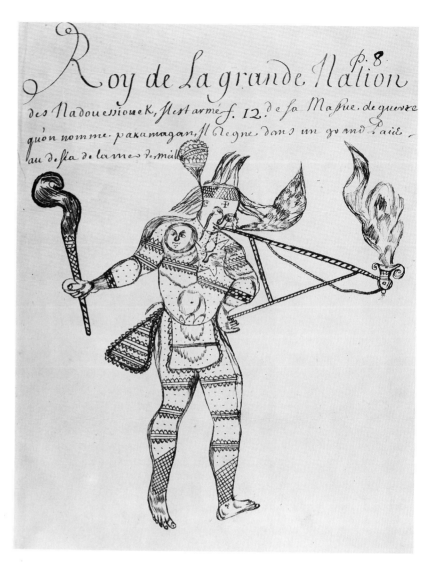

Roy de la grande Nation des Nadouessiouek, il est armé f. 12. de sa Massue de guerre qu'on nomme pakamagan, il regne dans un grand Païs, au d'ssa de la mer vermeil

FIGURE 2. King of the Great Sioux
Nation, holding a snake effigy war club;
pen-and-ink drawing attributed to
Charles Becard de Granville, ca. 1701.
The Gilcrease Museum, Tulsa.

The earliest evidence of Plains Indian effigy carving in wood
that I have found appears in the form of a pen-and-ink drawing
(figure 2) attributed to a French-Canadian cartographer, Charles
Becard de Granville, dated about 1701 and titled *Roy de la grande
Nation des Nadouessiouek* (King of the great Sioux Nation). This
leader is portrayed carrying in his right hand a wooden war club,
the head of which is carved in the form of a large snake about to
strike. This drawing may have been intended to picture Tioscate
("the first of his nation to have seen Canada"), a Sioux chief who
traveled in 1695 from his village near Mille Lacs to far-off Montreal
where he was received in a public ceremony by Count de Fron-
tenac. The chief became ill while in Montreal and died there
(Thwaites, ed. 1902, p. 178).

Another drawing of a Plains Indian holding a carved wooden
object in his right hand appeared a half century later in the form of
a decorative vignette embellishing a French map dated 1750 (figure
3). This map by the cartographer Philippe Buache was intended to
show new discoveries to the west of New France. The warrior in

16

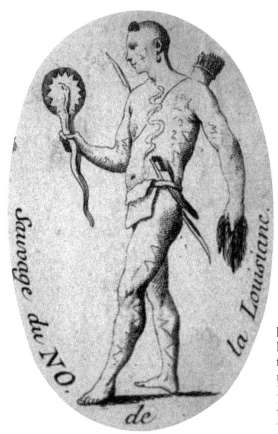

FIGURE 3. Savage of Northwest Louisiana, carrying a snake effigy mirror frame; vignette 2½″ high accompanying a map of land to the west of New France by Philippe Buache, dated April 8, 1750. *Lowery Collection, no. 394, Map Division, Library of Congress.*

the vignette is captioned *Sauvage du NO de la Louisiane* (Savage of Northwest of Louisiana). He carries a scalp in his left hand and what appears to be a long-handled mirror frame in the other, with its handle cleverly carved in the form of a writhing snake with its head at the top. This drawing also may be based upon something more substantial than an artist's imagination, for we know that as early as 1725 Etienne de Bourgmont took a delegation of Kansa Indians to visit France, where they had an audience with the great King Louis XV himself (Ellis and Steen 1974, pp. 385–405).

Specimens in museum collections and references in the literature reveal that within the historic period Plains Indians have executed many other ingenious effigies of wood that served a wide variety of purposes—from children's toys to the sacred tribal medicines of the Arapaho and Gros Ventres. These took the forms of wooden pipes with bird heads carved on them and a hoop in the shape of a snake. By and large the wooden effigies appear to have been made for the Indians' own use until near the end of the nineteenth century. Some—such as the feast bowls with effigies carved above their rims—are known to have been handed down from one generation to the next for several generations, so that they cannot be dated with a great degree of certainty.

Let us now begin this study of Plains Indian sculpture by examining the work of its earliest period.

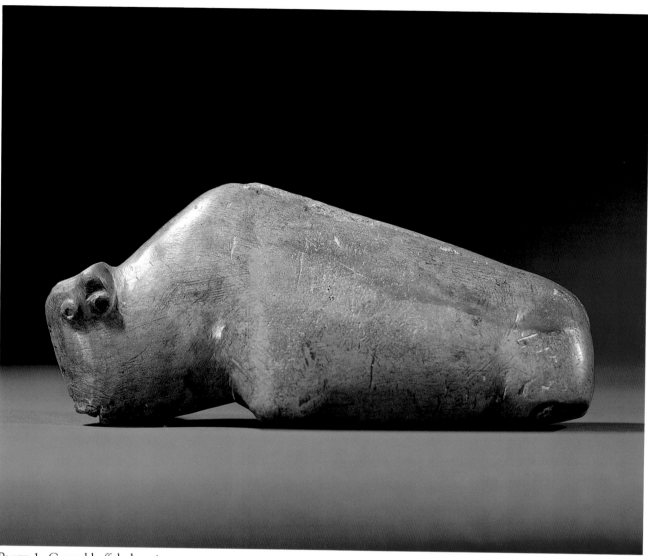

PLATE 1. Carved buffalo hunting
medicine(?) found in Wind River Valley,
Wyoming, in 1911; probably Crow, early
historic period; limestone; 8⅜" long.
Smithsonian Institution, cat. no. 431,143.

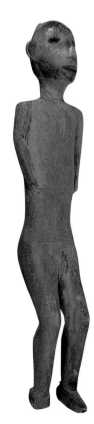

PLATE 2. Human effigy Tree-Dweller
Medicine, said to have been for 200
years in the Wabasha family; Santee
Sioux; painted wood; 6" high.
Minnesota Historical Society, cat. no. 6227/1.

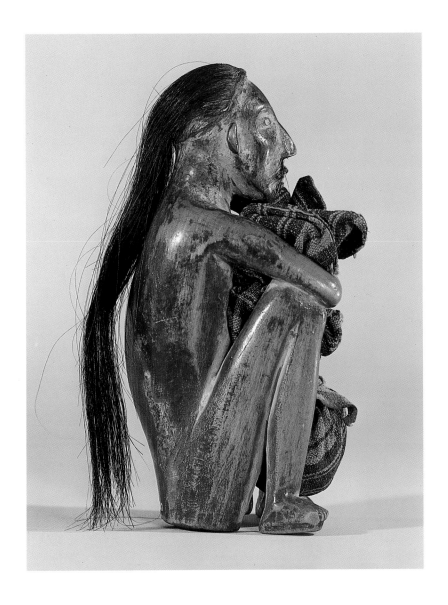

PLATE 3. Seated human figure; Caddo, probably quite old; painted wood, hair mustache and wig, holds cloth packet of medicine between legs; 6¾″ high.
Smithsonian Institution, cat. no. 378,577.

PLATE 4. Bighorn head effigy pipe; Oglala Sioux; collected in 1903; catlinite; 3½″ long, 3¼″ high.
American Museum of Natural History, cat. no. 50/4868.

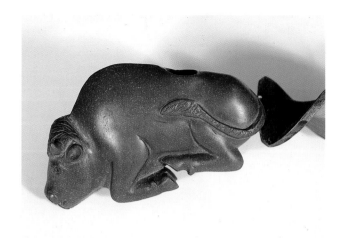

PLATE 5. Buffalo effigy pipe; "Cut by Indians of Dakotahs, 1872"; catlinite; 4⅛″ long.
Missouri Historical Society, St. Louis, acces. no. 1953.131.5.

PLATE 6. Horse head pipe; Old War Department Collection, before 1841; probably Santee Sioux; catlinite; 4⅛″ high.
Smithsonian Institution, cat. no. 6,019.

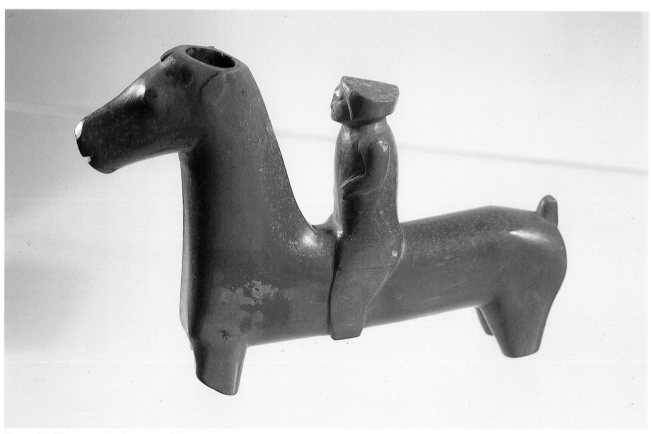

PLATE 7. Horse and rider pipe; Sioux; from White Swan, Fort Randall, 1884; catlinite; 5⅛″ long, 3⅛″ high.
Minnesota Historical Society, cat. no. 6020.1

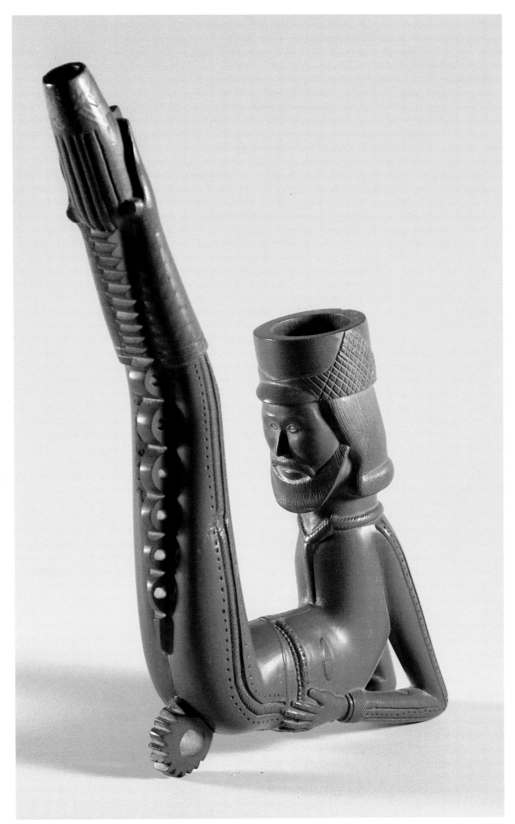

PLATE 8. Portrait of Rev. Moses Adams;
by Santee Sioux Indian, ca. 1875;
catlinite; 9½″ high.

*Minnesota Historical Society, cat. no. 3325/
E342.*

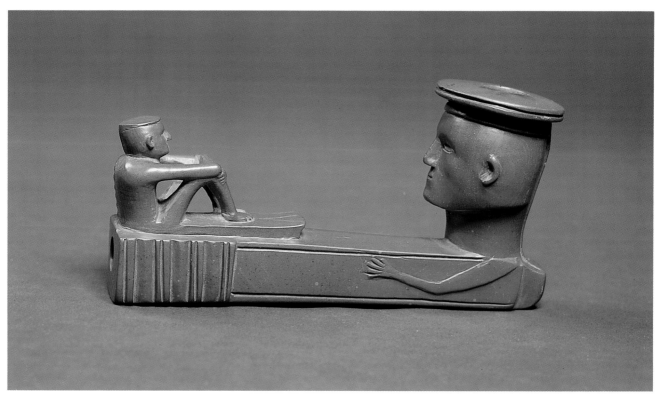

PLATE 9. "Not afraid to look the white man in the face"; Oto, probably 1820–1850; catlinite; 6¼″ long, 3″ high.

Museum of the American Indian, Heye Foundation, cat. no. 12/889.

PLATE 10. Chief offering liquor to follower; Santee Sioux, Old War Department Collection, before 1841; catlinite with lead inlay; 7¾″ long, 3⅝″ high.

Smithsonian Institution, cat. no. 2,622.

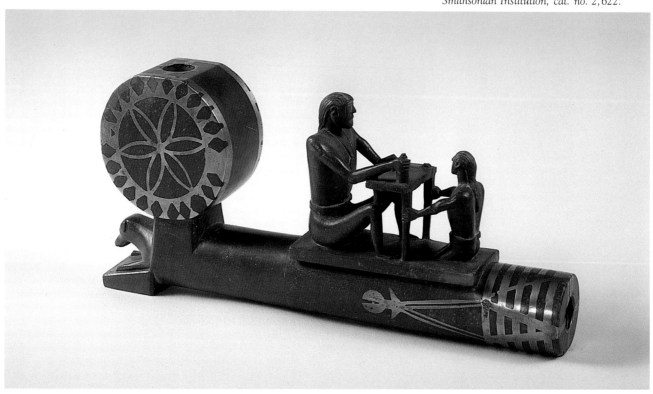

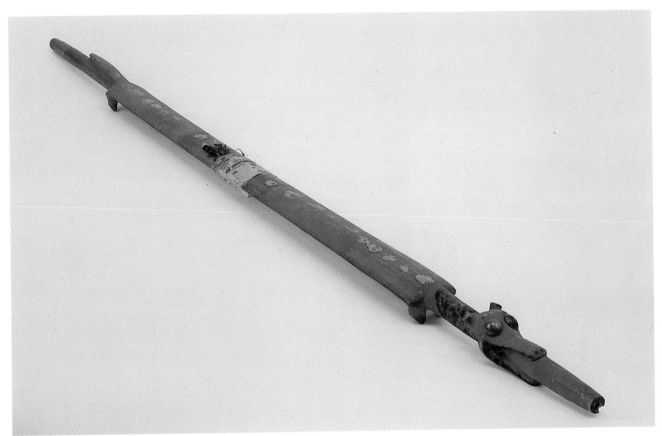

PLATE 11. Canine effigy pipe stem; Santee Sioux, collected by Dr. Nathan Jarvis in mid-1830s; painted wood, brass-tack eyes; 26″ long.
The Brooklyn Museum, cat. no. 50.67.85.

PLATE 12. Buffalo-turtle-bighorn effigy pipestem; Sioux, accessioned 1912; ash wood, wrapped porcupine quills, feathers, and ribbon; 28½″ long.
Smithsonian Institution, cat. no. 275,754.

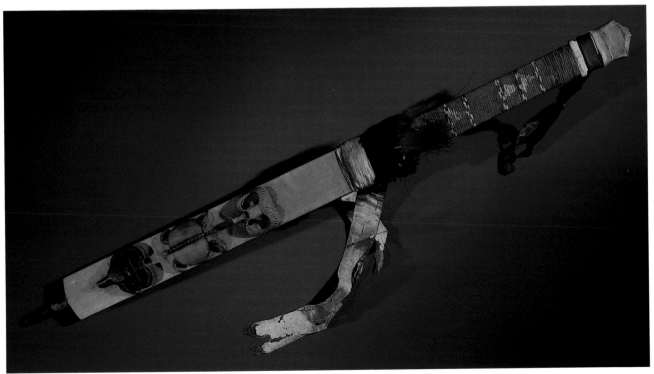

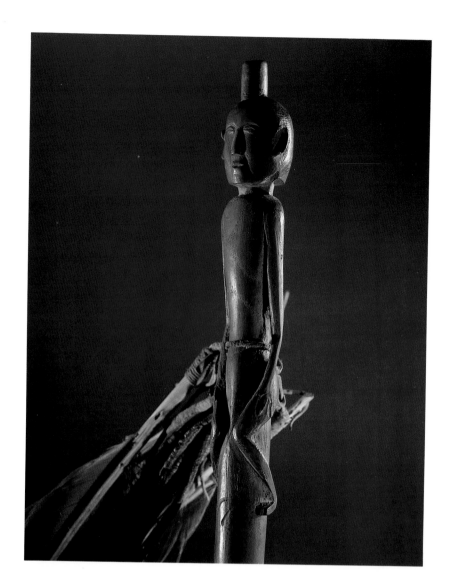

PLATE 13. Human effigy pipestem (detail); attributed to Tall Bull, Cheyenne chief, Summit Springs Battlefield, July 11, 1869; painted wood, pendant eagle feathers; human figure 6⅞″ high.

Smithsonian Institution, cat. no. 13,477.

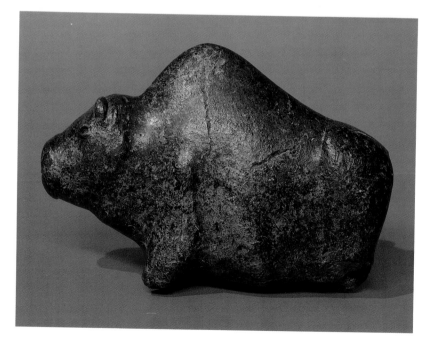

PLATE 14. Buffalo effigy, probable hunting medicine; found near Ardmore, Alberta, in historic Plains Cree territory, 1959; quartzite; 9″ long, 6½″ high.

Glenbow Museum, Calgary, cat. no. AX 70.

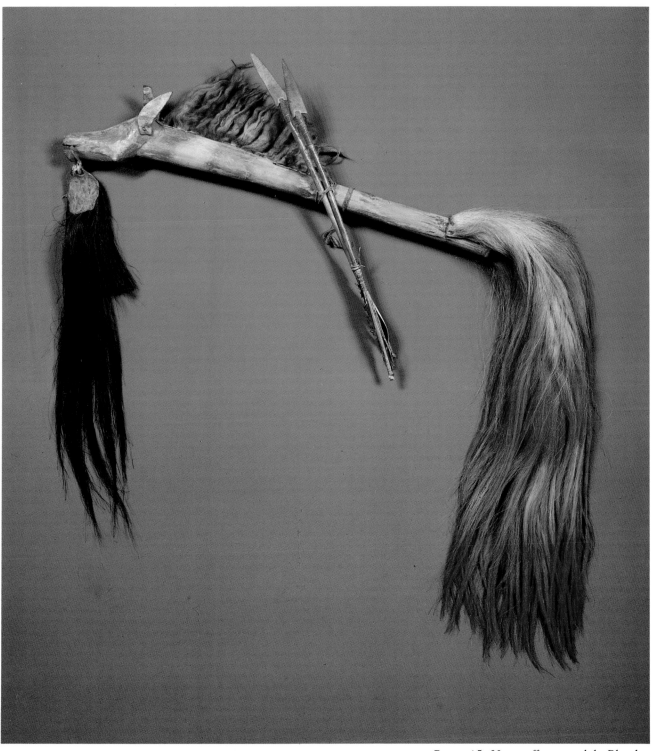

PLATE 15. Horse effigy war club; Blood, collected by Clark Wissler, 1905; painted wood, leather ears, buffalo hair mane, horsehair tail, pendant scalp; wood portion 28″ long.

Museum für Volkerkunde, Berlin, cat. no. IV B 8143.

PLATE 16. Human effigy war medicine
from Sun Dance Bundle; Crow, collected
in 1923; painted cottonwood, seed bead
necklace; 10¾″ high.

Museum of the American Indian, Heye
Foundation, cat. no. 12/3101.

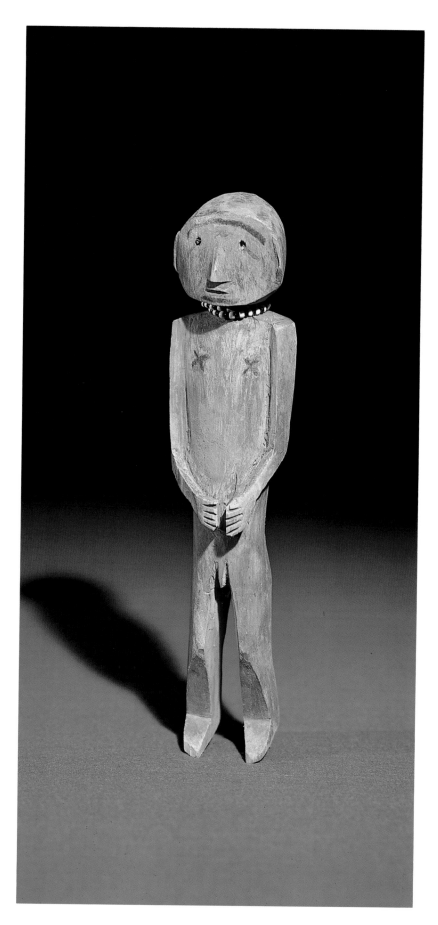

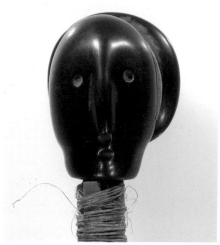

PLATE 17. Human effigy war pipe of
Wind Gens; Osage, collected by Francis
La Flesche, 1913; calcite, red paint in
eyes; 2⅜″ long.

Smithsonian Institution, cat. no. 276,133

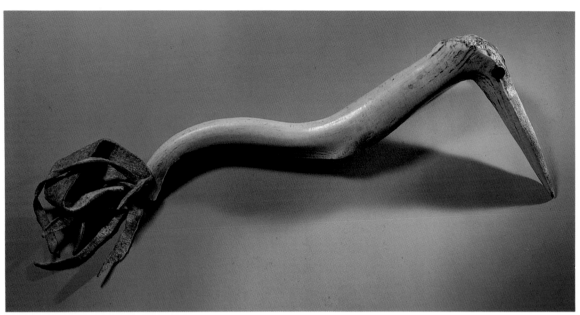

PLATE 18. Bird effigy war club; Sioux, Catlin Collection, 1830s; elk antler, brass button eyes; 19″ long.
Smithsonian Institution, cat. no. 73,278.

PLATE 19. Weasel effigy war club; Oto, collected in 1876; painted wood, dewclaw pendant on buckskin; 25″ long.
Smithsonian Institution, cat. no. 22,419.

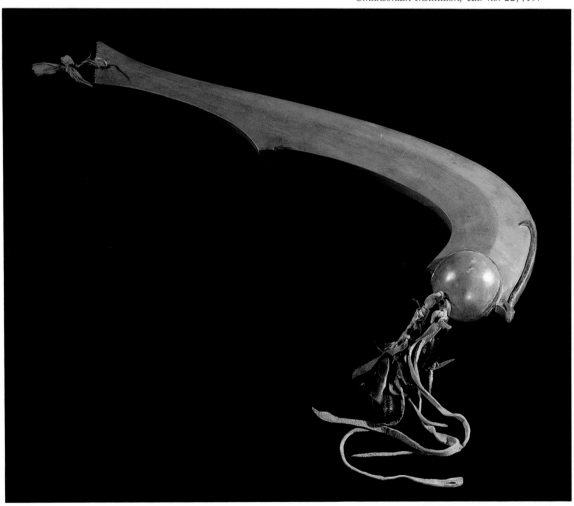

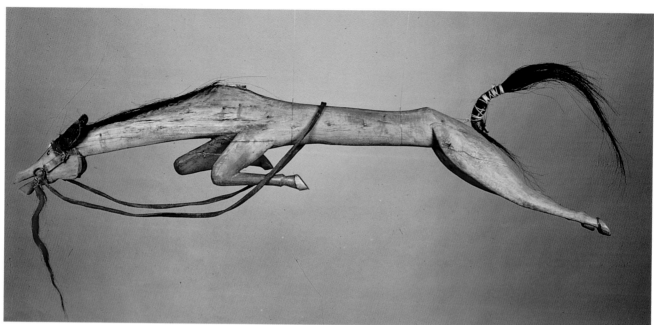

PLATE 20. Horse effigy dance stick; Teton
Sioux, collected 1884–1910; painted
wood, leather ears and reins, horsehair
mane and tail; 37¼″ long.

Robinson State Museum, Pierre, South Dakota,
cat. no. 74.2.122.

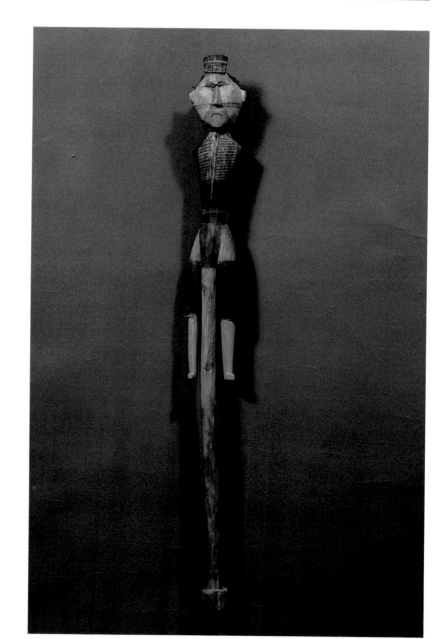

PLATE 21. Human effigy victory dance
stick; Teton Sioux, collected 1876–1887;
painted wood; 24½″ long.

Smithsonian Institution, cat. no. 376,361.

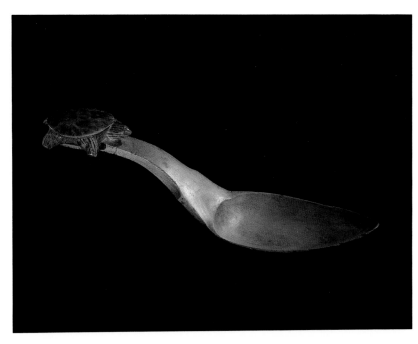

PLATE 22. Turtle effigy doctor's spoon; Sioux, collected in 1863; painted wood; 11″ long.
Smithsonian Institution, cat. no. 76,832.

PLATE 23. Elk effigy whistle; Sioux, accessioned 1899; wood, painted red and black, brass-tack eyes; 25½″ long overall, head only 7¼″.
Smithsonian Institution, cat. no. 200,588.

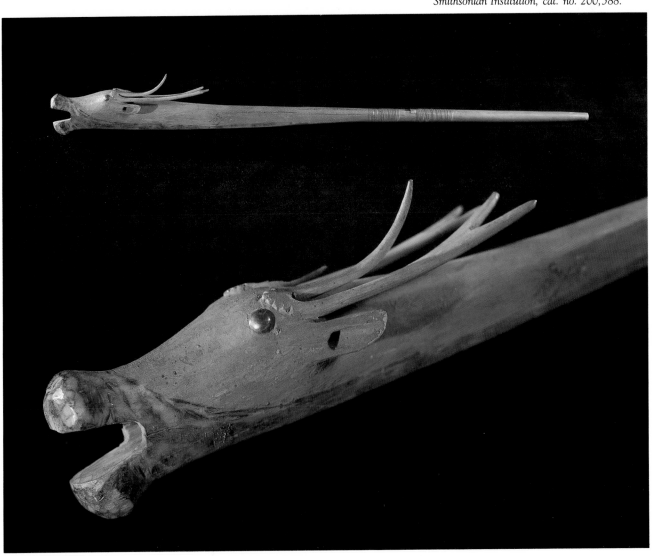

PLATE 24. Snipe effigy whistle; Hunkpapa
Sioux, late-nineteenth century; painted
ash wood, sinew binding, brass-tack eyes;
27″ long.

Smithsonian Institution, cat. no. 287,028.

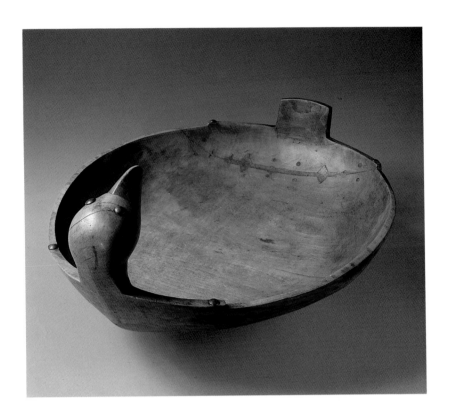

PLATE 25. Bird effigy feast bowl; Blackfoot Sioux, before 1865; painted wood, brass-tack eyes; 15″ in diameter.
Peabody Museum of Archeology and Ethnology, Harvard University, cat. no. 9,829.

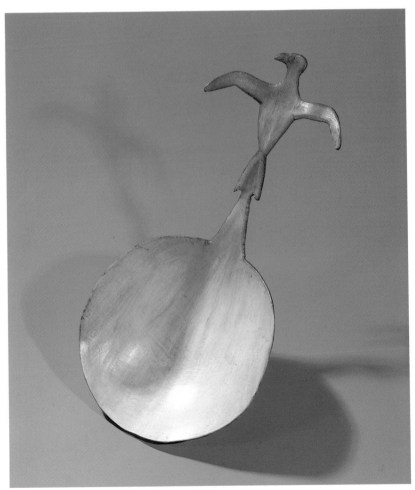

PLATE 26. Thunderbird effigy spoon; Sioux, Poplar River, Montana, before 1894; horn painted orange; 8¾″ long.
Smithsonian Institution, cat. no. L52.

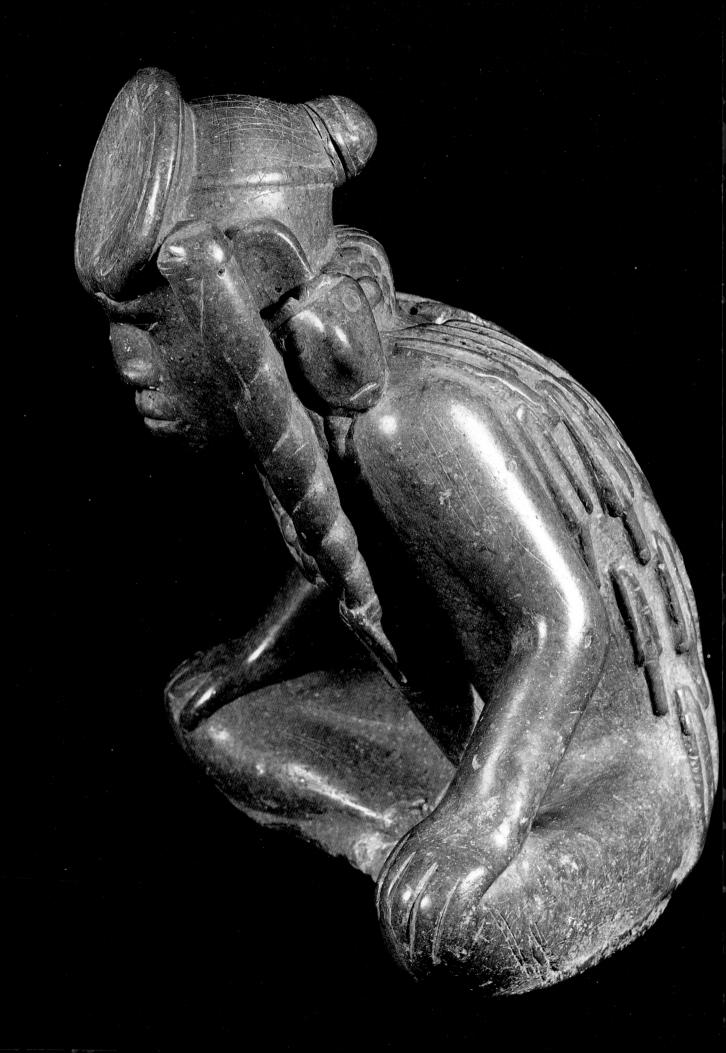

Plains Indian Sculpture before 1830

When we consider that the Great Plains were the home of big-game-hunting Indians for thousands of years before the European discovery of America, and that archeologists have explored their camp and village sites in this vast region for many years—most intensively since World War II—it is remarkable that the finds of sculptured life forms created in prehistoric and early historic times have been few in number and relatively quite recent.

If we survey the entire continent east of the Rocky Mountains, we find that the centers where prehistoric Indians fashioned many fine examples of carvings in miniature were to the east of the Great Plains—among the mound builders, who lived in sizable villages and practiced agriculture. One such center existed in the Ohio Valley among the Indians of the Hopewell Culture as early as the beginning of the Christian Era. Caches of stone tobacco pipes, many in the form of finely conceived and skillfully carved effigies, have been found buried in the mounds with the remains of their prominent men. These pipes attest to the Hopewell sculptors' remarkable talent for carving in miniature the essential forms and characteristic poses of the smaller animals, birds, and reptiles of their region. They also give evidence to the carvers' close observation of nature as well as their artistic abilities. Although these Indians preferred to carve aquatic animals and birds, they also created the smaller land animals and a few men's heads—executed with the same close attention to proportions and details as were their likenesses of the wild creatures. They mounted these figures on broad, flat platforms on the pipes, oriented so as to face the smoker.

Figure 4 reproduces one of these platform pipes, found in the

FIGURE 4. Human head effigy pipe; Mound City Group, near Chillicothe, Ohio; Hopewell Culture, 200 B.C.– A.D. 1.
After Squier and Davis 1846, fig. 145.

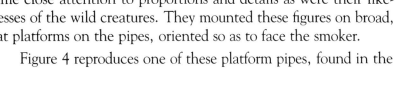

FIGURE 5. Human effigy pipe; popularly known as the "Big Boy" pipe; Spiro Mound, Oklahoma; Mississippian Culture, A.D. 1200–1350; 10¾" high.
University of Arkansas Museum.

33

FIGURE 6. Snake or mammal head pipe; Site WN5-22 Washington County, Nebraska; Nebraska Phase, A.D. 1175–1450; catlinite, shell inlaid eyes; 2¾″ long, 1⅝″ high.

Nebraska State Historical Society, cat. no. WN5-228.

altar mound of the Mound City Group near Chillicothe, Ohio, and pictured by E. G. Squier and E. H. Davis in their classic study, *Ancient Mounds of the Mississippi Valley*, the Smithsonian Institution's first scientific monograph, published in 1846. The authors praised this fine carving of a man's head as "unsurpassed by any specimen of ancient American art . . . not excepting the best productions of Mexico and Peru." (Squier and Davis 1846, p. 246 and fig. 145.)

Later in the prehistoric period another variant of moundbuilder culture, termed Mississippean by archeologists, developed in the Southeast. The bearers of this culture, which dated from about A.D. 700 to 1700, built their temples atop tall mounds and also raised food crops. Its outstanding centers of artistic activity were far-flung—from Etowah in northern Georgia, to Moundville in central Alabama, to Spiro in far eastern Oklahoma. These Indians also demonstrated a remarkable talent for carving stone pipes, which usually were larger and heavier than those of the Hopewell sculptors. Typically, the carved figures on these pipes faced forward, or away from the smoker. A number of them portrayed the full figure of a man in a kneeling or sitting position. One of the most impressive of these Mississippian effigy pipes is shown in figure 5. It is from the Spiro Mound, dating from A.D. 1200–1350. This prehistoric masterpiece, popularly referred to as the "Big Boy" pipe, depicts a warrior seated with his body bent forward and his hands on his knees in a very lifelike pose. His facial and bodily features are clearly defined, as are his ornaments, including an elaborate headdress and carved shell ear decorations portraying the mythical "Long-nosed God."

In a paper on *The Hopewell Complex of Ohio*, Olaf H. Prufer has suggested that the Hopewellians were the ancestors of the Algonquian-speaking peoples of the Ohio Valley (Prufer 1964, pp. 82–3). The Mississippians are regarded as ancestral to both the Siouan and Caddoan tribes. Indeed, the Indians who developed the Spiro Center in eastern Oklahoma are thought of as late prehistoric Caddoans—members of the same language family as the historic Caddo, Wichita and Pawnee Indians.

There can be no doubt that both the Hopewell and Mississippi cultures extended their influences westward across the Mississippi River in prehistoric times, and left their marks upon the lifeways of the prehistoric and early historic inhabitants of the Great Plains who carved pipe figures that might face the smoker in the Hopewellian tradition or away from the smoker in the Mississippian one.

Two small pipes from prehistoric sites in Nebraska and South Dakota reveal that effigy pipes of stone were known to Indians liv-

ing in the middle Missouri River Valley before the first white explorers appeared in that region. One of these is from Site WN5 in Washington County, extreme east-central Nebraska, which was surveyed by the Nebraska State Historical Society in 1938 and first described by Paul Cooper in the following year (P. Cooper 1939, p. 121, and pl. X, fig. 7). Preserved in the Nebraska State Historical Society and illustrated in figure 6, this little pipe is only 2¾ inches long and 1⅝ inches high. It is made of catlinite in the form of an elbow pipe with a projecting prow carved in the shape of the head of a mythical horned serpent or a mammal—depending upon whether the viewer chooses to interpret the pair of forward extensions at the top of the creature's head as horns or ears. An incision defines the rather large mouth, small circular indentations indicate a pair of nostrils, and circular shell fragments set into shallow sockets in the stone serve for eyes. Archeologists assign the site where this effigy was found to the Nebraska Phase, which they date some 900 to 525 radiocarbon years ago (Blakeslee and Caldwell 1979, p. 20, and pl. 9, fig. e).

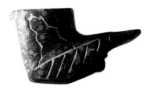

FIGURE 7. Bird effigy pipe; Talking Crow Site, Buffalo County, S.D.; Campbell Creek Phase, A.D. 1425–1500; catlinite; 1½″ long, ⅞″ high.
Museum of Anthropology, University of Kansas, cat. no. 16273.

The second pipe, pictured in figure 7, was found by Carlisle S. Smith, archeologist of the University of Kansas Museum, during his excavation of the Talking Crow Site in Buffalo County, South Dakota, during the years 1950–52. It was in a cache pit associated with pottery belonging to the Campbell Creek Phase, which Smith dated ca. 1425–1500 (Smith 1977, pp. 87, 152, and fig. 23). Carved of spotted catlinite in the form of a bird, which the finder identified as a prairie falcon, this pipe is even smaller than the one from Nebraska, only 1½ inches long and ⅞ inches high. The opening of the tobacco chamber is in the top of the bird's head. A small notched node defines the bird's beak, and the eyes are marked by two conical holes from which zigzag lines diverge downward, suggesting to the finder the feather color pattern of the prairie falcon. The throat is marked by five horizontal incisions, and the wings are rendered in low relief slanting upward from the breast and are marked with diagonal incisions. The tail projects backward over the pipe's hole to receive the stem, but the underpart of this recess is missing. The viewer must be impressed by the prehistoric carver's skill in rendering on so small a scale this highly stylized, simplified form with such a delicate touch.

These two pipes differ in theme and style of rendering life forms, yet they are alike in two noteworthy respects. Both have the effigies facing *away* from the smoker in the Mississippian tradition, and both are carved of red stone—presumably catlinite from the famous red pipestone quarry site in Minnesota. Although catlinite reached the village tribes of the Middle Missouri as early as A.D. 900–1400, we do not know whether these Indians "made trips to the quarries to obtain catlinite, as some village groups did in his-

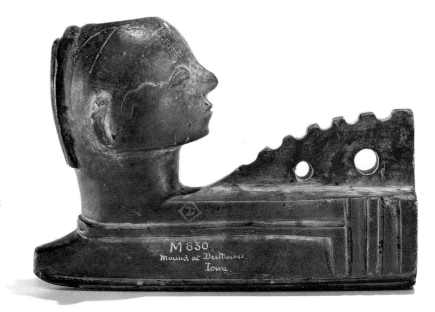

FIGURE 8. Human head effigy pipe; "From mound at Des Moines, Iowa," probably Chippewa origin, late eighteenth century; Wisconsin catlinite, 4⅜" long, 3" high.

American Museum of Natural History, cat. no. DM830.

toric times" or whether the stone may "have come to them via intermediate nomadic groups." (Wood 1974, pp. 12–13.) Equally uncertain is whether these effigy pipes were carved by Indians living nearer the pipestone quarry and traded to the Missouri Valley villagers, or whether the latter obtained the stone in the form of blanks from which they created their own pipes.

This same uncertainty applies to some effigy pipes in use among tribes living east of the quarry site in the early historic period. As early as 1710 Antoine Raudot, a French observer of the Indian tribes of the western Great Lakes, reported that the red stone calumet came from the country of the Sioux and "has the shape of some animal or axe to adorn it." (Raudot, in Kinietz 1940, pp. 346, 378.) But Raudot did not identify the Indians who carved those animals on the pipes.

We can be more sure of the tribal affiliation of the carver of the striking human head on a larger effigy pipe pictured in figure 8. In 1882 this pipe was listed in the catalog of Edwin A. Barber's large collection of tobacco pipes deposited in the Pennsylvania Museum and School of Industrial Art in Philadelphia as "Item 150. Sculptured Pipe—human head facing smoker, olive and brown stone, resembling Catlinite. From a Mound at Des Moines." (Barber 1882.) In that year A. E. Douglas of New York City purchased this pipe and others from Barber's collection for his large archeological collection, which passed to the American Museum of Natural History in 1899. This pipe still bore the old Douglas number M830 when I first saw it in 1972.

Because Barber was a serious scholar and the author of several informative articles on American Indian tobacco pipes during the early 1880s, there is little reason to doubt his statement that this

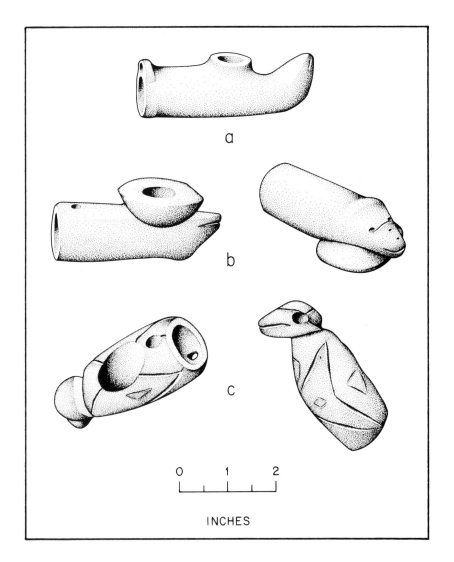

a

b

c

0 1 2

INCHES

FIGURE 9. Three effigy pipes of catlinite from the Utz Site, Saline County, Mo.: a. Indefinite animal head; b. Indefinite animal head (two views); c. Bird effigy pipe (two views).
Drawings by George R. Lewis, after Hamilton 1967.

pipe was found in a mound in Iowa. But surely it must have been intrusive. That "olive and brown stone" of which he said it was carved is the variety archeologists know as "Wisconsin catlinite." The pipe's Wisconsin origin is identified by the appearance of the effigy itself. The hairdress and general treatment of the head and neck, combined with a serrated crest above the shank, resemble closely those features on an effigy pipe of the 1760–1820 period from Madeline Island, a part of northwestern Wisconsin on Lake Superior. A principal settlement of the Chippewa or Ojibwa Indians was located on that island during those years. The archeologist George Quimby illustrated that Chippewa pipe, so like the one from Iowa we are considering (Quimby 1966, fig. 31). It is noteworthy that this historic period pipe of Algonquian origin positions the effigy to *face* the smoker, following the ancient Hopewellian tradition. The carver of this finely shaped and detailed head must have had access to sharp tools made from metal obtained from traders. There are holes bored in the effigies' ears from which metal ear ornaments may once have been suspended.

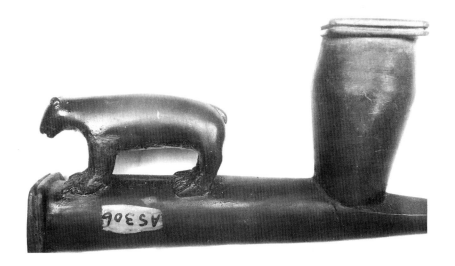

FIGURE 10. Bear effigy pipe; Pike-Pawnee Village site, Webster County, Neb.; Republican Pawnee, ca. 1775–1815; catlinite; 4¾" long.

Nebraska State Historical Society, cat. no. AS306.

During the period 700–1300, the Oneota Culture extended across the Mississippi into Iowa, Missouri, and Kansas. Archeologists consider the Oneontas to have been late prehistoric and early historic Siouan-speaking Indians, represented by such tribes as the Iowa and the Missouri. A characteristic pipe form of that culture had a flat, horizontal disk at the top, through the center of which the tobacco chamber was bored. This feature caused archeologists to refer to these as "disk pipes."

Pipes combining disks with rather elementary zoomorphic effigy carvings have been found in Iowa and Missouri. One of them, from the Upper Iowa River Valley, has an inverted animal head carved on the prow rendered in terms too general to identify its species (Mott 1938, pl. 11-g). Similar effigy pipes have been found at the Utz Site in Saline County, Missouri, believed to have been the large village of the Missouri tribes from "at least 1673 to about 1790." (Hamilton 1967.) Two of these pipes are shown in figure 9a and b. Both are very small—less than three inches long—and are carved of catlinite, a stone that does not appear to have reached the Indians of this region before Oneota times.

Evidence that this small disk pipe with an inverted effigy head carving was more widely diffused among the tribes of the Great Plains was found in the excavation of the Potts Village Site, Oahe Reservoir, in north central South Dakota (Stephenson 1971, p. 70, pl. 32, fig. 0).

Another catlinite pipe from the Utz Site was cleverly carved in the form of a semi-abstract bird (two views of it appear in figure 9c). The generalized head with incised mouth and deeply bored circular eyes is separated from the body by a constricted neck. The most birdlike features of this carving are the broad incisions representing wings folded close to the body. The tobacco chamber is a wide and deep hole in the bird's back that connects with a large,

circular hole for insertion of the pipestem. One must admire this carving as a simple statement of birdlike qualities in stone. I am indebted to the late Henry Hamilton for photographs of the effigy pipes from the Utz Site from which these drawings were made.

A well-documented effigy pipe of the pre-1830s period appears in figure 10. It was found in the spring of 1924 by A. T. Hill at a village site on the Republican River in Webster County, Nebraska, about five miles southwest of Guide Rock. Hill and his colleagues from the Nebraska State Historical Society identified this as the site of the Republican Pawnee village, occupied from about 1775 to 1815, which was visited by the American explorer Lieut. Zebulon M. Pike from September 25 to October 7, 1806. Hill described the circumstances of his finding this pipe:

> In the grave of a child of eight or ten years was found a beautiful pipe of the rarest workmanship. . . . The complete skeleton of an eagle rested upon the child's breast, showing how high was the esteem of this little one and how deep the love of those who laid the child away. Not one article in this deep grave was found which had come from white traders. (Hill 1927, pp. 164–65.)

The well-carved figure of a bear standing atop the shank of this pipe is about two inches long. The carver accented the bearlike characteristics of this animal in its heavy claws and stubby tail. This pipe must have been carved by a Pawnee sculptor at least seventeen years before George Catlin met the Pawnee Indians at or near Fort Leavenworth in 1832. Catlin praised the achievements of Pawnee effigy pipe carvers: "The Pawnees and Sioux manufactured more pipes of red stone than any of the other tribes, and the Pawnees may be said to be the most ingenious of the two, for design." (Ewers 1979b, p. 34.)

Figure 11 pictures a smaller catlinite pipe from the same site and further illustrates the inventiveness of Pawnee sculptors of the pre-1815 period. This pipe type—in the form of a simple stone tube—was known to my Blackfeet informants as a "straight pipe," and was both old and widespread among American Indians. This one is very small, less than an inch and a half in length, and the human head carved in relief on one side is less than half the length of the tube. The masklike appearance of the face is enhanced by its broad and deep-cut outline, causing it to stand out sharply from its background of the same color and material. The carver of this minute head took pains to render the nose in relief with both eyes and mouth open.

Archeologists have found effigy carvings that served functions other than the decoration of tobacco pipes in other prehistoric and early historic sites on the Great Plains. Some of these offer further proof of the widespread influence from east of the Mississippi. From

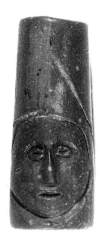

FIGURE 11. Human head effigy pipe; Pike-Pawnee Village site, Webster County, Neb.; Republican Pawnee, ca. 1775–1815; catlinite; 1⅛″ long.
Nebraska State Historical Society, cat. no. 1572.

Calf Mountain Mound in Manitoba was retrieved a mask gorget of shell bearing lightly carved, stylized human features, and an incised "weeping eye" motif such as appear on ceremonial objects of the Southern Cult from the mounds of Etowah, Georgia, and Moundville, Alabama. The gorget from Calf Mountain may represent the northwesternmost occurrence of one of these Southern Cult objects. It is preserved in the Royal Ontario Museum in Toronto, and has been illustrated in Waldo R. Wedel's *Prehistoric Man on the Great Plains* (Wedel 1961, pl. 20).

That same valuable source also illustrates shell and bone ornaments from Middle Missouri River sites and bone carvings of generalized bird heads from Mandan sites (Wedel 1961, pl. 4 and 15). Small birds and animals of cut shell have been found in numerous prehistoric and early historic sites on the Missouri. Some of them have holes drilled near their upper edges suggesting that they were worn as pendants. The birds with extended wings may have been intended as thunderbirds, those mythical sky creatures Indians credited with the power to cause destruction on earth by dispatching bolts of lightning.

Figure 12 illustrates selected shell and bone carvings from the Deapolis Site, the location of the Mandan Village on the south bank of the Missouri visited by Lewis and Clark in 1804 and 1805. Its dates of occupation have been estimated at from "about 1787 to 1822." (Lehmer, Wood, and Dill 1978, p. 429.)

Archeologists have speculated about the use of the small, carved bone heads of birds with attached handles of varying lengths found in Mandan sites. When first described during the first decade of this century, students speculated that they were objects of religious or ceremonial use (Brower 1904, p. 114; Will and Spinden 1906, pp. 172–73). I shall speculate further by suggesting that these bird effigies may have served some symbolic function in the ceremonies of the women's Goose Society conducted in the fall of the year, when geese flew south, and the following spring, when they returned, to remind the women that it was time to plant corn.

The German explorer, Prince Maximilian of Wied-Neuwied, reported that the Mandan women celebrated "the spring corn feast" on April 2, 1834, when he was with the tribe. Twenty-four years later (on September 25, 1858), the trader Henry A. Boller observed: "The Mandan women made their Goose Medicine today, on the prairie in the rear of Fort Berthold. This is to remind the wild geese now beginning their annual flight to the south that they have plenty of food, and have been well treated, and begging them to return in the spring." (Boller 1966, p. 132.) During his fieldwork among the Mandans in the 1930s, Alfred Bowers recorded a legend of the founding of their Goose Society by Good Furred Robe, a member of the family who first brought corn to the Mandan Indians (Bowers 1950, pp. 194–96).

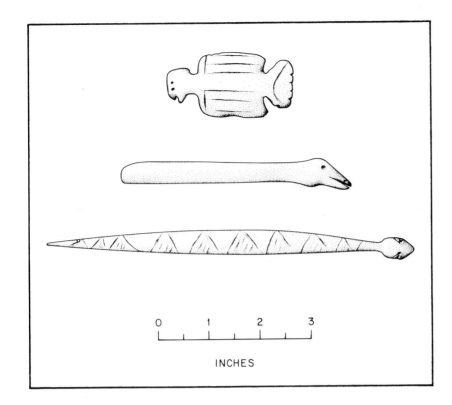

INCHES

FIGURE 12. Shell and bone effigies from the Deapolis Site 32ME5 on the Missouri River, N.D., Mandan Village of ca. 1787–1822. Top: Eagle or thunderbird of shell; center: bird head at end of handle of bone; bottom: snake effigy of bone. *Ralph Thompson Collection, North Dakota State Historical Society. Drawing from photographs by George W. Lewis.*

The occurrence of these carved bone bird heads farther down the Missouri in sites of the Mill Creek Culture in northwestern Iowa, which may date back as far as A.D. 1000, is one of several resemblances between that earlier culture and early historic Mandan culture that have caused archeologists to suggest that this "may represent the locality from which the ancestral Mandans started their movement onto the Plains and up the Missouri to their historic habitat in the Dakotas." (Wedel 1961, p. 99.) Evidence of the cultivation of corn and other crops has been found in Mill Creek sites. May we not speculate further, then, that the carved bird head had the same symbolic reference to the growth of corn in the ceremonies of the earlier Mill Creek people that it may have had for the historic Mandans?

There is evidence also that the nomadic tribes of the northern Great Plains, who did not cultivate the soil, had carved effigies symbolically associated with their major food quest—the communal hunting of the buffalo, their staff of life.

Figure 13 pictures a buffalo carved of limestone 8⅜ inches long and 3¾ inches high, weighing three pounds, in the collections of the Smithsonian's Department of Anthropology. This effigy was found by Glenn M. Staley, a geologist of the U.S. Geological Survey, in the course of field work in central Wyoming in 1911. It was partially exposed in the wall of a dry wash emptying into the Wind River about sixty miles northwest of Riverton, Wyoming. It was presented to the Smithsonian Institution in 1961 by Staley and Dr. W. E. Wrather, both of whom admired it as a work of art.

Plains Indian Sculpture before 1930

Colorplate 1 pictures this carved buffalo from its left side, on which the eye, ear, and horn are more precisely defined. Despite its small size, the effigy has a monumental character that is not diminished by the fact that the piece of stone from which it was fashioned permitted the legs to be represented only as short stubs. The shape of the stone also lent itself to an exaggeration of the animal's length in proportion to its height. Its Indian creator has provided an impressive interpretation of a massive and powerful animal with which he surely must have been well acquainted. Marks visible on the right side of the buffalo's belly may indicate that it was carved with metal tools, which probably did not reach the Indians of this interior region before the eighteenth century.

In 1862 Robert Meldrum, who had long been a prominent trader among the Crow Indians and was married into that tribe, told Lewis Henry Morgan that it was the practice of those Indians to rebury their honored dead at the foot of the Rocky Mountains farther west. "They remove or take them from the scaffold, tie them up in a bundle first of scarlet cloth, if they have any, and around this a lodge of skin, and then carry them on horseback for hundreds of miles to the mountains, where they will place them in clefts in the rocks or in crevices where they will be sheltered from the rain and snow." (Morgan 1959, p. 171.) Furthermore, it is known that the Wind River Valley was a favorite wintering location for the Crows during the early years of the nineteenth century. Presumably then, this buffalo effigy was washed down from its position in a decayed bundle burial in the rocks higher up.

In a later section of this book we shall consider a number of other stone effigies of buffalo, similar in size but different in detail from this one, and their presumed use as hunting medicines. (See pp. 123–26.) Suffice it here to present this fine effigy as a symbolic

FIGURE 13. Carved buffalo hunting medicine(?) found in Wind River Valley, Wyoming, in 1911; probably Crow, early historic period; limestone; 8⅜" long. *Smithsonian Institution, cat. no. 431,143.*

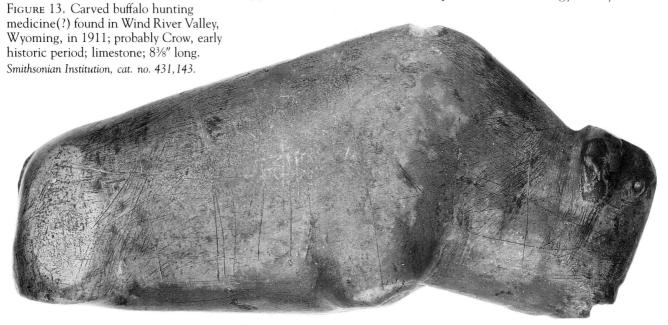

medicine that may have been used in buffalo-calling rites by the Crow Indians.

A much smaller buffalo effigy fashioned from a fossil cephalopod accompanied the burial of an older female in the cemetery of the double village of the Arikara Indians on the Missouri in South Dakota. This was the village whose people Gen. Henry Leavenworth sought to punish in the United States Army's first military campaign against any Plains Indian tribe, in 1823. Here again—in spite of the tiny size of the effigy—less than 1¾ inches long—its Indian creator managed very well to suggest the head and body of a buffalo (figure 14).

When I first saw this little carving in 1965 I was inclined to look upon it as a good luck charm of the woman with whom it was buried, because I had seen fossils of about this size among the Blackfeet Indians that were intended to bring good fortune to their owners. The Blackfeet knew these fossils as "buffalo stones," even though the resemblance of some of them to that animal was not obvious. However, Preston Holder, a man of considerable fieldwork experience among the Arikara, who was with me at the time, told me that his Arikara informants had explained to him that their magicians had used little effigies of this kind in sleight-of-hand performances during which they pretended to swallow or otherwise hide the effigies from view and later recovered them to the amazement of their onlookers. Support for that interpretation of the use of this little buffalo may be found in the writings of Pierre-Antoine Tabeau, a fur trader who lived among the Arikaras as early as 1804–5. He reported the ability of Kakawita, the chief of the Arikara village in which he resided, to astound his fellow tribesmen with his feats of sleight-of-hand magic (Tabeau 1939, pp. 183–89). Whatever the function of this tiny buffalo effigy in Arikara culture, it seems unlikely that it was a mere toy.

As indicated earlier, the lack of wooden effigies in prehistoric and early historic sites occupied by Plains Indians must not be interpreted as proof of the absence of the art of effigy carving in wood among those Indians in early times. We have seen in figure 2 a French artist's drawing of a snake effigy war club in the hand of a leading Sioux chief in about 1701. I have learned of no Sioux carvings of life forms in wood that were collected before 1823. In that year Constantine Beltrami, an exiled Italian lawyer exploring the headwaters of the Mississippi River in present-day Minnesota, obtained a bird-head whistle and fish-head end flute from Indians of that region who may have been Sioux. (See descriptions on pp. 160–61 and 162.)

Even so, an Eastern Sioux wooden figure that may date back to the eighteenth century is pictured in colorplate 2. This painted carving of a man standing with bent knees gives emphasis to the head on which the facial features are clearly defined—including a

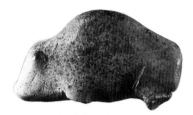

FIGURE 14. Buffalo effigy, from burial in Leavenworth Site Cemetery, S.D.; Arikara, 1803–1832; fossil cephalopod; 1¾″ long.

William L. Bass Collection, Department of Anthropology, University of Tennessee.

decidedly Roman nose. The body is elongated, while the arms, rendered in low relief at the sides, lack hands. Compared to the head size and the length of the torso, the legs are quite short. William R. Faribault, the son of a prominent Indian trader in the Minnesota region as far back as 1828, collected this figure before 1890. It was said to have been "200 years in the Wabasha family." That would have taken it back beyond the time of the first great chief of the Mdewakanton Sioux known to have borne the name of Wabasha. He was active in southern Minnesota before the French and Indian Wars of the mid-eighteenth century. Both a son and grandson of that chief bore his name and were also remembered as important leaders among the Eastern Sioux.

This carving was acquired by the Minnesota State Historical Society in 1922, but it probably was referred to in an earlier listing of Indian artifacts in the William Faribault Collection, which I saw in the St. Louis Missouri Historical Society where a number of other pieces from that collection are preserved. The list includes "Nos. 53 and 56 from the Wabasha family, wooden magi (or magic) man used and made to dance by some mysterious way." It is likely, then, that this figure may be the earliest known example of a Sioux "Tree-Dweller," a type of hunting medicine discussed on pp. 126–28 of this book.

Of less certain age, but worthy of consideration as a possible early example of wood carving from the southern Great Plains because of its artistic quality, is the human figure shown in color-plate 3. This carving in the Smithsonian collections was illustrated in John R. Swanton's *Source Material on the History and Ethnology of the Caddo Indians* in 1942. Swanton also cited references to wood carvings of birds and reptiles seen by eighteenth-century observers among the Caddo in eastern Texas in association with their temples (Swanton 1942, pl. 19 and p. 155). Perhaps this human effigy dates back to the time when the Caddo Indians lived in Texas, before they were removed to the Indian Territory in 1859.

This seated figure is 6¾ inches high, with his arms crossed and resting on his upraised knees. Its creator revealed his talent to best advantage in the striking head with well-defined eyes, nose, mouth, and ears. The addition of a mustache and wig of real hair contributes to its realistic appearance. Both head and body were rubbed with yellow paint. Between his legs this figure holds a small packet of medicine (?) wrapped in a piece of blue-and-white-striped cotton cloth. Whether this striking human effigy was used in doctoring the sick, in witchcraft, or for some other purpose we do not know, but it must have had a ritual function for its owner.

The map of the Great Plains in figure 15 shows the locations of its tribes in 1830. By that time the Indians who had moved out of the woodlands onto the plains had established themselves in or near the territories they would occupy until the buffalo were nearly

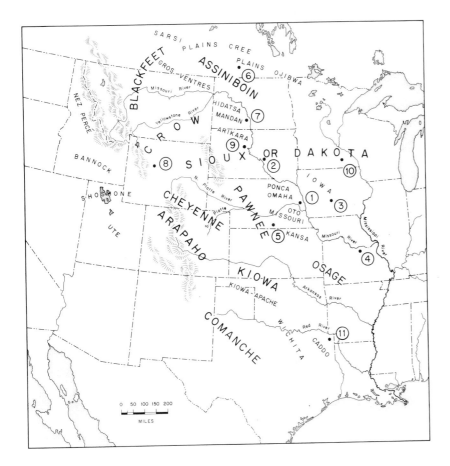

Figure 15. Locations of Plains Indian Tribes in 1830. Black dots near circled numbers show locations of origin of pre-1830 carvings discussed this chapter:

1. Snake or mammal head pipe, fig. 6;
2. Bird effigy pipe, fig. 7;
3. Human head pipe, fig. 8;
4. Indefinite and bird pipes, fig. 9;
5. Bear and human effigy pipes, figs. 10, 11;
6. Human effigy gorgets (not illustrated);
7. Shell and bone effigies, fig. 12;
8. Large buffalo effigy, fig. 13 and pl. 1;
9. Small buffalo effigy, fig. 14;
10. Human figure of wood, plate 2;
11. Human figure of wood, plate 3.

exterminated and the tribes were placed on reservations. The map also indicates the widely scattered locations from which the pre-1830 carvings discussed in this chapter were derived.

The earliest effigy pipes, dating back to prehistoric times, come from sites well within the Great Plains in the valley of the Missouri River. They may or may not have been created by the Indians who lived at the sites where they were found. Effigies from the early historic period—before 1830—are more numerous and varied. They were executed in stone, bone, shell, and wood, and they portray birds, animals, reptiles, and human beings—the last either as heads only or as full figures.

These carvings were intended to serve various functions. Some ornamented tobacco pipes; others were used as fetishes or as symbols in religious ceremonies. There are suggestions that the horticultural tribes created effigies for use in ceremonies to ensure the growth of crops; while the nomadic tribes used other effigies to bring success in hunting buffalo.

In the following chapters, we shall consider the much more abundant evidence of Plains Indian carving within the last century and a half, which points to a remarkable florescence of this art since about 1830. However, we shall not forget that effigy carving was known to Plains Indians in earlier times, and occasionally shall recall earlier precedents for some of the post-1830 creations.

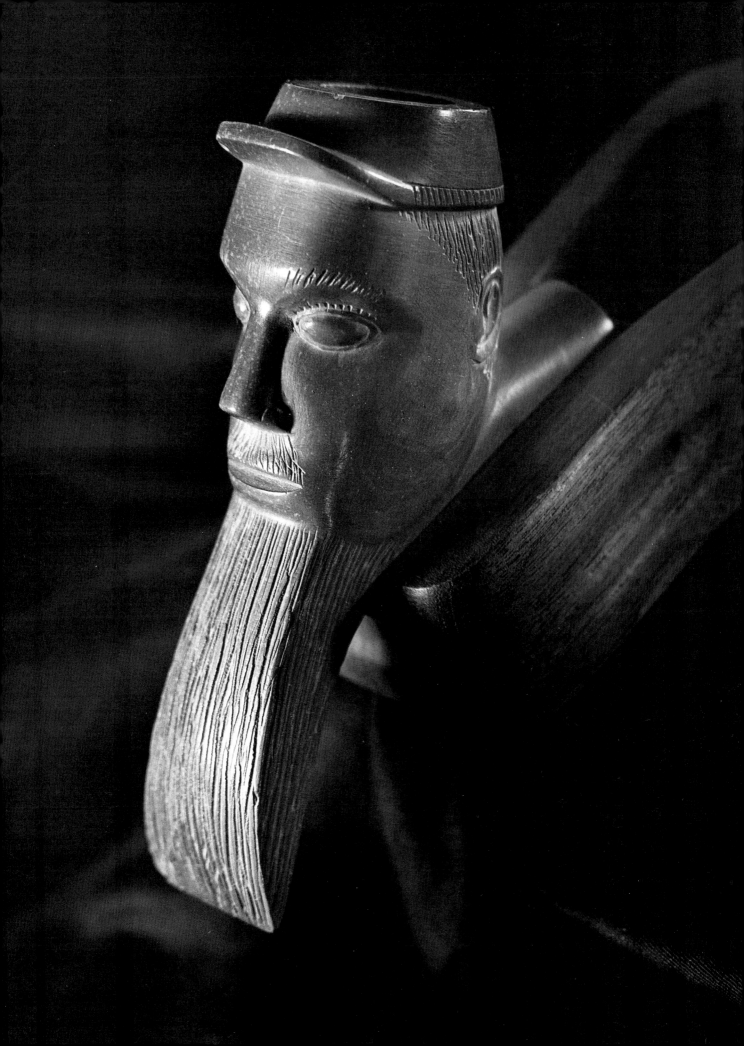

CHAPTER 2

Effigy Pipes
and Pipestems

Pipemaking: Materials and Methods

Only a small proportion of tobacco pipes made by Plains Indians bore sculptured life forms. Even so, pipes and pipestems account for more than half of the Plains Indian effigies preserved in museum collections. A few pipes were made of wood, but most were of stone.

Indians were very selective in their choice of stone for pipemaking. The stone had to be easily worked with the tools available to them. It had to take a fine polish and had to endure heat without cracking. Their favorite pipestone had another very appealing quality—it possessed a beautiful, rich, red color. Some 85 percent of the Plains Indian effigy pipes seen in museum collections are of this red stone, the great majority probably of stone from the famous quarry near present-day Pipestone, Minnesota, which was named catlinite in honor of George Catlin (Ewers 1979b, pp. 69–77, and pl. 3).

Although Catlin thought he was the first white man to see this quarry, he was not. In 1832 Philander Prescott, a trader, had accompanied a party of Sioux Indians to take stone from the quarry, and it was marked on French maps early in the eighteenth century (Murray 1965, pp. 12–13).

Nor was this quarry the only source of red pipestone. Alexander Henry the elder, traveling westward in 1775, reported a site then known as Roche Rouge west of Lake Winnipeg, where Indians obtained pipestone. "It is of light red color, interspersed with veins of brown, and yields very readily to the knife," he wrote (Henry 1809, p. 252). Numerous travelers on the Great Plains reported passing tributaries of larger rivers that were known locally by the name of Pipestone Creek because Indians obtained suitable stone along their courses. That stone might be—and usually was—something other than catlinite.

Portrait pipe—Dr. Jared Waldo Daniels; by a Santee Sioux Indian, 1862–1865; catlinite. [FIGURE 66]
From a private collection; photograph by Warner F. Clapp.

Next to catlinite the material most frequently used for pipes was a fine-grained shale or limestone, sometimes referred to by early travelers as marble. Samples of stone from Pipestone Cliff in the valley of the Two Medicine River on the Blackfeet Reservation in Montana were identified as calcareous shale. This was a favorite quarry of Blackfeet pipemakers. The Brule Sioux preferred a pipestone—identified as a shaly limestone—from Black Pipe Creek on their reservation in southwestern South Dakota. The Assiniboin, Blackfeet, Brule Sioux, Cree, and other Indians who fashioned their pipes from gray or light-colored stone liked to give them a shiny black surface finish by covering them with grease, holding them over a brush fire for darkening, and then polishing them with a piece of buckskin or cloth (Ewers 1963, pp. 45, 52–56).

Rev. Samuel Pond, describing the life of the Santee Sioux of Minnesota at the time he began missionary work among them in 1834, listed the quarrying of pipestone as one of their summertime activities. "Occasionally some of the men went to the red pipestone quarry and brought home pieces of the stone for pipes." (S. Pond 1908, p. 374.)

Dr. C. A. White visited the quarry with an Indian of Little Crow's Band of Santee Sioux in 1868 and reported that "the purer specimens may be worked without much difficulty with a common saw, file, or knife." (White 1869, p. 653.)

The best description of Sioux methods for making catlinite pipes in the days before a brace-and-bit was used for drilling the bowl and stem holes is that of Charles H. Bennett, a pharmacist of Pipestone, who was a perceptive collector of Indian-made pipes, and who knew many of the Indian pipemakers of the Pipestone-Flandreau region well during the 1870s and early 1880s:

> A piece of the rock is selected from the best portion of the vein, and the Indian sculptor, with an old piece of hoop iron, or a broken knife blade which he has picked up, fashions the block roughly into the desired form. Then slowly and tediously, with the same tools, he bores out the bowl and the hole in the stem before carving the exterior, so that if in the process of boring the stem should be split no labor would be lost. After all this is accomplished he shapes the surface into any design which he may have in view. This work often occupies weeks before it is completed, after which the carving is polished by rubbing it with grease or oils in the palms of the hands. (Barber 1883, p. 750.)

Bennett's description indicates that at that time the Sioux pipemaker still fashioned his own metal tools, as did The Flier, a well-known Ojibwa pipemaker farther east, who was active before 1857. Sir Daniel Wilson reported that The Flier made his own saw from a piece of hoop-iron (Wilson 1857, p. 333).

Green-Grass-Bull, my oldest pipemaker-informant among the Blackfeet, and carver of the two effigy pipes pictured in figures 60 and 69 of this book when he was a young man, told me that he had shaped the outside of the pipe with an old butcher knife and a file. He drilled the stem and bowl holes with a tool he had made from an iron rod about three-eighths of an inch in diameter, by heating it in the fire and pounding one end of the rod flat with a hammer. While the piece was still hot, he bent the other end of the rod into the form of a ring. After the iron cooled, he sharpened the drilling end with a file. The finished tool was about seven inches long. He covered the ring end with a rag to prevent his hand from blistering as he rotated his self-made drill by turning the ring handle. Because the pipestone quickly dulled the edge of his drill, he had to stop frequently to sharpen the expanded drilling end of his tool with a file (Ewers 1963, p. 47).

In 1947 Eagle Bird, an elderly Oglala Sioux on Pine Ridge Reservation, told me that pipemaking was a specialized craft among his people. Men who were skilled at it were paid well by other tribal members for the pipes they made. He himself had never made a pipe, but he knew that those who did obtained catlinite from the Yankton Sioux, who quarried the red stone back in Minnesota. He said that since about 1870 Oglala pipemakers had used white men's tools.

Pond observed that the Sioux in 1834 "often expend great labor in making and ornamenting pipes and pipestems, especially such as were to be used on great occasions or to be presented to important personages." (S. Pond 1908, p. 438.)

Certainly the creation of an effigy pipe bearing a likeness of a bird, animal, reptile, or human being or a combination of these was a task that required infinite patience as well as imagination and skill. To bring the likeness out of a block of solid stone by painstakingly removing particles from it demanded much more time and concentration than did painting a war record on a hide. Perhaps this may explain why a number of known Plains Indian sculptors were physically handicapped individuals—men who could not actively engage in raids against the enemy. Indeed, the earliest named Plains Indian creator of effigy pipes I have found was a one-armed man, Running Cloud, chief of the Five Wigwams Band of the Eastern Sioux. When Count Francesco Arese, an Italian traveler, visited him in August 1837, he was "sitting in front of his tent holding a piece of red stone between his feet and working it with one hand." The count tried in vain to obtain a Janus-headed pipe from him (Arese 1934, p. 107). The earliest effigy pipe I have found whose creator is definitely known by name was a talented Eastern Sioux cripple, One-Legged Jim. He carved the pipe in 1853. (See figure 26.)

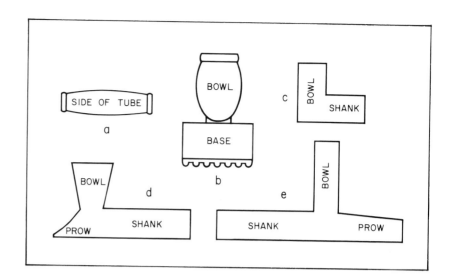

FIGURE 16. Basic forms of Plains Indian
tobacco pipes:
a. Tubular or straight pipe;
b. Modified-Micmac pipe;
c. Elbow pipe;
d. Prowed pipe with flaring bowl;
e. Calumet (inverted T-shape).
Drawing by George R. Lewis.

Basic Forms of Tobacco Pipes

Figure 16 illustrates in outline the five most common forms of tobacco pipes made and smoked by Plains Indians. Form a is a straight tube, with sides sometimes more bulbous than shown in the outline. The tobacco is placed in one end of the tube and the pipestem inserted in the other. Archeologists know this as the oldest form of North American Indian tobacco pipe. In 1833 Prince Maximilian observed that this form of pipe was used by members of war parties among the tribes of the Upper Missouri. My elderly Blackfeet informants called this a "straight pipe," an obsolete form found only in old medicine bundles (Ewers 1963, pp. 34–39). We have seen an early example of this "straight pipe" from the Pawnee Indians, bearing a man's head in relief on the side and dating back to before 1815, in figure 11. Even so, pipes of this contour with life forms carved on their sides, are very rare in museum collections.

Form b, which roughly resembles an acorn atop a heavy, blocky base, is known to ethnologists as a Modified-Micmac pipe because it resembles a pipe form smoked by the Micmac Indians and their neighbors on the Eastern Seaboard. I have suggested that this pipe form was carried westward in the expansion of the fur trade from Montreal through the western Great Lakes and up the valley of the Saskatchewan River by white traders or the eastern Indians who accompanied them. This has been the most common pipe form used by the Blackfeet Indians since the 1830s (Idem, pp. 39–42, 58–59). Pipes of this type decorated with sculptured life forms also are rare in museum collections.

Form c is L-shaped, and is commonly termed an elbow pipe. Its vertical bowl and horizontal shank are at right angles to one another. This is an old form that continued in favor among tribes of the Great Plains into the present century. Roughly 40 percent of all tobacco pipes bearing carved life forms seen in museum collections

50

are of this basic type. Some have the carving on the bowl only, with the figure facing either toward the smoker or in the opposite direction. Others have the carving on the shank only, facing in either direction.

Form d has a short prow extending forward of the bowl, which is generally narrower at the base than at the top, with its sides flaring outward. This was a common form of tobacco pipe among both the Sioux and the Pawnee before about 1850. Many of the best-carved pipes in museum collections are ones of this basic form. The carving may appear on the bowl or the shank or both; sometimes it is also on the prow. A good example of a pipe of this form from an early date is the Pawnee bear effigy pipe illustrated in figure 11.

Form e is both longer and taller than form d, with a longer prow and a high, parallel-sided bowl at right angles to the shank. Even though the prow usually is not as long as the shank, this form is referred to as an inverted-T-shape pipe. It is also sometimes termed a Siouan calumet. I have found no evidence in well-dated specimens, in the literature, or in the artists' records of the existence of this form of pipe among the Plains Indians before 1850. It appears to have originated among the Eastern Sioux very near the middle of the nineteenth century and spread rapidly thereafter to other tribes. It was adopted by white men who began to turn out catlinite pipes for the Indian trade with the use of power machinery in the early 1860s—pipes that did not have hand-carved effigies on them. Form e has continued to be popular among Sioux pipemakers to the present time. Roughly one-quarter of the Plains Indian pipes decorated with carved life forms in museum collections are of this popular form; I doubt if any of them were collected before 1860.

There are a small number of effigy pipes that do not fit into any of these five formal categories. They are sculptured effigies in which the tobacco chamber and the stem hole are ingeniously concealed within the representation of a bird or animal. Usually the tobacco chamber opens at the top of the creature's head, while the stem hole is in the anus. In some cases the bowl opening is over the animal's back. The bird effigy pipe from the Talking Crow Site (figure 7), dating before A.D. 1500, is one example. It proves that pipes of this character were old. They appear to have been occasional creations of ingenious and gifted carvers of different tribes over a long period of years.

Let us now look at a selection of pipes bearing sculptured life forms and collected since 1830. I have chosen these pipes to provide a fair sampling of the artistry and ingenuity of the carvers. May I repeat that this is a selection; it would not be practical to try to describe and to illustrate in a single volume *all* the variations in style and form of representing each animal, bird, reptile, and human being to be found on the sculptured Plains Indian pipes I have examined in some 150 museums.

Bear Effigy Pipes

The most awesome animal known to the Plains Indians was the grizzly bear. Weighing nearly 1,000 pounds, and standing fully eight or more feet tall on his hindlegs, the mature grizzly became a vicious killer when aroused. So it is not strange that these Indians recognized the grizzly bear as the symbol of ultimate strength and courage, and that audacious hunters and warriors actively sought to acquire some of this animal's supernatural power for themselves in dreams or visions of the bear.

In 1943 Fish Wolf Robe recited for me a well-known Blackfeet legend of the young man who acquired bear power. Long ago a young Piegan went in search of a fasting place where he might obtain a vision of power. He came upon a cave and entered it. After his eyes had become accustomed to the darkness, he found that the cave was occupied by a mother bear and her cubs, and he pleaded with the mother bear not to harm him. For four days and nights he remained in the den without food or water, praying all the while for the bear to give him of its power. On the fourth night he fell asleep. In his dream a male and a female bear appeared. They took pity upon him and gave him a number of objects that were sacred to them, including a bear-painted lodge, a bear knife (a sharp, double-edged knife with a bear jaw handle), and "a blackstone pipe carved in the shape of a bear." (Ewers 1958, pp. 165–66.)

George Catlin painted a blackstone elbow pipe from the Blackfeet, with a seated bear forming the bowl and facing the smoker. Presumably it was symbolic of bear power (Ewers 1979b, pl. 2, fig. b). We have seen in figure 10 a Pawnee pipe with the full figure of a bear carved on the shank, dating back to before 1815.

One of the most elaborately carved effigy pipes from the first half of the nineteenth century that I have seen appears in figure 17. It was collected by a German naturalist, Paul William, Duke of Wurttemberg, during his travels on the Great Plains, probably in 1830, and is preserved in the Linden Museum in Stuttgart, West Germany. This is a well-conceived and skillfully executed composition of a boy or man sitting atop the shank of a catlinite pipe, intently watching a bear facing him astride the shank. Catlin illustrated a pipe of this design in 1841 (see figure 1, third pipe from top). For some unaccountable reason, Catlin added a bear cub behind the larger bear in his later illustration of this pipe. Nevertheless, he positively identified the pipe as of Pawnee origin (Ewers 1979b, p. 36, pl. 8a).

Turning to the literature on the Pawnees, I found what seems to be a likely interpretation of the symbolism of this effigy pipe. It appears to illustrate a well-known Pawnee myth about a boy who obtained supernatural power from a bear. The bear, in turn, was said to have obtained its power from the sun through its paws,

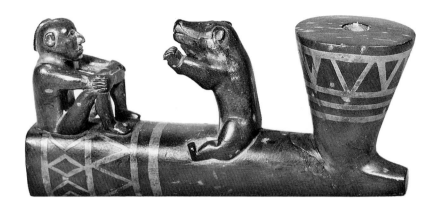

FIGURE 17. Bear and boy effigy pipe; Pawnee, collected in 1830, catlinite with lead inlay, 6¾″ long.
Linden-Museum, Stuttgart, cat. no. 12,599.

raised to face the sun. Presumably, then, this carving illustrates the transmission of bear power from the extended paws of the bear to the Pawnee boy seated opposite it (G. A. Dorsey 1904, pp. 138–39, 143, 343n). Surely this Indian sculptor demonstrated remarkable skill in working catlinite in rendering this boy watching the bear, while sitting with his arms crossed and resting upon his upraised knees. The boy's Pawnee-style hairdress is indicated, along with carefully defined facial features and hands. The bear is more stylized.

This pipe shows us that there was at least one master carver among the Pawnees as early as 1830. Whether he was the same man who created that bear effigy pipe before 1815, we do not know. He probably executed another pipe of the boy and bear theme now in the collections of the St. Louis Missouri Historical Society. That pipe was obtained by Gen. Stephen Watts Kearny when he was a young officer—no later than 1842. The pipe was illustrated in color and described as Sioux in an article on outstanding Indian artifacts in the collection of that museum (Schmitz 1980, p. 24). However, Marie Schmitz later informed me that museum records state that this pipe was obtained from the Osage. Presumably it passed from its Pawnee creator to an Osage Indian, and from him to officer Kearny.

Evidence of still wider occurrence of bear effigy pipes among Plains Indians during the 1830s was provided by Catlin, whose oil portrait of He-Who-Kills-the-Osages, executed from life in 1832, shows the Missouri Indian chief wearing a handsome bear claw necklace and holding an effigy pipe with a bear on the shank facing away from the smoker. Whether the animal was quite as crudely represented as Catlin's painting suggests is doubtful (Truettner 1979, fig. 83).

Catlin himself collected a bear effigy pipe that offers a better interpretation of the bear. As shown in figure 18, this bear stands

FIGURE 18. Bear effigy pipe; probably Sioux, collected by George Catlin, 1830s; catlinite (?) with lead inlay; 5″ long.
The University Museum, University of Pennsylvania, Philadelphia, cat. no. 38,377.

on the shank of the pipe, facing the smoker. Its bearlike qualities are accented in its sharp claws and stubby tail. Frances Eyeman, in a detailed description of this pipe, stated her opinion that the stone, though grayish in color, had come from the famous red pipestone quarry in Minnesota. She estimated that the pipe might date back to 1800. Both the material and the early dating of the pipe are questionable, however, as is its tribe of origin. Surely it must be from the Northern Plains (Eyeman 1966, pp. 33–40).

A single page of Catlin's monograph on pipes illustrates three other bear effigy pipes of catlinite from three different tribes. One, from the Sioux, has the bear standing on the shank facing the smoker much like the carving in figure 18. Another, from the Kansa, which was presented to Catlin by William Clark in St. Louis, has a reclining bear on the shank facing the smoker. The third and most ingenious one—of Pawnee origin—shows two bears standing on their hind legs with their forepaws atop the bowl and looking into it (Ewers 1979b, pl. 7). I should add that I have seen no pipes like the last two in museum collections.

Bear effigy pipes have not been as common or as well carved in the years since the 1830s as they were then. One pipe of more recent origin is unique. This pipe, figure 19, is made of speckled catlinite in elbow form with a disembodied bear's head carved in high relief on top of the shank. The carver indicated the eyes as prominent protuberances, a pair of short ears, nostrils, and an incised mouth. The pipe was collected by Amos H. Gottschall of Harrisburg, Pennsylvania, who was probably the most avid private collector of Sioux pipes during the half century following 1871. By 1921 he claimed to have 435 Sioux pipes, but did not say how many of those were effigy pipes (Gottschall 1921, p. 33). This pipe from the White Clay District on Pine Ridge Reservation in South Dakota, is presumably of Oglala Sioux origin.

FIGURE 19. Bear head effigy pipe; Oglala Sioux, before 1921, catlinite, 3¾″ long.
The University Museum, University of Pennsylvania, Philadelphia, cat. no. L84-1362.

54

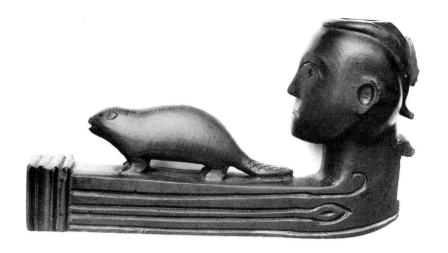

FIGURE 20. Beaver and man's head effigy pipe; Pawnee, 1820–1850; catlinite; 6¼″ long.
Colin Taylor Collection, Hastings, Sussex, England.

Beaver Effigy Pipes

Despite the great importance of the beaver in the early fur trade of the Northern Great Plains both in Canada and on the Upper Missouri, effigy pipes depicting the beaver are very rare in museum collections. Even so, there are two noteworthy examples.

One of them, which appears in figure 20, combines a beaver standing on the shank facing the smoker, with the head of an Indian on the bowl facing the same direction. The animal has a heavy body, and its characteristic flat tail is marked with incised crosshatching. The mouth is open, but the teeth are not emphasized. Nostrils and eyes are circular holes, and the ears are shown close to the side of the head. The arched brows and ears on the Indian's head are emphasized. The hair in back is partly broken off, but the distinctive Turk-like Pawnee hairdress is suggested. Little is known of the origin of this unique carving. Its owner, Colin Taylor, of Hastings, Sussex, England, who purchased it in his own country, found it without documentation. I believe it is Pawnee, and may date from the 1820–1850 period.

Figure 21 is a tubular pipe of catlinite with a beaver carved on its side in low relief. Its creator depicted the animal with a distinctive flat tail with crosshatched surface markings, simply incised mouth and eye, and only two legs. The entire beaver is less than 3 inches long. This pipe is reputed to have been obtained from Sitting Bull, the famous Hunkpapa Sioux chief, before he left Canada in 1881 to return to the United States.

FIGURE 21. Beaver effigy tubular pipe, Sioux, attributed to Sitting Bull, before 1881, catlinite, 4⅝″ long.
Royal Ontario Museum, cat. no. HK224.

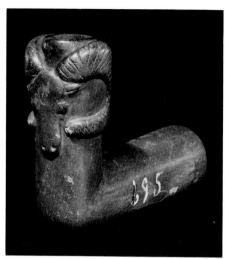

FIGURE 22. Bighorn head effigy pipe; South Dakota, probably Brule Sioux, undated; blackstone; 3½" long, 2⅛" high.

The University Museum, University of Pennsylvania, Philadelphia, cat. no. L84-1343.

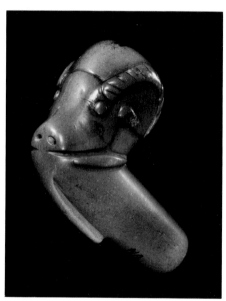

FIGURE 23. Bighorn head effigy pipe; Northern Cheyenne, collected in 1900; catlinite; 3¼" long, 2¼" high.

The University Museum, University of Pennsylvania, Philadelphia, cat. no. NA 7734.

Bighorn Effigy Pipes

Prince Maximilian, while ascending the Missouri River during the early summer of 1833, saw his first bighorn, or mountain sheep, the day before the steamboat reached Fort Union at the mouth of the Yellowstone. He later learned that bighorn abounded in the South Dakota badlands southwest of Fort Pierre, and that the Hidatsa Indians killed a hundred or more of these animals annually on their hunts to the Black Hills and other mountainous areas (Maximilian 1906, vol. 23, p. 246, 372; vol. 24, p. 90).

As a subject for artists, this animal appeared more commonly in Indian graphic art than in their sculpture. Campbell Grant has argued that the bighorn was a preeminent motif in the Indian paintings and incisings on rocks of western North America (Grant 1982, pp. 11–15). George Catlin pictured an effigy pipe in red stone from the Kansa with the head of a bighorn carved on the bowl facing front, behind which the figure of a man in relief straddled the shank (Ewers 1979b, pl. 2m). I have seen no such elaborately developed bighorn effigy pipe in museum collections.

Even though bighorn effigy pipes from the Great Plains are not common in museum collections, some of them reveal very well the individual styles of different artists in adapting the head of this animal to the bowl of a tobacco pipe. Let me cite three examples.

Colorplate 4 pictures a small catlinite elbow pipe on which the head of a bighorn ram is carved facing front. The sculptor has emphasized the distinctive thick, curling horns of this animal, and the ears are defined. The rest of the head remains nearly abstract, with only raised protuberances for eyes and a lightly incised mouth. This pipe was collected by Clark Wissler of the American Museum of Natural History during his field work among the Oglala Sioux on Pine Ridge Reservation, South Dakota, in 1903.

Two effigy pipes in the University Museum in Philadelphia are especially noteworthy for the different ways in which their Indian creators have chosen to interpret a bighorn. Figure 22 shows how a Sioux sculptor from South Dakota defined the head of a bighorn on a blackstone pipe. Again the large, heavy, curving horns show clearly that the animal is none other than the bighorn. But they are closely fitted to the curve of the bowl, while the head is rendered in low relief on the front with holes for nostrils and semi-abstract eyes and ears. The fact that this pipe is of blackstone suggests that the sculptor probably was a Brule Sioux from Rosebud Reservation. This fine, imaginative miniature sculpture probably dates from about the turn of this century.

The bighorn effigy pipe shown in figure 23 gives somewhat less emphasis to the animal's horns, but defines the other features of the animal's head quite sharply—its eyes and large-nostriled muzzle.

This pipe was collected by Howard Fuguet from the Northern Cheyenne at Lame Deer, Montana, in 1900.

Figure 24 pictures a small catlinite elbow pipe on which the head of a bighorn is carved. In this case, the carver opted to emphasize the prominent muzzle of this animal rather than its horns, which appear to be unnaturally thin. This pipe was part of a collection of older Sioux artifacts received by the Smithsonian in 1930, so that it may date back to 1900 or earlier.

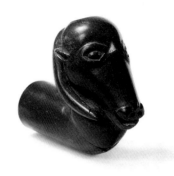

FIGURE 24. Bighorn head effigy pipe; Sioux, accessioned 1930; catlinite; 2⅝″ long, 2″ high.
Smithsonian Institution, cat. no. 345,986.

Buffalo Effigy Pipes

Carefully preserved on the Cheyenne River Reservation in South Dakota is the tribal medicine of the Sioux, The White Buffalo Calf Pipe Bundle, in the custody of a Sans Arc Sioux family. It was believed to have been given to the entire Sioux nation by the supernatural White Buffalo Calf Maiden in the far distant past. A description and photographs of the sacred pipe in this bundle indicate that there is no effigy carving on it (Thomas 1941, pp. 605–9). Even so, some recorded versions of the legend of the gift of this pipe to the Sioux describe the pipe as bearing a carved buffalo on its bowl or stem.

At the beginning of the century, this pipe was in the care of Elk Head, whose version of the origin legend was recorded and published by Edward Curtis. In it the pipe was termed "a red stone pipe with the carved image of a buffalo calf surmounting its wooden stem." (Curtis 1908, p. 58.) Another version of this legend, told to Joseph Epes Brown by the Oglala holy man, Black Elk, some years later, included the statement: "The bowl of this pipe is of red stone; it is the Earth. Carved in the stone and facing the center is the buffalo calf who represents all the four-leggeds who live upon your Mother." (Brown 1953, p. 6.) In 1962 Black Elk's son Benjamin claimed that "the pipe is described as having the calumet of T-shape with a catlinite bowl. On the stem portion of the bowl is a carved figure of a buffalo calf in the reclining position." (Black Elk 1962, p. 1.) Still more recently, in James La Pointe's *Legends of the Dakota*, published by The Indian Historian Press, the sacred pipe was described with still a different buffalo effigy on it. "On the extended end of the bowl there was a carving of a buffalo calf's head. This means that you must always venerate the four legs which inhabit the earth with you." (La Pointe 1976, p. 26.)

Aware of the different descriptions of the buffalo calf pipe in the several published versions of the origin legend, Vera Louise Drysdale, charged with preparing finely detailed illustrations for a new edition of Black Elk's account of the origin of this sacred pipe, decided to picture the pipe in several ways. In the frontispiece and in several other illustrations within the book, the buffalo stands in

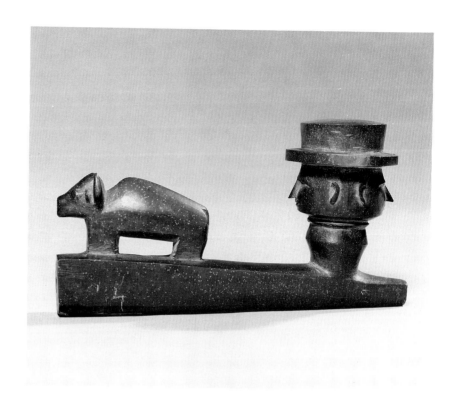

FIGURE 25. Buffalo and Janus-headed white man pipe; Santee Sioux, collected by J. N. Nicollet, ca. 1838; catlinite; 5½″ long, 2¾″ high.

American Museum of Natural History, cat. no. 12-52.

high relief on the shank, facing the bowl. In other illustrations the buffalo calf is on the prow, facing the bowl. In others, there is no effigy on the pipe at all (Drysdale and Brown 1982). It is indicative of their respect for effigies as well as for their sacred pipe that twentieth-century Indian reciters of the legend of the buffalo calf pipe should think of it as bearing a carved figure of a buffalo somewhere on it.

Whether or not some Sioux sculptors felt there was a taboo against representing buffalo on other pipes, there are not many examples of buffalo effigy pipes attributable to Sioux carvers before the present century. Catlin did not picture any buffalo effigy pipes in his monograph on tobacco pipes.

Two of the earliest buffalo effigy pipes I have seen in museum collections link the buffalo with the white man rather than the Indian. Both were probably made for sale to white collectors. Figure 25 shows a highly stylized small buffalo standing on the shank of a catlinite pipe facing the smoker, while the large Janus-headed carving of a white man is on the bowl. This pipe was collected by the noted French explorer Joseph N. Nicollet, probably during his trip to the Upper Mississippi in 1838. This may have been the creation of one of the Sioux carvers who executed effigy pipes for sale to soldiers and visitors to Fort Snelling on the upper Mississippi at that period.

The same theme is conveyed by the catlinite pipe in figure 26. However, the carver's style is quite different. In contrast to the rather angular forms on the pipe in figure 25, the buffalo and the

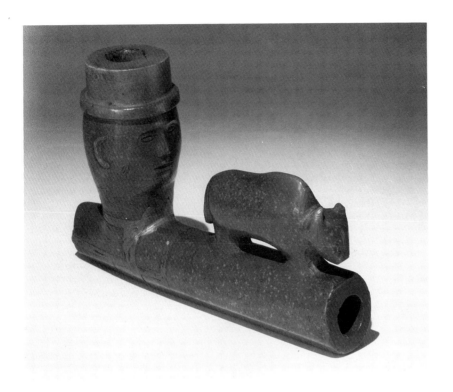

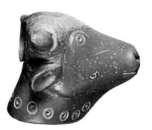

FIGURE 26. Buffalo and white man's head pipe; carved by One-Legged-Jim, Mdewakanton Sioux, in 1853; catlinite with lead inlay; 5½″ long.
Minnesota Historical Society, cat. no. 338/E345.

FIGURE 27. Buffalo head pipe; Santee Sioux, ca. 1870s; catlinite; 2⅛″ high.
Nebraska State Historical Society, cat. no. C32.

features of the white man's head on this pipe appear to be somewhat rounded.

The second pipe is of special interest because it is the earliest certain example of an effigy pipe executed by a Plains Indian whose name is known. Museum records in the Minnesota Historical Society state that this pipe was made by One-Legged Jim, a very active Mdewakanton Sioux cripple, in 1853. He lost a leg as a result of a wound received in a battle between the Santee Sioux under Chief Little Crow and the Chippewas in 1839. Jim used to say that when the Chippewas "deprived him of half his understanding, he had to turn white man, that is, go to work." He became well known to the people of St. Paul as a man who insisted on making his own way. In winter he made pipes and axe-helves; and in summer he caught fish for the St. Paul market. Respected by both Indians and whites, Jim signed the treaty of Mendota in 1851; he died in 1859 (Diedrich 1981, pp. 65–77). His obituary in the *Minnesota Weekly Pioneer and Democrat* for September 24, 1859, spoke of "One-Legged Jim" as a "well-known Sioux warrior," about sixty years of age at the time of his death. So he must have been in his fifties when he made this buffalo effigy pipe.

Colorplate 5 is a masterpiece of Plains Indian carving in the form of a buffalo effigy, which the sculptor made to serve as a pipe by boring the bowl hole vertically in the center of the animal's back and the stem hole horizontally in the general location of the animal's anus so as to meet in the center of the effigy. The entire pipe of polished catlinite portrays a buffalo with legs tucked up and tail on

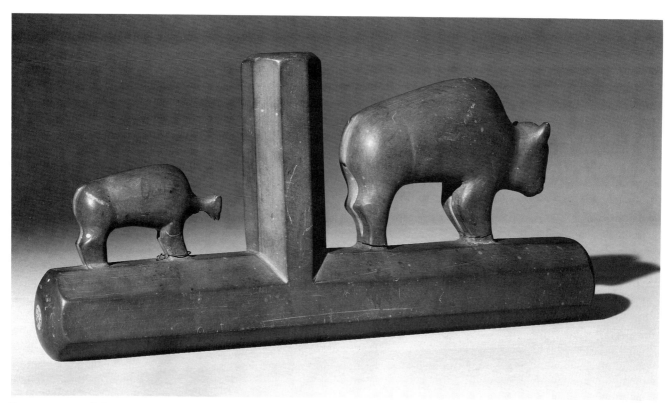

FIGURE 28. Buffalo cow and calf pipe; Pawnee, before 1876; catlinite; 10″ long.

William Bragge Collection, The British Museum, cat. no. D.C. 86.

the left, and with all the features of the head carefully detailed. The eye appears to have been made with the aid of a compass. Museum records of the Missouri Historical Society indicate that this carving was presented by John H. Terry and was "cut by Indians of Dakotahs 1872." This buffalo may remind the student of art history of the bison painted on the cave walls of Altamira, Spain.

The realistic buffalo head on the pipe in figure 27 is so like the head on the buffalo effigy pipe in colorplate 5 that both must be considered the creations of the same Sioux Indian sculptor. The eyes, forelocks, and horns are defined precisely in the same manner. In addition, the smaller pipe has a decorative band of circle-and-dot motifs around the animal's neck that must have been made with a compass. The entire head is only 2⅛ inches high. This pipe was received by the Nebraska Historical Society in 1901 with a Santee Sioux provenience. I saw a very similar buffalo head pipe on exhibition in the Pettigrew Museum in South Falls, South Dakota. Surely all three of these pipes were carved by the same man. He may have been one of the Santee Sioux who were removed from Minnesota to Nebraska after the Sioux War of 1862.

Very different in style is the catlinite pipe in figure 28. It displays the full figure of a buffalo cow standing on the shank and a calf on the prow, both facing the smoker. The forms of their bodies establish the identity of these animals as buffalo, even though their heads are distorted in shape and lacking in detail. This pipe was formerly owned by William Bragge, the noted English collector of

60

objects associated with the uses of tobacco, who listed it in his printed catalog of 1880. "D.C.86. A splendid pipe of catlinite—a buffalo cow and calf on stem. 10″ long. Weighs 2 lbs. 5 oz. . . . procured for me by James Park, Esq, of Pittsburgh, 1876. Pawnee make." This buffalo effigy pipe may have been contemporary with the Santee one in colorplate 5.

Figure 29 shows a slightly blackened elbow pipe of a gray stone with a buffalo head carved at the elbow facing front. This pipe was part of the William P. Sargeant Collection, received by the Peabody Museum of Yale University in 1937, which contained a number of objects from the Western or Teton Sioux. I judge this pipe to have been of Brule Sioux origin and of the period 1890–1920.

A highly stylized buffalo effigy pipe of blackstone with the animal standing rather stiffly astride the shank, the bowl hole in his hump and the stem hole in his anus, from the collections of the Denver Art Museum was published in Feder 1971, figure 41. Although this pipe has no accompanying history, it is attributed to the Northern Cheyenne in museum records, but is not dated.

Buffalo effigy pipes have become popular items for sale to visitors at Pipestone National Monument in Minnesota in recent years. I have seen these pipes in the collections of a number of museums in this country and in Canada; one was owned by a woman in southern France. Many of them were executed by George Bryan, the highly skilled Indian demonstrator of pipestone-working techniques at Pipestone National Monument. (See pp. 220–21 of this book.)

So the buffalo persists as a symbol of traditional Plains Indian culture, carved in catlinite and sold to non-Indian visitors to the historic pipestone quarry. Evidence suggests that many more buffalo effigy pipes have been created by Indian sculptors since the buffalo became extinct as a wild species in the 1880s than were carved when that animal was the staff of life for Plains Indians.

Dog Effigy Pipes

Before the Plains Indians acquired horses from the Spanish settlements farther south, dogs were the only beasts of burden to help them transport their lodges and household goods when camp was moved. After they acquired horses, some poor families continued to use dogs for transport, and barking dogs warned Indians of the approach of stealthy enemy raiders who entered their camps at night or at dawn to steal their horses. Nevertheless—and despite their long and close association with dogs—Plains Indian sculptors did not create many dog effigy pipes.

George Catlin pictured a Blackfeet effigy pipe of blackstone with a man's head on the bowl facing front and a small dog seated on the shank facing the smoker (Ewers 1979b, pl. 2, fig. c).

FIGURE 29. Buffalo head pipe, probably Brule Sioux, accessioned 1937, gray stone, 2½″ high.
Peabody Museum of Natural History, Yale University, cat. no. 49,112.

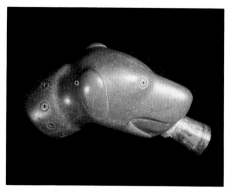

In the Museum für Volkerkunde, Vienna, is the small, short-prowed, and heavy-bowled catlinite pipe pictured in figure 30. The stylized animal carved in high relief standing on the shank facing the smoker appears to have the head of a dog, despite its heavy tail, which the carver may have thought was necessary for the strengthened support of the animal. Neither the tribe of origin nor the date of collection of this pipe was recorded, although it is known that its collector, Johan Georg Schwarz, was in America as early as 1819/21 and died in 1867. Judging from the shape of this bowl and the style of animal carving, I think it was probably of Santee Sioux origin within the period 1820–1850.

Dog lovers should appreciate the perky little fellow carved with a very sure hand on the catlinite pipe shown in figure 31. In addition to the very alert-looking head, with ears erect and mouth slightly opened, the carver has the dog's forelegs extending from the middle of the bowl to the shank at each side. The eye appears to have been marked with a compass. I judge this pipe to have been of Santee Sioux origin about the turn of the century.

Of the same age but of quite different design is the ingenious catlinite pipe pictured in figure 32. It is shown in an inverted position in order to present a better view of the dog's head. Actually, the bowl hole is in the dog's neck, the stem hole in his mouth. The head is rendered rather simply with compass-marked eyes and opened mouth. There is also a band of circle-and-dot motifs around the neck. Clark Wissler collected this pipe among the Gros Ventres (Atsina) in Montana in 1903, but it must be of Sioux origin of a somewhat earlier date.

Figure 33 presents a short-prowed catlinite pipe in the Victor J. Evans Collection at the Smithsonian Institution. The dog head on the bowl faces front and a small bear on the shank also faces away from the smoker. Both the bear and the heavy-jowled dog's head are rendered rather simply, but the carver took pains to elaborate the surface of the dog's ear with decorative markings and to provide a "collar" composed of a chain of incised triangles. Although the museum records offer no dating or tribal provenience for this carving, I judge it to be of Santee Sioux origin and no earlier than ca. 1890.

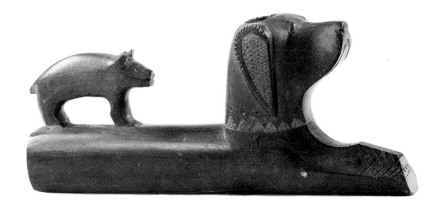

FIGURE 33. Dog head and bear pipe; Santee Sioux, 1890–1920; catlinite; 6¾" long.
Smithsonian Institution, cat. no. 359,098.

Horse Effigy Pipes

The Plains Indians' love affair with horses began as soon as they could acquire them from the early Spanish settlers in Mexico, Texas, and New Mexico. For a great many of them it has continued to the present time. During buffalo days a man counted his wealth in horses—and horses became a standard of value in intratribal and intertribal trade. Possession of horses revolutionized Indian warfare, hunting, travel, and moving camp. I have devoted a volume to a detailed analysis of the influence of the acquisition of horses upon Blackfeet Indian culture in particular and that of other Plains Indian tribes in general (Ewers 1955).

That Plains Indian sculptors shared their fellow tribesmen's admiration for horses is proven by the large number of stone and wood carvings of horses, especially the heads and arched necks, to be found in museum collections. They far outnumber buffalo and dogs combined. As a sampling of the variety of horse effigy pipes I have found, I have selected nine examples for discussion here. No other animal appeared as often on effigy pipes—most frequently in the form of the animal's head and neck.

A striking interpretation of a horse head carved in catlinite is shown in colorplate 6. It is in the Smithsonian collections, as is Seth Eastman's penciled outline drawing of it that was reproduced in Henry Rowe Schoolcraft's monumental *Historical and Statistical Information Respecting the History, Condition, and Prospects of the In-*

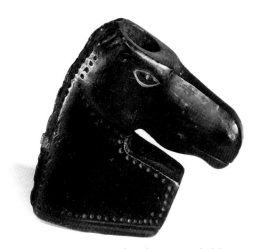

FIGURE 34. Horse head pipe; probably Teton Sioux, collected by George Catlin, 1830s; blackened stone; 3¾″ high.
The University Museum, University of Pennsylvania, Philadelphia, cat. no. 38,376.

dian Tribes of the United States (1851–57, vol. 2, pl. 69, fig. 3). In this effigy pipe, the bowl hole is at the back of the horse's head, while the stem hole is toward the bottom of the back of the neck. The carver very cleverly made use of mottling in the color of the stone to suggest a patch of lighter color on the head of this sorrel horse. Otherwise this, like many other masterpieces of so-called primitive art, is remarkable for its uncomplicated treatment of its subject. This carving is in the old War Department Collection, which was transferred to the National Institute in Washington in 1841 and thence to the Smithsonian collections during the 1850s. It may have been collected in the field for Thomas McKenney, who was in charge of the Indian Office at the War Department, even before 1830. Unfortunately, it is identified in the museum records only as from the "Indians of the Upper Missouri."

Frederic H. Douglas and Rene d'Harnoncourt selected this pipe for their exhibition *Indian Art in the United States*, at the Museum of Modern Art in New York City in 1940, which stressed the significance of Indian-made objects *as works of art*. They illustrated and praised this piece in their catalog—"occasionally someone like the unknown artist who produced this bowl had the imagination and independence to create a true piece of sculpture." (Douglas and d'Harnoncourt 1941, p. 148.) They may have been the first twentieth-century critics to recognize in writing the artistic merits of a work of Plains Indian sculpture.

Catlin himself collected the blackstone pipe shown in figure 34, which has the horse's head turned to face the smoker, with the bowl opening in the top of the head. The tribal origin of this pipe is not recorded. This may be the pipe Catlin illustrated, but not too precisely, in the plate of tobacco pipes from his 1841 book, reproduced as figure 1 of this book. I believe it more likely that this blackened pipe is of Teton Sioux than of Blackfeet origin. Surely it dates back as far as the 1830s.

Mdewakanton and Wahpukte Sioux Indians in Minnesota offered horse-head pipes for sale to whites in 1861. A newspaper account of a steamboat excursion from St. Paul down the Mississippi in June of that year to observe the payment of annuities to Indians of the Lower Sioux Agency reported that the Indians sold the whites red stone pipes, some of which were "imitating quite well, heads of men and horses." The white visitors included "a party of English tourists and other gentlemen from a distance." (*Minnesota Weekly Pioneer and Democrat*, June 28, 1861, p. 8.)

The most common class of horse effigy pipe in museum collections presents this animal in the form of a head and arched neck facing away from the smoker with the bowl hole opening atop the animal's head on a pipe carved of catlinite. Both prow and shank may be elaborated in different ways. Identified examples of these

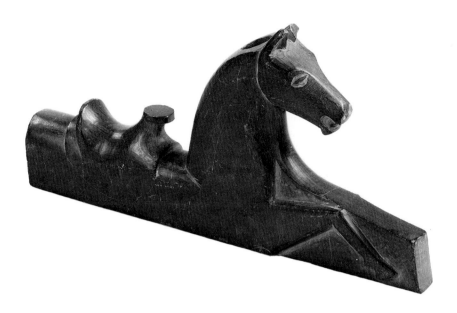

FIGURE 35. Arched-neck horse head and saddle pipe; Sioux, collected by H. T. Woodman, 1880; catlinite; 6⅞" long, 3½" high.
Smithsonian Institution, cat. no. 42,603.

pipes are of Sioux origin, although they were diffused to other tribes. In 1951 I investigated one of these pipes, which was purchased by Frank Red Crow, a Blood Indian, from Meat Face, a North Piegan of Brockett, Alberta, during the 1930s. Meat Face told Red Crow that he had obtained the pipe from a South Piegan Indian in Browning, Montana. Yet all my Blackfeet informants who were shown photographs of this pipe (now no. PiBi-3-P in the Denver Art Museum) were sure that it was of Sioux and not of Blackfeet origin. Another arched-neck horse-head pipe in that same museum bears the legend on the bottom of the pipe itself: "Otoe Agency, Indian Territory, Feb. 11, 1890." Possibly some pipes of this design were copied by men of other tribes, but it was a Sioux design, and it is more likely that any pipe of this kind collected from another tribe was carved by a Sioux Indian.

Many such pipes are credited to the Sioux in museum records. The earliest dated example I have seen appears in figure 35. The horse is carved with ears erect, mouth open, and with rather crudely incised eyes; the forelegs are rendered in low relief on the sides of the prow. A western saddle is in place on the shank. Accessioned by the Smithsonian Institution on December 31, 1880, this pipe was collected by H. T. Woodman from Sioux Indians in Dakota.

Superior to it in artistic quality is the catlinite pipe in figure 36 from the "old collection," dated before 1889, at the Peabody Museum of Natural History, Yale University. The head is very stylized as are the forelegs in low relief beside the prow, while the mane is carefully rendered in parallel incisions. An angular crest stands above the shank. Although not identified as to tribe, this carving probably is Sioux.

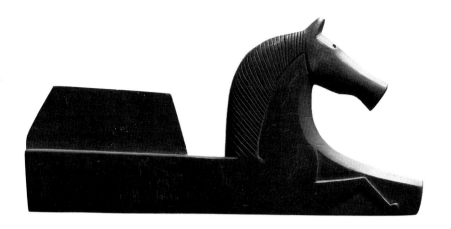

FIGURE 36. Arched-neck horse head and crest pipe; Sioux, before 1889; catlinite; 7″ long.

Peabody Museum of Natural History, Yale University, cat. no. 3,936.

Arched-neck horse-head effigy pipes appear to have been made in catlinite by a number of Sioux carvers over a period of years—until after the turn of this century. One reason for their popularity may have been the relative ease with which they could be made as items for sale to tourists and collectors. I showed photographs of several of these pipes in 1971 to pipemaker George Bryan, who pointed out that most of them were made from flat-sided blanks, requiring little carving in the round. Consequently, they could be made relatively rapidly by reasonably skilled carvers, and sold at a good profit. Bryan understood that some pipes of this class were carved by members of the Red Wing family of Santee Sioux at Flandreau many years before he began to make pipes during the 1930s.

A variant of the arched-neck horse-head pipe, said to have been obtained from the noted Oglala chief American Horse, is in the Pipestone National Monument collection. It has a recurved prow and a crest on the shank, and is illustrated in color in Robert A. Murray's booklet *Pipes of the Plains* (1968, p. 12). Another variant, with a stylized bear standing on the shank facing the smoker, in the collection made by Bishop Henry B. Whipple, is pictured in the exhibition catalog of articles from that collection entitled *Straight Tongue* (1980, fig. 16). Still different is a pipe in the Museum für Volkerkunde in Berlin in which the prow has the form of a horse's lower leg and hoof carved in the round (illustrated in Hartmann 1973, fig. 116).

On a few catlinite pipes the arched-neck horse is carved on the prow facing away from the smoker. A good example appears in figure 37 from the Victor J. Evans Collection in the Smithsonian Institution. Although the pipe is in the form of a Siouan calumet with a high, parallel-sided bowl, the horse effigy is similar to the arched-neck horse pipes with shorter prows and the bowl opening in the top of the horse's head. On seeing a photograph of this pipe, George Bryan said he believed that it had been carved "by the Red Wings of Flandreau."

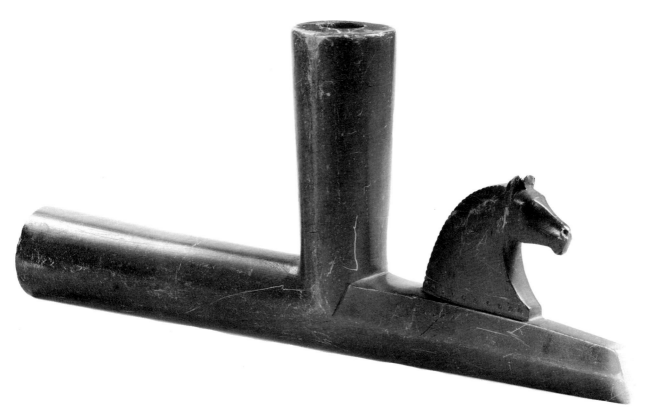

FIGURE 37. Arched-neck horse head on prow; Sioux, 1890–1920; catlinite; 10⅝″ long.
Smithsonian Institution, cat. no. 359,717.

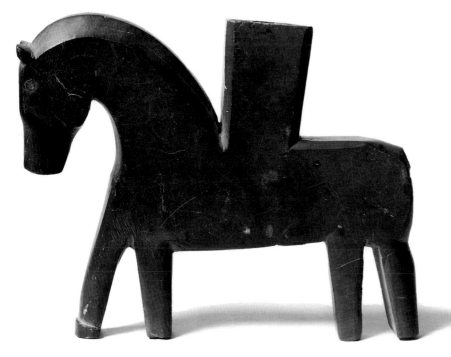

FIGURE 38. Entire horse effigy pipe; Sioux, accessioned 1878; catlinite; 6½″ long.
Museum für Volkerkunde, Berlin, cat. no. IV. b. 656.

More unusual is the full figure of a horse with arched neck, very large head, four short legs in line, and with the bowl standing upright above the horse's back (figure 38). The stem hole is in the animal's anus. This rendering of a whole horse well illustrates George Bryan's observation that a horse effigy could be made rather quickly from a flat slab of catlinite. The figure could be penciled on the side of a block of the stone, cut out with a hacksaw, and finished with a little shaping of the head and legs with the carver's knife. This horse was received by the Museum für Volkerkunde in Berlin as early as 1878. It is attributed to the Sioux.

Another stylized rendering of an entire horse straddles the shank of a catlinite pipe shown in figure 39. This pipe was bought from the widow of Old Horn, a Crow Indian. The carving differs from any other Sioux effigy pipe I have ever seen. Perhaps the design is that of a Crow artist, executed in catlinite obtained from the Sioux after the intertribal wars ended during the 1880s.

Much more lively in conception is the running-horse effigy pipe pictured in figure 40. Here the carver has clearly adapted his active animal to a typical Siouan calumet by letting the center of the horse's back provide the base for the bowl. He took pains to define the features of the animal's head, legs, and tail, adding a row of circle-and-dot compass markings at the base of the neck. This pipe is designated Sioux in the Emile Granier Collection, acquired by the Smithsonian in 1899.

I have seen four other running-horse pipes, all virtually identical to this one. All of them must have been carved by the same Sioux sculptor, probably during the period 1880–1910. Two of these have been published; the one in the Denver Art Museum appears in Feder 1971, figure 42; the other, in the Bishop Whipple Collection, in *Straight Tongue*, page 49. The fourth running-horse pipe is in the University Museum at Hampton University, Virginia, and the fifth is in the Museum of Anthropology and Ethnology in Florence, Italy. These running-horse pipes illustrate how widely the works of a single sculptor of roughly a century ago have been dif-

FIGURE 39. Horse effigy astride shank; Crow, from widow of Old Horn, before 1937; catlinite; pipe and stem 22″ long. *Peabody Museum of Natural History, Yale University, cat. no. 30,981.*

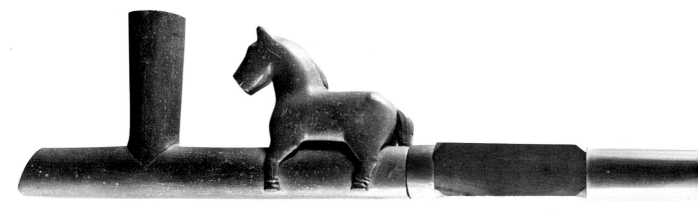

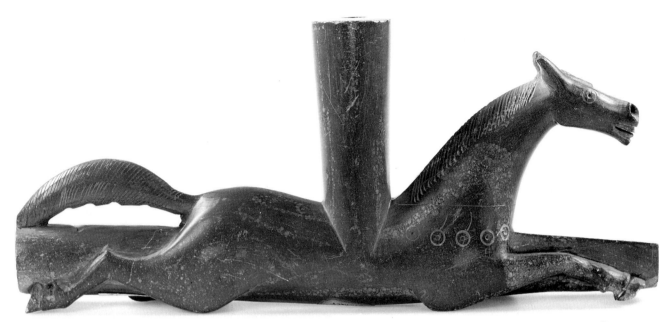

FIGURE 40. Running-horse effigy pipe; Sioux, accessioned 1899; catlinite; 9⅝" long.

Smithsonian Institution, cat. no. 200,307.

fused without becoming lost for research—if one troubles to seek them out. What was the source of motivation for these pipes? Had the sculptor seen and been influenced by the carved wooden horses on a white man's merry-go-round?

Equally stylized are three catlinite pipes representing an active horse and its Indian rider in the Bishop Whipple Collection (one appears in figure 41). All must have been executed by the same ingenious Sioux sculptor, probably in the period 1880–1900. The eager steed is held in check by reins passing around his lower neck. His forelegs in action are represented on the prow. The rider sits astride a stylized saddle (pad?), with his body bent forward, holding in his left hand a bow and an oversize arrow, and in his right hand a pipe, the last three items all in low relief.

Another Sioux effigy pipe that cleverly caricatures a horse and rider will be illustrated and discussed in my later consideration of humorous carvings on pipes. (See p. 96 and figure 80).

The best Plains Indian rendering of a horse and rider in stone that I have seen is the effigy pipe pictured in colorplate 7. Major J. C. Ferguson obtained it from a Sioux Indian named White Swan at Fort Randall, South Dakota, in 1884. Although this is only 5⅛ inches long, it appears in photographs to be much larger. To the student of art history it may suggest an Oriental association, but it is the work of an American Indian in the heart of North Amer-

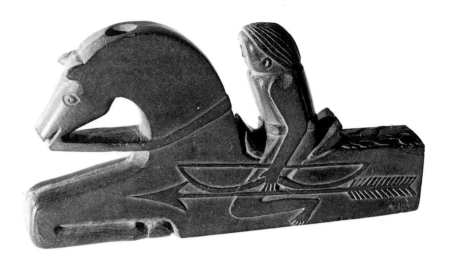

FIGURE 41. Horse and rider pipe; Santee Sioux, 1880–1900; catlinite; 5⅞″ long.

Sibley House Association, Minnesota Society, Daughters of the American Revolution, cat. no. A79:15:14a.

ica, executed in catlinite from southwestern Minnesota. The carver appears to have been especially adept in making his work fit the available block of stone. Notice how the head height is compressed to adjust to the outline of the block; the short stubby legs appear to be another concession to the limits of the material. The stone has permitted the sculptor to exaggerate the size of the horse's head and the length of its back. At the same time the carver has been content merely to suggest the rider's arms and legs. As with other effigy pipes where the pipe function must be made to fit the form of the effigy, the bowl hole is in the horse's head and the stem hole in its anus.

As the foregoing examples show, the horse was a popular subject for Plains Indian—and most especially Sioux Indian sculptors—from the 1830s through the nineteenth century. But horses have rarely appeared on Plains Indian effigy pipes carved more recently.

Raccoon Effigy Pipes

The raccoon was well known to many Plains Indian tribes, but I have seen only two effigy pipes portraying that animal—both in the Milwaukee Public Museum and from the Iowa tribe. The first was attached to one of the four sacred gens pipestems of the Iowa that were collected by Alanson Skinner and described by him in 1926 (pp. 215–38). Just how it became associated with the pipe of the Male Buffalo Gens is not explained. As depicted in figure 42, this elbow pipe renders the raccoon head in a highly stylized form, facing the smoker. The carver took pains to emphasize the mask-like effect of the area surrounding the eyes of this animal. The pipe is undated and presumably old, but I would doubt that it was originally intended to be used with the stem of the Male Buffalo Gens pipe.

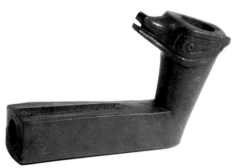

FIGURE 42. Raccoon effigy pipe; Iowa, from gens pipe, undated; catlinite; 4¾″ long.

Milwaukee Public Museum, cat. no. 30137/7322.

Bird Effigy Pipes

Effigy pipes representing bird heads or entire birds are numerous in Plains Indian collections. We have seen the cleverly conceived bird effigy pipe from the Talking Crow site dating prior to A.D. 1500 (fig. 7) and the stylized bird from the Utz Site, an early Missouri Indian village (fig. 9c). George Catlin pictured two bird-head effigy pipes of blackstone and of the 1830s period—one eagle, and one smaller bird—the former of Blackfeet origin and the latter Sioux (Ewers 1979b, pl. 2, fig. a and pl. 12, fig. h).

Plains Indian sculptors usually sought to portray a bird of a particular kind on effigy pipes; they were not content merely to show a bird. I am grateful to Dr. George E. Watson, former curator of birds, U.S. National Museum, for assistance in identifying birds depicted in some of my photographs of pipes from various museums.

Let us consider a number of the bird effigy pipes in turn:

Cormorant. Figure 43 pictures a conventionalized bird head that appears to have been adapted from the head of a cormorant. It is on the prow of a catlinite calumet in the collections of the Minnesota Historical Society, received from the estate of Mrs. Gertrude Norrish, who came from Minnesota. I judge the pipe to be of Santee Sioux origin, and the treatment of the eye suggests that it probably was carved no earlier than the 1870s. Artistically, it is a fine work. It was illustrated in color in Gilman 1982 (p. 60).

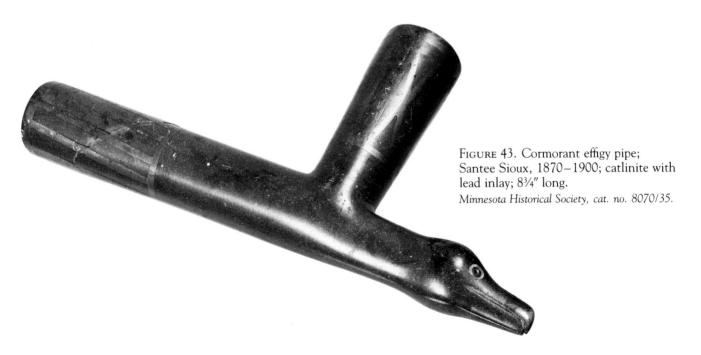

FIGURE 43. Cormorant effigy pipe; Santee Sioux, 1870–1900; catlinite with lead inlay; 8¾″ long.
Minnesota Historical Society, cat. no. 8070/35.

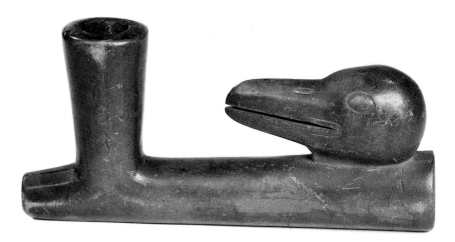

FIGURE 44. Crow head effigy pipe; Plains Cree, undated; catlinite; 6" long. *Museum of the American Indian, Heye Foundation, cat. no. 11/1307.*

Crow. A short-prowed catlinite pipe from the Plains Cree in the Museum of the American Indian, Heye Foundation, has the head of a bird carved in high relief on the shank facing away from the smoker. The length and heaviness of the bird's beak suggests that the carver intended to represent a crow in this work (figure 44).

Eagle. The Plains Indians' admiration for the eagle is reflected not only in their use of eagle feathers to decorate their shields and war bonnets, but in their graphic arts and sculpture as well. In painting their mythological thunderbird, they tended to portray it in the form of an eagle. Edwin T. Denig, the observant fur trader at Fort Union during the early 1850s, noticed that the Cree Indians represented the thunderbird on their lodges and medicine envelopes as an eagle (Denig 1968, p. 195). Clark Wissler found that the Sioux looked upon the American eagle as the white man's thunderbird, and believed that Indian drawings of thunderbirds in the form of eagles were influenced by their knowledge of white artists' representations of the eagle (Wissler 1907, p. 26).

The finest Plains Indian carving of an eagle in stone that I have seen appears in figure 45 on a short-prowed catlinite pipe from the Plains Ojibwa of the Riding Mountain Indian Reserve near Elphinstone, Manitoba, which was received in 1953 by the National Museum of Canada from J. Smart, director of National Parks for Canada. This small, handsome bird, seated with its head down toward an egg in front of him, has a monumental quality because the details are executed with the sureness of a master carver. The

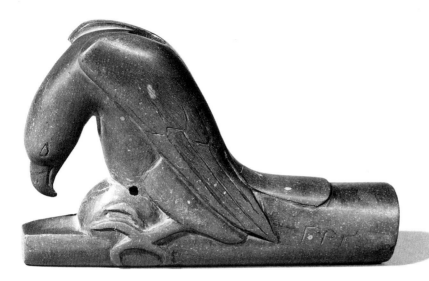

FIGURE 45. Eagle effigy pipe; Plains Ojibwa, before 1953; catlinite; 5¾″ long.
National Museum of Man, Ottawa, cat. no. V-F-17.

markings on the side of the shank signify "eagle" in the Cree syllabary. Very difficult to date, this work may not have been executed long before the National Museum of Canada acquired it.

A number of effigy pipes in museum collections depict an eagle (or thunderbird) sitting sideways on the shank of a catlinite calumet. Despite a degree of abstraction, the bird illustrated in figure 46 appears to me to convey the impression of an eagle very well. This pipe in the William P. Sargent Collection in the Peabody Museum of Yale University is identified as of Sioux origin from South Dakota. I judge it to be Eastern Sioux and of the 1870–1900 period.

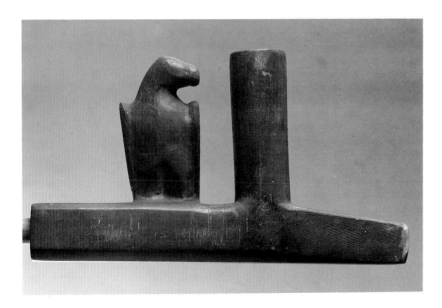

FIGURE 46. Eagle effigy pipe; Sioux, 1870–1900; catlinite; 3⅞″ high.
Peabody Museum of Natural History, Yale University, cat. no. 49,117.

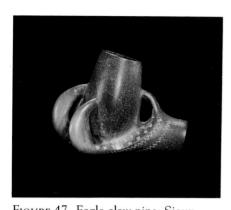

FIGURE 47. Eagle claw pipe; Sioux, 1870–1910; catlinite; 2½″ long, 1⅞″ high.

The University Museum, University of Pennsylvania, Philadelphia, cat. no. L-84-1401.

Eagle Claw. The effigy pipe in figure 47 is one of eleven claw pipes collected by Amos Gottschall during his numerous collecting trips to the west between 1871 and 1921. This is an elbow pipe elaborated into the image of an eagle holding the gently curved bowl in its talons. The Sioux themselves term pipes of this kind "claw pipes." They have been a favorite effigy pipe among the Santee Sioux for at least a century, and are still made by sculptors of the Pipestone-Flandreau area who sell their works through the Indian cooperative at the Pipestone National Monument.

While talking to some of these carvers, Barbara Hail obtained two interpretations of the symbolism of the bowl of the "claw pipes"—that it was an acorn representing the regeneration of life; or that it was an egg representing birth. She illustrated a catlinite claw pipe collected by Emma Shaw Colcleugh at Muskoka Lake, Ontario, as early as 1875, and another purchased from the Eastern Dakota carver Jack Crow at the Pipestone National Monument in 1974, some ninety-nine years later. Both of these effigy pipes are in the Haffenreffer Museum of Anthropology (Hail 1980, p. 242).

By the early 1890s, claw pipes with fish effigy pipestems also of catlinite had become popular pipestone souvenirs for sale to quarry visitors. James Austin, a dealer in objects made of catlinite in the town of Pipestone, pictured one of these pipes in his advertisement in *The Pipestone County Star*, September 30, 1892. D. H. Robidoux, writing from nearby Flandreau, South Dakota, on May 19, 1897, stated that all the "claw work" was by Daniel Weston (Dockstader 1972, pp. 108–9). Yet we know that by the turn of the century other Indians, including Episcopal lay minister William Jones, at Flandreau, were carving claw pipes. I purchased one carved by George Bryan at the Pipestone National Monument in 1971. The number of Sioux-carved claw pipes of catlinite sold to collectors must have been large for I have seen them in many museum collections in this country and abroad from California to Italy. Regretfully, many of them were less skillfully carved than the one in figure 47.

Owl Effigy. Plains Indians looked upon the owl as an awesome source of supernatural power. I first saw the effigy pipe in figure 48 in the collection of tobacco pipes from different parts of the world in the store of Alfred Dunhill Limited on Duke Street in London in 1970. Carved of catlinite, and left with a rather rough surface finish, this pipe depicts a large earless owl sitting astride an open-mouthed fish and facing the smoker. The owl's pumpkin-shaped head is equipped with a pair of deeply incised eyes and a protuberant beak. Although this work is not tribally identified or dated, I judge it to be unquestionably of Northern Plains origin and probably no earlier than the late years of the nineteenth century.

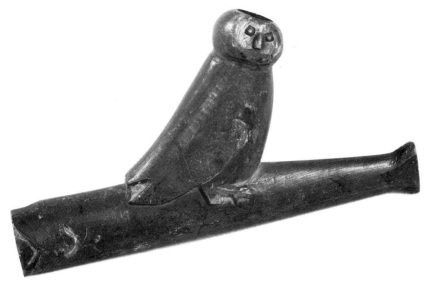

FIGURE 48. Owl and fish effigy pipe; Northern Plains, 1880–1910; catlinite; 5½" long, 3" high.
Alfred Dunhill Ltd., The Pipe Collection, London, cat. no. 14002.

Figure 49 is an elbow pipe of catlinite bearing a rather striking caricature of a large-hooded owl—probably a screech owl—facing the smoker. I judge it to be a turn-of-the-century piece, and probably of Sioux origin. It is from the Emil Lenders Collection in the Gilcrease Museum, Tulsa. Emil W. Lenders was a German-American artist who painted Plains Indians during the early years of this century.

A carved wooden pipe in the form of a small owl with the bowl hole in its back and stem hole in its breast, facing the smoker, appears in figure 50. The most striking features of this pipe are the large unpainted circles around the eyes, which stand out sharply from the blue painted eyes, and the blackened surface of the head and upper body. The bowl hole is lined with metal to prevent burning. This pipe was collected from the Yankton Sioux by Lenders, and was given to the American Museum of Natural History by J. P. Morgan in 1910. It is of Yankton Sioux origin, and probably was made about the turn of the century.

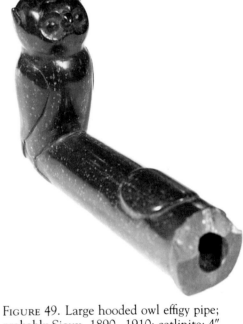

FIGURE 49. Large hooded owl effigy pipe; probably Sioux, 1890–1910; catlinite; 4" long, 2¾" high.
The Gilcrease Museum, Tulsa, cat. no. G-138.

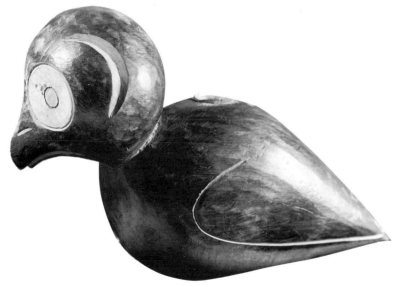

FIGURE 50. Owl effigy pipe; Yankton Sioux, before 1910; painted wood; 6¾" long, 4¼" high.
American Museum of Natural History, cat. no. 50.1/983.

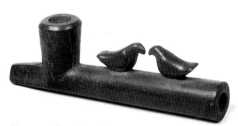

FIGURE 51. Small birds effigy pipe; Santee Sioux, before 1916; catlinite; 3″ long, ⅝″ high.

Milwaukee Public Museum, cat. no. 14,340/3639.

FIGURE 52. Rattlesnake effigy pipe; found Osceola County, Iowa, before 1876; catlinite; 1⅞″ long, 1½″ high.

Smithsonian Institution, cat. no. 24,263.

Unidentified Small Birds. Two very small birds, each less than one-half-inch long, confront one another atop the shank of the catlinite pipe in figure 51. They have an appealing cuteness, but lack distinguishing features that permit us to identify them by name. This pipe was presented to George A. West of the staff of the Milwaukee Public Museum by an old Indian at Pipestone in 1916. Doubtless of Eastern Sioux origin, the pipe probably was carved not very long before 1916.

Snake Effigy Pipes

Nearly one hundred years ago, James O. Dorsey of the Smithsonian's Bureau of American Ethnology learned that the Sioux had ambivalent attitudes toward snakes. They feared and were also in great awe of them. Some Sioux Indians would not kill a snake (J. O. Dorsey 1890, p. 479). A half century earlier, the trader Rufus Sage reported that the Brule Sioux "turned away from the spot with evident emotions of terror" when they saw that his party of whites had killed some thirty-six snakes. Sage found that those Indians "consider the act of killing [a snake] a sure harbinger of calamity." (Sage 1956, vol. 1, p. 247.)

The Sioux and other Plains Indian tribes executed numerous carvings of snakes in both stone and wood. We have seen (figure 2) that the earliest pictorial reference to Plains Indian wood carving appears in the form of a portrait of a Sioux chief carrying a snake effigy war club in about 1701. Catlin illustrated a Pawnee tobacco pipe with a snake coiled around both shank and bowl and with its head raised looking into the bowl opening (Ewers 1979, pl. 7, fig. i).

Figure 52 pictures a delicately carved small catlinite pipe with a rattlesnake wrapped around both shank and bowl. The snake's open mouth shows its fangs near the top of the bowl; its rattles are clearly defined near the rear of the shank. Of unknown tribal origin, this pipe was collected by one Giles Farwin in Osceola County, Iowa, and was accessioned by the Smithsonian Institution in August 1876.

Relatively common in museum collections are snake effigy pipes of catlinite with a snake wrapped two or three times around the shank and its head turned upward at the base of the bowl. On some of these carvings, diamondback rattlers are identified by the pattern of incised decoration on the surface of the reptiles.

An elaboration of this basic type has the snake's head grasping one leg of a frog climbing the bowl, as in figure 53. The carver of this example, which dates from the turn of the century, gave a mottled effect to the body of the snake and added incised floral decorations to the shank. Doubtless, pipes of this kind were popular with collectors because of their ingenious subject matter. They all appear to be of Sioux origin, beginning no later than the 1880s and

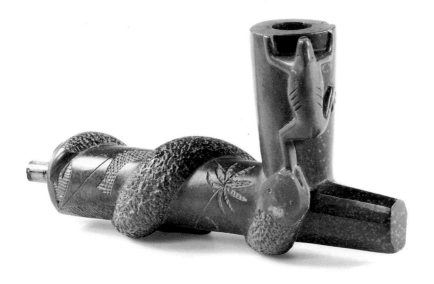

FIGURE 53. Snake and frog effigy pipe;
Sioux, 1880–1920; catlinite; 5½″ long,
3″ high.
Smithsonian Institution, cat. no. 345,987.

continuing into the 1930s among the Santee Sioux carvers of the
Flandreau community. George Bryan told me, after looking at
photographs of snake pipes, "They are not old. Joe Wabasha of
Flandreau made pipes with snakes carved on them."

One of the snake pipes in the Museum of the American In-
dian, Heye Foundation (cat. no. 23/2553), was said to have been
executed by an Indian member of Buffalo Bill's Wild West Show
during its appearance in Madison Square Garden about 1908.

Figure 54 shows a snake effigy pipe design that appears to have
been used only by one Blood Indian sculptor on the plains of Al-
berta, Canada. The snake effigy is added to a typical, smoke-
blackened Blackfeet type of Modified-Micmac pipe with a high,
curved bowl sitting upon the center of a heavy base. The snake has
its fangs extended from its head at the top of the bowl, its body
with incised chevron markings twined once around the bowl and
connecting with the top of the base at some distance out from the
bowl. The best documented example of this snake effigy pipe is the
one illustrated here, which is in the Pitt Rivers Museum, Oxford
University. It was collected by Nora Field, a British artist, while she
was painting Indians on the Blood Reserve in Alberta in 1895.

I have seen two other versions of this pipe that are virtually
identical to it. One of them is cat. no. 18/6709 in the Museum
of the American Indian, Heye Foundation, in New York, also re-
corded as from the Blood Indians of Alberta. The other example is
cat. no. AF 1356 in the Glenbow Museum in Calgary. It was not
acquired by that museum until 1962, and is attributed to the Black-
foot (Siksika).

I think these pipes must all have been carved by the same
man, whose name was Eagle Ribs, a minor chief among the Blood
Indians, who died in 1906. A missionary, John MacLean, wrote of
him in an article entitled *Canada's Native Sculptors:*

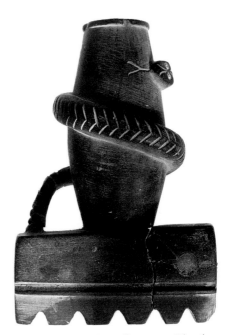

FIGURE 54. Snake effigy pipe; Blood;
carved by Eagle Ribs, before 1895;
blackened stone; 4¾″ high.
*Pitt-Rivers Museum, Oxford University,
England, cat. no. 1952.108.*

Then there was Petoqpekis [Eagle Ribs-jce], the Blood Indian pipe-maker, an old friend of mine, who was wont to make frequent journeys to the shore of Belly River at Lethbridge in quest of soft stone of a bluish hue that became hard through exposure to the air. With a bit of an iron hoop made into a blade and an awl, he carved beautiful pipes of various designs, some of them quite artistic, having the serpent symbol, an expression of the ancient form of serpent worship. Clinging to the religious beliefs of his fathers, he was chary of giving any explanation of these theological symbols, as the white folks would not understand and he would expose himself to radical reflections of foolish spectators. So he sold his wares and kept his wisdom to himself. (MacLean 1924, p. 298.)

Hugh A. Dempsey, a leading student of Blood Indian history, has informed me that Eagle Ribs "had no real interest in farming but was much more involved in religious and ceremonial life on the reserve."

Lizard (?) Effigy Pipe

One of the so-called gens pipes of the Iowa Indians in the Milwaukee Public Museum has a long-tailed, short-legged creature spread out on the shank facing the smoker, which may have been intended to represent a lizard (figure 55). With its rounded sides, topped by a rectangular platform at its opening, the bowl of this pipe resembles that of the old bear effigy pipe from the Pike-Pawnee Site (figure 10 of this book) and other known Pawnee pipes. I think it likely this pipe is also of Pawnee make.

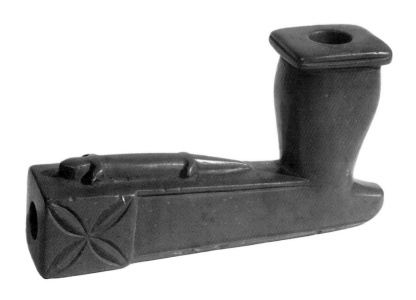

FIGURE 55. Lizard (?) effigy pipe; Iowa gens pipe, perhaps Pawnee origin, undated; catlinite; 5¾" long.
Milwaukee Public Museum, cat. no. 30,532.

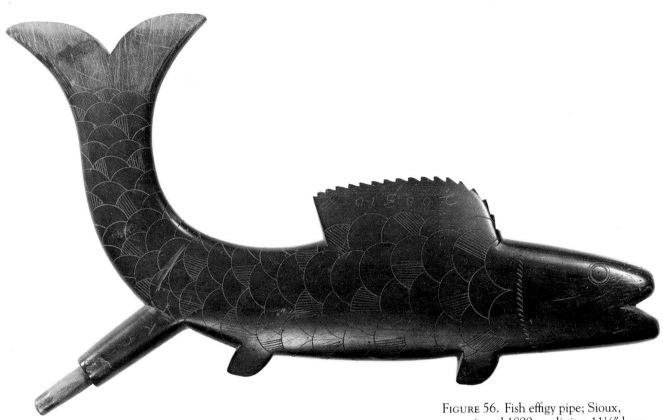

FIGURE 56. Fish effigy pipe; Sioux, accessioned 1899; catlinite; 11½″ long. *Smithsonian Institution, cat. no. 200,310.*

Fish Effigy Pipes

Effigy pipes carved in fish form seem to have originated in the Reservation Period (since about 1875) for sale to whites. Figure 56 is a good example of the most popular form of fish effigy pipe, which was carved by both Santee and Yankton Sioux sculptors in catlinite during the decade of the 1890s, when several of the fish pipes now in museum collections were obtained. Characteristically, these pipes present a fish with an open mouth, a serrated-edged dorsal fin, two rounded ventral ones, an uplifted tail, and a short tube extending backward. The bowl hole was in the mouth of the fish and the pipe could be smoked—if smoked at all—by applying the lips to the short tube. It did not require a separate stem. I found Indians at the Pipestone National Monument referring to such a pipe as a "lip pipe." The maker appears to have used a compass in incising the eye and the arcs that suggest the scales of the fish. The pipe pictured is one of the largest examples, measuring 11½ inches in longest dimension.

George Bryan said that these fish pipes were not made in his time, but that his Santee father-in-law had made them, and "a lot of Sioux made them even though the Sioux did not eat fish." The fact that these pipes were made for the market does not mean that some of them are not as old or older than many other Sioux pipes in museum collections.

Effigy Pipes and Pipestems

79

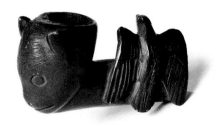

FIGURE 57. Buffalo calf and eagle effigy pipe; Sioux, 1890–1900; catlinite. 2½" long, 1¼" high.
Museum of the American Indian, Heye Foundation, cat. no. 2/3279.

Combination Effigy Pipes

Some carvers of effigy pipes ambitiously combined representations of two or more species on a single pipe. I offer a few examples:

Buffalo Calf and Eagle. Figure 57 shows a small pipe, only 2½ inches long, decorated by its skilled maker with the head of a buffalo calf on the bowl facing front, and an eagle with outstretched wings, at a relatively much smaller scale, perched on the shank, facing crosswise. The ears, eyes, mouth, and nostrils of the calf are defined, and the feathers of the eagle's wings are suggested. Artist Emil Lenders collected this pipe from the Sioux, probably around the turn of the century.

Eagle Claw and Dog Head. An elaborately sectioned pipe, which may also have been intended for smoking without a separate stem, like the fish effigy pipes, appears in figure 58. It combines features of the claw pipe with the open-mouthed dog-head one to produce an overly ornate pipe that must have had greater appeal to the souvenir hunter than to the judicious collector. It is in the Bishop Whipple Collection at Mendota, Minnesota, and probably is of the 1880–1900 period when Indian sculptors of the Flandreau region were using their ingenuity to create pipes that were different for sale at Pipestone.

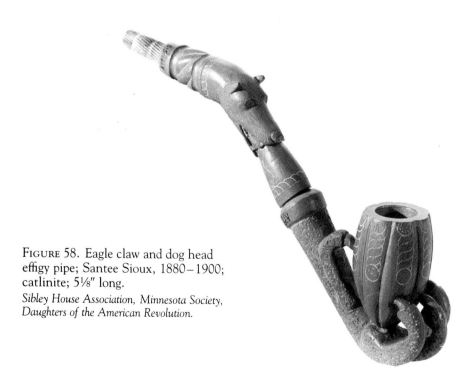

FIGURE 58. Eagle claw and dog head effigy pipe; Santee Sioux, 1880–1900; catlinite; 5⅛" long.
Sibley House Association, Minnesota Society, Daughters of the American Revolution.

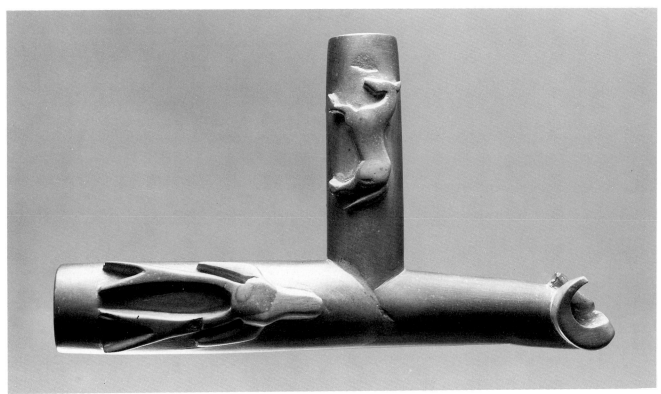

FIGURE 59. Complex effigy pipe—
bighorn, elk, horse, and turtle; Oglala
Sioux, before 1889; catlinite; 8″ long,
4½″ high.
*Peabody Museum of Natural History, Yale
University, cat. no. 15,664.*

Four Effigies in Low Relief. During that same period, Oglala
Sioux sculptors on Pine Ridge Reservation at the far side of the
state of South Dakota were taking delight in adorning the basic
calumet pipe form with representations of varied life forms of many
species, each rendered in low relief on the bowl, shank, and prow.
A good example appears in figure 59, from the Old Collection in
the Peabody Museum at Yale, which dates back to before 1889. On
the end of the prow is the inverted head of a bighorn. On the right
and left sides of the shank are the antlered heads of elk. On the
right side of the bowl and facing upward is an entire horse, while
on the opposite side of the bowl is a turtle. Each of the five crea-
tures is sharply outlined with no effort to define the details of any
of them.

Four Effigies in High Relief. At about that same time,
Green-Grass-Bull, a young Piegan pipemaker executed the elabo-
rate blackstone pipe shown in figure 60. Records at the Peabody
Museum, Yale University, state that this pipe was made by Green-
Grass-Bull about 1885 for Black-Comes-Over-the-Hill, a fellow
Piegan, who presented it to George Bird Grinnell a year or two
later. Although the bowl of this pipe resembles that of other Black-
feet pipes of that time, its long shank and prow are more like those
on Siouan calumets. The combination of life forms carved in high
relief on this pipe is quite unique in Blackfeet sculpture—including
a man riding astride a large-snouted, heavy-headed animal that has

Effigy Pipes and Pipestems 81

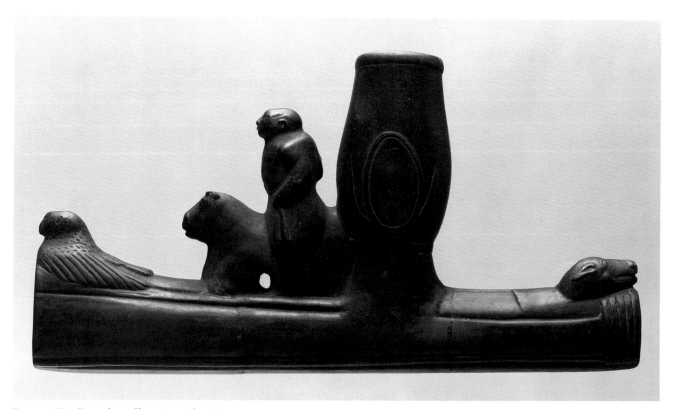

FIGURE 60. Complex effigy pipe—bear's head, man astride animal, eagle's head; by Green-Grass-Bull, Piegan Blackfeet, 1885; blackened stone; 10″ long.

Peabody Museum of Natural History, Yale University, cat. no. 1,986.

little resemblance to a horse; a bear's head facing forward on the prow; and a stylized eagle at the far end of the shank facing the smoker. Green-Grass-Bull was an old man when I knew him in the 1940s, and even though he no longer had the strength in his hands to make pipes, he was honored among his people as the dean of Blackfeet pipemakers. I had no knowledge of this pipe at that time, or I surely would have asked him about it. He told me that he did make some effigy pipes, but he did not mention any as elaborate or with such varied symbolism as this one. I must say the symbolism of this pipe is not clear to me.

Person Pipes

Many of the tobacco pipes carved by Plains Indians have the heads or full figures of human beings—male or female—represented on them. For want of a better term I shall refer to these by the alliterative name of "person pipes." There is abundant evidence that by the decade of the 1830s, a number of carvers—especially among the Sioux and Pawnee—were devoting their very considerable talents to creating a variety of person pipes. Figure 1, reproducing Catlin's plate 96 in his 1841 book, shows human beings in one pose or another in seven of the nine effigy pipes pictured. No fewer than twenty-four person pipes are shown in his illustrated monograph on tobacco pipes; the great majority of these were of Sioux or Pawnee origin, but there were also person pipes attributed to the Blackfeet, Cree, Cheyenne, and Kansa Indians (Ewers 1979b, pl. 2, 7, 8, 9,

and 21). Persons were represented in a variety of ways, ranging from the single head to groups of two or more full figures in repose or in action. These illustrations reveal that by the 1830s some Plains Indian carvers were using the shanks of tobacco pipes as platforms for meaningful social commentary. Through this medium of figures carved on tobacco pipes, they expressed their attitudes toward women, toward white men, and toward the liquor trade—sometimes seriously, at other times with an obvious sense of humor.

Let us see how actual pipes preserved in museum collections from the period of the 1830s onward reveal the sculptors' concerns with representing real and mythical human beings, and how these concerns changed over the years.

Heads. On a goodly number of effigy pipes, the human being was represented by a head only. We have already seen in figures 20 and 26 two examples of carved human heads appearing on pipes in association with animals carved on the shanks. Possibly the Indian head on the bowl overlooking the beaver on the shank may have been intended to suggest that the beaver was the supernatural source of that man's power. If my interpretation of the Pawnee pipe pictured in figure 17 is correct, the sculptor surely meant to portray the transfer of bear power to the boy seated opposite that animal. But it seems unlikely that such a connection between human and animal was in the mind of the sculptor who placed the head of a white man on the bowl overlooking the standing buffalo in figure 26.

The pipe in figure 61 is of special interest for several reasons. It originally had a carving of some animal in high relief standing on the shank also, but that figure is broken off, with only a small suggestion of the feet remaining. What remains is a very well-executed

FIGURE 61. Janus-headed person pipe; Santee Sioux, collected by Dr. Nathan Jarvis, 1833–36; catlinite with lead inlay; 5½″ long.
The Brooklyn Museum, cat. no. 50.67.104.

person pipe with a Janus head—apparently that of an Indian—carved on the bowl. The features are quite realistic, save for the ears. This pipe is definitely of the Catlin period, for it was collected by Dr. Nathan Jarvis while he was the physician at Fort Snelling near the Falls of St. Anthony on the Upper Mississippi from 1833 to 1836.

This may be the pipe listed in the original catalog of the Jarvis Indian Collection now in the Brooklyn Museum as "No. 23. Ornamented War Chief's Pipe. Sisseton Sioux." Perhaps this was the "Dakota pipe presented me by a chief" that Dr. Jarvis sent his family less than a month after his arrival at Fort Snelling in the early summer of 1833 (Feder 1964, pp. 10, 64). Perhaps the chief had intended this as a present to the new doctor at the fort if he had been treated well by the medical staff there in the past? It might, then, have been given to Dr. Jarvis by that one-armed chiefly pipemaker Running Cloud, from whom Count Arese tried in vain to obtain a Janus-headed catlinite pipe in August 1837. Running Cloud may have been the Sisseton Sioux chief Philander Prescott recalled was shot in the arm by a sentinal at Fort Snelling about 1825, had his arm amputated by the hospital sergeant in the absence of a doctor, and spent about a month recuperating in the fort's hospital (Parker 1966, pp. 73–74). That chief would have had reason to be grateful for the medical attention he had received at Fort Snelling, and to be interested in establishing a friendship with the new post doctor. If, then, this pipe in the Brooklyn Museum collection was carved by Running Cloud, it would be the oldest Plains Indian effigy pipe whose creator is known by name.

Count Arese was told that Running Cloud did not want to sell him his Janus-headed pipe, claiming "the Indians thereabouts attached considerable importance to it because it represents two heads, something after the manner of a Janus, that when there was a quarrel among them, the old man made them all smoke this pipe and that reconciled them." (Arese 1934, p. 107.) We do not know if the Sioux associated Janus-headed pipes with their belief in Heyoka, the anti-natural god, who "calls bitter sweet, and sweet bitter; groans when he is full of joy; laughs when he is in distress," and who was thought of as a man with two faces pointing in opposite directions. E. D. Neill, who sought to explain traditional Sioux beliefs in 1853, considered Heyoka one of four persons in their godhead (Neill 1872, p. 269).

Most non-Indians today tend to visualize the Plains Indian as a man wearing a flowing-feather bonnet, and I have sought to explain how that stereotype developed relatively late in the nineteenth century (Ewers 1968, pp. 187–203). A catlinite pipe bearing the feather-bonneted head of an Indian, from the James Austin Collection in the museum at the Pipestone National Monument, is illustrated in color in Robert A. Murray's leaflet *Pipes on the Plains*.

FIGURE 62. Feather-bonneted Indian effigy pipe; Oglala Sioux, ca. 1880–1910; catlinite; 4⅜" high.
Peabody Museum of Natural History, Yale University, cat. no. 49,114.

This pipe may date from the early 1890s, at which time Austin was dealing in Indian-made articles of catlinite in the town of Pipestone.

Figure 62 pictures another war-bonneted Indian head carved on the bowl of a catlinite pipe. The carver painstakingly rendered the feathers of the bonnet, and emphasized the Indian facial characteristics—including the high cheek bones, firm jaw, and large Roman nose. Accompanying records state that this pipe belonged to Chief Black Horse, a Sioux of Pine Ridge Agency, but do not provide a collection date. I believe it may be a turn-of-the-century work, perhaps carved by an Oglala Sioux man.

The feather-bonneted head did not continue to be a popular subject for Sioux pipe-makers. George Bryan told me he recalled none of them carved in his time, i.e., since about 1930.

Figure 63 shows a strikingly realistic head on a tobacco pipe in the British Museum from the old Bragge Collection. William Bragge described it as a "Pipe bowl in hard black stone carved in form of human head. Aquiline nose and whiskers under throat projection with a hole for attaching ornaments. Sent me from Red River, Pembina, by Mr. A. Boyd, December. 1868." The details of this head are rendered with remarkable accuracy—not only the eyes, ears, and nose, but also the lips, teeth, mustache, and whiskers. The hole in the base probably served for the attachment of a cord to connect this unique pipe to its wooden stem and to prevent its detachment from the stem and loss or damage to the pipe. Per-

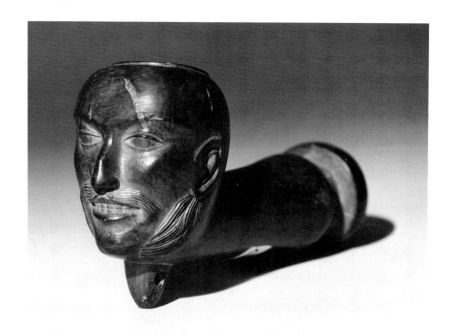

FIGURE 63. Head of a white man or Metis; Chippewa or Cree, Red River of North, 1868; blackstone; 4½″ long, 2″ high.
The British Museum, cat. no. Dc39.

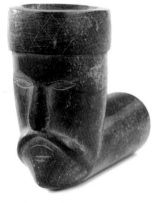

FIGURE 64. Head of a white man; probably Sioux, before 1908; catlinite; 2″ long, 2¹⁄₁₆″ high.
Smithsonian Institution, cat. no. L6010.

haps the carver of this pipe was one of the Red River Metis—of white and Cree or Ojibwa descent—who were numerous in the Red River Valley at that time. The subject of the pipe may have been a white man—perhaps a favorite trader or a member of the Metis community.

The same master carver may have executed another black-stone pipe in the Royal Scottish Museum in Edinburgh, which was exhibited and illustrated in the catalog of the *Sacred Circles* show in London in 1976 as no. 493. In it the sculptor portrayed an older man by defining wrinkles on his forehead and around his eyes, nose, and mouth. Museum records offer no documentation for this fine carving.

A much more simplified man's head on a catlinite elbow pipe in the Smithsonian collections appears in figure 64. This mustache-wearing man has the appearance of an old French engagee in the fur trade. This pipe did not reach the museum until 1908, but I judge it to be of late nineteenth century, and probably Sioux origin.

No better documented, but probably of the same period, is the effigy pipe shown in figure 65. This calumet-shaped pipe of catlinite has a man's head and neck carved on the bowl facing the smoker. He is a young man with eyes, nose, mouth, and ears clearly defined in a more stylized manner. The fact that he wears a hat shows that the carver intended to represent a white man.

White men were frequent subjects in the work of nineteenth-century Plains Indian artists. Both graphic artists and sculptors usually distinguished the white man by showing him wearing a hat. The gesture employed in the Plains Indian sign language to designate "white man" called attention to his being a hat wearer. The

sign-talker drew his right hand, palm down, across his forehead a little above the eyebrows, indicating the brimmed or visored character of the white man's headgear. Thus both sign-talkers and Indian artists seized upon the same trait to distinguish the white man from the Indian. Interestingly enough, it was a cultural not a racial trait, but it was based solidly on observant Indians' experience in meeting white men. I have found this fact helpful in trying to determine whether the subjects of some carvings were Indians or whites (Ewers 1979a, pp. 411–29).

Portraits. The highest achievement of the Plains Indian sculptors in portraying the human head was reached in the efforts of some of them to portray likenesses of particular individuals. Some Sioux Indians must have known of portrait pipes as early as 1829. Caleb Atwater, who negotiated with the Sioux and Winnebago Indians at Prairie du Chien in 1829, reported that the pipes of these Indians "are beautifully carved, so as to represent some living object," although Sioux pipes were of red stone and Winnebago ones black. He further observed, "The principal civil chief of the Winnebagoes had a very good likeness of himself cut upon the front of a war pipe, which he forwarded by me to the President with the request that it might be suspended under the President's looking glass." (Atwater 1850 p. 164.)

George Catlin pictured a pipe "in soft sandstone, carved by a *Sioux Boy*, whilst I was there, at the Falls of St. Anthony, as a portrait of the U. States Army Sutler at that post, and a very striking likeness." (Ewers 1979b, pl. 12, fig. e.) He was referring, of course, to Fort Snelling.

That fine pipe in figure 63 may have been intended as a portrait of a white man or a Metis. I now want to show three other much-better-documented effigy pipes, two of which are portraits of named white men, and the third a possible portrait of an identified Indian.

Figure 66 illustrates a portrait pipe in a private collection executed in catlinite of Dr. Jared Waldo Daniels, a U.S. Army surgeon. It probably was carved at Fort Snelling during the period 1862–1865 by an unnamed Mdewakanton or Wahpeton Sioux sculptor, who took great pains to show the doctor's beard as well as his facial features and army cap. Perhaps the artist was a patient in the hospital at Fort Snelling while Dr. Daniels was in charge there, and carved this interesting portrait in appreciation of the attention the doctor gave him.

The most elaborate portrait pipe I have seen is pictured in colorplate 8, and from another angle in figure 67. The old accession book at the Minnesota Historical Society indicates that this catlinite pipe was presented by the Sioux at Flandreau, South Dakota, to Rev. Moses N. Adams in gratitude for his kindness shown them

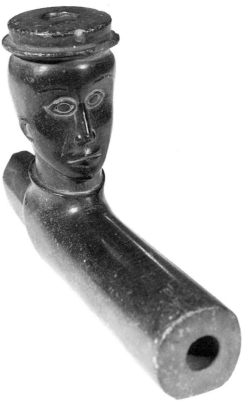

FIGURE 65. Head of a young white man; probably Sioux, ca. 1880–1910; catlinite; 6½″ long, 3⅞″ high.
The Gilcrease Museum, Tulsa, cat. no. G-946.

FIGURE 66. Portrait pipe—Dr. Jared Waldo Daniels; by a Santee Sioux Indian, 1862–1865; catlinite.
From a private collection; photograph by Warner F. Clapp.

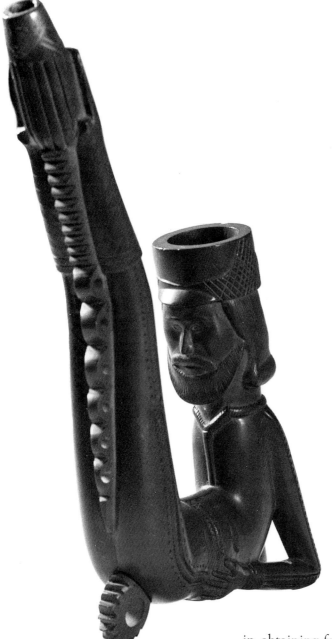

FIGURE 68. Photograph of Rev. Moses Adams, with head in same position as in carved portrait.
Minnesota Historical Society photo.

FIGURE 67. Portrait of Rev. Moses Adams; by a Santee Sioux Indian, ca. 1875; catlinite; 9½″ high.
Minnesota Historical Society, cat. no. 3325/E342.

in obtaining farming tools from the government a few years after the Sioux outbreak of 1862. Moses Adams, a Presbyterian clergyman, served as agent to the Sisseton from 1871 to 1875, and was most helpful to the Indians of Flandreau in 1873–74. He must have been given this pipe before he became an army chaplain in 1876.

Figure 68 is a photographic portrait of Moses Adams with his head in about the same position as the pipe in figure 67. A comparison of the two suggests that the Sioux sculptor created a very good facial likeness. He also showed a great deal of originality in posing the full seated figure dressed in cap, jacket, and trousers tucked into high boots, arms on hips, and legs high in the air. Surely this portrait pipe must have been executed by one of the most talented sculptors in the Flandreau community at that time, a man who had a sense of humor as well. It is unfortunate that he must remain nameless.

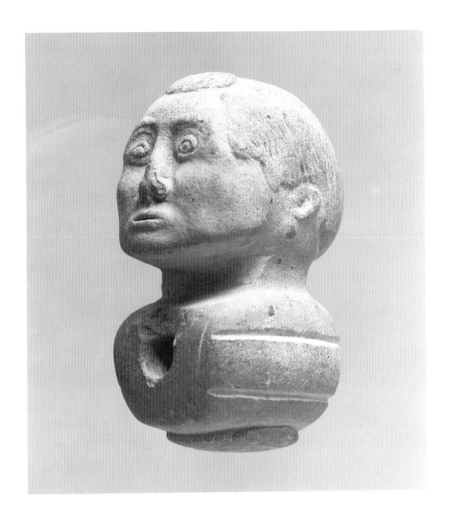

FIGURE 69. Portrait pipe—Four Horns, Blackfeet chief; by Green-Grass-Bull, Blackfeet, ca. 1900; shale; 4½″ high. *Peabody Museum of Natural History, Yale University, cat. no. 1,401.*

FIGURE 70. Four Horns, Blackfeet chief. *Photograph in National Anthropological Archives, Smithsonian Institution.*

The pipe pictured in figure 69 is unique in several respects. It is a human head adapted to the basic Blackfeet pipe type, with the man facing the smoker. The subject is an Indian and the pipe is the work of a known individual. The original note sent with this carving to the Peabody Museum of Natural History at Yale reads: "Blackfoot pipe of recent manufacture. Made by Green Grass Bull. Piegan, Blackfoot Agency, Montana, about 1900." Green-Grass-Bull told me that he made his first pipe when he was about thirty years of age. Since he was born in 1861, he would have been making pipes for nearly a decade by 1900. Although he did not mention this pipe to me, Green-Grass-Bull said that he had made a pipe or pipes for a wealthy Piegan band chief and cattleman on the southern part of the Blackfeet Reservation named Four Horns. Four Horns Lake, a landmark in that part of the reservation, was named for this man. Comparing this carving with a photographic portrait of Four Horns from the Smithsonian collections, figure 70, taken in 1903, I am impressed with the possibility that Green-Grass-Bull's Indian head was intended as a portrait of Four Horns. It has the same very broad face, high cheek bones, and sharp, staring eyes. It looks to me that in this effigy pipe Green-Grass-Bull was trying to create a portrait of his friend, Four Horns, in gray stone.

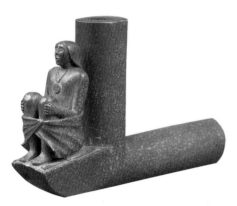

FIGURE 71. Seated medal chief on prow; Sioux, collected by Lieut. Hugh T. Reed, 1874; catlinite; seated figure 2⁵⁄₁₆″ high. *West Point Museum, United States Military Academy, acc. no. 255.*

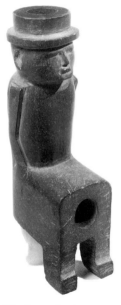

FIGURE 72. Seated white man effigy pipe; Sioux, Standing Rock Reservation, undated; catlinite; 4½″ high. *Milwaukee Public Museum, cat. no. 57841/18707.*

Seated Figures. George Catlin's monograph on tobacco pipes illustrates a number of full figures of Indians seated on the shanks of tobacco pipes. Although Catlin's renderings of these pipes are not precisely accurate, they do reveal that Pawnee sculptors were most active in carving seated figures on pipes during the 1830s (see Ewers 1979b, fig. 6, and pl. 7 and 8). That well-carved Pawnee interpretation of their myth of the transfer of bear power to a boy, pictured in figure 17, supports Catlin's high opinion of Pawnee carvings of the human figure by the 1830s. However, we shall see in examining photographs of actual carvings in museum collections that there were also Sioux carvers in the 1830s and in subsequent decades who demonstrated considerable artistry in carving the human figure in miniature in unyielding stone.

Pawnee carving seems to have reached its height in the rendering of human figures in repose or in action on tobacco pipes during the 1830s. It seems to have faded rapidly toward mid-century, and by the time the Pawnee Indians were removed from Nebraska southward to the Indian Territory (present-day Oklahoma) in the middle 1870s, Pawnee effigy carving virtually had disappeared. On the other hand, Sioux carvers of the human figure on tobacco pipes continued to be active and to do well in the closing decades of the nineteenth century, but faded rapidly during the early years of the present century.

A superb example of Sioux carving of the human figure in catlinite appears in the form of a lone Indian seated on the prow of a calumet in the museum of the U.S. Military Academy at West Point. Figure 71 shows this delicately carved image of a man only 2¼ inches high, but with precisely detailed head and body and accessories—his long hair, parted in the middle; his eyes, nose, and mouth; his naked upper body and his robe folded around his lower body and legs; his hands resting on his knees; his bare, well-proportioned feet. The same care was given to carving the calumet with a long stem on his right and tobacco pouch on his left. Museum records indicate that this pipe was purchased by Col. Hugh Reed of the West Point class of 1873 from a Sioux Indian in Dakota Territory in 1874, when Reed must have been on his first duty after leaving the military academy as a young lieutenant. The Indian is portrayed wearing a medal over his chest suspended from his neck by a cord or ribbon. The sculptor must have been portraying a Sioux chief.

A much more stylized, yet very clever, carving of a seated human figure appears in figure 72. Here the Indian sculptor has ingeniously adapted the form of a seated white man to that of an elbow pipe by letting the shank provide the man's upper legs, and adding two lower legs and simplified feet by extending the stem end of the shank downward. The facial features are roughly suggested; the arms rendered in low relief and without hands at the sides of the

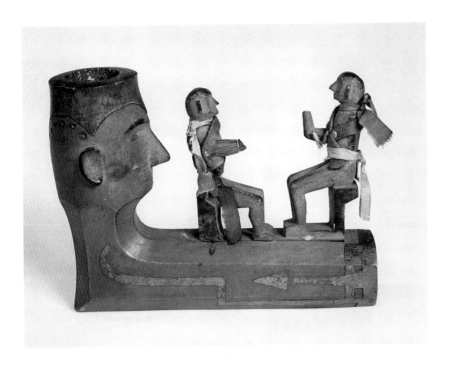

FIGURE 73. Large head and seated confronting figures; Iowa, probably mid-nineteenth century; painted wood, lead inlay, cloth ornaments; 4½" long. *Museum of the American Indian, Heye Foundation, cat. no. 24/473.*

rounded torso. Art critics who are not troubled by distortion and lack of detail in the carved human figure should find this person pipe appealing. It was collected from the Teton Sioux of Standing Rock Reservation, North Dakota, but the date of collection is not known. It may possibly have been carved in the present century.

Figure 73 shows a carved wooden pipe inlaid with banded decorations of lead that is attributed to the Iowa Indians. Two men are seated facing each other on simplified stools. A large (white man's?) head is carved on the bowl facing the two seated men. This pipe may date from the middle of the nineteenth century, judging from the basic pipe style and the similarity of the seated men to those appearing in a drawing of a wooden pipe in the Bragge Collection at the British Museum. That pipe, said to have been in the Cincinnati Historical Society, was said to have been carved "by the son of Black Hawk during his imprisonment." The Sauk and Fox and the Iowa were closely allied during the middle years of the nineteenth century.

Person Pipes as Media for Social Commentary. Proof of the high degree of skill in carving the human face and figure in miniature attained by some Plains Indian sculptors by the 1830s is found in the facility with which they portrayed persons in different poses. But some of them were not content merely to create miniature figures that appealed to the eye. They went beyond that to use the shanks and bowls of tobacco pipes as platforms for comment upon contemporary social issues in ways that should intrigue even the social psychologist who may have little interest in carving as a form of artistic expression.

Let us look at four recurring themes in these carvings that illustrate Plains Indian attitudes toward certain classes of people or contemporary cultural conditions.

Theme 1: Attitudes toward White Men. There is evidence from a number of sources that during the very early years of direct contact between Plains Indians and white men, these Indians viewed the newcomers with awe and veneration. They regarded the weapons and tools of iron that the white men introduced among them as "medicine," and they believed that the white men who knew how to use these strange and wonderful articles effectively possessed supernatural powers.

In 1796 Jean Baptiste Truteau, pioneer trader among the Arikara and their neighbors on the Upper Missouri, observed:

> All the savage people . . . which dwell on the west of the Missouri . . . have a great respect and a great veneration for all white men in general, whom they put in the rank of divinity, and all that comes from them is regarded by these people as miraculous. They do not know how to distinguish among civilized nations, English, French, or Spanish, et cetera, whom they call indifferently white men or spirits. (Nasatir, vol. 1, p. 382.)

But as Indians became better acquainted with white men they grew more aware of their human qualities and awe of them diminished. Among the Arikara this change in attitude appears to have taken place very quickly. Pierre-Antoine Tabeau, who began trading with the Arikara in 1804, the year of Lewis and Clark's ascent of the Missouri bound for the Pacific Coast, wrote:

> It is only a little while since the Ricara deified the French, who, unhappily, have only too well disabused them by their conduct and their talk. Thus they have passed today from one extreme to the other and we are indeed nothing in their eyes. (Tabeau 1939, pp. 200–201.)

During his field experiences on the Upper Missouri in 1832, Catlin learned that both Sioux and Pawnee warriors were trying to conquer any feelings of inferiority they might have in the presence of white men. At Fort Pierre he painted a portrait of Little Bear, a Hunkpapa warrior, in profile. The Dog, another Teton warrior, taunted Catlin's sitter for being "but half a man," a coward who was afraid to look the white man in the face. Those were fighting words, and in the ensuing fracas The Dog shot and killed Little Bear (Catlin 1841, vol. 2, pp. 190–92).

Some months later Catlin was given a pipe with a seated Indian carved on the shank, looking at a large white man's head on the bowl. Catlin explained that its Pawnee creator told him that "he could sit and look the white man in the face without being ashamed." (Ewers 1979b, pl. 8, fig. e). Presumably this was the

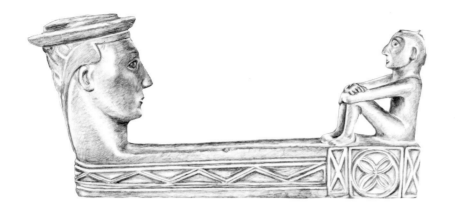

FIGURE 74. "Not afraid to look the white man in the face"; Pawnee, collected by George Catlin, 1832; catlinite; pipe and dimensions not found.
The University Museum, University of Pennsylvania, Philadelphia, cat. no. 38,378. Drawing by Marcia Bakry from photograph.

pipe reproduced in figure 74, showing a large white man's head on the bowl facing a much smaller entire Indian man seated at the far end of the shank, knees bent and arms folded over them, intently eyeing the white man's head. This pipe itself has not been found. Our figure 34 has been drawn from a photograph of it in the University Museum in Philadelphia.

I have seen four other versions of this subject. One appears in Catlin's oil portrait of He-Who-Exchanges, an Oto Indian man, holding what Catlin termed "a beautiful pipe in his hand" in the form of a seated Indian on the shank confronting a white man's head on the bowl, indicating the possession of a pipe of this design among the Oto Indians as early as 1832 (Truettner 1979, no. 121, p. 176).

A stylistically somewhat different example of this theme appears on the catlinite pipe illustrated in colorplate 9. The white man's head is more strongly carved than is the rather thin, flat-headed Indian. The carver also gave the white man a pair of arms, lightly indicated in low relief, one at each side of the shank. Although this pipe was collected by M. R. Harrington among the Oto Indians in Oklahoma in 1912, I judge it to be a much older work, probably dating from the second quarter of the nineteenth century. Whether or not its creator was a Pawnee, the differences in style suggest that it was not the work of the same sculptor who executed the pipe Catlin collected.

The pipe shown in figure 75 is of special historic interest because it was in a collection of Indian artifacts formerly owned by President Andrew Jackson at his home, The Hermitage, near Nashville, Tennessee. Previous writers have inferred that it was carved by an Indian from Tennessee. I believe that assumption is unwarranted; that the pipe probably was given to President Jackson by a member or members of a Plains Indian delegation to Washington during his administration, 1829–1837; and that it may have been carved by a Pawnee Indian. Whether or not Jackson was in-

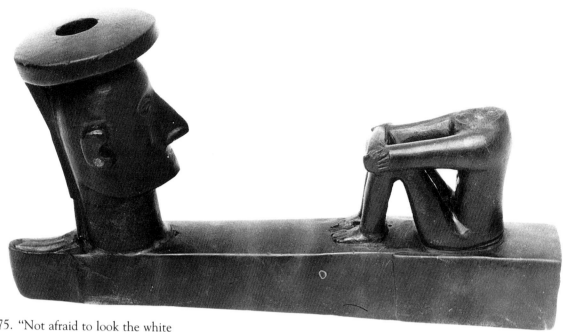

FIGURE 75. "Not afraid to look the white man in the face"; version presented to President Andrew Jackson, 1829–1837; tribe of origin not recorded; blackstone; Indian head missing; 8¼" long.
Museum of the American Indian, Heye Foundation, cat. no. 13/6457.

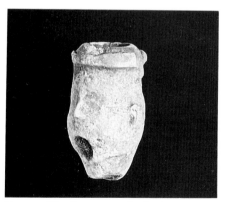

FIGURE 76. Open-mouthed white man effigy pipe; Pawnee; Site 25-SD-31 Saunders County, Nebraska, occupied during 1850s; sandstone; 2½" high.
Nebraska State Historical Society, cat. no. 25SD31(B-2)-18.

formed of its symbolism, this pipe may have provided encouragement to Indian delegates in their face-to-face confrontation with this Great White Father, a man renowned for his prowess as an Indian fighter. The pipe is of blackstone, and the head of the Indian, unfortunately, has been broken off. First described and illustrated by George Heye (1925, pp. 116–18), it was later illustrated by George West (1934, vol. 2, pl. 136, fig. 4).

Still another version of this theme is found in a pipe in the Texas Memorial Museum in Austin (cat. no. 1313-1). This pipe of unblackened limestone is less precisely carved than the others I have illustrated here. Documented as having been collected from the Shawnee Indians in Kansas during the 1840s, it testifies further to the popularity of pipes of this theme among the Indians and to their diffusion well beyond the Pawnee tribe before 1850.

During the second half of the century, some Plains Indian sculptors were offering humorous interpretations of white men. Figure 76 is an effigy pipe found at the site of a Pawnee village in eastern Nebraska, known to have been occupied during the 1850s. This pipe is of soft sandstone that lost its original surface finish during years of weathering in the ground. Nevertheless, we can see that it was intended as a clever caricature of a white man's head, with brimmed hat, mouth opened wide to receive the pipe stem, and cheeks distended as if the man is blowing smoke through the stem to the smoker.

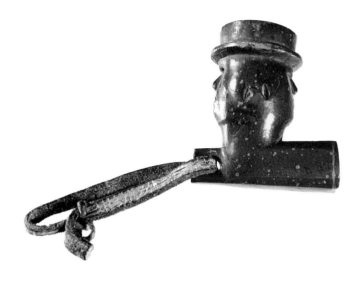

Another humorous effigy pipe portrays the white man as Janus-headed, with a small nose and rather bloated face. This caricature in catlinite, shown in figure 77, was purchased in 1888 from one of the wives of the famous Hunkpapa Sioux chief Sitting Bull, who has been quoted as saying "No Indian ever loved the white man."

A pipe in the Smithsonian collections, obtained from the Oglala Sioux during the middle 1870s, has a uniquely interesting symbolism. As shown in figure 78, the full figure of a boy on his knees and thumbing his nose is carved in low relief on the front of the bowl. Clark Wissler learned that this gesture had a very special meaning to the western Sioux in the early reservation years. It signified Big Cat in the Indian sign language, and that became these Indians' nickname for an Indian Bureau inspector sent from Washington on special assignment to check on the actions of Indian agents and traders on the reservations. So Indians used this gesture to pass the word that an inspector had been seen on the reservation (Wissler 1938, p. 37).

On one side of the shank of this pipe a Winchester repeating rifle is clearly defined in low relief. One of the duties of these inspectors in those days was to report on the illegal sales of repeating firearms to Indians who were potential hostiles. Even so, clever Indians managed to obtain the weapons through mixed bloods or white traders who operated illegally at some distance from reservation headquarters.

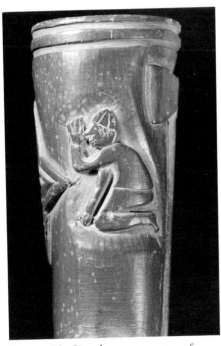

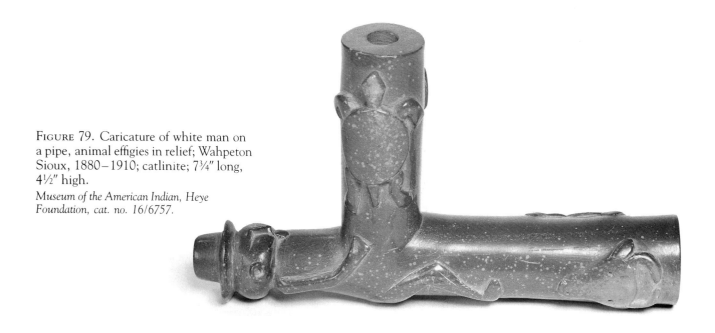

FIGURE 79. Caricature of white man on a pipe, animal effigies in relief; Wahpeton Sioux, 1880–1910; catlinite; 7¾″ long, 4½″ high.

Museum of the American Indian, Heye Foundation, cat. no. 16/6757.

Humorous also is the catlinite calumet pictured in figure 79 from the Wahpeton Sioux. Not only is the white man's head rendered in a comical way, but he is positioned on the pipe in such a way that the upright bowl appears to form a very large phallus.

Theme 2: Iktome, The Sioux Trickster. In Sioux mythology Iktome (the Spider) was a comical fellow who played a trickster's role, similar to that of Coyote for the Crow and Napi for the Blackfeet. He was a mischievous little imp who repeatedly and ridiculously got into trouble with the other creatures of this world. Children and adults loved to listen to the many stories of Iktome's adventures, which Indians told solely for entertainment on long winter evenings.

A few Sioux carvers liked to portray Iktome on effigy pipes. I judge the catlinite effigy pipe shown in figure 80 to have been a Sioux carver's fun piece—a representation of the adventurous Iktome trying to ride a horse. Certainly this composition is much more than another arched-neck horse with the addition of a rider. This particular rider is an intentional caricature of a man—with big ears, a silly smirk, and a capacious pot belly, which the rider holds with both hands, a ludicrous pose for an Indian horseman. The horse's head also appears to be a caricature. This pipe in the Royal Scottish Museum is unique in museum collections. I judge it to be of Sioux origin and of the period 1880–1910.

I have seen several other effigy pipes that appear to be the work of the same carver, but show Iktome by himself. These figures have the same silly smirk and the big belly. One of them in the Pohrt Collection, attributed to the Eastern Sioux, about 1880, was in the *Native American Heritage* exhibition at the Chicago Art In-

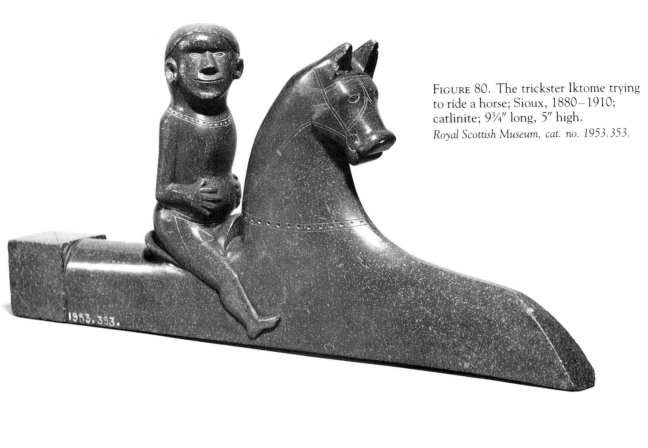

FIGURE 80. The trickster Iktome trying to ride a horse; Sioux, 1880–1910; catlinite; 9¾″ long, 5″ high.
Royal Scottish Museum, cat. no. 1953.353.

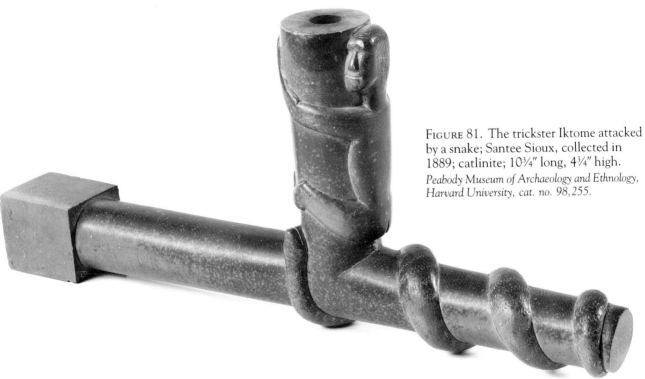

FIGURE 81. The trickster Iktome attacked by a snake; Santee Sioux, collected in 1889; catlinite; 10¾″ long, 4¾″ high.
Peabody Museum of Archaeology and Ethnology, Harvard University, cat. no. 98,255.

stitute in 1977. The seated figure provides both bowl and prow, facing away from the smoker, with his hands laced together over his stomach (Maurer 1979, fig. 173, p. 150).

Another Sioux sculptor preferred to show the trickster Iktome clinging for dear life to the upright bowl of a catlinite pipe of the calumet form, trying to keep away from a snake coiled around the prow of the pipe with his head pointing upward and close to the little man. Here again both the situation and the treatment of the human face and figure are comical. Figure 81 shows a large example of a pipe with this theme. Although this pipe is documented as having been received from the Chippewas by a member of the Rice Commission sent to treat with the Indians in northern Minnesota regarding their lands in 1889, I believe it portrays a theme in Sioux carving tradition, and that this pipe probably was carved by a Sioux. The human figure on that bowl closely resembles a little man clinging to a bowl in an effigy pipe pictured by Edwin A. Barber in his article "Catlinite" in *The American Naturalist* (vol. 17, July 1883, p. 751). That pipe also depicted a stylized monkey clinging to the bottom of the shank with both its legs and tail. Barber stated that that pipe was "made by a celebrated pipe maker belonging to the Flandreau Sioux." The pipe was sent to him by Charles H. Bennett of Pipestone, Minnesota, who had a better knowledge of the works of individual Indian carvers in the Flandreau-Pipestone area than did any other white man at that time.

Theme 3: Attitudes toward the Liquor Trade. Literate white men who had opportunities to observe the effects of the liquor trade upon the Indians at first hand held different opinions regarding it. Traders justified providing liquor to Indians in order to compete with unscrupulous others who offered it to them. Missionaries denounced the liquor trade for its demoralizing effects upon the Indians. Skilled Indian carvers offered their own opinions of the liquor trade in their miniature carvings on tobacco pipes.

Some Pawnee carvers touched upon some humorous aspects of the trade. George Catlin stated that the same Pawnee carver who executed the person pipe portraying himself looking the white man in the face, carved a pipe with two Indians seated opposite one another atop the shank of a pipe struggling for possession of a keg of liquor they were holding between them. Catlin pictured this pipe three times, first in his 1841 book (see figure 1 in this book). Later he showed it in outline and in color (Ewers 1979b, fig. 6, and pl. 8f).

In the possession of Major James Harvey Hook of the U.S. Army, Catlin saw a pipe portraying the smiling head of an inebriated Indian protruding out of a barrel head. In two renderings of this pipe, Catlin attributed it to different tribes, Pawnee and Kansa, (Ewers 1979b, fig. 6 and pl. 12b).

FIGURE 82. Pipe bowl carved in form of whisky keg; collected by George Catlin in 1830s; tribe not recorded; catlinite; 3¾″ high.
Smithsonian Institution, cat. no. 12,268.

Figure 82 illustrates a short-prowed catlinite pipe collected by Catlin himself. There are no human figures on it, but the very heavy bowl appears to represent a standing whisky keg with hoops encircling it near each end. This pipe is not identified as to tribe.

During the 1830s, the liquor trade thrived among the tribes of the Upper Mississippi despite the fact that it was unlawful to take liquor into the Indian Country, and the soldiers at Fort Snelling near the Falls of St. Anthony tried to prevent its being smuggled up river to the villages and camps of the Sioux and Ojibwa Indians. Even so, these Indians had developed a strong craving for "spirit water" (as the Sioux called liquor), and they regarded the obtaining of a keg or bottle of it as an achievement of which to be proud.

In *American Indian Art Magazine* (vol. 3, no. 4, 1978), I described and pictured two catlinite effigy pipes carved by the same unnamed Eastern Sioux master sculptor that very well illustrate the pride-of-possession attitude toward the liquor trade. Figure 83

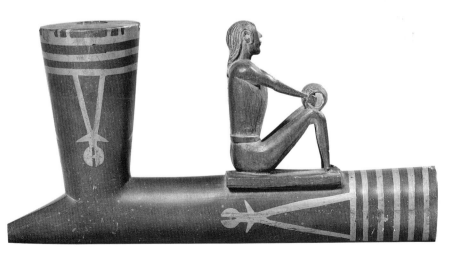

FIGURE 83. Man holding liquor keg on knees; Santee Sioux, collected by J. N. Nicollet, ca. 1838; catlinite with lead inlay; 5½″ long, 2¾″ high.
American Museum of Natural History, cat. no. 12-51.

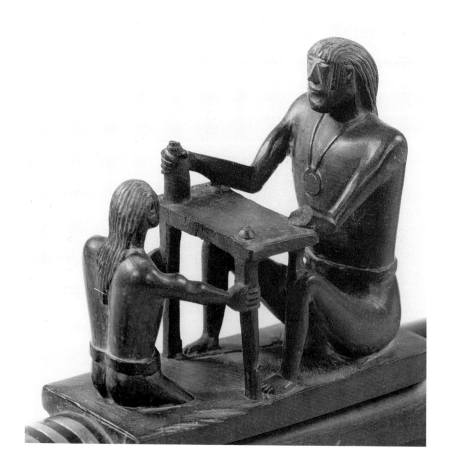

FIGURE 84. Chief offering liquor to follower (detail); Santee Sioux, Old War Department Collection, before 1841; catlinite with lead inlay; 7¾" long, 3⅝" high.

Smithsonian Institution, cat. no. 2622.

shows the simpler of these two, portraying a man seated on a small platform atop the shank of a short-prowed pipe, holding a small keg on his knees and between his outstretched arms. His eyes, nose, mouth, ears, and long, flowing hair are carefully delineated. His barrel-chested body is realistically proportioned; his shoulders and arms are well-muscled. By contrast, his legs are quite thin, his knees malformed, and his feet small. Collected by Joseph Nicollet, this pipe may have been one of the "calumets" he took back to Baltimore from the Upper Mississippi in 1837.

A second and more elaborate effigy pipe by the same carver is in the Smithsonian collections. It appears in colorplate 10, with a close-up in figure 84. Two men are facing each other on a platform atop the shank. The larger must have been intended as a chief, because he wears a medal suspended from a cord around his neck. He is seated at a low, four-legged table and holds a bottle with his right hand. His left hand, which is broken off, may have held a glass or a cup. Facing the chief and grasping two legs of the table with his outstretched hands is a smaller male figure carved in the round from a little below the waist upward. Presumably, he is waiting to receive some of the coveted liquor from the chief's bottle.

There can be little doubt that the figures on this pipe were carved by the same sculptor who created the man with the keg on

100

his knees shown in figure 83. The men are very nearly the same size, the larger of the two on the second pipe being little over two inches tall. The head and hair, the well-developed upper body, and well-muscled arms are alike. So are the thin legs, peculiarly arched knees, and small feet of the seated figures. All of the figures have a single article of clothing—a belt around their waists.

The larger pipe was part of the old War Department Collection that was transferred to the National Institute in the Patent Office in Washington in 1841. It may also have been collected by Nicollet in 1837, even though it was cataloged in 1867 after it had reached the Smithsonian as from the "Valley of the Missouri River." The pipe also includes a well-carved head and forepart of a dog on the prow.

As I have pointed out, this carver "must have possessed infinite patience to be able to produce such elaborately conceived works, and he must have learned from experience how fine a miniature arm or leg he could carve in brittle stone without breaking and spoiling one of his masterworks." (Ewers 1978, p. 53.) Perhaps in carving the seated chief and his follower he pushed his luck a little too far so that the lower left arm broke in the course of his carving. Certainly that arm is shown as broken in the exact place it is today in Seth Eastman's drawing of this pipe, executed before 1854, the original of which is also in the Smithsonian collections.

Theme 4: Attitudes toward Women. In his monograph on Indian tobacco pipes of the 1830s, Catlin pictured eight Plains Indian effigy pipes on which women are depicted. In each case, women are shown as sex objects. The subjects range from the nude torso of a woman to the frank portrayal of a man and woman making love. Three of these pipes were of Pawnee origin, two were Sioux, and the others were not identified as to tribe of origin. The last three belonged to Toussaint Charboneau, who had lived among the Hidatsa as a trader and interpreter for more than thirty years. The Sioux pipes belonged to Lawrence Taliaferro, a veteran agent for the Eastern Sioux, and at least one of the Pawnee pipes was owned by an experienced trader named Tilton. In every case these men were well known to the Indians, so that the pipes may have been specially carved to amuse white friends (Ewers 1979b, pl. 8e, 12f, and 21a, b, c, d, h, and i).

A few specimens of effigy pipes seen in museum collections seem to affirm some Plains Indian sculptors' interest in depicting women as sex objects. Two of these may be Pawnee. Pictured in figure 85 is one of them, in the old Bragge Collection in the British Museum. Executed in a highly polished blackstone, it shows a nude woman lying on her back on the shank with her head to the smoker. On the tall bowl of this elbow pipe is the head of a man—perhaps a white man—facing the woman. The entire work is well

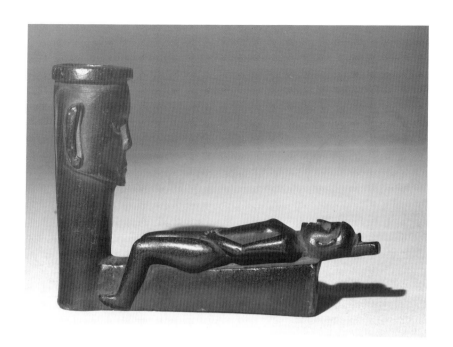

FIGURE 85. Man's head overlooking nude woman; probably Pawnee, before 1872; blackstone; 4½″ long, 3½″ high.
The British Museum, cat. no. Dc 42.

executed on a small scale, being only 4½ inches long. The record indicates that the pipe was bought in Paris in 1872, and that the Pawnee designation was supplied by Bragge *after* its purchase.

More overtly erotic is the pipe in figure 86, which appears to have been made of two different pieces of stone—a catlinite shank and bowl, with two carved human figures in blackstone standing on a small platform affixed to the shank. The figures appear to be involved in anal coitus. This specimen was purchased by George Heye from the old collection of W. C. Oldman in London. The pipe is listed as "probably Pawnee." I agree with that listing, and further suggest that it may date back to the mid-nineteenth century.

Figure 87 illustrates a Sioux effigy pipe obtained from Gen. George Lea Febiger, U.S. Army, by the Smithsonian Institution in 1880. Although the body of this human figure lacks any sexual details, some students are inclined to look upon it as female and to

FIGURE 86. Man and woman in anal coitus; probably Pawnee, mid-nineteenth century; catlinite pipe with blackstone figures; 5⅜″ long; Man 2⅜″ tall.
Museum of the American Indian, Heye Foundation, cat. no. 2/9792.

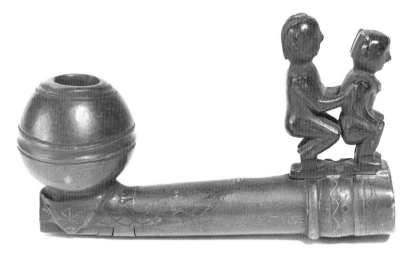

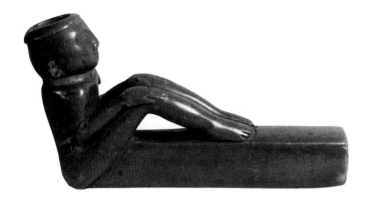

FIGURE 87. Questionably phallic symbol pipe; Sioux, accessioned in 1880; catlinite; 4½″ long, 2¼″ high.
Smithsonian Institution, cat. no. 42,669.

consider that its carver intended the shank of this pipe as a phallus. In his description of this pipe, published in 1899, Joseph D. Mc-Guire revealed considerable admiration for the sculptor's handling of this figure, which he looked upon as a man, "carved entirely in the round with unusual artistic feeling, the legs being drawn up slightly on the stem with the hands and arms extended along the legs and knees. It is quite modern in form, and there is yet wrapped around the neck a coil of fine brass wire, which in contrast to the cherry red of the stone gives a very pleasant effect. The lobes of the ears are bored evidently for the purpose of decorating them with pendants." (McGuire 1899, p. 579.)

Several effigy pipes executed by Plains Indian sculptors and collected within the reservation period since 1875 depict women in ways other than as sexual objects. Figure 88 shows a catlinite pipe with a woman's head on the bowl. It was listed in William Bragge's collection. "No. Am. Ind. from Pikes Peak Rocky Mountains. In catlinite, a female face with curious head dress, end of stem covered with pewter. Brought by C. C. Converse of Brooklyn with the intention of sending it to Baron Humboldt at whose death Mr. C. sold it to me for $15 in April, 1884."

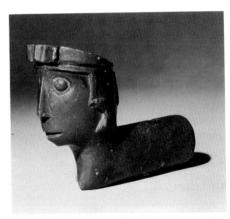

FIGURE 88. Woman's head on pipe bowl; before 1884; not tribally identified; catlinite and lead inlay; 3″ high.
The British Museum, cat. no. DC 58.

Two quite different effigy pipes in museum collections depict the Indian woman as a mother. Figure 89 shows one of these from the Oto tribe carved in the form of an elbow pipe of blackstone. It has a white man's head carved on the bowl, overlooking an Indian woman seated on the shank with a small child on her lap. There is no confrontation in this placid family group, comprising the white husband, his Indian wife, and their mixed-blood child—a common phenomenon in the Plains Indian country in the mid-nineteenth century, at which time, I believe, this pipe was carved.

Figure 90 pictures an effigy pipe in the form of a woman and child. It was collected in 1905 by Cora M. Folsom for the College Museum at Hampton Institute directly from the old Yankton Sioux man who created it. It quite simply and effectively depicts a stand-

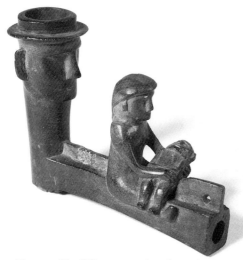

FIGURE 89. White man's head overlooking Indian woman with child on lap; Oto, probably mid-nineteenth century; blackstone; 3½" long, 2½" high.

Museum of the American Indian, Heye Foundation, cat. no. 20/2929.

ing woman on the bowl facing away from the smoker, and carrying her baby on her back inside her blanket. With her raised left hand she holds the corners of the blanket together. In her right hand she carries a plain walking stick. The clever sculptor has indicated the lower legs and feet of this woman below her long dress by incised outlines on the flat surface of the front of this elbow pipe. The bowl hole is behind her head.

I have seen no effigy pipe attempting to show a woman at work, unless it is the one in figure 91. This woman is seated with her head and body making the bowl and her legs the shank of an elbow pipe of catlinite. She is clothed, and in her outstretched arms she appears to be holding some tool, perhaps one used in dressing deerskins. On both sides of the shank and on the woman's back are quite elaborate floral designs in low relief. I judge it to be of Eastern Sioux origin, and it may have been carved not very long before it was received by the Smithsonian Institution in 1931.

FIGURE 90. Woman with child on back; Yankton Sioux, collected in 1905; catlinite; 4" long, 3⅜" high.

Hampton University Museum, Virginia, cat. no. 1840.

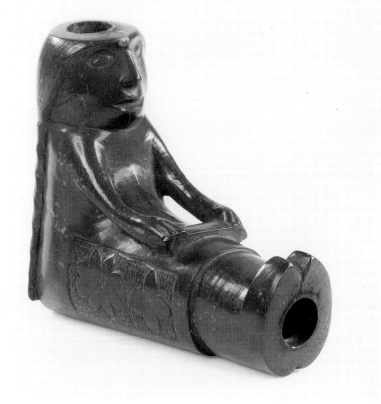

FIGURE 91. Seated woman with skin-dressing tool; Santee Sioux, 1890–1920; catlinite; 4½" long, 3⅜" high.

Smithsonian Institution, cat. no. 359,096.

Effigy Pipestems

In the traditional calumet used by Plains Indians in intertribal peace negotiations and tribal ceremonies, it was the pipestem and not the pipe that was regarded as sacred. Although ceremonial pipestems were elaborately ornamented with colorful bird feathers, dyed porcupine quills, trade cloth, and other materials, there is little indication that those pipestems were ornamented with carvings of birds, animals, reptiles, or human beings in early historic times.

George Catlin illustrated as many as forty-five pipestems in his monograph on Indian pipes based upon his examination of specimens during the 1830s. A few of them were decorated with lightly incised figures of living creatures, but only one with three-dimensional life forms carved on it. It was the stem of a pipe that belonged to William Gordon, a former fur trader, who was appointed an Indian subagent in the spring of 1833. Catlin illustrated this pipe and its elaborate wooden stem with two standing wolves carved upon it in relief. The fact that Indians who respected Gordon knew him by the name of White Wolf probably accounts for the representation of wolves on his pipestem. Catlin wrote that "this beautiful pipe" with its "stem so curiously carved in a single shaft of white ash . . . had an extensive notoriety on the Missouri, famed as the Bill Gordon pipe." (Ewers 1979b, pl. 12, fig. g.) However, the very elaborate nonfigurative carving that accompanies the wolves on this stem is so unlike known examples of Plains Indian work as to cast doubt upon the Indian origin of this pipestem.

The tribes of the northern Great Plains preferred to make their pipestems of ash if they could get it. Lazy Boy, my eldest Blackfeet informant (who was born about 1855), described the making of pipestems by his people:

> The Piegan preferred ash wood for pipestems. It is hard and has a grain. We got it from the Crow and Sioux country, but not necessarily in trade. If we couldn't get ash we used willow from this section—silver berry willow or service berry willow. But the grain of these was not as pretty as ash.
>
> Ash of the straightest grain we could get was what we liked best. The wood was put in the sun to dry. Then, when half dry, it was heated over a fire and straightened until it was perfectly straight. The pipemaker then took a hot piece of wire about a yard long. He prayed that the wire would go straight through and not burn out at the side. He made three passes at the end of the stem. On the fourth pass he pushed the hot wire through the length of the stem. If the wire didn't go straight, but came out at the side, it meant bad luck to the pipemaker.
>
> After the hole was made, the pipestem was smoothed on the outside with sandrock. (Ewers 1963, p. 57.)

It is doubtful if the practice of making pipestems of catlinite began before the reservation period—or not until Indian pipemakers obtained the brace-and-bit with which to drill holes in the stone stems.

Some effigy pipestems were made even in Catlin's time. Prince Maximilian, while among the Blackfeet near Fort McKenzie in the late summer of 1833, wrote that their wooden pipestems were "sometimes carved in imitation of a serpent." (Maximilian 1906, vol. 23, p. 108.) Dr. Nathan Jarvis, while stationed at Fort Snelling between 1833 and 1836, collected the very ingenious Sioux pipestem illustrated in colorplate 11. This has an open-mouthed canine head with eyes that seem to be of exaggerated size because they are made of brass tacks. It is 26 inches long, with a short pair of legs near the head and another pair near the far end of the body, with a tail extending backward in a straight line from that point. The entire surface of this ash pipe is painted red, with a few blue spots on the back.

George P. Belden, who had known the Sioux for several years, wrote of Sioux pipes and pipestems in 1871: "Carvings of birds, beasts, fishes, and men are cut on the bowls and stems, and filled with paint." (Belden 1871, p. 129.) In his reference to the painting

FIGURE 92. Bird head pipestem; Sisseton Sioux, accessioned in 1869; wood, painted and incised; 27¾" long.
Smithsonian Institution, cat. no. 8,657.

FIGURE 93. Bird head in relief atop pipestem; Sioux, collected by William A. Turner, 1873; Ash stem with brass tack eyes; bird head 3¼" long.
Peabody Museum of Archaeology and Ethnology, Harvard University, cat. no. 7,678.

FIGURE 94. Two birds in relief on pipestem; Blackfeet, by Green-Grass-Bull, ca. 1900; wood; 26⅞" long.
Peabody Museum of Natural History, Yale University, cat. no. 1,986.

he must have been thinking primarily of their pipestems, for most pipes were of stone and were not painted.

Let us look at some of the ways the different species were represented on effigy pipestems in museum collections.

Bird. Some of these pipestems date back to the period of which George Belden was writing in 1871. The one pictured in figure 92 is only one of two very similar pipestems from the Sisseton Sioux collected by acting assistant surgeon A. J. Comfort while stationed at Fort Wadsworth in 1869. This is an ash stem with an open-mouthed bird (perhaps a loon) carved near the center of the stem and facing the smoker. The bird's head is painted black.

Figure 93 illustrates another bird head carved on an ash pipestem. This heavy-beaked bird, possibly intended to be a crow, is painted black, with brass tacks for eyes. The pipestem was collected by William A. Turner in 1873.

Quite different from either of the above are the small birds with outstretched wings atop a pipestem that was well carved by Green-Grass-Bull, the Piegan Blackfeet pipemaker, as a young man before 1900 (figure 94).

Snake. Although Prince Maximilian mentioned the snake effigy pipestems of the Blackfeet in 1833, the only Blackfeet pipestem with snakes carved on it that I have seen is pictured in figure 95. It has two intertwined snakes—one blue and one pink—wrapped around nearly the entire length of a relatively short tubular stem 15 inches long. It was obtained from Frank Red Crow, a Blood Indian, during the 1930s.

Figure 96 illustrates a highly stylized snake carved in relief atop a catlinite pipestem. The head is emphasized with large eyes and a row of sharp teeth sharply defined, while the curves and angles outlining the body suggest a writhing movement. Collected by Chris S. Heintz in the Dakotas in 1883–85, the ingenious carving is likely of Sioux origin, though the tribe is not recorded.

The ash pipestem pictured in figure 97 depicts a painted snake approaching a spotted frog from the rear. This pipe was donated to the Grand Rapids Public Museum by R. A. McDonald in 1952, and was recorded as having belonged to Brown Bear, a Sioux, although its time of origin was not listed. A variant of this theme in the Science Museum of Minnesota in St. Paul (cat. no. 61/2890) shows the snake partly twined around the stem confronting the frog head to head atop an ash pipestem. Probably both of these pipestems were carved by the same Santee Sioux Indian in the twentieth century.

FIGURE 95. Two intertwined snakes on pipestem; Blood, from Frank Red Crow, 1930s; painted wood; 15″ long.
Denver Art Museum, cat. no. Pi-Bl-3-P.

FIGURE 96. Snake atop stone pipestem; probably Sioux, collected in mid-1880s; catlinite; 10⅛″ long.
Milwaukee Public Museum, cat. no. 11,563/6141.

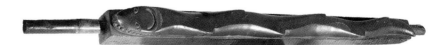

FIGURE 97. Snake approaching frog atop pipe stem; Santee Sioux, undated; painted ash wood; 24⅞″ long.
Grand Rapids Public Museum, cat. no. 183, 385.

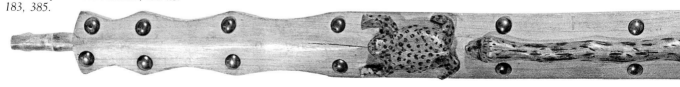

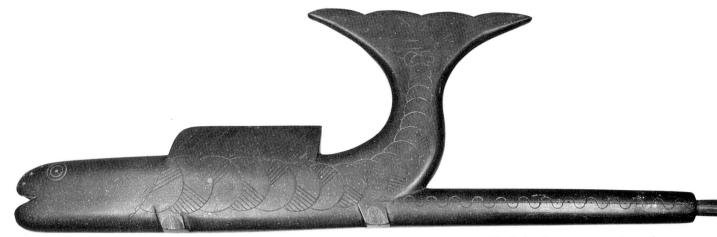

FIGURE 98. Fish effigy pipestem; Incised "James Goodacher, 1876" under tail; Yankton Sioux; catlinite; 19″ long. *Courtesy Norman Flayderman.*

Fish. A popular form of pipestem offered for sale to collectors and tourists of Pipestone during the late years of the nineteenth century was carved of catlinite in the form of an open-mouthed fish. Herman Haupt's illustrated manuscript in the Newberry Library states that fish effigy pipestems of catlinite were sold at Pipestone when he visited there in 1892. Two claw pipes with fish effigy stems of catlinite, said to have been carved by Daniel Weston in 1897, and now in the Museum of the American Indian, Heye Foundation, have been illustrated (Dockstader 1972, pp. 108–9). The very active collector, Amos Gotschall, listed forty-two pipes with "fish form stems" in his collection by 1921; of them, only eleven were claw pipes (Gotschall 1921, p. 33).

Figure 98 shows a well-documented catlinite fish effigy pipestem made before the 1890s. I am grateful to Norman Flayderman of New Milford, Connecticut, for this photograph of that pipestem, in his possession. This piece bears the date "1876" on its tail and the name "James Goodacher" incised on the underside of the belly. Presumably the name was a misspelling of the name Goodteacher, found among the Yankton Sioux. These data suggest that fish effigy pipestems with eyes and scales incised in the stone with the aid of a compass were created by a Yankton Sioux named Goodteacher as early as 1876.

From what we know of fish effigy pipestems and the large number of such pipestems in museum collections today, it is safe to say that they were carved by different sculptors among the Sioux over a period of at least a quarter century—beginning at least as early as 1876.

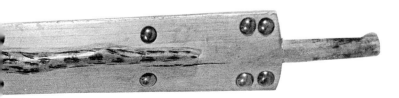

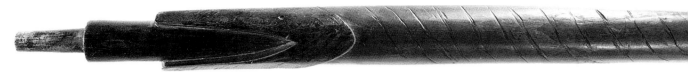

FIGURE 99. Fish effigy pipestem; "Upper Missouri River," accessioned 1899; wood; 27″ long.

Smithsonian Institution, cat. no. 200,340.

A quite different fish effigy pipestem carved of wood appears in figure 99. This longer, thinner, large-mouthed fish has no compass-marked scales, no fins, no upcurved tail. It fits rather closely the long, tubular form of the pipestem. It was part of the large collection of Indian artifacts obtained by the Smithsonian Institution in 1899 from the trader Emile Granier. In the records of that collection its provenience is given only as "Upper Missouri River."

Mammal. Even though the earliest example of an effigy pipestem I have found in museum collections portrays a stylized canine (see colorplate 11), very few representations of complete mammals carved on pipestems have been located. Two of the most interesting of these have been published. An undated and tribally unidentified pipestem in the Denver Art Museum has two well-carved otters standing one behind the other in high relief on an ash stem (Feder 1971, fig. 44). A bear stretched out about midlength on a small pipestem collected by Gilbert L. Wilson in the early 1900s is in the Minnesota State Historical Society and appears in the exhibition catalog *Where Two Worlds Meet* (Gilman 1982, fig. 46).

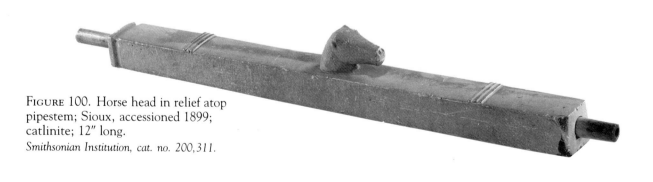

FIGURE 100. Horse head in relief atop pipestem; Sioux, accessioned 1899; catlinite; 12″ long.

Smithsonian Institution, cat. no. 200,311.

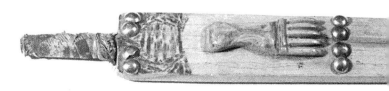

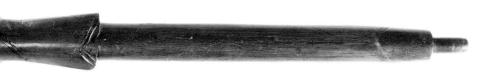

Centered on a squared catlinite pipestem in the Smithsonian collections is a small horse's head with ears, nostrils, mouth, and a short section of the horse's neck clearly indicated (figure 100). Of Sioux origin, the pipestem came to the Smithsonian Institution as part of the Emile Granier Collection in 1899.

Bear Claw and Whirlwind Worm. In 1905 Clark Wissler published a paper based on his field work among the Oglala Sioux entitled *The Whirlwind and the Elk in the Mythology of the Dakota*, in which he stated in part:

> The Dakota believe that there is a close relationship between the whirlwind and the fluttering wings of the moth. The cocoon is regarded as the bundle or mysterious object from which a power similar to that of the whirlwind emanates. I was told that the observed facts as to the emergence of the moth from this bundle were in themselves evidences of the sacred character of the moth because it had the power to escape from its enclosure. Like the wind it could not be confined. It represents, from this point of view, the kind of power desired by the Indians, viz. to be intangible, invisible, and destructive like the wind.
>
> [So the whirlwind worm] was regarded as a perpetual prayer to the power of the whirlwind. . . . It was also the custom to carve the image of the cocoon in wood, to model it of buckskin and decorate it with beads, or to represent it graphically.
>
> By some individuals it is believed that the bear has the power of the whirlwind. . . . This will change the symbolic acts of the warrior, as he will now paint his face with the symbols of the bear and then appeal to the power of that animal that the confusing whirlwind may place his enemies at his mercy. (Wissler 1905, p. 259.)

That explains the symbolism of two effigy pipestems bearing carvings of both bear paws and whirlwind worms. Figure 101 pictures one of these from the Sioux purchased by the noted collector A. E. Douglas in 1881. The other pipestem has the carved bear paw in the center, flanked by two whirlwind worms on an ash stem.

FIGURE 101. Bear claws and whirlwind worms on pipestem; Sioux, before 1881; painted wood; 24¼″ long.
American Museum of Natural History, cat. no. D M555.

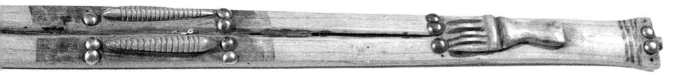

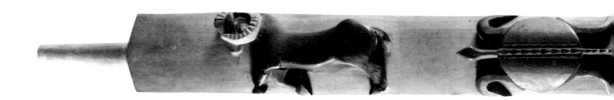

It is in the Adolf Spohr Collection at the Plains Indian Museum in Cody, Wyoming. Even though its provenience is not given in museum records, it is so similar in style to the pipestem in figure 101 as to suggest that both of these pipestems were carved by the same Sioux Indian.

Turtle and Land Mammal. Charles A. Eastman, noted Santee Indian writer on the traditional customs of his people, stated in 1905: "On the stem of the peace-pipe, used in council and diplomacy, is often found the figure of the turtle, symbolizing caution and steadfastness." (Eastman 1905, p. 699.) Ten years later, Rev. A. M. Beede wrote of Yanktonai pipes to the Smithsonian Institution: "if it is to be a sacred household pipe, two turtles are carved upon the stem, or else made and glued on." My examination of effigy pipestems in many museums revealed that ones with only turtles carved on them were rare, while those with one or more turtles and the head or heads of one or more of the larger land animals that provided food to the Indians were common.

Colorplate 12 shows a good example of an effigy pipestem on which is carved a whole turtle viewed from the top with head and legs extended, flanked by simplified heads of a bighorn and a buffalo with sharply cut outlines so as to cause the effigies to stand out clearly from their ashwood backgrounds. The effigies are also painted so as to accentuate their contrast with the background. The upper portion of the pipestem is wrapped in colorfully dyed porcupine quillwork. This pipe, of Sioux origin, was given to the Smithsonian in 1912; it may not be much older than that. After viewing a photograph of this pipestem, Beatrice Medicine, the Hunkpapa Sioux ethnologist, told me that this was the kind of work done by Crazy Bear, a Sioux on Standing Rock Reservation. The Smithsonian ethnologist James Mooney obtained a pipestem of this kind from the Southern Cheyenne in 1904, but Mooney recognized that it was of Sioux origin (cat. no. 96,980 in the Field Museum).

Similar pipestems with carvings of turtles combined with the heads of the same and other mammals are common in museum col-

FIGURE 102. Bighorn-turtle-and 2 elk effigy pipestem; Sioux, before 1889; painted ash wood; 27½″ long.
Peabody Museum of Natural History, Yale University. cat. no. 15,664.

lections. A stylized elk head may be even more common than those of the buffalo or bighorn. I counted nine pipestems with carvings of the bighorn, elk, and buffalo along with the turtle. Occasionally the plains skunk, thunderbird, or dragon fly is carved along with the more common turtle and in place of some of the common animal heads.

Figure 102 illustrates an unusual Sioux-carved pipestem, dating back earlier than 1889, on which the relief carvings include an elk head with horns, a full-length front view of an elk (at much smaller scale), a complete turtle, and a profile view of an entire mountain sheep. Obviously, Sioux carvers varied their patterns and choices of animals on pipestems.

Several variations of these effigy pipestems have been published during the past fifteen years. Norman Feder pictured a Sioux pipestem in the Denver Art Museum on which a stylized dragon fly and a buffalo head accompany two turtles (Feder 1971, fig. 45). Horst Hartmann illustrated a pipestem bearing only two heads—a buffalo and a bighorn—that was collected by Clark Wissler among the Gros Ventres in Montana in 1903. This specimen is in the Museum für Volkerkunde in Berlin (Hartmann 1973, fig. 111). Evan Maurer showed a pipestem with two turtles and two elk heads carved on it from the Southern Cheyenne (Maurer 1977, fig. 215). I have also seen effigy pipestems of this type in Blackfeet collections.

Doubtless, however, this type of effigy pipestem was developed among the Western Sioux after they were settled on reservations in the Dakotas and after the buffalo were exterminated. Probably nearly all pipestems of this type obtained from other Plains Indian tribes were actually made by Sioux sculptors.

An exception may be a carved pipestem described by George Bird Grinnell, which he saw smoked by Magpie Eagle during the third day of the Northern Cheyenne sun dance on Tongue River Reservation, Montana, in 1911. "The top of the pipestem was carved. Near the mouthpiece was a snake, below this another snake, then a turtle, a lizard and perhaps an imaginary animal—an otter, with a forked tail." (Grinnell 1923, vol. 2, p. 270.)

Effigy Pipes and Pipestems

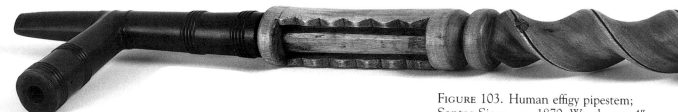

FIGURE 103. Human effigy pipestem; Santee Sioux, ca. 1870; Wood; man 4″ high, stem 27½″ long.
Museum of American Indian Heritage, Indianapolis.

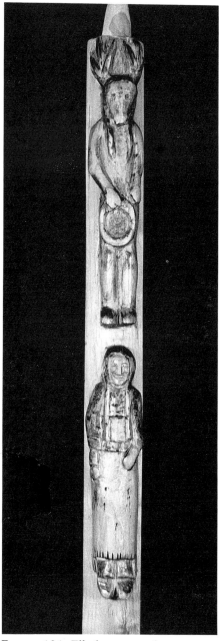

FIGURE 104. Elk dreamer and woman effigy pipestem; Teton Sioux, undated; Ash wood painted; 20½″ long.
Iowa State Historical Department, Des Moines, cat. no. 1001. Photograph by John Hotopp.

Human. Pipestems with human figures carved on them are uncommon in museum collections. Even so, I should like to call attention to four of them—all different in design. From a historical as well as an artistic viewpoint, the most significant of these is the one pictured in colorplate 13. This pipestem has an unclothed man with his arms at his sides and legs bent at the knees and curving around the stem. Although the eyes are mere curved lines, the nose, mouth, and ears are well defined, and the hair is darkened with burn marks from a hot file. The figure, at the smoker's end of the pipestem, is 6⅞ inches high.

This pipe was captured by men of the Fifth Cavalry in their attack upon the village of Tall Bull, famous Cheyenne chief, at Summit Springs, Colorado, on July 11, 1869. It was illustrated and described by Col. Richard I. Dodge in 1881 (Dodge 1882, p. ix, pl. 1, fig. 8). Tall Bull was killed in that battle, and his wife, who was captured, said "the scalps attached to the pipe were those of white settlers on the Saline River in Kansas, taken only two weeks earlier." The striking appearance of this figure is enhanced by the yellow paint rubbed on its surface. Perhaps this figure was intended to represent a Crow enemy; if so, we should remember it when we consider carved enemy effigies in the next chapter. This may be the best example of Cheyenne wood carving of the prereservation years to be preserved.

Figure 103 shows another man carved at one end of a Santee Sioux pipestem with his feet toward the smoker. The four-inch-high unclothed figure is represented as if lying on the pipestem with arms at his sides and legs bent at the knees. The head has no ears, and the eyes, nose, and mouth are simply incised. Its estimated date is about 1870.

Undated, but surely much more recent, is the pipestem in figure 104. Two fully clothed human figures are carved on it, one above the other. The lower one is an Indian woman, the upper a man carrying a hoop and wearing an elkhead mask. The upper figure must symbolize a Sioux elk dreamer, who obtained from the elk

114

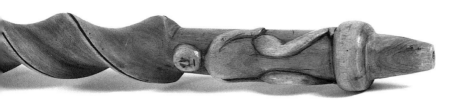

supernatural power to attract women. The elk dreamer in his dance wore a rawhide mask, with imitation elk antlers of wood, and carried a hoop.

An elaborately carved catlinite pipestem in the Crane Collection at the Denver Museum of Natural History has two carved white men of identical size and form standing back to back at the mouth end, as pictured in figure 105. Presumably intended as caricatures of white men, these figures wear no clothing other than tall hats. Their only well-defined facial features are their rather large noses. This pipestem also has elk and bighorn heads carved in relief in the same style as Western Sioux woodcarvers used in ornamenting pipestems. This piece was collected on Pine Ridge Reservation during the winter of 1890–91—the winter of the last major action in the Plains Indian Wars at Wounded Knee.

FIGURE 105. Caricature of white man on pipestem (detail); Oglala Sioux, collected in winter of 1890–91; catlinite; 3¾″ high.
Denver Museum Natural History, cat. no. 10,718-B.

FIGURE 106. Buffalo hoof pipe tamper (detail); Hunkpapa Sioux, from White Dog, 1883; wood; hoof ⅞″ high.
Minnesota Historical Society, cat. no. 6301.2.

Effigy Pipe Tampers

Plains Indians used long, thin pieces of wood with a relatively sharp point at one end to tamp the tobacco into their pipes. Some of these useful tools were decorated with carved effigies on their upper ends.

Four differently decorated pipe tampers from four museums are illustrated in figures 106 to 109. The one in figure 106 is carved in the shape of a buffalo's hoof, and painted red inside. It belonged to White Dog of Sitting Bull's Hunkpapa Sioux on Standing Rock Reservation, from whom it was collected in 1883. Figure 107 has the form of a very simplified human head. The black-painted hair atop the forehead suggests the pompadour of a Crow Indian warrior, so the Western Sioux Indian who carved this pipe tamper may have been mocking his Crow enemies. Figure 108 is a pipe tamper from the Yanktonai Sioux of Crow Creek Reservation, with the well-carved head of a bighorn at its top. Figure 109 bears the shape of a very simplified horse head, without eyes or ears, but with some emphasis upon the muzzle. It belonged to Grandma No Fat, an Oglala Sioux of Pine Ridge Reservation, and dates from the years 1920–1930.

Mark St. Pierre has informed me that some Western Sioux men still fashion pipe tampers from straight branches of sage. Occasionally, they carve the upper ends into the shape of a buffalo's hoof or a horse's head. He mentioned the name of Jim White Feather of Rosebud Reservation as a carver of especially attractive effigy pipe tampers.

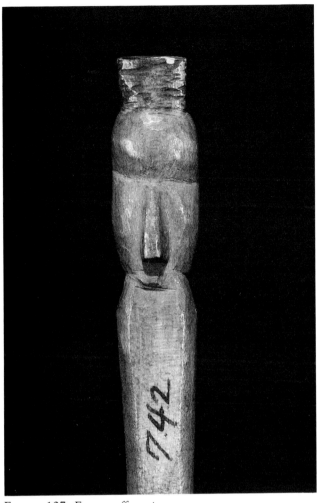

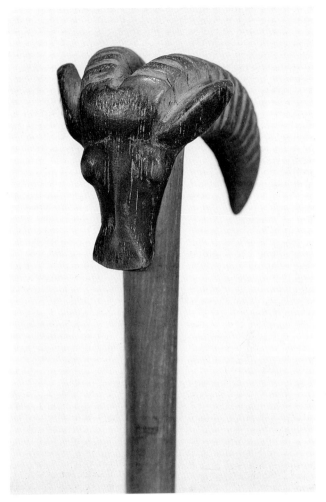

FIGURE 107. Enemy effigy pipe tamper (detail); Teton Sioux, undated; painted wood; head 4¼″ high.

The University Museum, University of Pennsylvania, Philadelphia, cat. no. L84-1336.

FIGURE 108. Bighorn head pipe tamper (detail); Yanktonai Sioux, Crow Creek Reservation, undated; painted wood.

David Clark Collection, Hampton, Connecticut.

FIGURE 109. Horse head effigy pipe tamper; Oglala Sioux, belonged to Mrs. No Fat, 1920–30; wood; 12¼″ long.

Robinson State Museum, Pierre, South Dakota, cat. no. 73.24.55.

Effigy Pipes and Pipestems 117

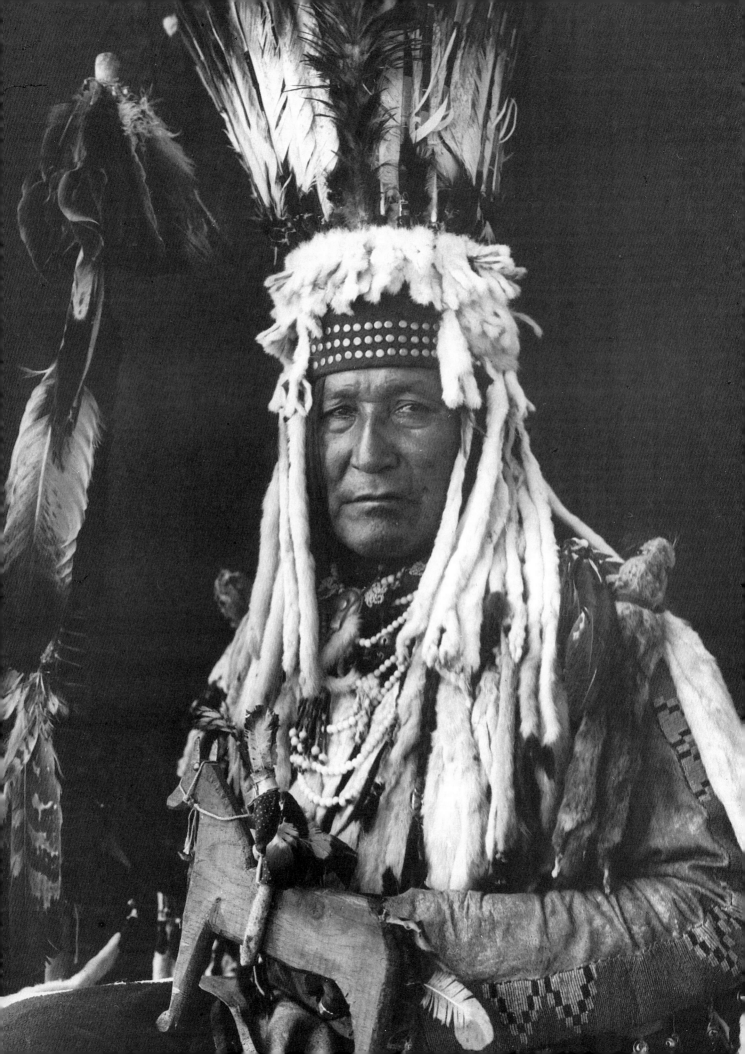

CHAPTER 3

Religious, Magical, and Ceremonial Effigies

Plains Indians believed that supernatural powers could be transmitted from the spirit world to human beings through carved or molded images to benefit or to harm human beings.

They showed a willingness to accept previously unknown effigies as media for the transmission of supernatural powers. Andele, a Mexican captive living among the Kiowa Indians, told missionary J. J. Methvin of the reaction of an elderly woman of that tribe to a broken stone effigy she had found beside a trail in the valley of the Washita River prior to 1870:

> As they went an old squaw discovered near the trail they were traveling a little hollow stone image with both legs and one arm broken off. She snatched up the image, called the hurrying crowd to a halt, held the image out in her extended hand, and began praying, "O good image, O grandfather, give us long life. Never let us grow old. Give immunity in war and success in battle. Make our enemies blind, that we may kill them. Give us long life, and in it all, youthful strength and beauty.

She then passed the image to the next in the circle, for by this time a large circle had been formed, with instructions to pray as she had done (Methvin 1899, pp. 89–90).

Robert Meldrum, the fur trader who had married into the Crow tribe, told Lewis Henry Morgan in 1863 that the first Crow sun dance doll—the enemy effigy displayed in the sun dance lodge of the tribe—was an old relic obtained from Mexico long ago (Morgan 1959, p. 185). Colonel Dodge was told that the tribal medicine of the Utes was "a little squat stone figure of Aztec or Toltec origin, and which the Utes probably obtained from the Navahoes or Apaches." (Dodge 1882, p. 134.)

Wooden horse effigy victory dance emblem held by Mountain Chief, Blackfeet veteran of the intertribal wars. [Figure 128]
Photograph by Joseph K. Dixon, Copyright 1913. National Anthropological Archives, Smithsonian Institution, neg. 76-1228.

Perhaps it should not seem strange, then, that the rock medicine bundle of Little Nest, which was considered "the most powerful rock medicine among the Crows," had as its central symbol a Haida Indian carving of an animal in slate. How this carving by Indians on the Northwest Coast reached the Crows in the Yellowstone Valley east of the Rockies is not known (Wildschut and Ewers 1960, pp. 105–10, and fig. 68).

The Arapaho, Blackfeet, and Crow Indians recognized fossil shells and naturally shaped stones that bore vague or imagined resemblances to known creatures as medicines. The Arapahoes used ones resembling birds or animals in doctoring the sick (Kroeber 1907, pp. 426, 442). The Blackfeet regarded a section of baculite bearing some resemblance to a buffalo as a sacred medicine formerly used in a ceremony for calling the buffalo when the camp was without meat and the people were hungry. Baculites, ammonites, and oddly shaped pebbles, found on the plains, were known as *Iniskims*, or buffalo stones, and were kept by the Blackfeet as good luck charms (Wissler 1912, pp. 242–5, fig. 33).

I recall that when members of the Indian Arts and Crafts Board and I attended a dinner to celebrate the twentieth anniversary of the opening of the Museum of the Plains Indian on the Blackfeet Reservation in 1961, the president of the Blackfeet Indian Cooperative Craft Shop, headquartered in the museum since the latter's inception, gave each of us an *Iniskim* in a little beaded buckskin bag as a good luck token.

The Crow Indians looked on peculiarly shaped rocks found on the plains as sacred, but did not consider them medicine unless the supernatural powers associated with them were transferred to the owners in dreams or visions. Figure 110 pictures a rock medicine that some Crow Indians considered both old and powerful. It was obtained from an Indian named Smells by William Wildschut in 1922 for the Museum of the American Indian, Heye Foundation. The central effigy of stone is framed and partially concealed by the elaborate decorations surrounding it. Wildschut described this rock medicine:

> The rock, about 2¼″ long, bears the distinct image of a face. As all the features are rounded it appears to have been shaped by rubbing rather than cutting. However, the mouth line and the eyes appear to have been incised. It is partly encased in buckskin and attached to a red-painted buffalo skin background, including strips of winter (white) weasel skin (some of which are colored with red paint), many varieties of large, colored trade beads, pieces of drilled abalone shell, shell disc beads, brass bells, brass thimbles, and nine scalplocks. (Wildschut and Ewers 1960, p. 112.)

Wildschut found that the most common kind of medicine bundles among the Crow Indians were the rock medicine ones, and

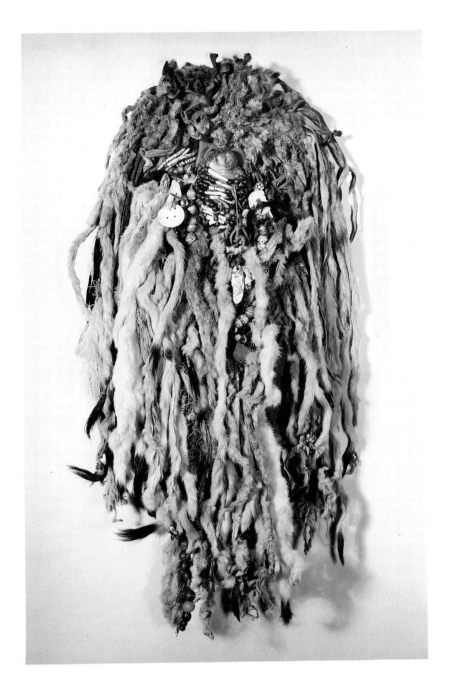

FIGURE 110. Human effigy rock medicine; obtained from Smells, a Crow Indian, 1922; stone lavishly ornamented with weasel skin strips, shell and glass beads, and shell moons; stone head 2¼" high.

Museum of the American Indian, Heye Foundation, cat. no. 11/6454.

that they served many purposes. Smells's rock medicine was a war medicine. Its "owner, a leader of war parties, always took the bundle with him on the war path. Before going into battle he invariably consulted this medicine. Whenever possible it was consulted the night before the party expected to meet the enemy. The bundle then would tell the owner the strength of the enemy party, whether there was a chief among them, and if so whether he would be killed. Whatever its prophecy, it always came true. Whenever an enemy chief was killed one of his scalplocks was attached to the medicine." (Idem, p. 111.)

Some Crow rock medicines served several purposes. Thus, Big-Medicine-Rock's rock medicine was used for calling buffalo, on

the warpath, and to abate storms and bad weather in general. Gray Bull's medicine was used for capturing horses and to keep himself and his family in good health. Spine's rock medicine was used for calling buffalo and for success in war. Short used his rock medicine mainly for success in gambling (Idem, p. 92).

In this chapter we shall consider particular effigies used by Plains Indian tribes to provide supernatural assistance in many activities—in hunting, in warfare, in bringing harm to personal enemies through witchcraft, in curing the sick, in courting and holding the affection of lovers, in ceremonial feasting, and—for a few tribes—as tribal medicines believed to be essential to the well-being and continued existence of their tribes.

Some of these effigies were of stone; many of them were carved of wood; some others were of horn or antler. These were not natural forms bearing some resemblance to bird, animal, or human forms, but were carefully and deliberately fashioned by Indians in accordance with instructions received from their supernatural help-ers. They varied in style and appearance from nearly abstract to very realistic representations of life forms.

While we examine these effigies, let us keep in mind that these Indians did not look upon the effigies as idols to be wor-shipped per se, even though some white observers, whose under-standing of Indian beliefs was limited, wrote of them as idols. For example, William K. Keating, the journalist of Major Stephen H. Long's official exploring expedition to the Upper Mississippi and the Red River of the North in 1823, wrote of Standing Buffalo, a noted prophet among the Eastern Sioux of "about twenty years ago," that he "usually carried about with him a little stone idol, carved in hu-man shape; this he called his little man, and to it he always applied when consulting in the way of his profession." Keating was told that on one occasion Standing Buffalo used his powers of prophesy to predict correctly the number of enemy killed, prisoners taken, and his own people killed in an attack upon an Assiniboin camp by a Sioux war party, which he himself led (Keating 1824, pp. 423–24).

James William Lynd, an experienced trader among the Eastern Sioux, wrote much more perceptively about the Dakota (i.e., Sioux) attitude toward their effigies some years prior to his death in 1862:

> Frequently the devout Dakota will make images of bark or stone, and after painting them in various ways and putting sacred down on them, will fall down in worship before them, praying that all danger may be averted from him and his. It must not be understood, however, that the Dakota is an idolator. It is not the *image* which he worships, any more than it is the cross which is worshipped by the Catholics, but the *spiritual essence* which is represented by that image, and which

is supposed to be ever near it. The essentially physical cast of the Indian mind (if I may be allowed the expression) requires some outward and tangible representation of things spiritual, before he can comprehend them. The God must be present, ere he can offer his devotions. (Lynd 1864, p. 154.)

Hunting Medicines

Animal Effigies Used in Medicine Hunts. In the days when buffalo were numerous on the Great Plains, there were times when the nomadic tribes—dependent upon game for their subsistence—were reduced to near starvation because game animals were scarce in the vicinity of their camps. Of the Plains Ojibwa, who lived in the northeastern portion of the plains in nineteenth-century buffalo days, James Howard wrote:

> In times of famine "medicine hunts" were staged. Herb medicines and paint were rubbed on small images or drawings of animals. The supplicant then beat a small hand drum, sang his medicine songs, and prayed for success. Later in a dream he would be told where he could find game. (Howard 1965a, p. 10.)

John Tanner, a white captive who lived and hunted with the Plains Ojibwa near the Red River Valley about 1810, recalled a time when the band was "so reduced by hunger, that it was thought necessary to have recourse to a medicine hunt. Nah-gitch-e-gum-e sent to me and O-ge-mah-we-ninne, the two best hunters of the band, each a little leather sack of medicine, consisting of certain roots, pounded fine and mixed with red paint, to be applied to the little images or feathers of the animals we wished to kill." (James 1830, p. 174.)

I have found no documented examples of carved animal effigies used by identified tribes of Plains Indians as hunting medicines in museum collections. However, a number of images of buffalo made of stone have been found at widely scattered locations well within the prehistoric and early historic buffalo range which may have served Indian hunters on "medicine hunts" or the masters of the hunt in ceremonies to call the buffalo into pounds or over high cliffs to destruction in the valley below.

We have seen a fine example of one of these miniature stone buffalo from the Wind River Valley of Wyoming in colorplate 1. I know of a dozen other stone buffalo that have been found on the Great Plains in the Canadian provinces of Alberta and Saskatchewan and in the states of Montana, North Dakota, Minnesota, and Iowa. All of them were found in the present century; several were plowed up by farmers, which suggests that they may have been made as recently as the historic period. Nevertheless, and even though metal knives and/or files may have been used in making

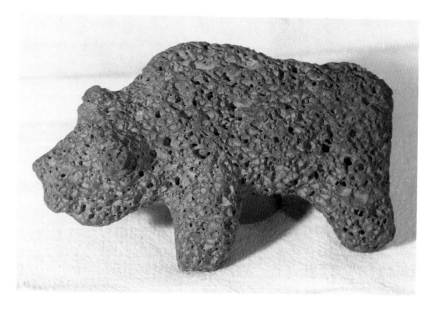

FIGURE 111. Buffalo effigy probable hunting medicine; found in historic Blackfeet territory, Montana, 1942; volcanic lava painted red; 6¼" long, 3" high.

Museum of the Plains Indian, cat. no. 1837.

some of these effigies, none of them can be attributed to a particular tribe of Indians with any degree of certainty.

Figure 111 pictures one of these miniature buffalo that was found in 1942 in the Montana area that was inhabited during the early nineteenth century by the Blackfeet Indians. It is of scoriaceous lava 6¼ inches long, worked to shape, and painted red. The volcanic material of which it is made is fairly common in nearby Glacier National Park. The Indian who executed this effigy was content to suggest a buffalo with only two legs (one front and one back), and without trying to define precisely its eyes, ears, or horns. He did suggest a hump, and there is no doubt that he intended his work to be a buffalo.

In contrast to this is the miniature buffalo in colorplate 14, which was found in historic Plains Cree territory, near Ardmore in east-central Alberta, in 1959. Carved of quartzite 6½ inches long, this is the most realistically rendered of all the Great Plains miniature stone buffalo that I have seen. It has a very prominent hump, incised eyes, well-defined horns and ears, and a well-turned body, even though the front legs are stubs and the rear ones are broken. Compared with the buffalo effigy from Wyoming in colorplate 1, this one appears to exaggerate the animal's height while the other one exaggerates its length. Both specimens are noteworthy examples of primitive animal sculpture.

Two buffalo effigies from Alberta made of coal have been described and pictured (Zierhut 1968, pp. 1–4; and *Alberta Archeological Review*, cover illus., Autumn 1983). Both are smaller than the ones described above. Three stone buffalo effigies found in Saskatchewan, and illustrated by E. Hedger (1968, pp. 13–16), range in length from 4½ to 9½ inches. Two are of quartzite and one of natural asphalt. All the animals have bulging eyes and protruding tongues.

124

In 1954 Alan R. Woolworth published descriptions and photographs of four miniature stone buffalo, three from various locations in North Dakota and one from the vicinity of Heron Lake, Jackson County, southwestern Minnesota. All four of these effigies were found since 1925 within the area occupied in historic times by Siouan-speaking tribes. The one from Minnesota was made of reddish sandstone; two of those from North Dakota were of granite, the other of quartz (Woolworth 1954, pp. 93–6, pl. 1 and 2). These four effigies vary greatly in appearance, but all are relatively crude representations of buffalo when compared to the one from Wyoming and the largest of those from Alberta.

In 1965 Charles R. DeBusk, former director of the Sioux City Public Museum, sent me a description and photograph of a sculptured animal of Sioux quartzite turned up by a plow on the farm of Robert Gust, about six miles south of Mapleton, Iowa, in 1964. The piece is ten inches long but only four inches high, has no hump, and is so generalized that archeologists who had examined it thought it might have been intended to represent a prairie dog or woodchuck. Our knowledge of the buffalo effigies that have been found, and the variety of styles employed in presenting that animal by Plains Indian sculptors, suggest to me that this stone carving from Iowa was also intended to represent a buffalo.

Although we have no Indian testimony to the effect that any of the stone buffalo mentioned above were used in ceremonies to call the buffalo, that probable use is not based entirely on the conjectures of anthropologists. William Wildschut learned of Crow rock medicines used in buffalo hunting. Claude Schaeffer, during his field work among the Piegan Blackfeet in the middle of this century, was told that White Calf Bull, a Piegan band chief who signed the first Blackfeet treaty with the United States in 1855, was a leader in buffalo-calling rites that attracted these animals to the cliffs over which buffalo were lured to destruction in earlier days. In his buffalo-calling ritual, he made a smudge of sweetgrass and an altar of white earth and placed a buffalo stone beside the smudge (Claude Schaeffer Papers, Glenbow-Alberta Institute).

James R. Murie, a Pawnee ethnologist, told of a buffalo-calling ritual among the Pawnee South Bands that was derived from a stone buffalo found on the plains, surrounded by a circle of buffalo skulls. "The finder became keeper of the buffalo ritual." (Murie 1981, vol. II, pp. 443–46.)

During his investigations of Kiowa Indian culture in Oklahoma in 1904, James Mooney obtained from his artist-informant, Silverhorn, the penciled sketch of the rainbow-painted tipi reproduced in figure 112. It also shows a stone buffalo with ribs painted on it, which was kept in a boat-shaped medicine bundle at the back of this tipi near its top. Mooney's notes term this stone buffalo a *Taime Oka-i*: "It was not the real Taime but accompanied it." Nu-

FIGURE 112. Pencil sketch of carved stone buffalo fetish kept in rawhide case at back of Kiowa Rainbow Tipi. Drawn by Silverhorn, Kiowa artist, for James Mooney in 1904.
Mooney Papers, National Anthropological Archives, Smithsonian Institution.

FIGURE 113. Buffalo effigy charm for a hunting horse; Teton Sioux; collected in 1890; catlinite; 2⅜″ long, ⅜″ high.
Smithsonian Institution, cat. no. 385,938-A.

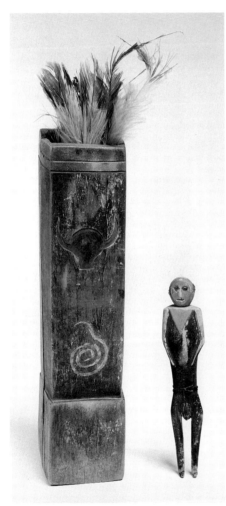

FIGURE 114. Tree-Dweller image beside symbolic home; Wahpeton Sioux, ca. 1820; painted wood, feather lining; Image 6¾″ high.
Museum of the American Indian, Heye Foundation, cat. no. 9/595.

merous descriptions of the Kiowa sun dance do not mention this buffalo effigy, but they do tell of two ceremonial buffalo hunts that were part of the complex ritual. The first was made to obtain the buffalo hide to be placed in the crotch of the center pole for the medicine lodge. Then just before the sacred Taime was brought into the lodge, another ceremonial hunt was enacted by men covered with complete buffalo hides who played the parts of buffalo that were corralled into the sun dance lodge. It seems most probable that the stone buffalo Silverhorn pictured was used in one or both of the buffalo-calling rituals associated with those ceremonial hunts.

It is not surprising that the Kiowa might have been the only southern plains tribe to use a stone buffalo effigy ceremonially, for the Kiowa are thought to have migrated southward early in the historic period. They maintained relations with the Crow Indians and some of the other tribes of the north after their move.

Evidence also exists for the use of carved wooden buffalo effigies as hunting medicines by the Plains Indians. During his field work among the Crow Indians in the early years of this century, Robert H. Lowie was told by Old Dog of a "stick carved into a buffalo head . . . that was merely a single man's medicine, the owner praying to it when the people were hungry." (Lowie 1913, p. 163.)

A buffalo effigy bearing a more tenuous relation to buffalo hunting is shown in figure 113. It is a piece of catlinite 2⅜ inches long and only ⅜ of an inch high, with a stylized buffalo head carved at one end and parallel grooves further back. This unique little carving was collected among the Teton Sioux in 1890 by Dr. James D. Glennan, who described it as a "carved stone charm attached to a horse ornament." Presumably its purpose was to prevent a man's prized buffalo-hunting horse from being gored by a buffalo or falling and injuring its rider.

Sioux Tree-Dwellers

The Santee Sioux respected the supernatural powers of Canhotdan, the Tree-Dweller, to help or harm the hunter. James Lynd emphasized this spirit's power to draw "the hungry hunters to the depths of the woods by imitating the voices of the nefarious 'cice, cice' (the form of invitation to a feast), when he scares them out of their senses by showing himself to them" (Lynd 1864, pp. 153–54). On the other hand, the missionary Stephen R. Riggs, who looked upon images as household gods among the Sioux, described one of them, which had recently come into the possession of the missionaries, as "that of a little man, and is enclosed in a cylindrical wooden case, and enveloped in sacred swan's down." (Riggs 1869, p. 71.)

Probably that well-carved wooden effigy I have reproduced in

colorplate 2 served the family of the Wabashas as a Tree-Dweller, or hunting medicine. If so, it must be the oldest Tree-Dweller in any museum collection.

Another example, said to have been created in 1820, had been the property of the grandmother of Rev. Amos Greyshall of the Wahpeton Sioux. It was one of several Tree-Dwellers collected by Alanson Skinner for the Museum of the American Indian, Heye Foundation. As illustrated in Figure 114, this painted wooden man stands 6¾ inches high beside the symbolic hollow tree in which he lived. The Sioux carver rendered the facial features of the little man, but not his ears; his arms, but not his hands; while he especially emphasized his genitals. His hollow tube home of cottonwood is four-sided, nearly twice as tall as he is, and is decorated with three graphic symbols—at the top an inverted thunderbird (symbolic of the Medicine Lodge Society to which the owner belonged); beneath it the incised and painted head of a buffalo bull (symbolic of courage), and under that a coiled snake, incised and colored with yellow paint.

In his field studies, Skinner found that the Sioux believed the Tree-Dweller had the power to confront and confuse a lonely hunter so that the first person of his family he meets on his way home must surely die. On the other hand, "the owners of these images are able to make them dance magically during the rites of the (Medicine Dance) society, and are renowned as hunters, for the Tree-dweller is a notable dispenser of luck to followers of the chase." (Skinner 1925, pp. 66–73.)

Another Wahpeton Sioux Tree-Dweller with its symbolic home appears in figure 115. The little man originally had a pair of hawk claws inserted in his head to simulate horns; one of them is missing. The figure appears to be not as well carved. The stump was made in two halves, tied together to make the circular tube. There is a little slot at the bottom, through which a stick can be inserted to make the little figure dance when it is inside its home and its owner sings. Accompanying information states that this Tree-Dweller also served as a curing medicine. It was thought that "If the patient can hear the dancing then he will get well."

Two Tree-Dwellers and one cylindrical home collected from the Santee Sioux in Nebraska in 1906 are in the Colorado State Museum in Denver. They were pictured by Norman Feder in 1971 (fig. 55). These little Tree-Dwellers appear to combine some of the features of those illustrated here in figures 114 and 115. Both have male genitals defined; one has horns.

Since World War II, several Tree-Dweller images of carved wood by named Indians have been collected by the late James Howard, an ethnologist. One of them, made by John Saul, a well-known Yanktonai Sioux wood carver, is shown in figure 116. Al-

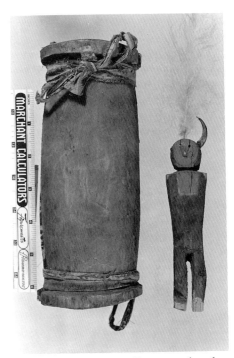

FIGURE 115. Tree-Dweller image beside symbolic home; Wahpeton Sioux, collected ca. 1956; painted wood, bird claw horn; image 5⅞" high.
State Historical Society of North Dakota, cat. no. 13,267.

FIGURE 116. Tree-Dweller image in symbolic home; Yanktonai Sioux, carved by John Saul, ca. 1965; wood, string hair added; image 6¼″ high.

W. H. Over Museum, University of South Dakota, cat. no. E. 534.

though this short and rather grotesque human figure is well carved, its container (home) is barely large enough to hold the image. In 1961 James Howard obtained an "excellent carving of *Inadinga*, the Ponca wood sprite." It is mentioned, but not illustrated, in Howard 1965b (p. 51).

There is no evidence that the Sioux Tree-Dwellers were intended for use only as buffalo-hunting medicines. Alanson Skinner, who studied both the Santee Sioux and neighboring tribes to the east of them in the Great Lakes region, recognized close parallels between the Santee Tree-Dwellers and carved wooden effigies made and used by such tribes as the Prairie Potawatomi, Sauk and Fox, and Menomini. He concluded that the "Tree-dweller image of the Wahpeton Dakota seems, therefore, to form the westernmost extension of a type of magic image that occurs from tidewater New York westward, and which are found most usually among Algonkian tribes, among some one of which it possibly had its origin." (Skinner 1925, p. 73.)

Hidatsa Eagle-Trapping Snake Sticks

Gilbert Wilson described the use of a ceremonial bundle owned and used by Wolf Pack, an Hidatsa eagle trapper, which included "two poles or small logs that we called our snake pillows. They were of ash two inches thick and an Indian fathom long. They represented snakes and were for this reason called snake sticks."

During the ceremony of preparation for eagle trapping, one of the men took up the two snake sticks, and "with the lower end of the sticks resting on the ground, Small-ankle sang the snakes' song." (G. L. Wilson 1928, pp. 145–46). How, or even if, these "snake sticks" were carved we do not know.

War Medicines and Other War-related Effigies

The Great Plains was an active theater of intertribal warfare from prehistoric times until after the buffalo were exterminated and the westernmost tribes of this area were settled on reservations during the 1870s. Whether an ambitious young man raided the enemy as a member of a small party to take horses, or a large one to gain revenge and to take scalps, warfare offered him the surest road to fame. Long after the conflicts ended, veterans of those intertribal wars continued to participate in dances in which they dramatically reenacted their winning of war honors. As late as 1941 I saw two aged Blackfeet veterans recounting their coups in the sun dance of their people.

A variety of carved effigies of wood or stone associated with Plains Indian warfare are preserved in museum collections. Some of them represent animals or reptiles that were the warriors' supernatural helpers, but a considerable number of them are in human

form, and a goodly proportion of those are enemy effigies symbolizing either enemies they hope to gain revenge upon, or ones they already had defeated.

War Medicines. Each Plains Indian warrior sought his own war medicine to protect himself from harm and bring success in war. A young man tried to obtain his medicine directly from some supernatural power in a dream or vision in which a spirit would appear, express pity for him, and give him some of its power, along with complete instructions for making the symbol of its power and the use of that symbol. Failing to acquire a war medicine in this way, a young warrior appealed to an experienced one—whose war record had proved the potency of his personal medicine by bringing him safely through a number of successful encounters with enemies—to give him some of *his* power.

These personal war medicines were represented by power symbols that varied greatly in size, materials, and complexity—from a single feather or a bunch of feathers tied in the hair to elaborate war shirts, headdresses, bandoliers, necklaces, or weapons of different kinds. A number of these war medicines were composed in whole or in part of carved effigies.

Figure 117 pictures a small, netted wooden hoop that was worn in the hair as a Cheyenne warrior's war medicine. It is in the form of a snake whose carved wooden head protrudes only 1¼ inches. This ingenious war medicine was obtained from the Southern Cheyenne by missionary H. R. Voth, some years before his collection passed to the Smithsonian Institution in 1893.

FIGURE 117. Snake effigy personal war medicine; Southern Cheyenne; wood, cord netting, buckskin ties; 4″ Hoop diameter.
Smithsonian Institution, cat. no. 165,859.

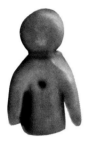

FIGURE 118. Human effigy on war medicine necklace; worn by Limpy, Cheyenne participant in the Battle of the Little Bighorn, June 25, 1876; catlinite effigy, with mescal beans, dried lizard, packets of medicine in skin; effigy 1¼" high.

Thomas B. Marquis Collection, Custer Battlefield National Monument, Montana, cat. no. 98.

A better-documented Cheyenne personal war medicine, pictured in figure 118, is in the form of a necklace worn by Limpy, a Northern Cheyenne cripple, in the Battle of the Little Bighorn in which Gen. George A. Custer and his immediate command were wiped out by a combined Sioux and Cheyenne force on June 25, 1876. This necklace consists of eighty-three mescal beans strung on a buckskin cord, to which are tied three small packets of medicine (probably botanical substances) wrapped in buckskin, the dried skin of a lizard, and a little man carved in catlinite. The human effigy is a little over an inch in height, with a featureless face, handless arms, and an upper body only—all in flat silhouette.

Early in this century Clark Wissler, a noted student of the Blackfeet Indians, collected from the Blood Indians of southern Alberta the war medicine pictured in colorplate 15, along with a brief account of its origin and use. "A war horse once appeared to a man in a dream and gave him his magic power. The dream-horse carried two arrows on its back, so in the specimen. He gave the man specific directions as to how the symbolic object was to be made, carried, and used. In battle it was carried on the back of the owner; this would give his own horse the power of the dream horse. Two songs were taught the man:

The man speaking: You see my horse is powerful.
The horse speaking: I am powerful."

Now preserved in the Museum für Volkerkunde in Berlin, this personal war medicine is in the form of a carved, painted, and decorated wooden stick 28 inches long, with the carved horse's head at one end elaborated with cut leather ears, buffalo hair mane, and a scalp suspended from the horse's mouth. It was customary for Blackfeet warriors who had taken an enemy scalp to return home with that scalp dangling from their horse's war bridle. A dyed horsehair tail is also attached to the far end of the wooden stick. The two arrows mentioned in the origin legend are painted red and are tied to the horse effigy about midway in its length.

A rare example of a carved personal war medicine representing an inanimate object belonged to Mato-tope (Four Bears), who had the best war record of any man in the Mandan tribe during the early 1830s, when he was well known to George Catlin, Prince Maximilian, and Karl Bodmer. Although this second chief of the Mandans had many coups to his credit, he was most proud of the one he had earned by killing a Cheyenne chief with that opponent's own knife in hand-to-hand combat. Thereafter, Four Bears wore a carved wooden replica of that knife, painted red along the sharp side of the blade, as a war medicine. Both Catlin and Bodmer's portraits of Four Bears in full dress show this knife tied to his handsome horned bonnet. In a third portrait of Four Bears, dressed to participate in the dance of his military society, he wears this wooden knife

in his hair. Prince Maximilian prevailed upon Four Bears to make a wooden replica of the knife for his collection. It is now in the Linden-Museum in Stuttgart, and is illustrated in Schultze-Thulin 1976 (fig. 19, pl. 13–14).

Some war medicines were intended to benefit an entire war party or even an entire tribe or major division thereof. Rev. Peter Powell has pictured and described the use of the *Ox'zem*, or Sacred Wheel Lance, of Box Elder, a famous Cheyenne holy man. It consisted of a netted wheel with pendant eagle feathers tied to the shaft of a wooden lance. The shaft had a metal lance head at one end and a small carved head of Sweet Medicine, the Cheyenne culture hero, at the other. This medicine was reputed to have been made by Box Elder's father, and Box Elder himself was born as far back as about 1795. He was old and blind when the power of his Sacred Wheel Lance was said to have protected the women and children of Morning Star's camp when it was attacked by Gen. Ranold McKenzie's cavalry on the morning of November 25, 1876, in a canyon of the Red Fork of the Powder River (Powell 1969, vol. 1, pp. 94, 143–59; vol. 2, p. 451).

In 1923 William Wildschut obtained a Crow Indian bundle that contained both a buckskin sun dance doll and a wood carving of a man standing 10¾ inches tall, which was "said to have been used on the warpath." Presumably it was carried by the party leader or partisan to bring success to the entire operation. As we see in colorplate 16, this is a conventionalized figure of a nude man, carved of cottonwood and rubbed with red paint. The eyes are inset trade beads and the necklace is a string of alternate black and white pony beads. The curved brow and the crosses on the chest are painted green. The face is broad, hands are placed over the stomach, and the genitals are indicated (Wildschut and Ewers 1960, p. 32). A simpler human effigy of wood obtained by Wildschut from Three-Fore-Top may also have served as a war medicine (Idem, fig. 10). Both of these Crow effigies are in the Museum of the American Indian, Heye Foundation, in New York City.

James Murie told of the Skiri Pawnee uses of carved human effigies as war medicines:

> Another deity was an iron (stone) man that was found by the Skiri somewhere in the south. This iron man had been kept in the mountains by other tribes and there were many presents spread on the ground. When the Skiri found it and gave native tobacco to it, they were successful in their raids among their enemies. So they added this to their list of Gods. Later the image disappeared, and the ceremonies were discontinued.

In a brief reference to other warriors' bundles among the Pawnees, Murie wrote: "Sometimes a human image of wood is found in these bundles. In their meetings they pray to this image,

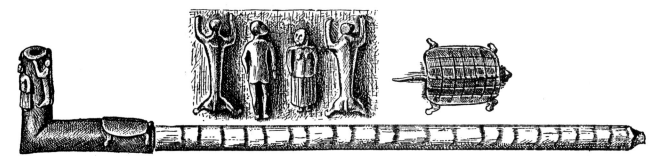

FIGURE 119. Sacred pipe of peace or war; Pawnee, collected by George A. Dorsey, 1900; catlinite, wood stem.

Field Museum of Natural History, cat. no. 59,488. As illustrated in Dorsey 1904, fig. 23.

for it represents a being in the heavens." (Murie 1981, part 1, p. 40.)

I have seen only one possible Pawnee war medicine with carving on it in museum collections. An effigy pipe from the Skiri, on exhibit in the Field Museum of Natural History, it was collected by George A. Dorsey in 1900 and is termed "sacred pipe of peace or war." Figure 119 reproduces Dorsey's illustration of 1904, which well portrays the four small relief carvings surrounding the tobacco chamber. They include the fully clothed full figures of a man and a woman, flanked by two mammals with their legs outstretched. A turtle carved in relief straddles the shank, facing the smoker. The significance of the figures on this pipe is not explained.

In 1819 the naturalist Thomas Nuttall, in reporting on some of the customs of the Osage Indians of the central Great Plains, stated: "Before going to war they raise the pipe towards the heavens, or the sun, and implore the assistance of the Great Spirit to favor them in their reprisals, in the stealing of horses, and the destruction of their enemies." (Nuttall 1905, p. 239.) Almost a century later—1913—and long after the intertribal wars had ended, an American Indian ethnologist, Francis La Flesche, obtained for the Smithsonian collections the war pipe of the Wind Gens of the Osage. That pipe had not been used for many years, and was in imminent danger of being sold to a private collector.

During his intensive studies of Osage ceremonialism, La Flesche learned that in the days of intertribal warfare this pipe was offered ceremonially to the man who was selected to lead the warriors on an expedition against the enemy. In this ritual the war leader was instructed: "When you go to the setting sun toward your enemies, and carry the pipe as an offering; when you make your supplication for aid your prayers will always be granted." (La Flesche 1921, pp. 195–97.)

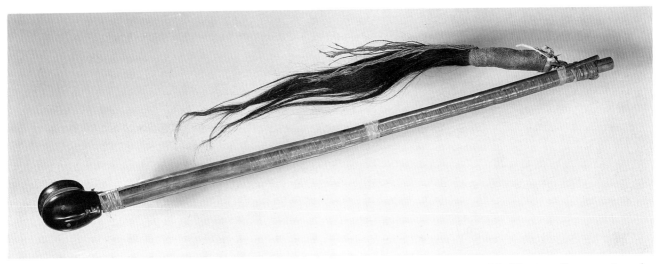

FIGURE 120. Human effigy war pipe of the Wind Gens; Osage, collected by Francis La Flesche, 1913; calcite, wood stem, hair pendants.
Smithsonian Institution, cat. no. 276,133.

As pictured in figure 120, the pipe has a long, thin, tubular wooden stem with a scalp attached near one end and a pipe of highly polished black calcite at the other. The pipe and stem together were looked upon as the symbol of a man, the pipe representing the head. The pipe is disk-shaped with the face of a person carved on its under side. As shown in colorplate 16, the nose is large and long, but the eyes and mouth are simply small, round indentations. The eyes are filled with red paint. This head measures only 2⅜ inches in height.

The neighboring Kansa Indians also had a war pipe, on which the only carving was an incised eye on each side. James O. Dorsey, a thorough student of Kansa Indian culture, wrote:

> The war pipe was kept in 1882 by Pahanle-wak'ii, the son of Alinkawaho for the two Hunga gens. This pipe has an eye on each side so that it can see the enemy! There is no pipestem, but there is one hole to which the mouth is applied, and the bowl is another hole in which the tobacco is placed. The pipe, which is all of one piece, is of catlinite, about as thick as two hands. It is never taken from its wrappings, except when all the men of the Hunga gentes assemble at the lodge of the chief Alinkawaho. (J. O. Dorsey 1890, p. 415.)

Effigy War Clubs. Probably the use of effigy war clubs by the Siouan tribes of the Great Plains must be regarded as a westward extension of a widespread Woodland Indian custom. Wooden clubs with human or animal heads carved upon them from eastern Indian tribes dating back to colonial times may be seen in museums in this country and abroad. In 1779 Col. Arent De Peyster, the British commandant at Fort Mackinac, urged the Ottawa and Ojibwa Indians to join the British in their war against the Americans by calling upon them to take up their war clubs—"Curiously wrought with heads of beasts, True emblems of the warrior's feast." (Kellogg 1908, p. 389.)

Religious, Magical, and Ceremonial Effigies 133

FIGURE 121. Snake effigy war club, carried by He Dog, Oglala Sioux warrior, probably 1870s. Club is of wood, with three inserted knife blades, brass tacks. *Photograph by D. S. Mitchell.*

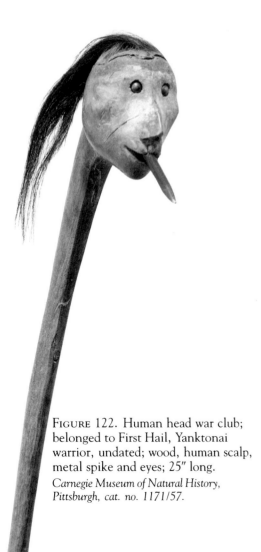

FIGURE 122. Human head war club; belonged to First Hail, Yanktonai warrior, undated; wood, human scalp, metal spike and eyes; 25" long. *Carnegie Museum of Natural History, Pittsburgh, cat. no. 1171/57.*

As we have seen in figure 2 of this book, a Sioux Indian chief was pictured carrying a snake effigy war club as early as about 1701. This is the earliest pictorial record I have found of effigy carving in wood by any Plains Indians. Yet by the 1830s, when the Eastern Sioux were well equipped with firearms, war clubs had become little more than status symbols for them. Missionary Samuel Pond, recalling Sioux customs when he first came to know them in 1834, wrote of their war clubs: "These clubs were highly ornamented and were carried a good deal about home, as canes are carried by gentlemen who do not need them, but the war-club was not depended upon much in battle." (S. Pond 1908, p. 357.)

Whether as weapons or as status symbols, carved war clubs survived among the Sioux and their Siouan-speaking neighbors on the Great Plains until after the end of the Indian Wars in that region. They appear in photographs of Indians taken since 1870 as well as in examples in museum collections.

Let us look at some different designs on carved war clubs:

The photograph of the prominent Oglala Sioux warrior, He Dog, shown in figure 121, probably was taken during the 1870s. He holds a long wooden war club bearing the carved head of a snake, and the pattern of a writhing snake's body executed in brass tacks is carried down the handle. This snake effigy may be unique, but the wooden war club armed with three parallel knives set into the side of the handle was not. Because of its deadly striking power, the snake effigy made a very appropriate war medicine.

Some Sioux war clubs were made of antler. A very ingenious one, which appears in colorplate 18, probably dates to the 1830s or earlier and was collected by George Catlin. Simply by cutting off the main stem of the antler just above the first prong, the sculptor fashioned an effigy war club in the shape of the neck and long bill of a waterbird. To heighten the likeness he added flat brass buttons for eyes. The entire club is only 19 inches long. A buckskin wrist hanger was added to enable the user to exert a stronger blow with the club.

A very striking Sioux war club in the form of a carved Indian head at the end of a long wooden handle, and with a sharpened iron spike held in the man's mouth, is pictured in figure 122. The man's eyes are inset brass tacks, and a scalp with hair is tacked to the top and back of the wooden head. This club belonged to a Yanktonai warrior named First Hail, who lived on the Crow Creek Reservation. The Crow Creek agent reported in 1880 that the Grass Dance was popular on that reservation at the time, so First Hail may have carried this club in that ceremony. The agent also identified First Hail as an active participant in the government's program to convert Sioux hunters and warriors into farmers. He then occupied a house not far from the agency, owned a horse, two

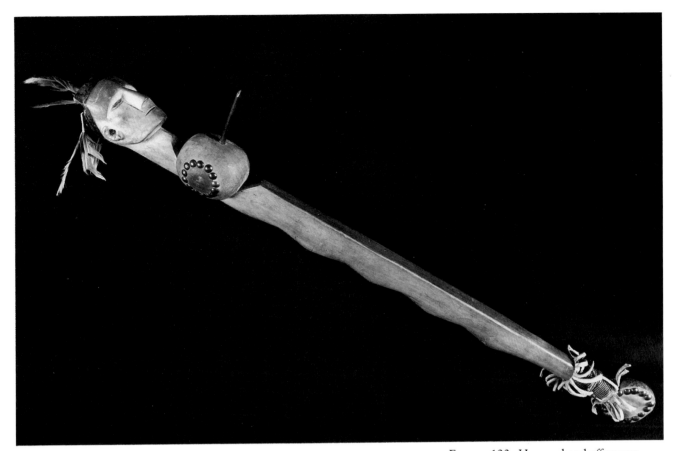

FIGURE 123. Human head effigy war club; Sioux, Standing Rock Reservation, 1880–1900; painted wood, metal spike and tacks, feathers; 29¼″ long.
State Historical Society of North Dakota, cat. no. 2,594.

cattle, five chickens, and cut a ton of hay. Five years later the agent reported that the Indian's son, Eugene First Hail, had returned from school at Hampton Institute in Virginia and was employed as a skilled woodworker in the shop at the agency, where he had made a desk for the Indian agent. Could it have been that the son derived his interest in woodworking from his father, and that First Hail himself had carved that interesting human head war club now preserved in the Carnegie Museum of Natural History in Pittsburgh? (*Annual Reports*, Commissionar of Indian Affairs, 1880, p. 26; 1885, p. 253.)

Another style of human effigy war club appears to have enjoyed some popularity among the Sioux Indians on Standing Rock Reservation during the early years of the Reservation Period. A fine example of one of these clubs is illustrated in figure 123. The strongly carved head is that of an enemy tribesman—either Crow or Arikara—so identified by the pompadour hairdress. The face is painted yellow, the forehead red. Below it is a large ball with a spike inserted into it, and at the bottom a disk-shaped handle. Both ball and handle are liberally decorated with brass tacks. From the ball to the handle the front edge is straight, the back one meandering. This piece was documented as from Standing Rock, and was acquired from a North Dakota collector in 1928.

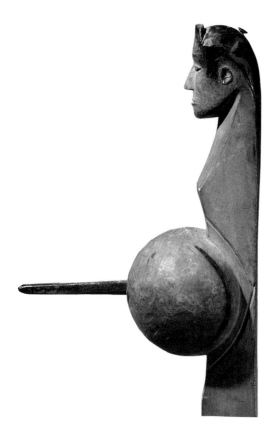

FIGURE 124. Human head effigy war clubs (details):

a. Carved and painted wood, metal spike; Cree? before 1885; head 2³⁄₁₆″ high.

Museum für Volkerkunde, Vienna, cat. no. 21,571.

b. Carved and painted wood; Sioux, Standing Rock Reservation, 1880s; head 3½″ high.

Hampton University Museum, cat. no. 1076.

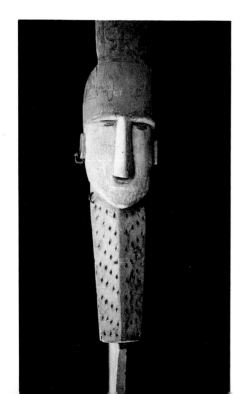

There are variants of this Standing Rock type of human effigy club in other museums. Figure 124a was acquired by the Museum für Volkerkunde in Vienna in 1885 from Hugo Muller, who collected among the Sioux and Cree in Canada. Although termed Cree in museum records, this club is of the Standing Rock type, and so was probably made by Sioux there. Figure 124b is the best documented of the three examples of this type of club we are considering here. With its simplified facial features and exaggeratedly high pompadour, it is more stylized than either of the other two carved heads. This carving was collected on Standing Rock Reservation during the 1880s, and is documented as the head of an Arikara Indian. The club is identified as a "Dance Club or Wand or Pose Club," suggesting that it was never intended as a weapon, despite its menacing appearing spike, but as a symbol for display in victory dances, or possibly as an implement carried by an officer of a military society to symbolically whip members of that society into taking part in its dances. The carved head served to mock the tribal enemy of the Sioux Indian who carried it.

Another variant of this Standing Rock type of human effigy club has the head of a large open-mouthed bird forming the top and a much smaller enemy effigy head below it. It is illustrated in the catalog of *The Native American Heritage* exhibition at the Chicago Art Institute in 1977 (Maurer 1977, fig. 187). It is in the collections of the Cranbrook Institute of Science, and must be much older than its assigned collection date of 1947.

Another type of ball-headed wooden effigy club was found among the Oto and Missouri, Omaha, and Iowa, small Siouan-speaking tribes who were enemies of the Sioux and lived south of them in the Missouri Valley. Carved at the top of the club was an animal that has been termed a weasel by some writers, and an otter by others. I am inclined to favor the weasel identification because, even though weasel and otter are closely related animals biologically, and both are very tenacious ones, the Plains Indians looked upon the weasel with particular awe as the most aggressive animal for its size and they admired it for its courage in attacking much larger animals. They decorated their war bonnets and war shirts with strips or entire pelts of the white winter weasel (Ewers 1977).

An early example of one of these weasel effigy war clubs was originally in the old War Department Collection. It may have been collected during the 1820s or earlier. Figure 125 shows only the uppermost part of this club. From the outline of the figure at the top, this might not be recognized as a representation of an animal at all. But on closer examination, one sees a lightly incised line defining the bottom of the animal's belly, and a rear leg. The entire surface of this club is painted red, and the ball head is fitted with an iron spike. It is not tribally identified.

With this club in mind one can see that what may at first ap-

136

pear to be a rather abstract, darkly colored form on the head of an Omaha war club, pictured by Karl Bodmer in 1833, probably was also intended to be a weasel (figure 126). Bodmer was picturing a war club carried by an Omaha Indian in a dance he and Prince Maximilian witnessed at Cabanne's trading post on the evening of May 5, 1833. The prince observed that one of those Indian dancers carried a war club "mounted on top with a round ball of white wood studded with yellow nails; on the end of the handle the hide of a quite colorful skunk." He failed to mention the weasel carving (Orr and Porter 1983, pp. 376, 379).

In their classic account of the Omaha Indians, Alice Fletcher and Francis La Flesche told of those Indians' use of a war club of ash wood, and "not infrequently a weasel was carved on top above the rounded end." Unfortunately, however, the native drawing of a war club accompanying their description showed the weasel facing *away from* instead of toward the ball head as all known specimens of this type of club do (Fletcher and La Flesche 1906, p. 448 and fig. 99).

Colorplate 18 pictures a very good example of one of these weasel effigy war clubs that was collected by James W. Griest, Indian agent for the Oto tribe in Kansas, and transferred to the Smithsonian Institution in the spring of 1876, in time for it to be shown in the Centennial Exhibition in Philadelphia, which opened early that summer. On this club the entire weasel effigy has been darkened (as on the club pictured by Bodmer) to set it off from the lighter colors of the rest of the club. Its head is raised in the direction of the round ball, as if to add the vaunted striking power of the weasel to any blow of this club delivered upon an enemy. The weasel's long, thin body and tail are atop the club, while its hind legs, rendered in relief, extend downward on either side. Tied to the short iron spike protruding from the ball are animal hoofs strung on leather cords, which must have produced a jingling sound when its owner carried this club. This addition suggests that the club was not a weapon but was used for ceremonial purposes.

Figure 127 shows Bushy Head, a member of an Oto and Missouri delegation to Washington before 1894, holding a weasel effigy club while that group posed for a photograph in the Nation's Capital. The details of this club, including the pattern of arrangement of the brass tacks added for ornament, are so like those of a club collected among the Oto after their removal to Oklahoma during the early years of the present century and now in the Museum of the American Indian, Heye Foundation, as to suggest that they were the same war club. It was described and pictured by M. R. Harrington (1920b), and pictured again by Frederic Dockstader in 1961 (fig. 208). Both authors referred to the animal effigy as an otter.

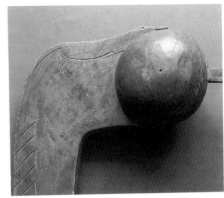

FIGURE 125. Carved and incised weasel atop old war club (detail); Upper Missouri; Old War Department Collection, before 1841; painted wood, metal spike.
Smithsonian Institution, cat. no. 2,649.

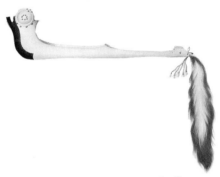

FIGURE 126. Apparent animal effigy war club; Omaha; field drawing by Karl Bodmer, 1833.
Joslyn Art Museum, Omaha.

FIGURE 127. Weasel effigy war club held by an Oto tribal delegate to Washington during period 1871–1894.
Photograph by Hillers. National Anthropological Archives, Smithsonian Institution.

FIGURE 128. Wooden horse effigy victory dance emblem held by Mountain Chief, Blackfeet veteran of the intertribal wars.
Photograph by Joseph K. Dixon, Copyright 1913. National Anthropological Archives, Smithsonian Institution, neg. 76-1228.

Harrington also described and illustrated an "archaic Iowa tomahawk" that was tied to an old Iowa war bundle he collected and was said to have been owned by Chief Ben Holloway "from whose ancestors it had descended for a number of generations." It was fitted with a copper spike, and the author termed the carved animal effigy atop the club an otter (Harrington 1920a, pp. 55–58, and pl. 1).

I find it significant that all tribally identified examples of these weasel (or otter) effigy clubs are from three small neighboring tribes to the south of the Sioux—the Oto, Omaha, and Iowa. I am aware that some examples of these clubs in the British Museum have been attributed to unnamed tribes of the Great Lakes Region—with considerably earlier dates. Perhaps in the light of the more definitive findings offered here, based on better-documented examples, those attributions should be reexamined.

Effigies Displayed in Victory Dances. At the sun dance encampment of the South Piegan tribe of the Blackfeet Indians during the summer of 1898, Walter McClintock witnessed and described one of the dances:

> Another dance in single file, with Wolf Plume in the lead, was for brave warriors who in the night had cut the ropes of horses tied close to enemy tipis. One of these dancers named Rides to the Door (sic), carried the carved wooden figure of a horse to remind people of his bravery and skill in raiding enemy horses. (McClintock 1937, p. 13.)

I knew Rides-at-the-Door as an elderly man who told me of a number of his successful raids upon enemy horse herds—but he did not mention that "carved wooden figure of a horse." Perhaps McClintock referred to a carving of an entire horse figure like the one carried by Mountain Chief (figure 128), who was a few years older than Rides-at-the-Door and a veteran of horse raids on several enemy tribes. This horse, which may have been cut out of a pine board, has only two legs (one front and one back), ears rendered as part of the silhouette, eyes fashioned of brass tacks, and a tail. There is a doll-like figure of a man astride the horse. This photograph was taken about 1912 by Joseph K. Dixon of the Wanamaker Expedition.

Figure 129 shows another Blackfeet horse effigy in use during grass dances on the Blackfeet Reservation in 1905–1910. This cut-

FIGURE 129. Blackfeet veteran of intertribal wars reinacting counting coups with the aid of a wooden horse effigy implanted in ground.
Photograph by Thomas Magee, ca. 1910.
Courtesy Donald Magee, Browning, Montana.

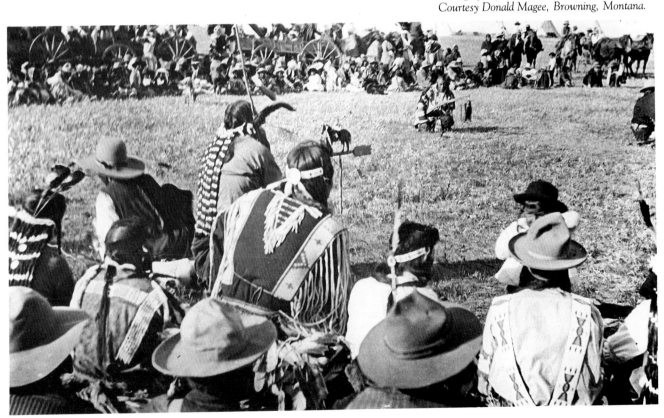

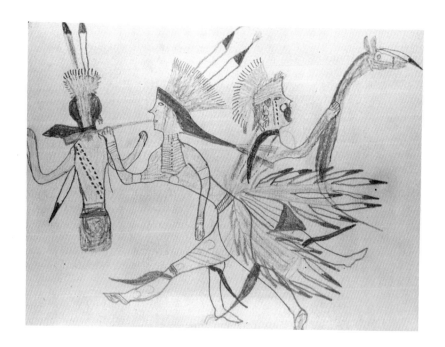

FIGURE 130. Carved horse dance stick carried in victory dance. Crayon drawing by Chief Rain-in-the-Face, Hunkpapa Sioux, 1885; 4½″ × 7″.
Museum of the American Indian, Heye Foundation, cat. no. 20/1628.

out horse has four legs rather than two and has been placed atop a wooden arrow and attached to a wooden pin upright in the ground. At a distance a man carrying a wooden replica of a gun appears to be approaching cautiously while reinacting one of his thefts of enemy horses or some other coup on the warpath. I am grateful to Donald Magee of Browning for this photograph taken by his grandfather, Thomas Magee.

The Blackfeet use of cutout figures of horses in reinacting their coups must have been known and followed to some extent by their neighbors to the east, the Gros Ventres and Assiniboin on Fort Belknap Reservation, during the first decade of this century. One of Sumner W. Matteson's photographs taken on that reservation during the middle of that decade shows a man holding a wooden horse in silhouette, painted a light color and equipped with a mane and tail of horsehair (Casagrande and Bourns 1982, fig. 61).

De Cost Smith, a New York artist, visited the Standing Rock Reservation in 1885, made friends with the Hunkpapa chief Rain-in-the-Face, and painted his portrait. One of several drawings on paper that Rain-in-the-Face executed for Smith is reproduced in figure 130. Three Indian dancers are shown in action, one of them holding high a carved wooden horse head, with upright ears and a bridle added, at the end of a long handle.

A number of these long-handled horse effigies, carved by Teton Sioux Indians and carried in ceremonies are preserved in museums in this country and abroad. In 1969 Beatrice Medicine told me that carved clubs with heads were carried in horse dances on Standing Rock until almost the beginning of World War I, and that men used a stick with a carved horse head and horse hair attached to it to beat time to the music while the horses danced.

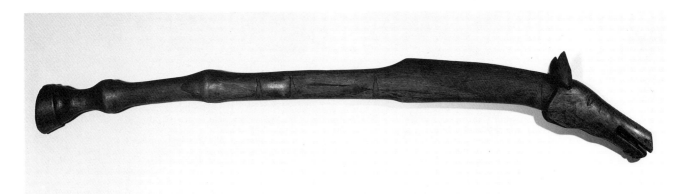

Sioux horse-dance sticks vary considerably in style, complexity, and details of added ornamentation. Figure 131 portrays one of the simpler sticks—33⅜ inches long, with a realistically carved horse hoof for a handle and an elongated horse head with separate ears glued in place at the opposite end. About midway in its length are three triangular marks that symbolize wounds suffered by the owner's horse in action against the enemy. The stick has been lightly rubbed with black paint over much of its surface.

A carved wooden horse-dance stick of a more elaborate style, with elongated neck and legs merely suggested by roughly triangular projections, is shown in figure 132. Attachments include two brass-tack eyes, separately carved wooden ears, a bridle of black leather, and horsehair mane and tail secured to the wood with car-

FIGURE 131. Horse head and hoof dance stick; Teton Sioux, Adolf Spohr Collection; painted wood; 33⅜″ long. *Plains Indian Museum, Cody, Wyoming.*

FIGURE 132. Horse effigy dance stick; Oglala Sioux, accessioned in 1910; painted wood, leather reins, horsehair mane and tail; 42¼″ long overall, wood 23½″. *American Museum of Natural History, cat. no. 50.1/515.*

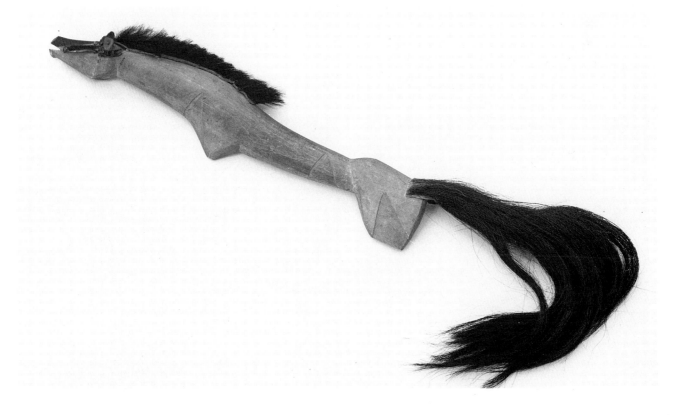

Religious, Magical, and Ceremonial Effigies

pet tacks. The surface of the stick is painted yellow, with three triangular wound marks in red. Other touches of color are red for inside the mouth, nostrils, and underside of the head, and a blue stripe on the top of the head. Collected among the Oglala Sioux by the artist Emil Lenders, this carving was acquired by the American Museum of Natural History in 1910. There are two horse effigy sticks of this kind in the Smithsonian collections that may be older than this one, but they appear to have lost most of their attachments. These specimens bear catalog numbers 378,333 and 378,334, and were collected by Major George Keiser Sanderson, U.S. Army, while he was stationed at posts in the Sioux Country from 1876 to 1887.

Colorplate 20 pictures a Teton Sioux horse-dance stick of the most elaborate style, which has gained recognition as a classic example of Plains Indian wood carving since it was selected as the subject of a poster advertising the *Sacred Circles* exhibition of American Indian Art held in London in 1976. It is carved to represent a complete horse, 37½ inches long, as if in violent action, with his head and neck eagerly thrust forward, front legs bent, and rear ones extended. Its ornamentation includes not only brass-tack eyes, leather bridle, reins, and ears, and horsehair mane and tail, but also a red-dyed hairlock pendant from the lower jaw. The wood is painted with touches of red and blue on the head, neck, legs, and body. I find this piece worthy of the recognition it has received, even though the art critics who have praised it have not studied Plains Indian sculpture, and thus have tended to regard it as more unusual than it actually is. This example, in the Robinson Museum of the South Dakota State Historical Society in Pierre, was collected by Mary C. Collins, a missionary to the Sioux, on Standing Rock Reservation from 1885 to 1910.

A very similar horse-dance stick in the museum of the Gold Seal Company at Medora, North Dakota, is known to have been created by No-Two-Horns, a Hunkpapa Sioux Indian veteran of the Battle of the Little Big Horn. It was intended to honor his horse, which was killed in action in that battle after receiving seven wounds in different parts of its body. The locations of those wounds are designated on the carved horse by red-painted holes from which triangular paths of painted blood flow. I have been interested to observe that some Sioux graphic artists who pictured war actions used this same convention for designating horse wounds, that is, triangular areas of red flowing from a wound at the apex of the triangle. It is said that No-Two-Horns carried this stick in ceremonial dances for many years before his death in 1942.

Ian M. West has illustrated both the specimen in Medora and the one in Pierre in his article *Plains Indian Horse Effigies* (West 1979, figs. 5 and 6, pp. 291–302), and suggests that both were carved by No-Two-Horns. The resemblances in style are striking;

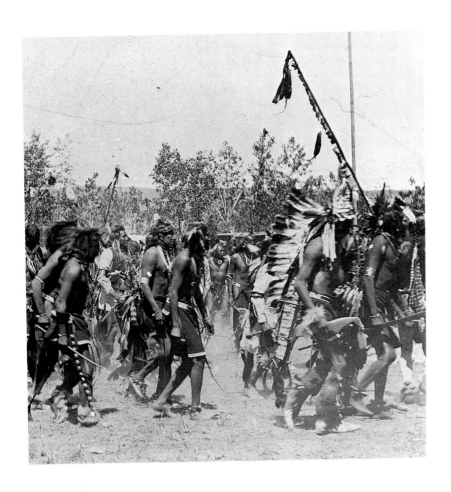

FIGURE 133. Horse effigy stick carried by Crow Indian dancer. Photograph taken in 1898.
Montana Historical Society, Helena.

I concur in West's opinion. No-Two-Horns is also known to have carved several of the simpler forms of horse-dance sticks, including some of the head-and-hoof design that are in the collections in the Museum of the American Indian, Heye Foundation, in New York City, and in museums in North Dakota. Horse-dance sticks from various museum collections have been illustrated in an earlier paper by Ian West (1978, pp. 58–67); by Christian Feest (1968, fig. 23a); and by Norman Feder (1971, fig. 51). Whether No-Two-Horns should be credited with having created all of these horse-dance sticks is doubtful.

We know that the use of carved horse effigies as symbols in dances was not limited to the Sioux. Another form of horse effigy, illustrated in figure 133, appears in a photograph of a Crow hot dance taken on the Crow Reservation in 1898, in which one young man carries a short stick bearing the representation of the head and neck of a horse. An Indian painting in the Smithsonian collections of a group of Hidatsa dancers, executed on a deer skin, also shows a participant carrying a wooden horse effigy at the end of a stick in one upraised hand (cat. no. 165,055).

Beatrice Medicine answered my question about the use of dance sticks with human heads carved on them as follows in 1969: "According to John Tiger, wooden clubs with carved heads were

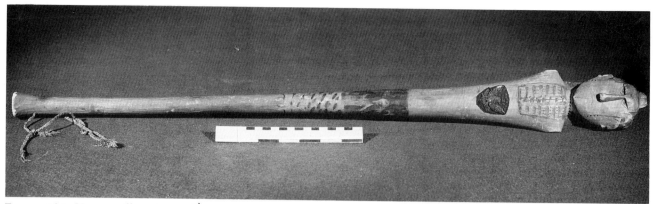

FIGURE 134. Human effigy victory dance stick; Sioux, South Dakota, undated; painted wood; 32" long.

Rochester Museum and Science Center, cat. no. 2946.

used in victory dances and in earlier times were adorned with scalps. Some of these sticks were long and served as staffs. . . . I have seen older Dakota men using such sticks to pound the ground to emphasize war exploits."

There are several thin-shafted dance sticks with the heads of enemy tribesmen carved on them that must have been intended to defy and/or to ridicule the enemy as well as to memorialize past successes in conflicts with enemy tribesmen. One of these, pictured in figure 134, portrays a long-headed and sharp-chinned Arikara or Crow with his front hair in a pompadour. His ears, long nose, and stern brow are carved, but his eyes and mouth are merely painted. Although he wears a small, painted breastplate, he has no arms and no bodily features below the shoulders. This work is designated Sioux from South Dakota, but its date of collection is not recorded.

The human effigy stick shown in colorplate 21 is of Teton Sioux origin, collected by Major Sanderson between 1876 and 1887, and now in the Smithsonian collections. From the top of his pompadour to the bottom of his feet, this enemy effigy measures only 14 inches high, but his exaggerated phallus extends another 10½ inches to provide the handle. Again, the man's ears and nose are carved in three dimensions, but his eyes and the glum expression on his mouth are painted. Like the example in figure 134, this enemy lacks arms and has a painted breastplate. But this one has two legs and feet that seem to be necessary for contrast with the size of the enormous phallus. There are enough similarities between these two enemy effigies to suggest that they may have been carved by the same Sioux man, who liked to poke fun at the enemies of his people with his wooden caricatures.

Little more flattering to the enemy is the 4⅝-inch-high stone head with an elongated nose, at the end of a long, thin handle, from the Chandler-Pohrt Collection pictured in figure 86 of the catalog of the exhibition *Two Hundred Years of North American Indian Art* at the Whitney Museum in 1972 (Feder 1972). Although termed a war club, this was more likely carried as an emblem in victory dances.

144

An ingenious instrument for accompanying victory dances—and one quite rare in museum collections—is pictured in figure 135. It is of Sioux origin and was acquired for the Crosby Brown Collection of Musical Instruments in 1889. Frances Morris, in her catalog of the Crosby Brown Collection at the Metropolitan Museum of Art in New York, cites an unpublished manuscript by Robert Sweeney, a St. Paul pharmacist who was a close observer of the Santee Sioux as early as the 1850s, to explain the use of this object:

> A smooth hard rod about 12 to 18 inches long held lightly with the fingers of the right hand taps briskly upon any sonorous object, such as the back of a bow, pipe stem, the blade of a tomahawk, or a buffalo rib. I have heard the tappers on a large number of tomahawks make wonderful music. By moving the fingers along under the side of the blade on a tomahawk the note is changed. (Morris 1914, vol. 2, p. 174.)

This example is a pointed stick, 27½ inches long, cut to form a small pavilion, or open box, near the upper end, in which there are two movable balls. Above and below this are loose wooden rings; the loose balls and rings make a rattling or jingling noise when tapped. At the top of the piece is a carving in the form of a delicately formed and painted head and upper body of a man with a pompadour—another enemy effigy.

Another of these tappers, with only two rings and one ball but with a similar carved and painted wooden enemy effigy at the top, is recorded as having belonged to Sitting Bull, the famous Hunkpapa Sioux chief. Figure 136 shows the upper, carved portion of this piece. The carved heads of the two tappers may be enough alike to suggest that they were the work of the same hand. Both are so like other wooden enemy effigies known to have been carved by Indians of Standing Rock Reservation during the early years of the Reservation Period as to identify them as additional examples of the distinctive war-related wood sculpture created on that reservation during the last quarter of the nineteenth century.

Figure 137 shows a carved wood dance wand in the form of a painted snake with a painted bird astride its back. Although documentation is lacking, the piece is well carved, probably of Sioux origin. Its loose ring suggests that it might also have served as a tapper.

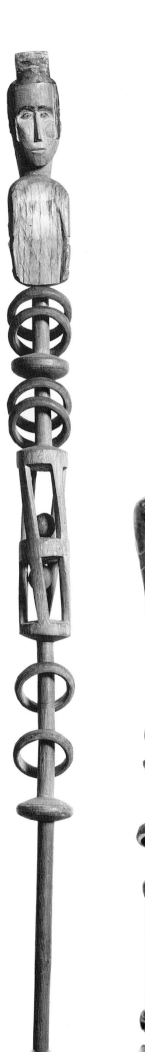

FIGURE 135 (*left*). Human effigy victory dance tapper; Teton Sioux, before 1889; carved and painted wood; 27½″ long.
The Metropolitan Museum of Art, cat. no. 89.4.601.

FIGURE 136 (*right*). Human head victory dance tapper; Hunkpapa Sioux, attributed to Sitting Bull, 1890; painted wood; head 4½″ high, total length 32″.
Minnesota Historical Society, cat. no. 581.E173.

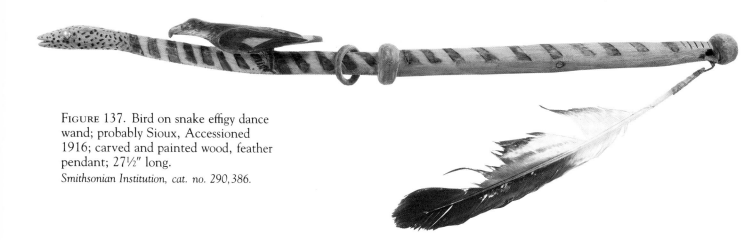

FIGURE 137. Bird on snake effigy dance wand; probably Sioux, Accessioned 1916; carved and painted wood, feather pendant; 27½" long.
Smithsonian Institution, cat. no. 290,386.

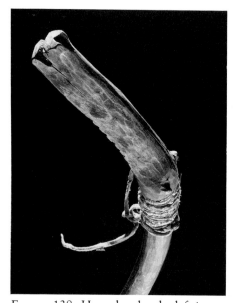

FIGURE 138. Horse head stake left in trail by returning horse raiders to confuse enemy pursuers; Shoshone, before 1874; head 5½" long, overall 40".
Peabody Museum of Archaeology and Ethnology, Harvard University, cat. no. 7894.

Effigies as Military Society Emblems. Writing of a Snake (Shoshone) Indian attack upon a small hunting party of Piegan Indians about the year 1785, David Thompson, a trader to the Piegans, stated: "The camp . . . had been destroyed by a large party of Snake Indians, who left their marks, of snake heads painted black on sticks they had set up." (Thompson 1962, p. 247.) In 1874 H. A. Morrow gave the Peabody Museum of Archeology and Ethnology at Harvard University a specimen of what he described as another instrument for Shoshone Indian communication with their enemies in the form of a stick 40 inches long with a semi-abstract head of a horse carved at one end, and a point at the other so that it could be inserted in the ground. Figure 138 shows the effigy end of this stick. Greatly exaggerated in length, and little like the shape of a horse's head in outline, this stylized effigy has an open mouth, nostrils, ears, and small eyes. It is painted red and black. Morrow offered this explanation of its use by the Shoshone: "When a returning war party wishes to delude its pursuers, this is placed in the trail usually at a point where two or more trails intersect, and it is thought to have a charm by which its pursuers were induced to follow the wrong trail."

More recent studies of this piece, knowing that very similar effigy sticks were the emblems of the Arapaho military society known as the Tomahawks, have been inclined to ignore Morrow's interpretation of the use of this stick, and identify it as another Arapaho Tomahawk Society emblem. Perhaps we should not be too quick to try to demonstrate our superior knowledge of this type of carving. Morrow collected this horse effigy at least two decades before our first knowledge of the horse emblems of the Arapaho Tomahawk Society, and in the light of Thompson's much earlier report of Shoshoni use of message sticks to communicate with enemies, his interpretation of this effigy does not sound unacceptable. I find it interesting, too, that Loretta Fowler, an able student of the

146

modern Northern Arapaho (who share the Wind River Reservation with the Shoshone), found that they have two of these emblems in their museum, which they refer to as "Shoshone." Perhaps, then, the Arapaho borrowed the form of the Shoshone horse stick, and gave it a new significance after they were placed on the Wind River Reservation.

Figure 139 pictures a Southern Arapaho Tomahawk Society emblem collected by James Mooney at a dance on the North Canadian River on October 22–24, 1905, for the Smithsonian collections. The stick is of cottonwood, 39 inches long, and its surface is painted red. The horse head is carved on the uppermost 7 inches of the stick, and the underside of the head is painted black. Its maker emphasized the muzzle of the horse and the length of the head, and gave a notched edge to its underside. Brass tacks make the eyes, and a mane is suggested by a quantity of horsehair bound to the stick with sinew wrapping, just behind the head so that some of the hair extends forward. A piece of red flannel with attached dewclaw rattles and pendant eagle feathers is wrapped around and bound to the stick near the bottom end.

Some years earlier Mooney had learned that all members of this military society—the third in the ascending order of age-graded military societies among the Arapaho Indians—with the exception of their leader, who carried a club, "carried sticks carved at one end in the rude semblance of a horse head, and pointed at the other. In desperate encounters they were expected to plant these sticks in the ground in line in front of the body of warriors and to fight beside them to the death unless a retreat should be ordered by the chief in command." (Mooney 1896, pp. 987–88.)

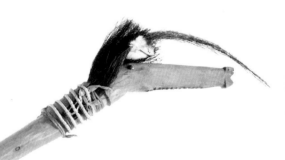

FIGURE 139. Horse effigy emblem of Tomahawk Society; Southern Arapaho, collected by James Mooney, 1903; cottonwood, brass tacks, horse hair, cloth wrappings, dew claw rattles, feather; 39″ long.
Smithsonian Institution, cat. no. 233,095.

Although Alfred L. Kroeber published a detailed account of the Arapaho Tomahawk Society based on field work among them at the turn of the century, and collected examples of their emblems for the American Museum of Natural History, he erroneously identified the animal carved on them as a buffalo (Kroeber 1904, pp. 186–88, and fig. 58).

Sherman Sage, an elderly Arapaho Indian, who joined the Tomahawk Society as a young man, told Sister Inez Hilger how these society emblems were made. "In taking the branch off the tree, a part of the tree trunk was chopped off also, but in such manner that it remained attached to the branch. The tree trunk section was carved to represent a horse's head. It had a mouth and eyes carved in it." (Hilger 1952, p. 123.)

There are more of these horse effigy emblems of the Arapaho Tomahawk Society in museum collections than there are carved effigies associated with any other Plains Indian military society. I have seen a dozen of them in museums, and others are reputed to be in private collections. Some of these have been published. (See Conn 1982, fig. 104, 105; Coe 1977, fig. 464.)

Wooden Leg, a Northern Cheyenne elder, described the use of carved snake effigy instruments by members of the Elkhorn Scrapers or Elk Scrapers Society, which he joined in his young manhood:

> As they danced they were scraping their rattlesnake sticks, the special emblem of Elk membership. Each of these sticks was made of hard wood, in the form of a stubby rattlesnake seven or eight inches long. On each stick was cut forty notches. Another stick was used for scraping back and forth along the notches. The combined operation of many instruments made a noise resembling the rattlesnake's warning hum. Each member owned his personal wooden stick, but there was one made from an elk horn that was kept always by someone as a trustee for the society. (Marquis 1931, p. 59.)

The Elkhorn Scrapers Society derived its name from this instrument. Other writers on this military society inferred that all members used an elkhorn effigy, and that it was larger in size. George A. Dorsey, an ethnologist from the Field Museum of Natural History in Chicago, described it:

> The elk antler used by these warriors is real. It is straight and has a body about two inches thick and about eighteen inches long. It has a head and a tail. It is fashioned like a snake. On the top of the snake's back are grooves cut about half an inch apart. . . . When used for singing and dancing they put one end of the antler snake on top of a piece of rawhide and hold the snake's tail in the left hand and with the right hand they hold the shin bone of an antelope and rub it backwards and forwards over the snake's back, thus producing a loud, shrill sound like that of an animal. (G. A. Dorsey 1905, pp. 18–19.)

148

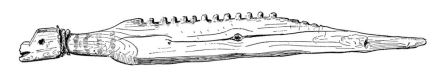

FIGURE 140. Snake effigy emblem of Notched Stick Society; Hidatsa, collected by Robert H. Lowie, 1910; wood, braided fiber neck wrapping; 45″ long.
American Museum of Natural History, cat. no. 50.1/4356.

Dorsey included a very small outline drawing of one of these snake effigies as figure 5 of his report. He was also told that in former times the antler emblem of the leader of this society also was used in ceremonies to call the buffalo (Idem, p. 19).

Rev. Peter Powell has published a photograph of a Northern Cheyenne Elk Society Bundle, including both the snake effigy instrument of elkhorn, which has only nineteen notches, and the bone used to play it (Powell 1969, vol. 2, p. 454).

Karen Peterson found mention of the Cheyenne Elk Scrapers Society as early as 1838, and she believed that it went back to prehistoric times (Peterson 1964, p. 160). Even so, it was not unique among the Plains Indians, for the Hidatsa Indians on the Upper Missouri also had a Notched Stick Society, whose emblem was a notched stick in the form of a snake, which was played by drawing a stick backward and forward over the notches. One of these Hidatsa instruments, collected in 1910 for the American Museum of Natural History by Robert Lowie, appears in figure 140. Carved of a section of cottonwood 49¾ inches long, this snake effigy differs in appearance from the ones of the Cheyenne military society. It has a large head with open mouth and circular eye, a long neck, and a still larger midsection, with a dozen notches cut into its top surface. Yet this snake effigy must be only a miniature of a much larger one used as an instrument in the annual rain ceremony held at the old Hidatsa village of Awaxawi each summer (Bowers 1965, pp. 389–91). It would be difficult to believe that the Hidatsa Notched Stick Society and the Cheyenne Elk Scrapers were not historically related. The seemingly greater importance of this kind of instrument in Hidatsa culture suggests that those Indians were the first of these two tribes to make use of these snake effigies in their ceremonies.

During his intensive studies of Plains Indian military societies for the American Museum of Natural History in the early years of this century, Lowie was told of the use of animal effigy emblems of wood by Hidatsa, Crow, and Kiowa informants. He learned that the buffalo carved on a wooden stick—the emblem of the Lump-wood Society of the Hidatsa—was given to two young men of that tribe who went out to seek a vision of power when people of their village were hungry. Lowie's Lumpwood Society emblem in the American Museum of Natural History is a rather distorted head of a buffalo carved on the end of a wooden stick (Lowie 1913b,

pp. 259–61, and fig. 5). He learned that other members of that Lumpwood Society carried sticks bearing the heads of other animals. One of them was a bear. If the Hidatsa warriors surrounded an enemy, but were afraid to approach him as he stood at bay, the bearer of this bear effigy was obliged to advance against him.

Similar animal-head effigy emblems were carried by the members of the Lumpwood Society among the Crow Indians, close relatives of the Hidatsa (Lowie 1913b, p. 163). Lowie also learned that the leaders of the Kiowa societies of the Shepherds and of the Rulers of Horses carried emblems that were "flat sticks about the length of a man's arm, carved with figures." (Lowie 1916, pp. 845–46.) I have seen no examples of Kiowa military society emblems in the form of carved effigies.

The earliest reference to carved society emblems in the literature may appear in Prince Maximilian's account of an Hidatsa buffalo-calling ceremony that he witnessed on November 26, 1833. He observed that two of "the bulls" that entered the medicine lodge and fixed their weapons in the ground in front of them "had clubs, with a head on which a human face was carved." (Maximilian 1905, vol. 24, p. 28.) Figure 141 reproduces a drawing of one of those clubs executed by the prince himself or by his artist, Karl Bodmer. It suggests that the head was roughed out without any attempt to refine the facial features or other details. Probably "the bulls" who possessed such clubs were members of the society of older men of that name which existed among the Hidatsa at that time.

Figure 142 illustrates a possible society emblem of the Teton Sioux of a much later date. It is a staff in the form of a painted writhing snake cut out of wood 47 inches long, and backed with a long strip of red flannel to which some thirty-nine eagle feathers are attached. The function of this staff is not recorded, but its origin is given as Teton. In the Ayer Collections at the Newberry Library in Chicago, I saw a drawing by a thirteen-year-old Indian schoolboy,

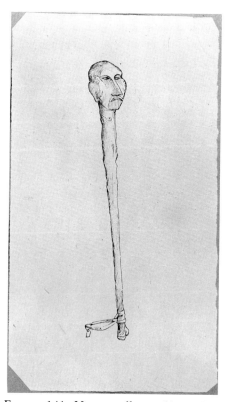

FIGURE 141. Human effigy emblem of Bull Society; Hidatsa; drawing by Karl Bodmer, 1833.

Joslyn Art Museum, Omaha.

FIGURE 142. Snake effigy feathered staff; probably Teton Sioux; wood, red flannel, eagle feathers; 47″ long.

Peabody Museum of Natural History, Yale University, cat. no. 49,276.

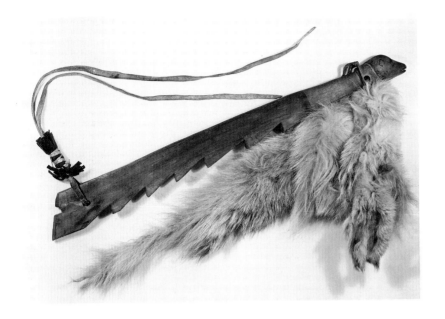

FIGURE 143. Effigy whip of Kit Fox Society; Minneconjou Sioux; made by White Feather, before 1915; 20½" long. *St. Joseph Museum, St. Joseph, Missouri, cat. no. 143/3412.*

Joseph Brownface, collected by A. McG. Beede of Standing Rock Reservation, about 1913. It shows two men with painted faces standing and facing each other, while between them is a feathered staff in the form of a writhing snake standing upright without any visible means of support. Both figure 142 and this drawing may refer to an emblem of a Teton military society. Which one I cannot say.

I have seen two effigy whips of types said to have been used by officers in military societies to urge society members to dance at proper times. Both of these were made in the form of long, flat clubs notched along one edge. Figure 143 pictures one of these symbolic whips, said to have been made by White Feather and to have been used in the Kit Fox Society of the Minneconjou Sioux. Explorer Joseph Nicollet mentioned the Kit Fox Society among the Sioux in 1839. He wrote: "The kit fox is taken as the emblem of vivacity and activity. The savages of the prairie say that the kit fox is the most alert and quickest of the animals that they know." (Nicollet 1976, p. 277.) Collected in 1915 or earlier, the flat-sided whip in figure 143 has two rawhide lashes attached to it near the end opposite the handle. The wooden portion is 21½ inches long and the handle end is carved in the form of the head of a canine, with open mouth, upright ears, and eyes delineated clearly.

The other ceremonial whip is from the Southern Arapaho in Oklahoma, and is pictured in figure 144. It must have been cut from a pine board 27½ inches long. It has a rounded handle ornamented with pendant feathers, side notches, and an entire horse cut as a silhouette near the top. There are no lashes, but the maker of this whip decorated the greater part of its length with brass tacks. The name of the Arapaho military society that used it is not recorded.

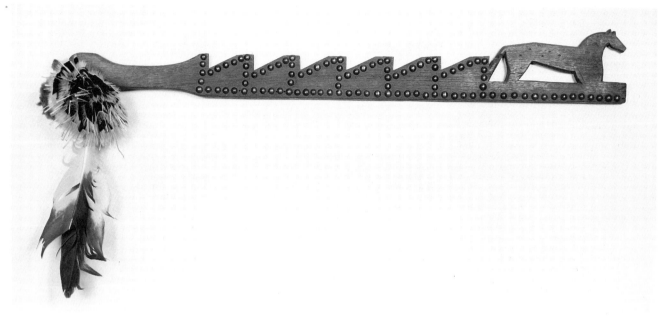

FIGURE 144. Horse effigy military society whip; Southern Arapaho; wood, brass tacks, eagle feather pendant; 27½" long. *Museum of the American Indian, Heye Foundation, cat. no. 16/7185.*

If we had more complete information on the emblems of Plains Indian military societies, doubtless there would be references to other carved wooden effigies of humans, animals, or reptiles. Those military societies began to break up shortly after the intertribal wars ended in the 1870s, and, except for the horse sticks of the Arapaho Tomahawk Society, few society emblems were collected by museums. One reason why there are a goodly number of the Tomahawk Society horse sticks surely is because that society was revived during the twentieth century, and several of their horse sticks appear to have been collected since that revival.

Curing Medicines

In dreams or visions, Plains Indian men and women obtained powers to treat the sick. Some acquired these powers by transfer from other Indians, who had obtained supernatural powers earlier by that same means. In their treatments, some Indian doctors used carved effigies, symbolic of the supernaturals who bestowed their healing powers upon them. As these sources of power differed, so did the effigies used in doctoring.

A number of curing effigies are known only through references to them in the writings of white men. As early as 1820 the men of Stephen H. Long's overland expedition to the Rocky Mountains met the Kiowa Apache (Kaskia) Indians on their return journey in the valley of the Canadian River. Edwin James, chronicler of that expedition, observed:

> The great number of images of the Alligator, which they wear, either as ornaments, or as amulets, for the cure or prevention of disease and misfortune, afford sufficient proof of

152

their extending their rambles to districts inhabited by that reptile. These images are of carved wood, covered with leather, and profusely ornamented with beads. They are suspended about the neck and we saw several worn in this manner by the children as well as by adults. (James 1823, vol. 2, p. 112.)

After watching Red Mouse, a Kaskia chief, use an alligator effigy in treating his own wound, James wrote:

Immediately after he dismounted, on the halting of his party, a small wooden dish was brought to him, containing some water. He had received a wound some time before apparently from an arrow, which had passed through his arm. Placing the dish on the ground before him, he dipped his hand repeatedly in the water, then seizing a small image of an alligator, profusely ornamented with blue and white beads, he pressed it in his hand with all the strength of the wounded arm. This we saw him repeat a great number of times. The alligator appeared to be the great medicine, on which he relied for the cure of his wound, no dressing or application of any kind was made immediately to the affected part. (Idem, vol. 2, p. 106.)

During the first decade of this century a Blackfeet doctor told Clark Wissler of his acquiring and using curing power:

FIGURE 145. *Dakota Doctor Making Medicine*, ink wash drawing by Robert O. Sweeney, about 1860.
Minnesota Historical Society.

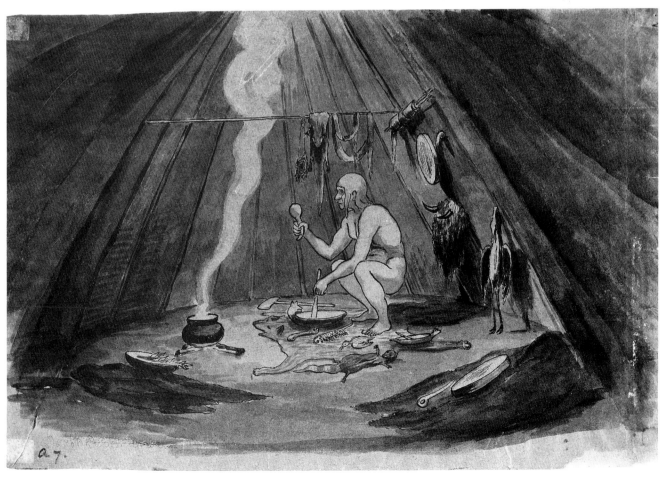

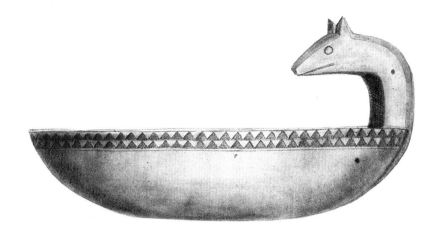

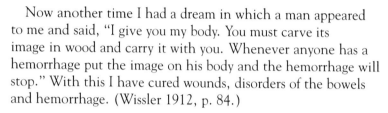

FIGURE 146. Effigy bowl made by a Sioux of Shakopee Village, ink-wash drawing by Robert O. Sweeney, 1852. (Dimensions of original bowl not given.) *Minnesota Historical Society.*

Now another time I had a dream in which a man appeared to me and said, "I give you my body. You must carve its image in wood and carry it with you. Whenever anyone has a hemorrhage put the image on his body and the hemorrhage will stop." With this I have cured wounds, disorders of the bowels and hemorrhage. (Wissler 1912, p. 84.)

And G. H. Pond wrote of Santee Sioux medicinal practices in 1867:

The doctor ascertains the sin which had been committed, and the particular god which has been offended and inflicted the disease. Then he makes an image of the offended god, which he hangs on a pole and which is shot by three or four persons in rapid succession. As the image falls the spirit of the god which is within the doctor, leaps up, and falls upon the image kills it. On this it is expected that the sick will recover. But it is not absolutely certain that even this will prove effective. (G. H. Pond 1867, p. 56.)

FIGURE 147. "Whirlwind Worm" effigy, used in doctoring by Black Fog, Sioux Medicine Man; antler, skin-wrapped packet medicine attached; antler 4¼" long.

State Historical Society of North Dakota, cat. no. 4,411.

Robert Sweeney, an amateur artist as well as a close observer of Santee Sioux customs, pictured an Indian doctor preparing his medicines in an ink-wash drawing executed about 1860. Figure 145 reproduces this drawing, entitled *Dakota Doctor Making Medicine.* The larger of the two effigy bowls shown must be the one made by a Santee Sioux of Shakopee or Little Six Village, which Sweeney pictured in detail in 1852 (figure 146). The grotesque head carved on the handle of that bowl may have been intended to represent a mammal or a horned snake.

Black Fog, a Sioux doctor, used an antler carving of a whirl-wind worm in the treatment of his patients long ago. This effigy (figure 147) is 4¼ inches long, with incised eyes and mouth, and numerous parallel, circular grooves on the body. A small packet of medicine is tied to the carving with a buckskin cord. According to information on the use of this medicine accompanying it, "the worm was placed on the chest of a sick person and if it moves the patient will not recover."

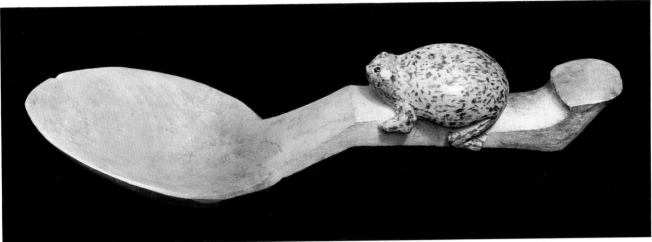

FIGURE 148. Frog effigy doctor's spoon, used by Carry-the-Kettle, Teton Sioux; painted wood; 12¾″ long.
Museum of the American Indian, Heye Foundation, cat. no. 6/7961.

Figure 148 shows a wooden spoon with a carved and painted frog astride its handle facing the bowl, collected by Frances Densmore on Standing Rock Reservation between 1911 and 1914. This spoon was said to have belonged to Carry-the-Kettle, a Teton Sioux, who "lived many years ago" and "doctored under the tutelage of the frog. . . . He was remembered as a particularly successful medicine man." (Densmore 1948, p. 179.)

Colorplate 22 illustrates an especially well-carved wooden spoon in the Smithsonian collections, which was obtained from the abandoned Sioux camp by the U.S. Army after the battle of White Stone Hill on September 3, 1863. The turtle at the end of the handle and facing the bowl has its head extending outward from its shell and its four legs are well defined. The shell is darkened with intentional burn marks. This probably was the property of an Indian doctor whose tutelary was the turtle, a creature admired by the Indians for its tenacity of life.

The Pawnee doctor who used the small wooden bowl with a turtle incised in its bottom, pictured in figure 149, also must have called on turtle power to aid him in ministering to the sick. Collected in 1915 by James Murie, the Pawnee Indian student of the customs of his tribe, this bowl is exhibited in a case devoted to Pawnee religion in the American Museum of Natural History. The literature indicates that a bowl with an incised creature in the bottom also was found among other tribes. E. D. Neil in the early 1850s wrote of Gray Iron, a principal chief in Black Dog's village, four miles above Mendota, Minnesota, having been given a wooden bowl when he was initiated into the medicine society of his people "on the bottom of which is carved a bear complete." (Neill 1862, p. 270.)

A very ingeniously carved standing figure of a white man wearing a high hat, obtained from the Crow Indians, appears in figure 150. It was donated to the M. H. De Young Memorial Museum in San Francisco in 1903 by Dr. Joseph Simms without any

FIGURE 149. Bowl with incised turtle in bottom, used by a Pawnee doctor before 1900; wood; 5″ in diameter, 1¾″ deep.
American Museum of Natural History, cat. no. 50.1/8474.

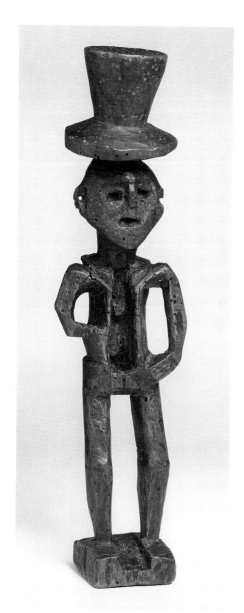

FIGURE 150. Effigy of white man with excavated body cavity, probably for curing medicine; Crow, collected in 1903; wood; 10¾″ high.

M. H. De Young Memorial Museum, San Francisco, cat. no. 23425.

explanation as to its use. The deep cavity in the front of the body of this figure must have been intended to receive a packet or packets of medicine. Perhaps this rare carving belonged to a Crow Indian doctor who believed he derived his power from a white man. It is well known that since the time of Lewis and Clark at the beginning of the nineteenth century, many Plains Indians sought the power of white men to cure their physical ills.

There is no doubt about the use of the Crow wood carving in figure 151. It is a stomach kneader, 18½ inches long, of carved wood, used by the Crow Indians in treating women's ailments. A Crow myth tells of a woman who was given the power to "tell those who had a stomach ache to knead their stomachs." (Lowie 1918, p. 126.) The wider end of the stomach kneader was pressed against the stomach and upward to relieve indigestion and gas. Usually these devices were used by Indian women to treat themselves. Two of them are illustrated in Wildschut and Ewers 1960 (fig. 66). The specimen shown here in figure 151 is unique in having a writhing snake carved in relief on each side. Brass-tack eyes were added. This specimen is in the collection of Drew Bax of Morrison, Colorado, who obtained it at Pryor on the Crow Reservation a number of years ago. Perhaps this stomach kneader was thought to have come from the snakes that were said to live in the spring on the property of the famous Crow Chief Plenty Coups at Pryor. It was from that spring that Slippery Eyes was said to have derived a snake medicine bundle that made him one of the most famous doctors in the tribe (Idem, pp. 136–38, and figs. 58, 59).

The Ojibwa and Cree Indians are known to have practiced a form of general preventive medicine through the use of a wooden post with a rather crude human head carved at the top, known to them as a *Mantokan*. The earliest reference to one of these carved posts that I have found appears in the journal of the British fur trader, Peter Fidler, for September 1799. While ascending the Beaver River north of the Saskatchewan River in what is now eastern Alberta, Fidler saw on the south side of that river "an image" made by the Bungi (Plains Ojibwa) when they first came into that region with the hope that "the great Menneto will grant them and their families health while they remain in these parts" and they will remain healthy during their return to their own country near Rainy Lake and Grand Portage. Fiddler noted that the Indians had dressed the image in cloth and left useful presents beside it." (MacGregor 1966, pp. 115–16.)

In the literature on the Cree and Ojibwa, such a carved post has come to be known by the Indian name of *Mantokan* i.e., Manitou-like. R. Tait McKenzie's drawing of one of these images, executed in 1886 and reproduced by F. E. Peeso in 1912 (p. 56), shows clothing, but does not clearly delineate the carved head.

156

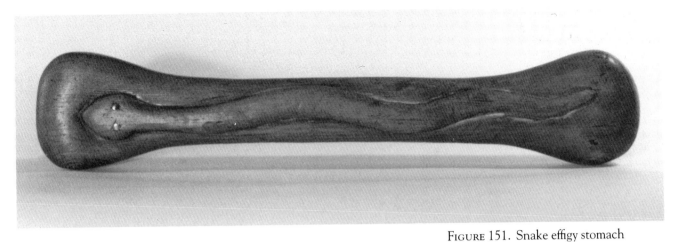

FIGURE 151. Snake effigy stomach kneader; Crow, Pryor, Montana, about 1950; wood, brass-tack eyes; 18½″ long. *L. D. and Drew Bax Collection, Morrison, Colorado.*

The best illustration of a *Mantokan* that I have found was published in 1972 in an article on the use of those effigies on Rocky Boy's Reservation in Montana by Emmett A. Stallcop, to whom I am indebted for the print reproduced in figure 152. This photograph was taken on Rocky Boy's Reservation by R. W. Leonard of West Lyn, Oregon, in 1931. Stallcop learned that this *Mantokan* was carved by an Indian named White Sky and was erected on a hill near his cabin. White Sky died in 1942. The post was carved from a quaking aspen log and the figure is represented in a seated position. Its head, of greatly exaggerated size, was ornamented with tin ears. The post is dressed in a hat and clothing, and around it are a number of presents given by Indians of that reservation, among them a covered copper trade kettle such as was traded to Indians by the Hudson's Bay Company in Canada over a long period of years.

Witchcraft Images

Indians who practiced witchcraft used carved images to bring bad luck, injury, or death to their personal enemies or those of their patrons. Because this was a secret activity practiced by men who risked serious harm to themselves should their enemies learn of their actions, our knowledge of effigies employed in witchcraft comes entirely from white men who came to know Indian individuals and customs well.

Most references to Plains Indian witchcraft images pertain to the practices of the Algonquian and Siouan-speaking tribes of the Northern Plains. Yet they go back to the period when the Plains Ojibwa were just moving out of the woodlands onto the plains at the beginning of the nineteenth century. John Tanner, a white captive among those Indians, who hunted with them on the northeastern plains about 1810, wrote:

> A drawing of a little image is made to represent the man, or woman, or animal on which the power of the medicine is to be tried; then the part representing the heart is punctured with a sharp instrument, if the design is to cause death, and a little of

Religious, Magical, and Ceremonial Effigies 157

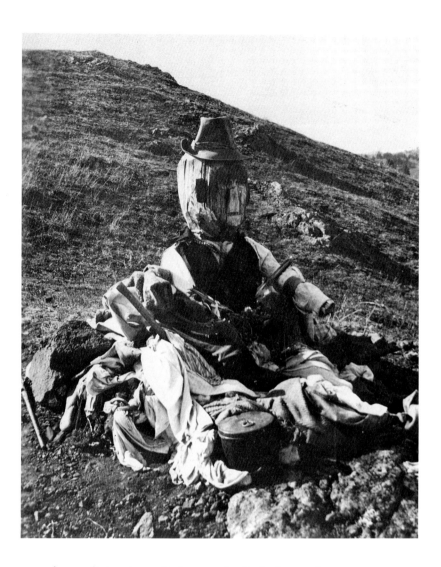

FIGURE 152. Human effigy spirit post. (*Mantokan*), surrounded by presents given it by Cree Indians to assure their health and well-being.
Photographed on Rocky Boys Reservation, 1931. Courtesy Emmet A. Stallcop, Havre, Montana.

the medicine is applied. . . . the little figure of a man or woman . . . is sometimes traced on birchbark, in other instances more carefully carved of wood. (James 1830, p. 174.)

During the winter of 1833–34, spent near the Mandan Indians, Prince Maximilian learned that "they believe that a person to whom they wish ill must die, if they make a figure of wood or clay, substituting for the heart, a needle, an awl, or a porcupine quill, and bury the image at the foot of one of their medicine poles." (Maximilian 1906, vol. 23, p. 341.)

Walter McClintock, who studied the Blackfeet closely over a period of many years beginning in the middle 1890s, told of the Piegan Chief Little Plume's witchcraft medicine. "It consisted of a small stone or wooden image of a person, a porcupine quill and some red paint, by which the owner was able to cast an evil spell over people. If he placed the red paint between the eyes of the image, the one whom he desired to injure became ill; if over the lungs he had a hemorrhage; if over the heart, it caused death." (McClintock 1910, pp. 190–91.)

158

Verne Dusenberry learned that the use of carved wooden images in sorcery was still practiced among the Plains Cree on Rocky Boy's Reservation in Montana after World War II (Dusenberry 1962, p. 85).

There may have been images used in witchcraft rites among some of the wood carvings of human beings I have seen in museum collections that were not documented as to their use. However, I think the effigy most likely to have served this purpose appears in figure 153. Carved of antler, not of wood, it was collected by Edmund Morris, a Canadian artist, and listed in the 1909 published catalog of his collection as "No 10. Image of Moose horn, found by a French settler buried under the ground in a box made without nails on the Yellow Quill Trail, Manitoba, 1878. The Medicine men held that these images gave them control over the souls of others." Although this effigy has a cone-shaped head with carefully detailed features, it possesses neither arms nor legs.

Love Medicines and Courting Flutes

Among the tribes of the Great Plains, the Cree Indians were most famed for their use of love medicines that would help a man or woman win or regain the affection of a desirable mate of the opposite sex. Even so, the Cree themselves claimed that their knowledge of the preparation and use of love medicines was obtained from their neighbors, the Ojibwa Indians, in the forests to the east.

Ojibwa love medicines often included two little wooden figurines each about an inch high. One represented a man, the other a woman. They were bound together by some strands of the hair or a small piece of material from the clothing of the person to be charmed. The figurines were placed in a little bag along with a small packet of botanical medicine, and sometimes the parings of the fingernails of the beloved. In activating one of these charms, medicine might be placed on the lips or on the hearts of the little figurines.

I have not seen any carved wooden love medicine figurines from the Plains Indians in museum collections, but I have published a photograph of a pair of Ojibwa ones in a short article entitled "Love Medicine" that appeared in *The Beaver* (Autumn, 1958, pp. 40–41).

Among the Siouan-speaking tribes and the Pawnee, the elk was the animal whose aid was most often sought in matters of love. This must have seemed logical to Indians, who observed the ability of the bull elk to attract females in mating season. Prince Maximilian observed and commented on this action while on his way down the Missouri from Fort McKenzie to Fort Union in mid-September 1833. He saw on shore "a troop of six elks with a large stag, which covered one of the animals three times in our presence.

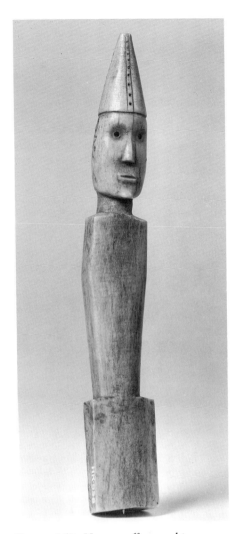

FIGURE 153. Human effigy used in witchcraft? Saulteaux; found in 1876 on Yellow Quill Trail, Manitoba; moose antler; 7″ high.
Royal Ontario Museum, Toronto, cat. no. HK 956.

We saw him lay his horns on his back when he uttered his singular whistling cry." The prince went on to explain: "The cry of the male elk . . . is a shrill whistle, which for the most part, runs regularly up the scale, and then suddenly falls to a low, gutteral note. The notes perfectly resemble a run upwards on the flageolet." (Maximilian 1906, vol. 23, p. 176.)

While on the Upper Missouri fourteen years later, the English sportsman John Palliser wrote of the elk: "In the breeding season the wapiti chants the most beautiful musical sound in all the animal creation; it is like the sound of an enormous soft flute, uttered in a most coaxing tone." (Palliser 1969, pp. 146–47.)

Is it any wonder that the Sioux should have sought elk power as a love medicine, and have referred to their courting flutes as "elk whistles"? I have seen several flutes in museum collections with large elk heads carved on the end away from the player. A good example is pictured in colorplate 23. This delicately carved elk head is portrayed in the act of calling his mates—with his mouth wide open and his scaled-down antlers low against his neck. It is of cedar with the entire instrument painted red except for the yellow antlers and touches of black around the mouth. The carver indicated the animal's ears and added brass tacks for eyes. This elk whistle is part of the Emile Granier Collection accessioned by the Smithsonian Institution in 1899. Another elk whistle, said to have been owned and possibly made by John Yellow Wolf of the Rosebud Reservation about 1870, is pictured in a pen-and-ink drawing in Herman Haupt's manuscript in the Newberry Library, Chicago (p. 51).

An effigy love whistle found among the Sioux and their neighbors sometimes has been termed erroneously a "grass dance whistle" because these simple instruments often were carried by young men who participated in the grass dance, or Omaha dance, which was diffused from the Omaha to the Sioux in 1860, and from them to other tribes of the Northern Plains. However, this single-note whistle, with a conventionalized head of the long-beaked snipe carved at the far end, was in use among tribes other than the Omaha before 1860.

Constantine Beltrami, the adventurous Italian who explored the Upper Mississippi in 1823, collected one of these whistles, which I saw in the Museo Civico di Scienze Naturali in Bergamo, Italy, in the fall of 1984. It is not identified as to tribe, but Beltrami is known to have visited both the Eastern Sioux and the Ojibwa during his travels upriver beyond Fort Snelling. Dr. Nathan Jarvis collected one of these whistles from the Ojibwa Indians while he was at Fort Snelling in 1833–36. It is in the Brooklyn Museum, and was illustrated in Feder 1964 (fig. 51).

A well-carved and well-documented example of this snipe-head whistle appears in colorplate 24. It is 27 inches long—the bill

and head comprising 10½ inches of its length. The narrow tube is only ⅝ of an inch in diameter. The entire surface is painted yellow, with a red-orange accent on the inside of the bill and blue filler in the linear incision at the head. Rev. A. McG. Beede, who collected this whistle before 1915, wrote that it was made by the grandfather of Spotted Elk, a Hunkpapa Sioux, about fifty years before he acquired it.

Frances Densmore illustrated another snipe-head whistle that belonged to the Sioux Indian wife of the Indian agent John McLaughlin on Standing Rock about 1880 (Densmore 1918, fig. 30). A unique variant of this whistle, attributed to the Sioux, on which the bird has a shorter and heavier bill and a buffalo head carved in relief atop the tube behind the head, is pictured in Feder 1971, plate 49.

Royal Hassrick's Sioux informants on Rosebud Reservation assured him that even though the bird-head whistle could play only a single note "this one note, if played in accordance with magical instructions, was believed to have influence over women." (Hassrick 1964, p. 146.)

Frances Densmore also told of the use of a "courting whistle" of this design by the Mandan and Hidatsa Indians, and she pictured a man playing one of these instruments (Densmore 1923, pl. 10).

Henry Black Tail, an elderly Assiniboin Indian on Fort Peck Reservation, in describing the traditional courting customs of his people to me in 1953, stated: "The young man took a wooden whistle to the girl's tipi, stood outside and blew on the whistle. This whistle generally was made with the head of an open-mouthed bird on the front of it. On hearing the whistle the girl was supposed to come out to the young man."

One of Christian Barthelmess's portraits of Indians near Fort Kehoe, taken about 1890, pictured Bird Wild Hog, a young Cheyenne of about twenty-one years, in his grass dance costume and holding one of these snipe-head whistles. He was "noted among the Cheyennes as a particularly fine dancer, much admired by women." (Frink and Barthelmess 1965.)

A more common type of courting instrument among the Plains Indians was the flageolet, or end flute, with five or more holes making it capable of producing a number of sounds. Samuel Pond described the Santee Sioux making and use of these flutes in 1834, when he first began missionary work among those Indians. "Flutes might be made of sumac, but by the Medawakantons they were commonly made of red cedar. A stick was first made of the requisite size and shape for the tube, then it was split through the middle, and the two pieces were hollowed out and glued together again." As to the effectiveness of these instruments, Pond added: "That women were pleased with the sounds of the flute may be in-

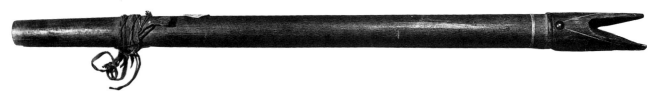

FIGURE 154. Fish effigy courting flute; probably Sioux, collected in 1823 on the Upper Mississippi by Constantine Beltrami; painted wood; 25¾" long. *Museo Civico di Scienzi Naturali, Bergamo.*

ferred from the fact that it was much used in serenading young ladies." (S. Pond 1908, p. 399.)

In 1941 Ella Deloria, a Sioux Indian ethnologist, obtained a Santee Sioux legend of the origin of the courting flute from Zeneas Graham of Flandreau, South Dakota. It told of a poor boy who was rebuffed in his efforts to court the daughter of a chief. He was visited in a dream by two elks in the form of handsome young men, who took pity on him and gave him a flute from the mouth of which "made like a gar, came a sweet, piercing sound." After they showed him how to play it, the boy returned to camp and walked among the lodges at night playing his flute. "As the music filled the air, the women all arose from their beds and dragging their blankets followed him." (Deloria and Brandon 1961, pp. 5–7.)

The oldest Santee Sioux courting flute preserved in any museum may be the one shown in figure 154, collected by Constantine Beltrami during his travels on the Upper Mississippi in 1823. This six-hole instrument has an open-mouthed creature carved at the front end that may have been intended as the head of a fish—the gar mentioned in the Sioux origin legend.

There is no question that the front of a flute obtained from Frank Blue Horse at Rosebud Agency, South Dakota, about 1900, reproduced in a pen-and-ink-drawing by Herman Haupt in the Newberry Library, was meant to represent a snake. Haupt said that he could not explain the choice of a snake for a symbolic carving on a courting flute. This flute appears to have been unique (Haupt, p. 50).

Numerous courting flutes of Sioux origin with carved bird heads at the end away from the player may be found in museum collections in this country and abroad. A good late nineteenth-century example appears in figure 155. It is made of two pieces of cedar glued together. Relatively long, measuring 30⅝ inches, this flute has five incised rings and a similar one at the mouthpiece. It is painted red except for the bird's beak, which is black. Its eyes are brass tacks. The long-billed bird was probably intended to represent the loon, or great northern diver. A similar flute, collected at Fort Pierre on the Missouri, was illustrated in Winchell 1911 (pp. 493–94), where the bird head was termed a loon.

Alanson Skinner, writing of the Eastern Sioux during the

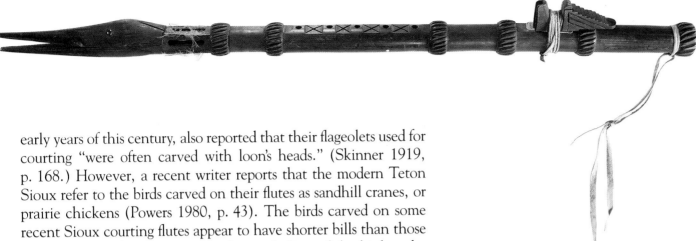

early years of this century, also reported that their flageolets used for courting "were often carved with loon's heads." (Skinner 1919, p. 168.) However, a recent writer reports that the modern Teton Sioux refer to the birds carved on their flutes as sandhill cranes, or prairie chickens (Powers 1980, p. 43). The birds carved on some recent Sioux courting flutes appear to have shorter bills than those on older examples. In any case, the symbolism of the bird as the conveyor of sweet melodies persists.

An essential part of each Plains Indian flute is the adjustable block of wood that covers most of the sound orifice—an open slot at the top of the instrument between the mouth end and the finger holes. By moving the location of this block of wood forward or backward ever so slightly, the player can tune his instrument. Variously referred to by different writers as a flue cover, air-director, or stop, this block will be termed a stop here, even though a Sioux flute player once told me that he just referred to it as a tuner, because it was so essential to the tuning of his instrument. Most of these stops are held in place by buckskin cords wrapped around the barrel of the flute and the center of the stop.

Although a block was necessary for the proper operation of his flute, it was not necessary for the flutemaker to decorate this block. It must have been his desire to create an attractive-looking, as well as a sweet-sounding, instrument that motivated him to embellish this block with a miniature representation of a bird, animal, or even a human being.

Fletcher and La Flesche reported that the Omaha flutemaker "would readjust the stop piece, bound to the top over the opening and usually carved." (1906, p. 372.) Figure 156 pictures Chief Na-ka-ga-hi, an Omaha flutist, playing an instrument made from a discarded gun barrel with a wooden stop that appears to have been carved in the form of a semi-abstract wooden bird facing the player. There are several Plains Indian flutes fashioned from gun barrels, but their stops are of wood, and usually are carved to resemble some living creature.

Bird effigy carved stops appear on flutes from many tribes, but they are especially typical of the Kiowa instruments. Stops from four cedar flutes of Kiowa origin in the Smithsonian collections, all collected within the period 1888 to 1900, are shown in figure 157.

FIGURE 155. Bird head courting flute; Sioux; cedar wood painted red and black, brass-tack eyes; 30⅝″ long overall, head 7¼″.
Smithsonian Institution, cat. no. 200,563.

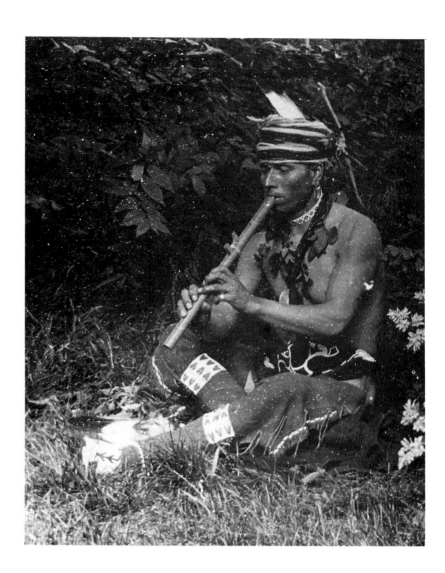

FIGURE 156. Chief Na-ka-ga-hi, an Omaha, playing a flute made from a discarded gun barrel fitted with a bird effigy stop of wood, before 1906.

Photograph by DeLancey Gill. National Anthropological Archives, Smithsonian Institution, neg. 3987.

They appear to me to represent four variants of Kiowa flutemakers' efforts to carve birds on their stops. Figure 157a is from a flute collected by Capt. R. W. Pratt in 1888, in which the bird is so geometricized as to be virtually abstract. Figure 157c is on a flute collected by James Mooney in 1891; it has a very rough-hewn conventionalized bird form. Figure 157b, also collected by Mooney, five years later, is a more realistic bird, painted green, red, and blue with eyes of tiny white seed beads. Figure 157d, collected by Dr. James Glennan, the surgeon at Fort Sill during the latter 1890s, appears to represent a road runner in a more conventionalized form.

Seeing these varied elaborations of bird forms on the functional wood blocks that were the stops on Kiowa flutes reminds me of Franz Boas's study of the decorative designs on Alaskan needle cases in the Smithsonian collections, published near the beginning of this century (Boas 1908). Boas regarded the carved ivory needle cases as demonstrations of variation in the native carvers' ingenuity in decorating those essentially functional objects with geometrical

164

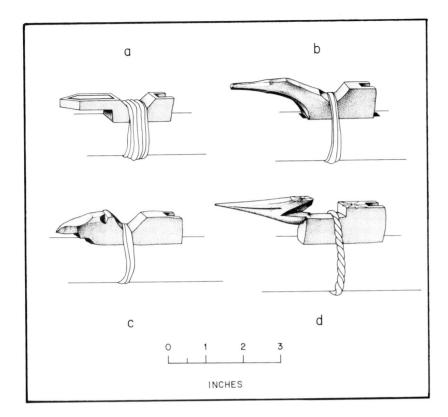

FIGURE 157. Variations in form of carved wooden stops on Kiowa flutes in the Smithsonian collections:
a. Abstract; collected by Capt. R. H. Pratt, 1888. cat. no. 153,584.
b. Bird head with glass bead eye; collected by James Mooney, 1896. cat. no. 175,632.
c. Crude bird head; collected by James Mooney, 1892. cat. no. 152,899.
d. Stylized road runner; collected by Major James Glennan, 1890s. cat. no. 385,877.

Drawn by George R. Lewis.

and realistic life forms. With similar ingenuity, the Kiowa flutemakers expressed their individuality in their decoration of the wooden stops atop their instruments.

The most realistic bird form on any Kiowa flute stop that I recall is on a flute seen on exhibition in the American Museum of Natural History, collected by Pliny E. Goddard in 1911, and pictured here in figure 158. It has inlaid bead eyes, and is painted red and yellow, with a black bill.

Roland White Horse, a Kiowa sculptor, told me that some Kiowa flutemakers sought to represent the water turkey or darter on their stops. However, none of the examples shown here look like they were intended to interpret that long-necked bird.

Among other tribes, stops carved in the form of animals were more common. Especially interesting are the ones with horse

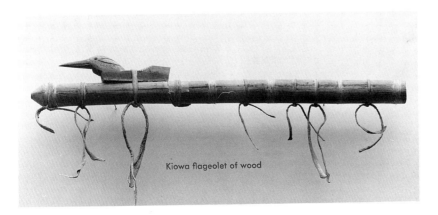

Kiowa flageolet of wood

FIGURE 158. Flute with large bird effigy stop; Kiowa, collected in 1911; painted wood; 17″ long.

American Museum of Natural History, cat. no. 50.1/6338.

FIGURE 159. Arched-neck horse effigy stop on flute; probably Sioux, collected in 1839; painted wood, rawhide binding; stop 2¾″ long.

Museum für Volkerkunde, Berlin, cat. no. IV B.39.

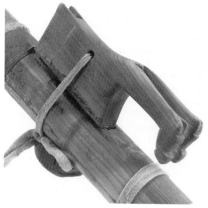

FIGURE 160. Two-headed horse effigy stop on flute; Comanche, about 1890; cedar wood with buckskin bindings; stop 3¾″ long.

Smithsonian Institution, cat. no. 270,086.

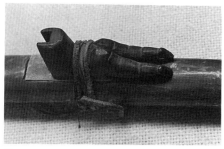

FIGURE 161. Nude woman effigy stop on flute; made by Kills Enemy, Brule Sioux, ca. 1915; wood with buckskin bindings; stop 3¼″ long.

Father Eugene Buechel Memorial Museum, St. Francis, South Dakota, cat. no. H13.

effigies on them. Royal Hassrick observed that the Big Twisted Flute, a "dangerously powerful instrument of love," highly valued and greatly respected by the Sioux, was equipped with "an adjustable block for changing pitch," which was "decorated with the effigy of a horse, most ardent of all animal lovers." (Hassrick 1964, pp. 116, 146–47.) Alanson Skinner observed also that the stops on Menomini flutes were "often carved to represent some animal of especially amorous nature," and the example he illustrated "shows a spirited stallion's head." (Skinner 1921, pp. 356–57, fig. 73.)

The earliest documented example of a stop carved in the form of an arched-neck stallion appears on a flute collected by Ronne in 1839 and attributed to the Sioux in the Museum für Volkerkunde in Berlin. See figure 159. This horse is painted black and contrasts sharply with the red barrel of the flute. Perhaps the arched-neck stallion pose in Plains Indian sculpture appeared first in wood carving and in the decoration of love flutes, and was carried over into effigy pipes of catlinite at a later date.

A Comanche variant of the horse effigy stop appears in figure 160. In this carving the horse has two heads and two necks, but the necks are not arched. This flute was collected by Capt. Allyn Capron, probably while stationed at Fort Sill Oklahoma during the 1890s.

In his description of Sioux Indian flutes, Clark Wissler wrote: "The figure of a nude woman is often placed near the vent." (Wissler 1905, p. 266.) There appear to be no examples of this form of decorating a flute stop in the American Museum of Natural History, for which Wissler collected. In fact, the only example I have seen is in the fine collection of Sioux objects brought together by Father Eugene Beuchel for the museum at St. Francis Mission on the Rosebud Reservation. This stop, shown in figure 161, has the figure of a nude woman only from the waist down. I am indebted to Harold Moore of the staff of that mission for this photograph.

I have offered here only a small sampling of the more than 300 effigy whistles and flutes that are preserved in museum collections. How many were created for Indian use and how many for the collectors' market I do not know. Certainly, effigy whistles and flutes rank with pipe stems as the most common articles of wood that were carved by Plains Indians. Love flutes have continued to be made by a few Indian specialists on a number of reservations in recent years. I shall come back to them in my discussion of trends in Plains Indian carving in chapter 5.

Effigy Bowls and Spoons Used in Ceremonies

Effigy Bowls. In the year 1851, a Baltimore artist, Frank B. Mayer, visited the villages of the Santee Sioux on the Upper Mississippi River where he made numerous sketches of these people and their

activities. Based on his field studies, Mayer created the striking watercolor of a Santee Sioux harvest ceremony reproduced here as figure 162. The two central figures are religious leaders offering wooden bowls of corn to the spirits in what must have been the tribe's thanksgiving ceremony for a bountiful harvest. On the bench in the right foreground is a closer view of one of their wooden feast bowls. It has a carved animal head protruding above one side and facing into the bowl. The details of this bowl are taken from a pencil sketch of a Santee ceremonial bowl Mayer executed in the field and which is preserved in an album of his field drawings in the Rare Book Room of the New York Public Library.

Figure 163 shows a wooden bowl approximately 10½ inches in diameter, with a very similar animal head carved on it, with its ears erect, a relatively pointed snout, and brass-tack eyes. This may have been intended as the head of a bear or a dog. A stubby tail rises above the opposite edge of the bowl, and two pairs of legs are suggested by four protrusions above the bowl's edge between the head and the tail. So the bowl gives the general impression of an animal lying on its back with its head, tail, and legs pointing upward. This bowl is cataloged as of Comanche origin, but its close similarity to the one pictured by Mayer, and the fact that *no* other Comanche effigy bowls are known, attest to the Santee Sioux origin of this interesting example of Plains Indian carving, acquired by the American Museum of Natural History in 1877.

It was Sioux custom for each person to furnish his own bowl for a ceremony at which food was served. The very early French explorers, Pierre Radisson and Sieur des Grosseilliers, must have been familiar with that custom when they first met the Sioux in 1660 and were invited to a feast, for they reported that they went back to their baggage to get their wooden bowls (Radisson 1885, p. 214).

Father Louis Hennepin, the French priest who was a captive of the Santee Sioux on the Upper Mississippi in 1680, must have been referring to their method of making wooden bowls before they acquired metal tools from the whites, when he wrote: "When the Savages are about to make Wooden Dishes, Porringers, or Spoons, they form the Wood to their purpose with their Stone Hatchets, make it hollow with Coles out of the Fire, and scrape them afterward with Beaver Teeth so to polish them." (Hennepin 1903, vol. 2, p. 527.)

The literature offers evidence that beaver incisors were widely used by Indian tribes both east and west of the Great Plains in working wood in very early days. As early as 1623 Gabriel Sagard observed that the Huron Indians in the St. Lawrence valley used the four large teeth of the beaver "to scrape their bowls made out of tree knots." (Sagard, in Tooker 1964, p. 67.) A hafted beaver

FIGURE 162. Santee Sioux Corn
Ceremony, showing use of effigy bowls.
Watercolor by Frank B. Mayer based on
his field studies on the Upper Mississippi
in 1851.

From photograph in Smithsonian Institution.

FIGURE 163. Bear or dog effigy feast
bowl; probably Santee Sioux, before
1877; wood, brass tack eyes; 10½″ in
diameter.

*American Museum of Natural History, cat.
no. 1/2603.*

tooth, used by prehistoric occupants of the Ozette Site on the Washington Coast for woodworking, was pictured by Earl Clark (1984, p. 29). An old beaver-tooth knife, set in a bone handle, collected among the Tlingit Indians during the late years of the nineteenth century, is in the American Museum of Natural History (cat. no. E1343).

Although J. V. Brower pictured a beaver tooth found in a Mandan village site, he may not have been justified in claiming that "the beaver's tooth was long used as a knife in domestic conveniences by all the Plains Indians." (Brower 1904, pp. xxixxi.) Plains Indians may have used beaver teeth for woodworking in prehistoric and early historic times, but no hafted ones have been found in their camp or village sites.

It does seem certain that metal knives were among the first tools of European make to reach the Plains Indians. French traders took "6 dozen canoe knives" into the Illinois Country in 1688, and the Hudson's Bay Company offered "crooked knives" for trade at its posts in 1748 (Quimby 1966, pp. 65–66). A list of merchandise sent to Indians by the Spanish in 1769 included "12 gross woodcutter's knives." (Nasatir 1952, vol. 1, p. 68.)

The trader Daniel Harmon, writing of tribes on the Canadian Plains before 1816, stated: "Wooden dishes they construct with crooked knives." (Harmon 1911, p. 377.) Rev. Samuel Pond described the Santee Sioux's woodworking kit in 1834: "For edge tools they had little beside hatchets and knives, and with these they made whatever they manufactured of wood. The knife, which was ground only on one side, served for a draw knife and plane, and in whittling they drew it toward them, cutting when they wished to very straight." Pond also referred specifically to their use of hatchets and crooked knives in making wooden bowls and spoons. "Their wooden dishes were well formed and valuable. They were made of hard knots cut from the sides of trees, hewn into shape with a hatchet, and finished with a knife bent at the end. Their spoons and ladles were made in the same way, but provided with a handle." (S. Pond 1908, pp. 356–57.)

Oddly enough, even though there are these reliable literary references to the use of crooked knives (also known in the trade as canoe knives) by the Algonquian-speaking tribes of the Canadian Prairies and the Santee Sioux, no hafted crooked knives have been found in archeological sites on the Great Plains.

All evidence from the literature and museum collections indicates that although most if not all Plains Indians tribes made and used wooden bowls and spoons, the fashioning and use of bowls with effigies carved on them was restricted to the Siouan tribes and the Pawnee. Among those tribes, their fine wooden bowls tended to be handed down from generation to generation as heirlooms, so

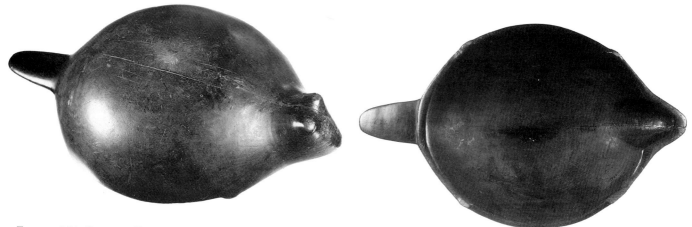

FIGURE 164. Beaver effigy feast bowl:
a. exterior view; b. Interior view;
Omaha, said to date from ca. 1807;
wood; 18½″ long.
Nebraska State Historical Society, cat. no. 1927.

that one cannot judge the age of a bowl by the time of its collection, even if the date of the latter is well known.

Fletcher and La Flesche (1911, p. 338) learned of an Omaha bowl of black walnut that was said to have been made as far back as the eighteenth century. The oldest Plains Indian effigy bowl, and one of the oldest examples of Plains Indian wood carving preserved in any museum, is a beaver effigy bowl from the Omaha in the Nebraska State Historical Society, which belonged to the mother of Joseph Little Bear and was said to date back as far as 1807. As pictured in figure 164a and b, this bowl best presents its beaver effigy when placed upside down. Then one can see its very conventionalized head and broad, flat tail protruding from the opposite side. The tail extends 4½ inches outward from the bowl, which is 14 inches long. In style, this bowl closely resembles another upside-down beaver effigy bowl in the Detroit Institute of the Arts, thought to have come from an unidentified tribe in the Great Lakes Region (illustrated in Feder 1972, fig. 78). It differs from the two standing beaver effigy bowls attributed to the Kaskaskia, which were collected by Judge George Turner of the old Northwest Territory in the 1790s. One of them is in the University of Pennsylvania Museum and the other in the Peabody Museum of Archeology and Ethnology of Harvard University. These bowls have been illustrated in Dockstader 1961 (fig. 216) and Maurer 1977 (fig. 130).

The very great majority of Plains Indian effigy bowls in museum collections are from the Santee or Eastern Sioux. E. D. Neill, writing of their Medicine Dance in 1855, stated that the initiate being instructed in the mysteries of that society "is also provided with a dish and spoon. On the side of the dish is sometimes carved the head of some voracious animal, in which resides the spirit of Eeyah (glutton god). This dish is always carried by its owner to the Medicine Feast, and it is his duty ordinarily to eat all which is served upon it. Grey Iron has a dish which was given him at the time of his initiation, on the bottom of which is carved a bear complete." (Neill 1972, p. 270.)

Although effigy bowls of Sioux origin bearing carved heads of bears, dogs, turtles, and humans are more common in museum collections than ones with bird heads, the most striking of their effigy bowls that I have seen bears the upraised head of a large, heavy-beaked bird on one side and its tail on the other. Colorplate 25 shows this entire bowl, and figure 165 is a close-up of its massive, smoothly-rounded head and beak, and its inset brass-tack eyes. The bird head is 3¾ inches long and 2½ inches wide; the bowl is 15 inches in diameter. Records of the Peabody Museum of Archeology and Ethnology state that this bowl was captured from an encampment of Blackfeet Indians in 1865 by Col. Sibley, U.S.A. Presumably this reference was to the Blackfoot division of the Teton or Western Sioux rather than to the Algonquian-speaking Blackfeet Indians. The former were involved in an action with the army on July 28, 1864 (not 1865), known as the Battle of Killdeer Mountain in the southwestern portion of present North Dakota.

A number of carved bowls in museum collections portray the supernatural the Sioux knew as E-ya, the god of gluttony, in human form. The missionary Stephen Riggs explained this Sioux concept in his study of their traditional beliefs: "A people who feast themselves so abundantly as the Dakotas do, when food is plenty, would necessarily imagine a god of gluttony. He is represented as extremely ugly, and is called E-ya. He has the power to twist and distort the human face, and the women still their crying children by telling them that Eya will catch them." (S. R. Riggs 1880, p. 270.) A Wahpeton wooden bowl 17¼ inches long, collected by Alanson Skinner before 1920 for the Museum of the American Indian, Heye Foundation, is said to bear the carved head of Eya. The distortion in this head appears in the enormous ears and the size of the brass-tack eyes in comparison with the smaller nose and mouth. See figure 166.

FIGURE 165. Detail of bird effigy feast bowl; Blackfoot Sioux, before 1865; painted wood, brass-tack eyes; head 3¾" long.
Peabody Museum of Archaeology and Ethnology, Harvard University, cat. no. 9,829.

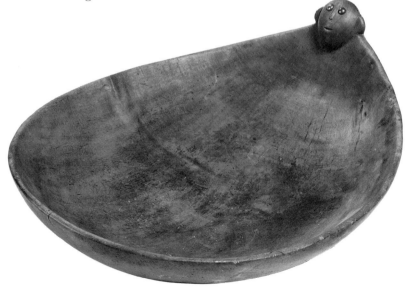

FIGURE 166. Human effigy feast bowl representing Eya, the spirit of gluttony; Santee Sioux; wood, with brass tack eyes; 17½" long.
Museum of the American Indian, Heye Foundation, cat. no. 4/5335.

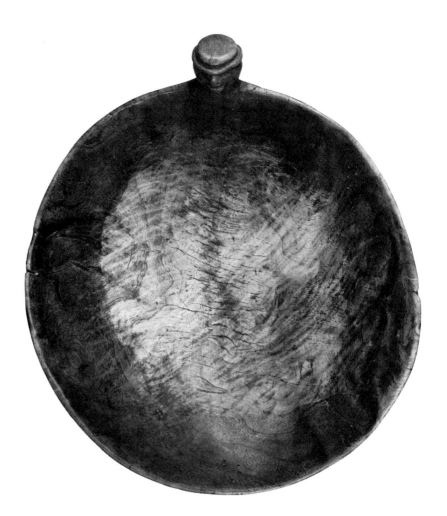

FIGURE 167. White man's head on feast bowl; carved by Iron Ring, Devil's Lake Sioux, accessioned 1932; wood; 18″ in diameter.

State Historical Society of North Dakota, cat. no. L476.

Two Sioux bowls have the heads of white men—hat wearers—carved on them. Figure 167 shows one of these, in the State Historical Society of North Dakota. This large bowl, 18 inches in diameter, was reported to have been carved by Iron Ring, a Devil's Lake Sioux from Fort Totten, North Dakota. The other is a Sisseton Sioux bowl of smaller dimensions, in the Museum of the American Indian, Heye Foundation, collected by L. Palm, a trader in that region. It has two white men's heads—one above each side of the bowl, facing each other (cat. no. 3/6832).

The largest collection of Sioux effigy bowls is found in the Museum of the American Indian, Heye Foundation, owing in considerable part to the active field collecting of Alanson Skinner during the first quarter of this century. Some other museums with relatively large Plains Indian collections have no effigy bowls from the Sioux. Since 1970 a number of fine examples of these bowls have been included in the large, temporary exhibitions of North American Indian Art and have been illustrated in the catalogues of those shows. A Yanktonai Sioux bowl from Crow Creek Reservation appears in *American Indian Art: Form and Tradition*, 1972 (no. 144, p. 57). Three effigy bowls from the Eastern Sioux are illustrated in Dockstader 1973 (fig. 394); Coe 1976 (no. 449); and Conn 1982 (fig. 12).

The most active effigy bowlmakers among the non-Siouan tribes of the Great Plains appear to have been the Pawnee Indians, before their removal from Nebraska to the Indian Territory (Oklahoma) during the mid-1870s. John Dunbar, an early missionary to the Pawnees, reported that women were the bowlmakers in this tribe and claimed that they shaped bowls "with the aid of fire." (Dunbar 1880, p. 279.) But ethnologist Gene Weltfish obtained a Pawnee woman's account of bowlmaking that made no reference to any use of fire in the process: "A wooden bowl is made by first cutting the knot from the tree. The knot selected depends upon the size of the bowl to be made. A sharp hatchet is used to whittle around the knot. While the knot is green a hole can be made more readily than when it begins to dry and harden. After the hole is the required size the handle on the rim is carved with a crooked knife. This little projection is called heads-on-top. It takes from one to three days to make a bowl. . . . Several bowls are made at the same time." (Weltfish 1937, p. 48.)

When I questioned Dr. Weltfish some years before her death about those "heads-on-top," she expressed the opinion that they were representative carvings, but she did not know what creatures were represented. There are two Pawnee wooden feast bowls in the Field Museum of Natural History with carved bird effigies; figure 168 shows one of them. The head of the bird—probably intended to be a duck—stands high above one side and faces away from the interior of the bowl. The head has brass tacks for eyes, and the tail is suggested by a projection above the opposite side of the bowl.

Perhaps Pawnee effigy-bowlmaking in the nineteenth century may be considered a survival of an old Caddoan custom, for eighteenth-century missionaries among the Caddo in eastern Texas reported seeing wooden platters, some with heads and tails of ducks, others of the alligator or lizard (Swanton 1942, p. 161). Archeologists to whom I have shown photographs of Plains Indian effigy bowls of wood have told me they reminded them of prehistoric Mississippian effigy bowls of pottery.

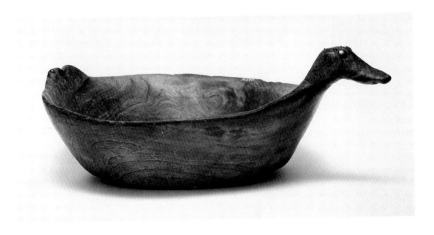

FIGURE 168. Duck effigy feast bowl; Pawnee, collected by George A. Dorsey, 1902; wood, brass-tack eyes; 10¼" in diameter.
Field Museum of Natural History, cat. no. 71,597.

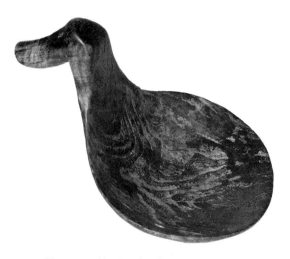

FIGURE 169. Duck effigy spoon; Omaha, collected by Melvin R. Gilmore; wood; 6″ long.

Museum of the American Indian, Heye Foundation, cat. no. 12/6212.

Effigy Spoons. A French observer, Antoine Raudot, writing of the Indian tribes of the Western Great Lakes in general in 1709, stated that men "make dishes of knots of wood and spoons on which they carve the figure of some animal." (Kinietz 1940, p. 351.) Effigy spoons as well as effigy bowls also were made by Plains Indian tribes living farther west—most especially the Siouan tribes who fashioned effigy bowls, although effigy spoons came to have a wider distribution than did the bowls during the late years of the nineteenth century.

We have seen two wooden spoons from the Sioux with quite realistically carved figures on their handles—a turtle and a frog—used by Indian doctors in preparing and/or administering their medicines. One is in colorplate 22, the other in figure 148. Many wooden spoons from the Sioux, Omaha, and Iowa Indians in museum collections, however, have more conventionalized heads of birds or animals carved on the ends of their handles. They are more like the duck head appearing on the Omaha spoon in figure 169. This spoon probably had brass-tack eyes also, but they were missing when I examined it. No other features of the head were delineated. It is a small spoon—only six inches long—probably intended for use with a small bowl. It is in the Museum of the American Indian, Heye Foundation, which has a fine collection of effigy spoons from Plains Indians. As with this example, wooden spoons usually were carved with the effigy head facing away from the bowl and pointed downward so that the bend at the end of the handle would serve the practical purpose of fitting over the rim of the bowl and preventing the handle from sliding into it.

Spoons made from the horns of the bighorn or the buffalo seem to have been as common among the Plains Indians as were ones of wood. One of Frank Mayer's field sketches among the Santee Sioux on the Upper Mississippi in 1851 (now in the Rare Book Room of the New York Public Library) pictures a buffalo-horn ladle with the end of the handle carved in the form of a snake's head, and with cross-hatched markings on the handle to represent the snake's body. J. O. Dorsey learned that the buffalo-horn spoons of the Omaha often had handles that terminated in the head of a bird (J. O. Dorsey 1896, p. 277).

Horn spoons with carved effigy handles seem to have been especially favored by the Teton or Western Sioux during the second half of the nineteenth century. Army officers on duty in or near the Sioux Country collected a number of these effigy spoons of buffalo, mountain sheep, or domesticated cow horn. No doubt their presence nearby provided further stimulus for Indian carvers to create these effigy spoons.

Figure 170 pictures a buffalo-horn spoon with an effigy handle in the form of a caricature of the head of a white man. Although only 1⅛ inches high, this head has been painstakingly carved to

174

show the man's brimmed hat, fat cheeks, eyes, nose, and mouth; while the lengthy handle gives the impression of a ridiculously long neck. This spoon, in the Smithsonian collections, was the gift of Gen. William B. Hazen's widow in 1892.

A spoon fashioned from the horn of a bighorn, on which the handle terminates in the head of a snake, with open mouth and inlaid white seed bead eyes, is shown in figure 171. The head seems to flow easily into the handle so as to suggest the snake's body. This Oglala Sioux spoon was collected by Lieut. Cornelius C. Cusick, who saw action against the hostile Sioux in several engagements during the 1860s and 1870s. He sold it to the Smithsonian Institution in February 1872.

The bighorn spoon in colorplate 26 has the upper portion of the handle cut into a silhouette of a large-beaked bird—probably intended to represent a thunderbird—with its head turned to one side and its wings outspread. The bird is red with a blue painted eye, while the remainder of the spoon is painted yellow. Major James M. Bell obtained this spoon from the Sioux at Poplar River, Montana. Those Sioux may have been local Yanktonai, or followers of Sitting Bull who began to come south from exile in Canada in 1880 to give themselves up to United States authorities.

After the buffalo were exterminated in the early 1880s, a number of Teton carvers turned to making effigy spoons of cowhorn, for sale to whites as well as for Indian use. They found a ready source of material in the horns of cattle slaughtered on their own reservations to provide rations for the Indians. These carvers demonstrated both cleverness and skill in developing new formal interpretations of animal and bird forms in this new medium.

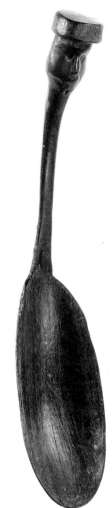

FIGURE 170. White man's head spoon; Sioux, collected by Gen. William B. Hazen, accessioned 1892; buffalo horn; 8″ long.
Smithsonian Institution, cat. no. 153,944.

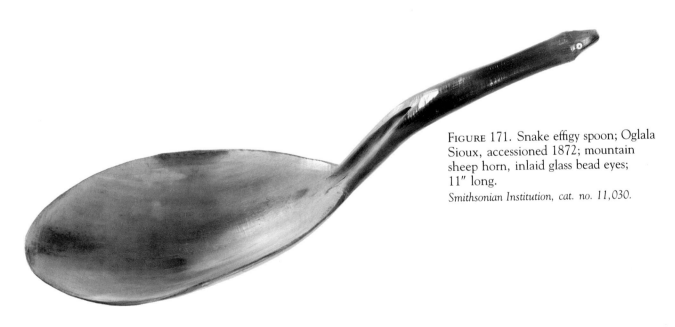

FIGURE 171. Snake effigy spoon; Oglala Sioux, accessioned 1872; mountain sheep horn, inlaid glass bead eyes; 11″ long.
Smithsonian Institution, cat. no. 11,030.

Religious, Magical, and Ceremonial Effigies　　　175

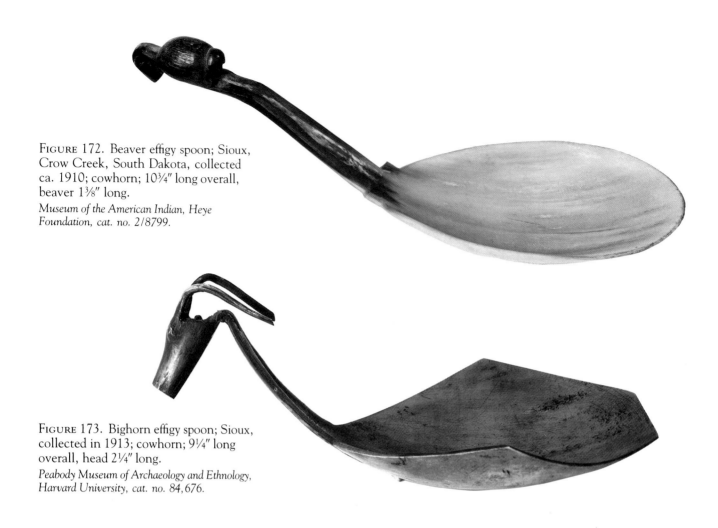

FIGURE 172. Beaver effigy spoon; Sioux, Crow Creek, South Dakota, collected ca. 1910; cowhorn; 10¾″ long overall, beaver 1⅜″ long.

Museum of the American Indian, Heye Foundation, cat. no. 2/8799.

FIGURE 173. Bighorn effigy spoon; Sioux, collected in 1913; cowhorn; 9¼″ long overall, head 2¼″ long.

Peabody Museum of Archaeology and Ethnology, Harvard University, cat. no. 84,676.

Figure 172 pictures a cowhorn spoon with a small beaver effigy carved at the end of the handle and facing the bowl of the spoon. The artist made no attempt to depict the features of the head in detail. He curved the flattened tail downward so the end of the spoon would fit the rim of a bowl. The entire beaver effigy is only 1⅜ inches long. This spoon was collected during the early years of this century by William C. Orchard for the Museum of the American Indian, Heye Foundation, on Crow Creek Reservation, so that it may be of Yanktonai rather than Teton origin.

What art historians might look upon as a strikingly modern head of a bighorn is carved at the end of the handle of a cowhorn spoon collected by Grace Nicholson from the Sioux in 1913 (figure 173). Yet this head looks very like that of a bighorn painted by an Indian on the wall of a pictograph site in northeastern Wyoming many years earlier (see fig. A3.9 top, in Frison 1978). The carved head on the spoon measures 2¼ inches from the muzzle to the bend in the horns.

An elk-head spoon of cowhorn appears in figure 174. The handle is bent at the end so that the elk head faces the same di-

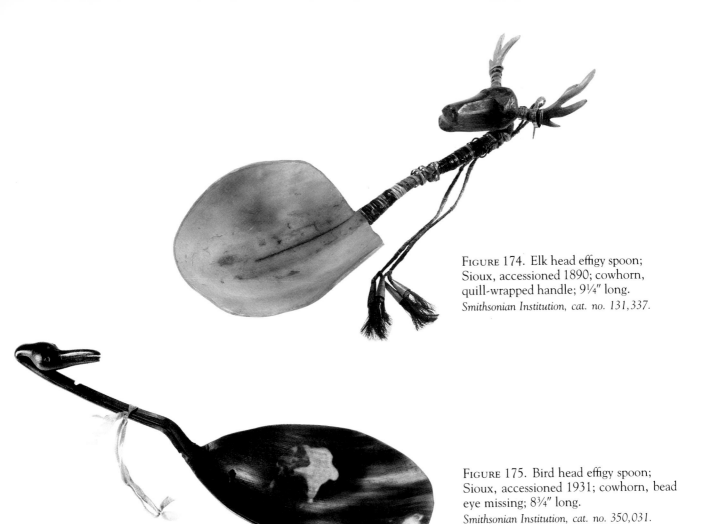

FIGURE 174. Elk head effigy spoon; Sioux, accessioned 1890; cowhorn, quill-wrapped handle; 9¼″ long.
Smithsonian Institution, cat. no. 131,337.

FIGURE 175. Bird head effigy spoon; Sioux, accessioned 1931; cowhorn, bead eye missing; 8¾″ long.
Smithsonian Institution, cat. no. 350,031.

rection as the bowl of the spoon. The carver took pains to show the animal's open mouth and lightly incised nostrils and eyes, as well as its spreading horns. A decorative touch was added by wrapping the handle with colorfully dyed porcupine quillwork and pendant buckskin cords ending in rolled tin cones. Of Sioux origin, the spoon was accessioned by the Smithsonian Institution on February 14, 1890.

As early as June 16, 1882, Robert Sweeney drew a pen-and-ink illustration entitled *Implements and Utensils of the Dakotas of Minnesota*, which is in the Minnesota State Historical Society. It includes two views (front and side) of a cowhorn spoon with a long-beaked bird head carved at the end of a long inverted handle, facing the same direction as the bowl of the spoon. This appears to be the earliest record of a style of bird-head spoon in cowhorn, which must have been made in rather large numbers by several Sioux carvers for sale to collectors during the succeeding quarter century.

One of these spoons, with a long-beaked bird head at the end of the recurved handle, appears in figure 175. This spoon originally

had inlaid blue seed beads for eyes, but one of them is missing. Although accessioned in the Smithsonian collections in 1931, this spoon may have been made a number of years earlier.

These bird-head spoons of cowhorn reveal considerable differences in detail and relative gracefulness of execution. Some of them are very long-beaked, identified as crane heads. They are now both numerous and widely scattered in museum collections. I have found them in museums as far apart as San Diego, California; Rome, Italy; and Berne, Switzerland. A number of them have been illustrated since 1970, including one in the Denver Art Museum in Conn 1982 (pl. 8). Others are pictured in Feder 1971 (figs. 80 and 81); *Indian Arts: Form and Tradition*, 1972 (pl. 5); J. Thompson 1977 (fig. 112); and Gilman 1982 (fig. 45).

Effigies in Major Ceremonies

To appreciate fully the importance of sculptured effigies in traditional Plains Indian culture, we must consider the functions of some of them in major ceremonies among both the horticultural and the nomadic tribes—ceremonies such as the ones performed by the sedentary tribes to ensure the growth of their crops and by the nomadic tribes to appease the thunder, as well as the great annual Okipa of the Mandans and the Sun Dances of other tribes. We must look to the literature and to the pictorial record compiled by non-Indians and Indians who observed these ceremonies, because these effigies were not the kinds of objects that Indians relinquished to institutional or private collectors, unless they were effigies that customarily were remade before each ceremony or were associated with ceremonies that Indians felt were no longer important to their welfare.

Effigies of the Foolish One among the Mandans. While wintering near the Mandan Indians at Fort Clark in 1833–34, Prince Maximilian learned that one of the supernaturals of great concern to those Indians was "*Ochkih-Hadda*, whom it is difficult to class, and of whom they have a tradition that who ever dreams of him is doomed to die. He appears to figure in their traditions as a kind of devil, is said to have once come to their villages, and taught them many things, but has not since appeared. They are afraid of him, offer sacrifices to him, and have in their villages a hideous figure representing him." (Maximilian 1906, vol. 23, p. 303.)

In his description of Mih-Tutta-Hang-Kush, the largest of the Mandan villages at that time, Maximilian wrote that in the open space at the center of the village there was a figure placed atop a high pole "made of skins, with a wooden head, the face painted black, and wearing a fur cap and feathers which is intended to represent the evil spirit, *Ochkih-Hadda* (corresponding with the devil), or a wicked man, as they affirm, who once appeared among them,

FIGURE 176. Effigy of the Evil Spirit atop a pole in the center of a Mandan village, 1833–34. Detail from an engraving after Karl Bodmer.

Smithsonian Institution.

had neither wife nor child, and vanished, and whom they now stand greatly in dread of." (Idem, p. 269.) Maximilian's description of the other Mandan village, Ruhptare, also mentioned "the figure of *Ochkih-Hadda* on the pole before the medicine lodge." (Idem, vol. 24, p. 22.)

Maximilian's artist-companion Karl Bodmer drew a pencil-and-ink sketch of the center of the larger of the two Mandan villages, which showed the wooden effigy of the head of the Mandan evil spirit atop its pole (Goetzmann 1984, pl. 303). However, this purposely hideous wooden head, apparently painted black and white, is more sharply defined in Bodmer's classic engraving of the members of the Mandan Buffalo Society dancing in the center of one of their villages. Figure 176 is a detail from the left side of that illustration, showing this effigy.

Even though Maximilian wrote that the Mandan devil once visited their villages "but had not since appeared," George Catlin, a year earlier, learned that an impersonator of that devil took part

FIGURE 177. Evil Spirit (wearing carved and painted wooden phallus) being rebuffed by the sacred pipe of Lone Man during the Mandan Okipa Ceremony. Watercolor by George Catlin, who witnessed the ceremony in 1832.
The British Museum, London.

each summer in the major tribal ceremony, the Okipa. Catlin witnessed that ceremony, which was performed to insure plenty of buffalo and the tribe's general welfare. He told of the appearance of this evil spirit on the third day of the ceremony, when he approached the village to test his power with that of Lone Man, the Mandan culture hero.

Catlin wrote that this "bizarre and frightful character," whom he termed *O-ke-hee-de* (the owl or evil spirit), "approached the village from the prairies, and entered the area of the buffalo-dancers to the terror of the women and children, had attached by a small thong encircling his waist, a buffalo's tail, behind; and from under a bunch of buffalo hair covering the pelvis, an artificial penis, ingeniously (and naturally) carved in wood, of colossal dimensions, pendulous as he ran, and extending somewhat below his knees. This was, like his body, painted a jet-black, with the exception of the glans, which was as glaring red as vermilion could make it." (Catlin 1967, p. 83.)

As this devil moved toward the screaming women of the village, Lone Man confronted him with his upraised medicine pipe, and prevented his further movement toward the women. Thereupon the devil proceeded to pretend to mount several of the dancing buffalo until he appeared to be exhausted. Then, no longer fearing him, the women drove him onto the prairie, and one of them wrested the artificial penis from him, and carried it back to the Medicine Lodge, "from whence she harangued the multitude for some time, claiming that she held the power of creation and life and death over them; that she was the father of all the buffaloes and that she could make them come or stay away as she pleased." (Catlin 1867, pp. 84–85.) She conducted the Feast of the Buffaloes ceremony, performed the following night.

In the British Museum is Catlin's pictorial interpretation of the Mandan devil, with his hideously painted body and large, painted penis, being confronted by the tribal culture hero, Lone Man, with his sacred pipe. It is reproduced here as figure 177.

Lewis Henry Morgan, sometimes referred to as "the father of American anthropology," arrived at Fort Berthold the day after the Okipa ended at the combined Mandan-Hidatsa-Arikara village of Like-a-Fishhook nearby in 1862. The account of the ceremony he obtained from a young Indian who had witnessed it, corroborated Catlin's testimony regarding the carved and painted penis worn by the impersonator of the evil spirit:

> There was one person who personated either a clown or the
> Evil Spirit. He wore a mask, was painted black, with white
> rings and red spots in the middle. On his back was painted the
> new moon. He wore a beaver skin bonnet, and showed in front
> the male organ in wood of large size, with buffalo hair pendant.
> (Morgan 1959, pp. 193–95.)

Effigy Pipes in Mandan and Hidatsa Corn Ceremonies.
Alfred Bowers found that next to the Okipa the most important Mandan ceremonies were the corn ceremonies, which according to tribal tradition were established by Good Furred Robe, who introduced corn among the Mandans, taught them how to plant the seeds and to care for the growing crops. He organized the Goose Society of older women, who met each year in the spring to welcome the migrating birds back from the south at planting time, and each fall to wish the birds well on their flight southward and pray for their return the following spring.

A major bundle associated with the corn ceremonies was the Sacred Robe bundle, which was thought to have been handed down from Good Furred Robe himself. It contained an effigy pipe as well as a painted robe. This bundle belonged to Moves Slowly, the last head of the corn ceremonies at Like-a-Fishhook Village, who died about 1900. His right to the bundle passed to his daugh-

ter Scattercorn. "She lost the robe and most of the bundle when their earth lodge burned, but saved the pipe." (Bowers 1950, pp. 183–87.) Some years after Scattercorn's death in 1940, her son, Rev. James Holding Eagle, deposited this pipe in the State Historical Society of North Dakota. As pictured in figure 178c, this pipe is fashioned of a single piece of wood in the form Indians of the northern plains refer to as a flat pipe. The bowl hole has a metal lining, and there is a metal plate on top of the disk. Near the mouth end is the carved head of a waterbird facing the smoker. The bird effigy has brass tacks for eyes. This pipe measures 20¼ inches long, and the bird head itself, 4¾ inches.

Presumably the bird head was intended as that of a goose, for Bowers described it as "carved to represent a goose." More than a century earlier, Prince Maximilian, explaining the bird symbolism in the Mandan women's corn ceremony, wrote: "The wild goose signifies maize; the swan, the gourd; and the duck beans." (Maximilian 1906, vol. 23, p. 335.)

Bowers found that the Hidatsa Indians also had a goose effigy pipe—"A wooden pipe with the carving of a goosehead on the stem represented the goose as the harbinger of spring and the termination of the growing season in autumn." (Bowers 1965, p. 345.)

Trader Henry Boller referred to both Mandan and Hidatsa women's societies' when he noted that in 1858 the Mandan women "made their Goose Medicine" near Fort Berthold on September 24 "to remind the wild geese now beginning their annual flight to the South that they have plenty of food, and have been treated well, and begging them to return in the Spring." He recorded that the Hidatsa women made their "Goose Medicine" the following day, September 25, 1858 (Boller 1966, p. 132).

Snake Effigy in Rain Ceremony at Hidatsa Village of Awax-awi. In the old Hidatsa village of Awaxawi, a ceremony was held at the hottest time of the summer each year to bring rain to the Indians' parched fields and growing crops. Hidatsa informants told Alfred Bowers that a unique feature of this ceremony was "the use of a carved log to represent a snake with eyes, mouth, and nostrils at one end and carved notches along the back. . . . During the performance of this ceremony, the leaders ran back and forth beside the log dragging a vibrator over the notches. The resulting noise was believed to represent the sounds made by snakes when bringing rain." (Bowers 1965, pp. 389–91.)

This Hidatsa ceremony became defunct many years ago, and there are no known pictures of that large snake effigy. Perhaps it resembled—but on a much larger scale—the carved wooden effigy of the Notched Stick Society illustrated in figure 140 of this book. It is significant that the Notched Stick Society, like the Rain Ceremony, existed only in the old village of Awaxawi.

Effigies Associated with Thunder Ceremonies among Nomadic Tribes. While the sedentary tribes performed ceremonies to bring rain to their fields, the nomadic tribes of the high plains to the westward sought to appease the great thunderbird in the sky who brought destructive lightning, winds, hail, and rain. Both the Blackfeet and their neighbors, the Gros Ventres, possessed medicine pipe bundles, thought to have been given to them by the thunder, which they opened each spring soon after hearing the first thunder, in ceremonies to protect their people from the ravages of storms. I know of no medicine pipes with effigies carved on them among the Blackfeet. For them the stems and not the pipes were the sacred portions. But I do recall seeing a large wooden tobacco cutting board carved in the shape of a turtle in one of their medicine pipe bundles.

The Feathered Pipe of the Gros Ventres was regarded as a gift from the thunder. It contained a calumet-shaped catlinite pipe with a human head carved at the end of the prow, oriented with its face upward. Father John Cooper's lengthy account of the origin, functions, and appearance of this Feathered Pipe bundle includes two small and rather indistinct photographs of this image (J. Cooper 1957, pp. 140–45, and pl. 3, figs. c and d). This pipe remains with the Gros Ventres of Montana.

Carved Sun Dance Dolls of Crow, Shoshone, and Ute Indians. William Wildschut, who conducted the most intensive studies of Crow Indian medicine bundles, expressed the belief that their sun dance bundle was a very old one and in early times may have been a tribal bundle. The heart of this bundle was the effigy or doll that symbolized the enemy against whom revenge was sought by the giver of the ceremony. In the account of the origin of the sun dance bundle told to Wildschut by Chief Two Leggings, the first sun dance doll was carved of ash wood and its body was wrapped in deerskin.

Most of the Crow sun dance dolls Wildschut collected for the Museum of the American Indian, Heye Foundation, were of softer material, but two were carved of wood, and both of them were said to have been carried on war expeditions. We have already seen the most striking of these in colorplate 16, and referred to its use in our discussion of effigies as war medicines. The other carved wooden doll appears in Wildschut and Ewers 1960 (fig. 10 and pp. 20–33).

West of the Crow Indians, the Wind River Shoshone and the Ute Indians both had sun dance dolls carved of wood. David Shimkin was told that before 1900 the leader of the Wind River Shoshone sun dance commissioned an able carver each year to fashion a doll for use in the ceremony. That doll had a wooden head with a feather stuck in the back (Shimkin 1953, p. 418). In the collections of the Museum of the American Indian,

Heye Foundation, is a carved wooden figure wrapped in skin, which hung from the sun dance pole of the Ute Indians (cat. no. 10/6017).

We know that both the Teton Sioux and the Cheyenne hung enemy effigies from the center poles of their sun dances too. But those symbols were not carved of wood but were silhouettes cut out of rawhide—other variants of the widely held Plains Indian concept of the enemy in effigy form.

Effigies as Tribal Medicines

The Concept of Tribal Medicine. Some tribes of Plains Indians had sacred objects whose care and preservation were deemed essential to the very existence of their tribes. Entrusted to holy men, who cared for them and exposed them to the view of other tribal members only briefly on certain ceremonial occasions, these objects were recognized as tribal medicines. Not all of them were in the form of carved effigies. Certainly the tribal medicine of the Cheyennes was not. It was a bundle containing four medicine arrows, which sometimes was carried on major war expeditions as well. When those arrows were captured in a battle with the Pawnees in 1830, the Cheyennes feared for their future until they got them back. The tribal medicine of the Sioux was the buffalo calf maiden pipe, which was not carved, but some origin accounts of that pipe referred to it as if it had a buffalo calf carved upon the pipe or its stem. (See pp. 57–58.)

The term "tribal medicine" was used in the literature as early as 1881 by Colonel Dodge, when he retold a story told to him by an Arapaho Indian during the many years he served on the Great Plains before 1881:

> The Medicine of the Utes was a little squat figure, of Aztec or Toltec origin, and which the Utes probably obtained from the Navahoes or Apaches. There is a story among the Arapahoes that a few years ago a small party of that tribe penetrated some distance into the Ute country, and surprised and plundered a camp, capturing this stone figure. They retreated with all possible expedition, but were so closely pursued by an overwhelming force of Utes that they had to disperse to hide their trail. Most of them escaped, but some were killed, among them the warrior who had the medicine, but the Utes did not recover it. The presumption is that when so closely pressed in the mountains that he had to abandon his horse, he hid or buried his treasure, for no one has ever heard of it since. The Utes are said to attribute all their troubles of late years to the loss of their medicine. (Dodge 1882, pp. 134–35.)

184

Dodge also observed that the tribal medicines "were not worshipped, but loved, venerated, and held in sacred awe." (Idem, p. 131.)

The Flat Pipes—Tribal Medicines of Arapaho and Gros Ventres.

More than a century ago, Colonel Dodge learned that the Arapaho Indians had a tribal medicine, but its identity was kept secret, and he thought "it is likely to remain a secret until accident or its capture in war shall disclose it." He stated further: "What constitutes the medicine of the Arapahoes is known to no man except the initiated few. The parfleche in which it is kept is paraded on all occasions of ceremony. It is hung up, where all may see the elaborately painted outside but to touch or to look into it would be a sacrilege worthy of immediate death." (Idem, pp. 132, 134.)

Undoubtedly, the secrecy regarding the identity of this tribal medicine stimulated the curiosity of succeeding literate observers of the Arapaho and their customs. And as time passed some Arapaho converts to Christianity became more willing to discuss their former beliefs. Alfred Kroeber learned that the tribal medicine preserved by the Northern Arapaho in Wyoming was the Flat Pipe. He did not see it, but was told that it was "tubular seeming to be made of a piece of black and a piece of white stone." (Kroeber 1902, p. 21.)

Nearly sixty years after Dodge first mentioned an Arapaho tribal medicine, John Carter published a paper devoted exclusively to the Arapaho flat pipe, based on the testimony of persons who had seen it, in which he corrected Kroeber's description of its form and the material of which it was made. He wrote that the pipe was about a foot to 15 inches long, and had the head of a duck carved on it. On the basis of this testimony he offered a simple, outline drawing showing the appearance of this pipe (Carter 1938, pp. 94–95, and fig. 10).

The Gros Ventres Indians of Fort Belknap Reservation, Montana, close relatives of the Northern Arapaho, also had a flat pipe as their tribal medicine, which Father John Cooper was told of during his studies of their traditional religious beliefs and practices. He found that their flat pipe was carved of one piece of wood, about 18½ inches long, with a round, low, and flaring bowl, while "the proximal end of the pipe is carved in the shape of a duck head." (Father Cooper also provided a pen-and-ink drawing of the Gros Ventres flat pipe (J. Cooper 1957, pp. 69–70, and fig. 1).

In Figure 178, illustrator Robert Lewis has combined faithful copies of the published drawings of the Northern Arapaho and Gros Ventres flat pipes with a drawing from a photograph of the

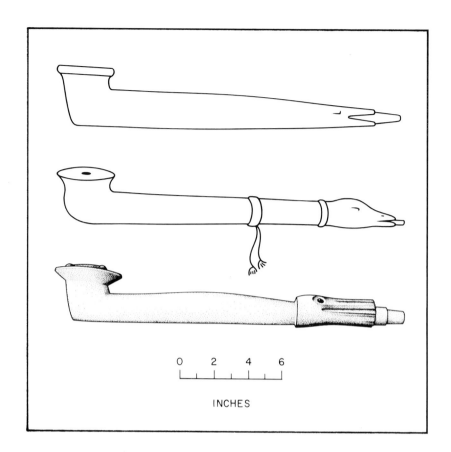

FIGURE 178. Three sacred flat pipes from the Northern Plains:
a. The Flat Pipe, Tribal Medicine of the Arapaho (after outline drawing in Carter 1938, fig. 10);
b. The Flat Pipe, Tribal Medicine of the Gros Ventres (after drawing in J. Cooper 1957, Fig. 1);
c. The Goose Society Pipe of the Mandan (after photo of specimen in the State Historical Society of North Dakota.)

Drawn by George R. Lewis, Smithsonian Institution.

Goose Society pipe of the Mandan Indians in the State Historical Society of North Dakota. Even allowing for the fact that the drawing of the two tribal medicines are approximations, based on informants' memories of the actual pipes, the similarities among these three are quite striking. Their overall shapes are much alike, and the bird heads, though differing in detail, occupy the same relative positions on all three pipes, facing their smokers.

I suggest that while the Gros Ventres and Arapaho spoke of the birds on their tribal medicine pipes as ducks, and the Mandans knew their pipe to be a goose, all three were related forms of a ceremonial pipe used by horticultural tribes in ceremonies to honor the migrating birds who helped to insure the growth of their crops. Perhaps the Arapaho and Gros Ventres pipes hark back to the time when they—possibly as a single tribe—lived farther east and nearer the Mandans and Hidatsas, where they too may have cultivated corn and other vegetables.

Which of these four tribes, then, is most likely to have originated the bird effigy ceremonial pipe? We cannot be sure, of course, but evidence suggests that this form of pipe was most firmly established in Mandan culture. We know that during the 1830s the Mandans treasured two other flat pipes of this general form—but without the bird effigy. One of them was carried by Lone Man in the Okipa and used by him in fending off the Foolish One or devil at a dramatic high point in that ceremony. Edward Curtis pictured

186

the contents of the Lone Man bundle, including that flat pipe (Curtis 1908, vol. 5, p. 22).

In 1834 Karl Bodmer pictured another sacred pipe, which then belonged to one of the Mandan religious leaders, Dipäuch, and which was said to symbolize The Lord of Life. Even though it was made of two pieces, a red clay pipe and a wooden stem, its overall design is much like that of the other pipes we have considered here. This pipe is illustrated in color in Goetzmann 1984 (pl. 342).

The Sacred Wheel—A Major Medicine of the Southern Arapaho. During his field studies among the Arapaho Indians at the turn of the century, George Dorsey learned that the Sacred Wheel, in the possession of the Southern Arapaho Indians in Oklahoma, was the second most sacred medicine of the tribe, ranking next only to the Flat Pipe kept by the Northern Arapaho in Wyoming. He described the Sacred Wheel as "about eighteen inches in diameter . . . of wood, one end tapers like the tail of a serpent, the other being rudely fashioned to represent a serpent's head . . . at four opposite sides of the Wheel are incised designs, two in the form of crosses, the other two representing the conventionalized Thunderbird. . . . The inside of the Wheel is painted red, outer periphery stained black."

Dorsey was told that the hoop represented the sun; the serpent, a harmless water snake, the water surrounding the earth; and the four markings the Four Old Men or the gods of the four world quarters. "The Wheel as a whole, then, may be said to be symbolic of the creation of the world, for it represents the sun, earth, sky, the water, and the wind." (G. A. Dorsey 1903, pp. 12–14.)

Figure 179 reproduces Dorsey's photograph of the Sacred Wheel as he saw it supported in a vertical position by a crotched stick behind the buffalo skull on the altar of the Southern Arapaho sun dance in 1902. He was told that this wheel was a replacement for an older one that was cracked in a windstorm in 1890. The new one was recarved by a young man.

Perhaps the smaller snake effigy wheel that served a Southern Cheyenne warrior as his war medicine, which I have pictured in figure 117, was inspired by that warrior's knowledge of the potency attributed to the Sacred Wheel of the neighboring and closely allied Southern Arapaho Indians.

The *Taime*—Tribal Medicine of the Kiowa. During his intensive field studies of the Kiowa Indians in western Oklahoma in the 1890s, James Mooney learned a great deal about the *Taime*, the tribal medicine of those people. It was in the keeping of the Kiowa band, which was in charge of the tribal medicine lodge constructed for the annual sun dance. During that ceremony its keeper carefully

FIGURE 179. The Sacred Wheel of the Southern Arapaho, a wooden hoop carved in form of a snake, as it appeared in the tribal sun dance of 1902. After a photograph in George A. Dorsey 1903, plate I.
Field Museum of Natural History.

removed the *Taime* from its wrappings for display upon the altar within the medicine lodge, and he returned it to its bundle at the close of the sun dance.

Mooney did not see the *Taime*—it had not been displayed since the last Kiowa sun dance in 1887. But the Smithsonian ethnologist described it on the basis of verbal accounts from his informants:

> This is a small image, less than 2 feet in length, representing a human figure dressed in a robe of white feathers, with a hairdress consisting of a single upright feather and pendants of ermine skin, with numerous strands of blue beads around its neck, and painted upon the face, breast and back, with designs symbolic of the sun and moon. The image itself is of dark green stone, in form rudely resembling a human head and bust, probably shaped by art like the stone fetishes of the Pueblo tribes. It is preserved in a rawhide box in charge of the hereditary keeper, and is never under any circumstances exposed to view except at the annual sun dance when it is fastened to a short stick planted within the medicine lodge, near the western side. (Mooney 1898, p. 240.)

The *Taime* had a unique history. According to tribal tradition it was given to an Arapaho man who had participated earnestly in the Crow sun dance and so impressed the Crow leader of the ceremony that he gave this medicine to him. Apparently it was the Crow sun dance doll in that ceremony. The Arapaho became very successful in capturing enemy horses, and on a later visit to the Crow Indians, jealous members of that tribe stole this effigy from him. But the Arapaho made a duplicate. Later he married a Kiowa woman, came to live with the Kiowa, and they adopted his effigy as their tribal medicine.

Mooney estimated that the *Taime* came to the Kiowa about 1770. It was substituted for an equivalent image of buckskin used in their tribal sun dance. During the summer of 1833, Osage enemies captured the Kiowa *Taime*, and it was not recovered until the summer of 1835.

Two smaller effigies accompanied the *Taime* on the sun dance altar. In 1868 they were taken "as a palladium of victory, upon a war expedition, when they were met by a party of Ute, who defeated them, killed the bearer of the medicine, and carried off the images, which have never since been recovered. The larger of the images is still with the tribe." (Mooney 1898, p. 242.)

In 1911 Capt. Hugh L. Scott, a close student of the Kiowa during the years he was stationed at Fort Sill and was in charge of Troop E of the 7th Cavalry, composed of selected Indians from the tribes of the Southern Plains, published a detailed account of the Kiowa sun dance, which was illustrated by Silverhorn, a religious traditionalist from a prominent Kiowa family, who was also a mem-

188

FIGURE 180. Drawing from memory by Silverhorn, Kiowa artist, showing the *Taime*, tribal medicine of the Kiowa, as it appeared with other sacred objects in the medicine lodge of the sun dance. *As illustrated in Scott 1911, plate XX.*

ber of Scott's cavalry troop. Silverhorn was an unschooled artist of considerable talent. One of his drawings—reproduced here as figure 180—shows the Kiowa *Taime* as he remembered it, and as it appeared on the altar in the sun dance supported atop a pole secured in the ground. Among the other items in the grouping in front of the *Taime* is a smaller image of an Indian, which Scott termed "Komandy's innovation." (Scott 1911, pl. XX.)

The Kiowa *Taime* is still in the tribe, in the keeping of Nina Kodaseet, granddaughter of A-mai-ah, who was the keeper of this sacred image from 1894 to 1939 (Boyd 1981, pp. 32–33).

We should note that of the examples of carvings that came to be recognized as tribal medicines by the Northern Arapaho and Gros Ventres, the Southern Arapaho and Kiowa, two were bird effigies that were similar to the Mandan Goose Society pipe; one was a human effigy that may have been a Kiowa sun dance doll; and the fourth was a snake in the form of a hoop. None of these appear to have been admired so much for their beauty as they were venerated as symbols of supernatural power, potent enough to ensure the preservation of the tribe. That fact alone made them the most treasured carvings in their respective tribes.

Religious, Magical, and Ceremonial Effigies

CHAPTER 4

Miscellaneous Effigies

In my studies of the life and customs of Plains Indians, I have found that they carved representations of human or animal forms on a number of objects that served functions other than those we have considered in the preceding chapters dealing with pipes and smoking equipment and with religious, magical, and ceremonial purposes. Let us consider these other uses of sculptured effigies.

Children's Toys

At an early age Indian children began to play with toys made for them by their elders. My elderly Blackfeet informants told me of simple wooden dolls made for little girls to play with back in buffalo days.

> A little girl of six or seven years who accompanied her grandmother into the brush to collect firewood might beg the old woman to make her a birch doll. The grandmother would cut a section of a birch limb about one foot long and four inches in diameter with her axe. She used her butcher knife to cut a groove around the piece about four inches from one end. This formed the doll's shoulder line. Above this line she whittled a crude, knob-like head and bored little holes in one side of the knob to suggest eyes, nose, and mouth. The simple doll had no ears, hair, or legs. The body retained the unaltered form of the birch cylinder below the shoulder line. Little girls clothed these dolls by simply wrapping a piece of buckskin or trade cloth around the cylinder. (Ewers 1958a, p. 146.)

I later learned that small children of other tribes also played with dolls made in this way—but none of these dolls were to be seen in museum collections. Akin to them in simplicity of conception and execution, however, are two reputedly old-style dolls small

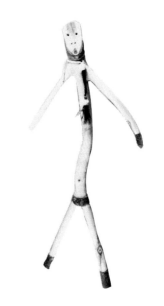

FIGURE 181. Wooden doll for small child; Blackfeet, carved by George Bull Child, 1950s; chokecherry wood; 18½" high.
Museum of the Plains Indian, cat. no. 1770.

FIGURE 182. Doll with carved stone head; Cheyenne, 1880–1900; slate, buckskin, trade beads; 16" high.
Museum of the American Indian, Heye Foundation, cat. no. 23/850.

191

FIGURE 183. Pair of clothed wooden dolls; Cree, Rocky Boy's Reservation, 1930–1950; wood, buckskin, cloth; male 11½″ high.

Museum of the American Indian, Heye Foundation, cat. nos. 22/4749, 22/4751.

children played with that were made for the collection of the Museum of the Plains Indian by the versatile craftsman George Bull Child, a middle-aged Piegan, during the early 1950s. One of these appears in figure 181. It is fashioned of a single branch of choke-cherry with some of the bark left on, providing a scarecrowlike contorted human figure with arms and legs, and eyes, eyebrows, and nostrils incised on a flat surface representing the head.

One may find fully clothed Plains Indian dolls dating as far back as the 1850s in museum collections. Undoubtedly, many of these were made by Indian women for sale to non-Indian collectors, and the number of dolls increased as that market developed. Even so, dolls with carved wooden heads or heads and bodies are not common. A Cheyenne doll of the period 1880–1890 is unique in having a large head carved of greenish stone nearly four inches in height. Not only are a woman's facial features indicated, but actual hair is glued in place on the stone head to add more realism to this miniature Cheyenne woman clad in her best beaded buckskin dress (figure 182).

192

A center for the production of fully dressed, carved wooden dolls during the middle years of the present century existed on the Rocky Boy's Reservation in northern Montana, home of the Chippewa-Cree Indians. Figure 183 shows a pair of these dolls, which illustrate the makers' skill in rendering lifelike facial features. The wooden bodies are covered with accurately scaled cloth garments such as were worn by conservative members of the tribe. In 1951 I purchased a carved wooden doll, made by Mrs. Joe Gopher on the Rocky Boy's Reservation, which was for sale in the Northern Plains Cooperative Crafts Shop at the Museum of the Plains Indian at Browning, Montana. Its carved head resembled that of the male doll in figure 183.

One of the most active creators of carved wooden head and hand dolls in recent years has been Nick-Fast-Horse, an Oglala Sioux from Pine Ridge Reservation. In 1974 I bought at a shop in Rapid City his version of a dancer in full costume, pictured in figure 184. The arms and legs are made of heavy wire so that they can be bent to place this dancer in different poses.

Traditionally, adults fashioned a variety of wooden animal toys for children, although relatively few of these can be found in museum collections. One of the oldest must be a long-necked bear (?) head carved of hard wood in which the ears are delineated in relief, along with large, bored eye sockets, incised nostrils and mouth. This toy (figure 125) was collected by the army physicians Charles C. Gray and Washington Matthews, and was accessioned by the Smithsonian Institution in 1869.

During his field work among the Kiowa Indians of Oklahoma in the 1890s, James Mooney collected a small (3½ inches long) buffalo head carved of wood with inlaid seed bead eyes. The horns were separately carved of little pieces of wood and inserted into holes drilled at each side of the head. The animals' nostrils and mouth are incised and a conventionalized beard is suggested (figure 186).

Ingeniously fashioned toy horses were made by tribes of the Northern Plains—each from a single section of a willow branch. By simply splitting one end of this piece and bending one half upward, the neck and ears were formed. The other half of this split section was bent down to make the forelegs, while the other end was split, half of it bent upward to make the animal's tail, the other half bent downward to form its rear legs. A small whittled piece of the same wood was inserted into the front of the upper portion of the neck section to make the horse's head. In 1942 Mrs. Mae Williamson, president of the Blackfeet Indian Arts and Crafts Cooperative, made two of these horses as a Christmas present to my little daughter, Jane. The largest of these is pictured in Ewers 1955 (pl. 12a). My elderly Blackfeet informants had told me they used to play with toy horses made in this way when they were children.

FIGURE 184. Doll in dance regalia; Oglala Sioux, by Nick-Fast-Horse, 1974; wood, wire, buckskin, cloth, beads, and feathers; 10″ high.
Margaret E. Ewers Collection.

FIGURE 185. Toy bear head of wood; Arikara, collected in 1869; 4½″ high.
Smithsonian Institution, cat. no. 8,426.

FIGURE 186. Toy buffalo head; Kiowa, collected by James Mooney before 1897; painted wood; 3½″ long, 2½″ high.
Smithsonian Institution, cat. no. 176,688.

FIGURE 187. Toy horses of bent willow; Plains Cree, made in 1894; largest 5½″ long.
Montana Historical Society, Helena, acc. no. X82.41.01 b and c.

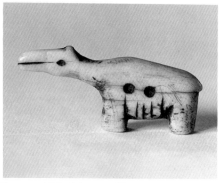

FIGURE 188. Moose effigy gaming piece; Plains Cree, File Hills Reserve, Saskatchewan, twentieth century; Bone; 1⅝″ long.
Museum of the American Indian, Heye Foundation, cat. no. 11/8034.

I was pleased to find two smaller and daintier horses made in this manner in the collections of the Montana Historical Society in Helena. They were made by a Plains Cree Indian for Mrs. C. A. Palmer when she was a child in 1894. See figure 187. During her field work among the Arapaho, Sister Inez Hilger learned that they also made toy horses from bent willow for their children (Hilger 1952, p. 107).

Blackfeet children also "rode" hobbyhorses made from the thick trunk of a tree with a double bend in it, supported by burying the basal end in the ground. Boys or girls sat on the seat afforded by the bend. Some of these hobbyhorses were given a more realistic appearance by the attachment of a carved head to the upper portion (Ewers 1955, pp. 226–27, fig. 32). In April 1971 W. C. Hubbard, son of a white trader to the Blackfeet, wrote me that he used to play with one of these hobby horses, equipped with a carved horse head, when he was a small boy. His father had found it in an abandoned Piegan camp near his trading post in 1869. That hobbyhorse was destroyed in a fire that consumed the shed in which this Indian-made toy was stored. I have seen no Plains Indian hobbyhorse with a carved horse head of this kind in the collections of any museum.

In the Smithsonian collections is a "child's play horse" obtained from the followers of Sitting Bull after their return from exile in Canada to surrender to Major David H. Brotherton at Fort Berthold in the summer of 1881 (cat. no. L64). There is no reason to doubt that this piece was "ridden" as a child's plaything *at that time*, but it likely was originally intended as a victory dance horse effigy, such as those described on pages 139–43. It is a long-handled horse head with leather reins added.

Gaming Pieces

Some of the dice used by Plains Indian adults in playing traditional games of chance were carved in the form of very small birds or animals. A good example is shown in figure 188, which is a carved bone die from the File Hills Reserve in Saskatchewan collected by Donald Cadzow for the Museum of the American Indian, Heye Foundation. Only 1⅝ inches long and bearing on its surface two paint-filled circles and several incised parallel lines—markings that were meaningful according to the rules of a game—this tiny bone carving is a clever caricature of one of the largest and most imposing animals in the Canadian wild, the moose.

During his field work among the Arapaho Indians at the turn of this century, Alfred Kroeber collected small counters used in guessing games carved of wood or bone in the shapes of buffalo, turtles, and birds, which are preserved in the American Museum of Natural History (Kroeber 1907, figs. 131 and 137).

Hair Parters

In 1907 Charles M. Russell painted an Indian woman dressing the hair of her husband, and titled the work *Beauty Parlor*. The artist pictured her wielding a long, tubular, wooden implement known to older Plains Indians of his time and earlier as a "hair parter." See figure 189. Although these implements may have been in common use among the plains tribes in buffalo days, they are rare in museum collections, and most Indians and museum curators today know nothing about them. They were seldom mentioned in the literature on the Plains Indians, and it is likely there are a number of examples of them in museum collections that have been cataloged erroneously as something else—such as awls.

More than a half-century ago, Elsie Clews Parsons offered a Kiowa Indian's description of the way in which members of that tribe used to make their toilet. "Both men and women parted their hair with a little pointed stick and applied yellow pigment in the parting." (Parsons 1929, p. 123.) No further details regarding that "pointed stick" were given. However, James Mooney in 1891 collected among the Kiowa a wooden "pin used to make the part in the hair" of cedar exactly eight inches long, which bears the carved representation of a peyote button at the far end. On the back of the button a many-pointed, starlike design is incised, and further down that back surface are five chevrons with red paint rubbed into them. Not only is this hair parter a rare object in Plains Indian collections, the appearance of a botanical subject in Plains Indian wood carving is also. Doubtless the owner of this specimen was a member of the peyote cult, which had been introduced among the Kiowa Indians earlier in the nineteenth century. See figure 190.

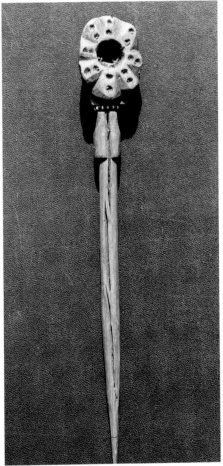

FIGURE 190. Peyote button effigy hair parter; Kiowa, collected by James Mooney, 1891; cedar wood, painted; 8″ long.
Smithsonian Institution, cat. no. 152,937.

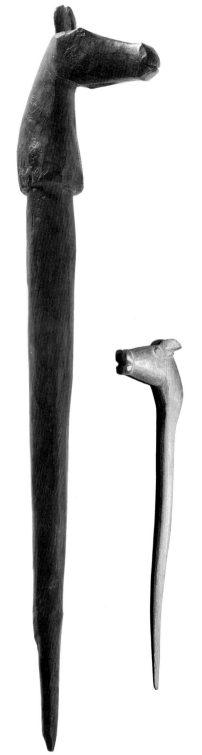

FIGURE 191 (left). Horse head effigy, probable hair parter; Sioux? accessioned 1931; red-painted wood; 15″ long. *Smithsonian Institution, cat. no. 361,042.*

FIGURE 192 (right). Bighorn effigy hair parter or awl? Crow, collected before 1905; horn, painted red; 6½″ long. *Carnegie Museum of Natural History, Pittsburgh, cat. no. 2418/135.*

A reference to a secondary use of hair parters among the Sioux of Standing Rock Reservation appears in Ella Deloria's account of the sun dance of those Indians. Hair parters were used as scratching sticks by sun dancers who were forbidden to touch their bodies with their hands (Deloria 1929, pp. 408–11).

Figure 191 shows a wooden implement in the Smithsonian collections some 15 inches long, pointed at one end, and bearing a well-executed carving of a horse head at the other. The eyes are not defined, and the piece is completely covered with red paint. When Beatrice Medicine kindly showed photographs of this piece to elderly Indians on Standing Rock Reservation for me in 1973, they identified it as a Sioux hair parter, most likely used by a man in combing his wife's hair, because it was customary for women to have the middle part of their hair painted red.

There may be another carved hair parter in the Crow collection made for Fred Harvey and acquired by the Carnegie Museum of Natural History in Pittsburgh in 1905. This piece was described in accession records as a "charm worn about the neck, consisting of an interesting representation of an animal carved from mountain goat horn, encased in beaded buckskin." Because this piece, pictured in figure 192, was kept in a beaded case that resembled some Plains Indian awl cases, some students have thought of it as an awl. But the facts that the working end of this implement is rather blunt, and that its entire surface is covered with red paint, suggest to me that it was a Crow hair parter.

Mirror Frames

Some of the first objects of European manufacture white traders provided for the Plains Indians were small glass mirrors, which the traders commonly referred to as looking glasses. Among the items Henry Kelsey, the first white man known to have visited the tribes on the Northern Plains, in 1691, took with him to give or trade were "2 Leath looking glasses." (Ray 1974, p. 67.) During the eighteenth century, looking glasses also reached the Plains Indians from French and Spanish sources. They were especially coveted by young men—dandies who came to spend much time before their mirrors painting their faces and making up for dances and ceremonies.

The acquisition of mirrors stimulated Plains Indian creation of a variety of wooden frames into which the mirrors were inserted. Some of them were made with long handles; some with short handles; some with grip handles, and some with no handles at all. Many were decorated with carved representations of animals.

Figure 3 of this book—a drawing of an Indian of French Louisiana, adapted from a French map that dates back as far as 1750—appears to show a young warrior holding in his right hand a long-handled mirror in which the handle is carved in the form of a snake.

An early reference to carved wooden mirror frames in use among the tribes of the Southern Plains appears in Edwin James's account of the explorations under Major Stephen Long in 1820. Even though Long's party had to travel light, they took along small presents to give to Indians they might meet who were helpful to them. Those presents included a number of looking glasses. On July 21, 1820, on the upper Arkansas River, they met a young Kiowa-Apache (Kaskia) man named The Calf, who was eloping with a young woman of his tribe, and who provided helpful geographical information to Long's party. They gave him one of their looking glasses, which The Calf "immediately stripped of the frame and covering, and inserted with some ingenuity into a large billet of wood, on which he began to carve the figure of an alligator." (James 1823, vol. 2, p. 61.) A few days later, when the explorers met a band of Kaskia Indians, they noticed that the "rude frames of the looking-glasses carried by several men were carved to the approximate form of an alligator." (Idem, p. 112.) Whether these effigies were intended as alligators, which were not found on the Southern Plains, or lizards, which were, we cannot be sure. The explorer's observations certainly indicate that the Kaskia Indians were decorating their mirror frames with carved effigies as early as 1820. One of them, The Calf, appears to have been the first Plains Indian carver of wooden effigies to be named in the literature. He was not a Sioux from the Northern Plains, but a Kiowa-Apache from the present-day Oklahoma area.

Figure 193 pictures a Sioux mirror frame, apparently cut from a pine board, obtained for the Smithsonian collections by Paul Beckwith, the Indian agent at Devil's Lake in the Dakota Territory in 1876. It is without any handle, but is sawed and whittled into a flat-sided and rather angular representation of an open-mouthed bear.

A U.S. Signal Corps photograph, dating from the 1880s, pictures a young Cheyenne grass dancer holding a long-handled mirror frame carved in the form of the silhouette of a turtle with its neck

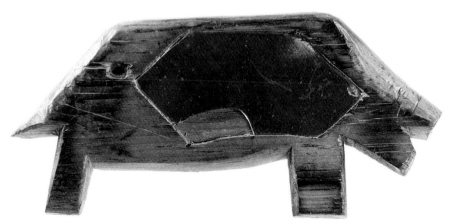

FIGURE 193. Bear effigy mirror frame; Sioux, Devil's Lake Agency, 1876; pine board with inlaid glass; 7¼" long. *Smithsonian Institution, cat. no. 23,746.*

Miscellaneous Effigies

FIGURE 194. Turtle effigy mirror frame carried by a Cheyenne Indian grass dancer. Signal Corps photograph, probably 1880s.

The National Archives, neg. 111-SC-83716.

extended. See figure 194. Another variant of the turtle effigy mirror frame, collected by Alfred Kroeber from the Assiniboin of Fort Belknap Reservation in 1900, has a grip handle. It appears to have been first drawn on the surface of a 14¾-inch length of 1-by-10 board, sawed to shape, and finished with a knife and sandpaper. The mirror side is painted with a blue background; the reverse in yellow. See figure 195.

I have seen grass dancers carrying mirror frames with effigies carved on them in a few Plains Indian paintings on hide or cloth in museum collections. In the Montana Historical Society is a lively dance scene attributed to a young Crow Indian named Aho'ha Tar'ish and dated 1886, which was first drawn with a pencil, and then colors were added with a stick; one of the dancers holds a mirror in a frame carved in the generalized form of a human being.

198

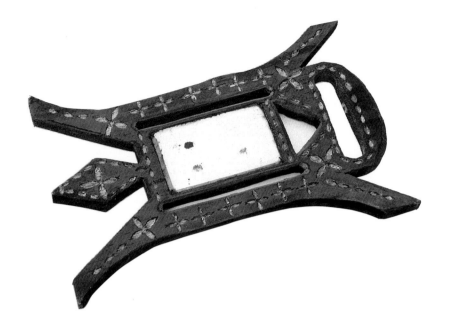

The most common form of effigy mirror frame in museum collections bears the "ardent stallion" motif—the head and arched neck of a horse—which we have seen executed by Plains Indians on catlinite pipes and on the small wooden stops of flutes. Figure 196 shows one of these mirror frames collected among the Kansa Indians in Oklahoma during the 1920s. In this case the horse effigy serves as the short handle of a circular frame for an inset circular mirror. James Howard mentioned the horse effigy mirror frame as a "common type of dance mirror" among the Ponca, and he saw one carried by a participant in the annual Omaha pow-wow in 1949 (Howard 1965b, p. 51; 1950, p. 1). Norman Feder has illustrated horse effigy mirrors from the Iowa (1971, fig. 50) and Omaha (1972, fig. 76), both of which have heart-shaped cutouts. A mirror frame in the Oklahoma Historical Society bears a carved head of a long-eared animal (rabbit or mule?), and is termed an "Osage flirtation mirror." That designation and the heart shapes on other mirrors reflect the common use of these effigy mirrors as objects carried by amorous young men in dances.

The major concentration of horse-effigy mirror frames among the tribes from the east-central plains relocated in Oklahoma—the Omaha, Ponca, Iowa, Kansa, Oto, and Osage—suggests that the arched-neck mirror frame originated among this group of tribes before, or more likely after, their removal to Oklahoma. Even so, there is evidence that the ardent stallion form of mirror frame had a much wider distribution. I have seen a very elaborate variation of it, complete with heart and arrow motifs, in the Charles M. Russell Studio Collection in Great Falls, Montana. It is attributed to the Cree Indians of the Northern Plains.

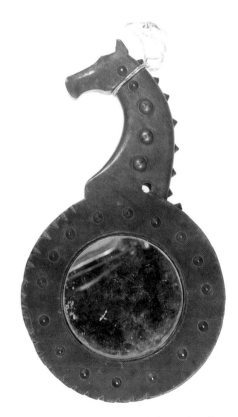

FIGURE 197. Snake and dog head effigy cane carried by Gotebo, a prominent Kiowa Indian, ca. 1900; wood barrel, possibly catlinite head.

National Anthropological Archives, Smithsonian Institution, neg. 56,406.

FIGURE 198. Dog head at top of cane; Santee Sioux, from Good Thunder, ca. 1875; catlinite; head 3¼″ high.

Minnesota Historical Society, cat. no. 7401.2.

Effigy Canes

The carving of wooden canes bearing representations of snakes and/or heads of animals appears to have been a late-nineteenth-century development among the Plains Indians, stimulated by encouragement from non-Indian collectors, even though some of these canes remained in Indian hands and were carried by some of them. An undated portrait of Gotebo, a prominent member of the Kogui Band of the Kiowa, is reproduced in figure 197. It shows him holding a wooden cane with a snake twined around the greater part of its length and a conventionalized dog's head at the top. The head may have been separately carved and fitted to the barrel of the cane. Whether it is of wood or stone is uncertain. When this photograph was taken, about the turn of the century, Gotebo may have looked upon this cane as a status symbol.

200

Perhaps the oldest Indian-carved cane I have seen is one in the collections of the Minnesota Historical Society that is well documented as having been obtained from Good Thunder at Pipestone some sixty years before its donor presented it to the society in 1935, which would date it to about the year 1875. Good Thunder was a prominent member of the colony of Santee Indian homesteaders at Flandreau, and was Bishop Whipple's first Sioux convert to Christianity. Like Gotebo's cane, this one has a snake twined around the wooden barrel, with a separate dog's head. This head is definitely of catlinite. It is well—but simply—carved, with oval incised eyes and mouth, circular incised nostrils, and large ears in low relief. Probably this cane was carved by Good Thunder himself. See figure 198.

The long barrel of the cane must have made it a fitting subject for decoration with twined snakes by Indian carvers, just as it was for white and Negro carvers. In fact, it may be impossible to distinguish the race of the carver of a snake effigy cane from its appearance alone. Michael Kan observed that a nineteenth-century snake effigy cane carved by an Afro-American "is similar to ones made by Sioux Indians." (Hemphill 1976, p. 63.)

Sioux canes certainly predominate among the Indian-made canes of known provenience in museum collections. But men of other tribes carved them also. Figure 199 shows two canes in the Smithsonian collections. The twined snake diamond willow one on the left was acquired in 1901 from the Northern Cheyenne Indians. The unique one on the right, with a handle in the form of a carved shoe, is undocumented, but the porcupine-quilled decoration of the barrel suggests that it is of Sioux make.

Effigy Drum Supports

The traditional large ceremonial drum Plains Indians used to beat time and to accompany singers in social dances was supported above the ground in a horizontal position by four matching wooden stakes, each with its lower portion firmly planted in the earth. I have seen four sets of drum supports in museum collections on which the upper portions of the long stakes were carved to represent life forms.

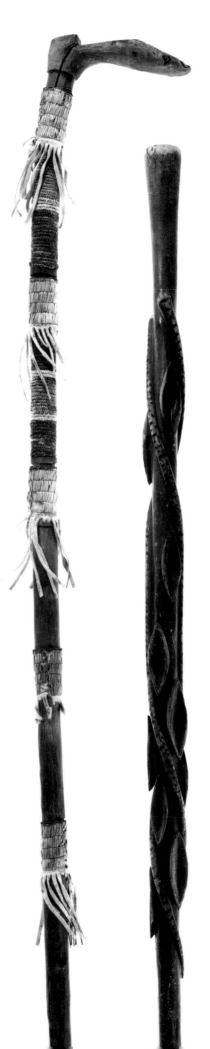

FIGURE 199. Two effigy canes from Plains Indians: Left: cane head carved in form of shoe; probably Sioux; 42¾″ long. Right: diamond willow cane with intertwined snakes; Northern Cheyene, accessioned 1911; 37″ long.
Smithsonian Institution, cat. nos. T-1598 and 270,081.

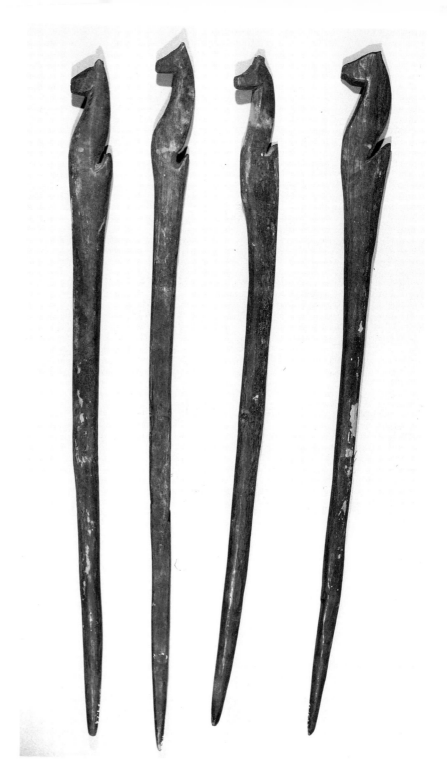

FIGURE 200. Set of horse effigy drum supports; Kansa; collected in 1900; oak wood; 30⁵⁄₁₆″ to 31¹¹⁄₁₆″ long.
Kansas State Historical Society, cat. no. 62.159.

Two of these sets had horse head carvings on them. Figure 200 pictures one of these, which was presented to Jessie Mehejah, a Kansa Indian, at a dance in 1900, and was later given to the Kansas State Historical Society by his children. The other set was collected by George Dorsey among the Omaha Indians in Oklahoma during the spring of 1902. It is catalog no. 71,706 in the Field Museum of Natural History, Chicago. Three of the four matching pieces of this set are illustrated in Feder 1971 (fig. 52).

In 1900 James Mooney purchased a set of four drum supports from the Southern Arapaho Indians on which small, carved and

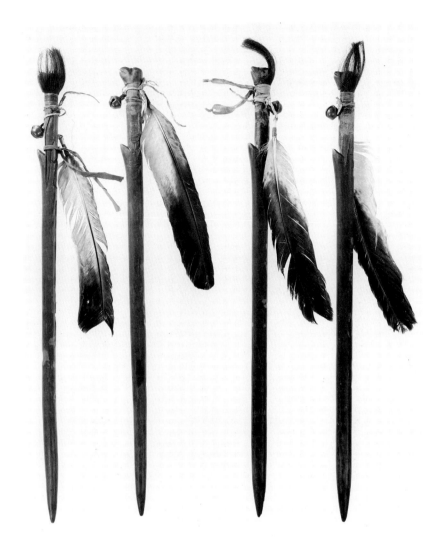

FIGURE 201. Set of bird head effigy drum supports; Southern Arapaho, collected in 1900; painted wood, horsehair, metal bell, and feather pendant; each about 25¼″ long.
Smithsonian Institution, cat. no. 204,543.

painted bird heads decorate the stake tops. Each bird head is only ½ inch high and 1⅜ inches long. Each must have originally had an erect horsehair fringe at sides and back that concealed much of the bird's head from view. The supports were further embellished with metal bells and pendant eagle feathers. See figure 201.

The ceremonial drum used for the warrior's dance of the Kiowa Indians in former times was remembered by older men of the tribe as "supported by four sticks, and at the end of each stick is the carved head of a warrior wearing one eagle feather." (Boyd 1981, p. 67.) A set of drum supports answering this description was displayed in the *Native American Heritage* exhibition at the Art Institute of Chicago in 1977. The exhibition catalog terms these carvings "Chippewa?" and suggests a dating for them of "ca. 1885." However, since all other sets of effigy-carved drum supports are from Plains Indian tribes in Oklahoma, and since the Kiowa elders recall the use of human head drum supports by their people, it appears probable that this set of human head supports in the Saint Joseph Museum, Saint Joseph, Missouri, was of Kiowa origin.

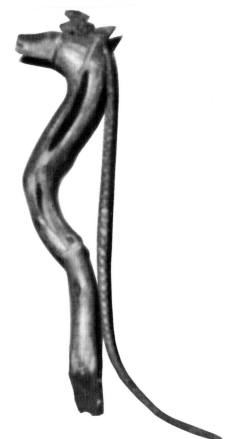

Effigy Horse Gear

Some Plains Indians took pains to decorate items of horse equipment made of wood or antler with effigy carvings, although relatively few are preserved in museum collections. The earliest example appears to be a quirt collected by Prince Maximilian while on the Upper Missouri in 1833–34 and preserved as catalog no. 35,977 in the Linden Museum in Stuttgart. It is pictured in Bodmer's drawing of it in Goetzman 1984 (fig. 348) and photographically in Schulze-Thulin 1976 (fig. 48). Some two feet in length, its long wooden handle is carved with two intertwined, painted snakes, and its sharp-curved antler head is provided with a long, sharp beak that served as a prod. Bodmer's drawing gives this effigy riding crop an Assiniboin provenience. A twined-snake, more traditionally formed quirt handle from the Sisseton Sioux is in the Museum of the American Indian (cat. no. 3/3724).

Figure 202 pictures a rather rudely but interestingly carved horse head quirt made from a twisted willow branch and said to have been used by the Blackfeet medicine woman in the procession to the sun dance site.

Equally ingenious is the carved and painted wooden handle of a rawhide-lashed quirt carved and painted in the form of a caricature of a Negro soldier, known to the Plains Indians as a "buffalo soldier." Black soldiers served in the army during the Plains Indian Wars of the 1860s and 70s, and later were stationed at posts in the Indian country. No history of this piece in the Victor J. Evans Collection at the Smithsonian Institution is available. As we see in figure 203, the Indian carver has caricatured this black soldier by exaggerating the size of his lips and the flatness of his nose. He has relied on his sense of humor in mocking his black enemy as much as did Western Sioux carvers in portraying enemy effigies on their victory dance sticks. I judge that this unique effigy quirt was the creation of a Sioux carver before 1900.

Figure 204 pictures a unique Indian-made saddle with a wooden pommel carved in the form of the neck and head of a horse. Although the head is well formed, the artist did not try to show the animal's ears, probably because the entire saddle tree was covered with tightly fitted rawhide, applied wet so that it shrank and fitted

FIGURE 202. Horse head effigy quirt; Blackfeet; used by medicine woman during camp movements preceding tribal Sun Dance; Carberry Collection, before 1941.
Museum of the Plains Indian, cat. no. 305.

FIGURE 203. Black soldier effigy quirt handle; Sioux? late-nineteenth century; painted wood, rawhide lashes, and wrist hanger; handle 15″ long.
Smithsonian Institution, cat. no. 360,317.

204

the form of the wooden horse head snugly as the rawhide dried. Elaborately ornamented with brass tacks, this saddle was presented by the Santee Sioux chief Cut Nose to Bishop Henry Whipple, a long-time friend of the Santee Sioux, in 1888. The unusually large size and fragile decoration of this saddle suggests that it was intended as a symbolic gift and keepsake rather than as a practical piece of riding gear. This saddle was donated to the Smithsonian Institution in 1972; its elaborate decoration is described in detail in Ahlborn 1980 (pp. 128, 130–31).

I have seen no other Plains Indian saddles with carved horse-head pommels. However, I recall seeing two Menominee saddles with carved horse-head pommels covered with rawhide. One was on exhibition in the Wisconsin State Historical Society in Madison. The other, collected among the Menominee in Wisconsin in 1903, is in the collections of the American Museum of Natural History (cat. no. 50/4848). It was illustrated in the exhibition catalog *American Indian Art: Form and Tradition* at the Minneapolis Institute of the Arts in 1972 (fig. 170).

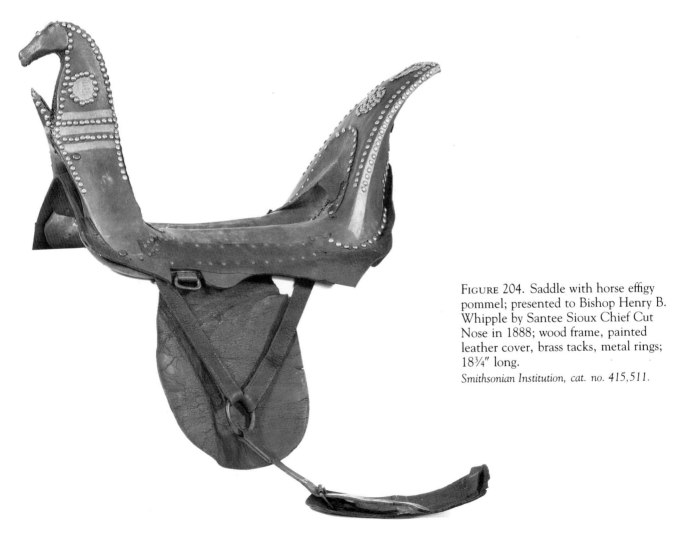

FIGURE 204. Saddle with horse effigy pommel; presented to Bishop Henry B. Whipple by Santee Sioux Chief Cut Nose in 1888; wood frame, painted leather cover, brass tacks, metal rings; 18¾″ long.
Smithsonian Institution, cat. no. 415,511.

Trends in Plains Indian Sculpture

L et us now review briefly the history of Plains Indian sculpture as we have come to know it in this study. For convenience I have divided this history into four periods of unequal length. We should be mindful, however, that some sculptors' careers began in one period and continued into the next. In fact, I have known some of them who were active over a period of forty or more years, and whose styles and subject matter remained quite constant throughout much of that period. Little can be gained by trying to date the works of such artists too precisely.

Period 1. Before 1830: Creating for Indian Use

Although archeological evidence (set forth in the first chapter of this book) reveals that catlinite effigy pipes have been found in late prehistoric sites in the Missouri Valley, they are too few in number to suggest that they are typical creations of the Indians who inhabited those sites. They may have been the work of other Indians who lived nearer the famous red pipestone quarry. During the historic period, catlinite effigy pipes appeared among the Missouri Indians in the state of that name and the Pawnee in western Nebraska—but their numbers were not significant. Evidence does indicate the presence of stone effigy pipes among Plains Indians before the 1820s, but they were rare.

It appears most probable that during this early period, sculptured effigies were made primarily to serve religious purposes among both the horticultural and the nomadic tribes of the Great Plains. Examples are the stone buffalo from Wyoming that must have been used in buffalo-calling rituals by nomadic Indians (figure 13 and colorplate 1), and the carved bone bird heads with handles from the Mandan Indians, which I have suggested served a symbolic

Mountain goat, by John Clarke, Blackfeet, 1925; painted wood; 27″ high. [Figure 209]
Museum of the Plains Indian, cat. no. 1599.
Photograph U.S. Department of the Interior, Indian Arts and Crafts Board.

function in the goose ceremonies of the women in honor of the migrating birds, whose presence during the growing season helped to insure the growth of crops.

Despite the fact that wooden effigies have not been found in archeological sites on the Great Plains, I would contend that during this early period the great majority of effigy carvings created by the Indians of this region were of wood. L. S. B. Leakey, in considering the development of sculpture in the Old World, has argued that sculpture in wood and other soft materials preceded the creation of examples of carvings in ivory and other hard materials, so that "we may safely assume that the earliest known examples are not the earliest efforts at sculpture of Stone Age man." (Leakey 1954, p. 153.) On technical grounds one may assume that before the acquisition of metal tools from whites it would have been much easier for Plains Indians to create effigies of wood than of stone with their primitive tool kit of stone knives and scrapers—and perhaps beaver teeth.

What is more, we have positive evidence that during this prolonged period when Indians executed sculptured works for their own use or that of other Indians, wooden effigies served a variety of functions in their culture. We have seen that the earliest drawing of a Plains Indian, dating from the beginning of the eighteenth century shows a Sioux chief brandishing a snake effigy war club (figure 2), and that a drawing of another Plains Indian of the period 1741 pictures him holding a snake effigy mirror frame (figure 3). We have also seen a finely carved human effigy of wood said to have been in the possession of the Wabasha family since the eighteenth century and which probably served as a hunting medicine, known to the Sioux as a Tree-Dweller (colorplate 2). Other examples of wood sculpture from that period preserved in museum collections include a fish effigy flute (figure 154), collected on the Upper Mississippi in 1823, and a beaver effigy bowl from the Omaha (figure 164), believed to date back to the opening years of the nineteenth century. Furthermore, the writings of white traders and explorers who knew some of the tribes of this area before 1830 refer to their use of wooden animal effigies as hunting and doctoring medicines and of human figures of carved wood in their practice of witchcraft.

Even though the Indians acquired metal from whites from which they could fashion sharper and stronger tools for working catlinite and other stone, there is little evidence that the availability of better tools led to any rapid development of effigy carving in stone before the second quarter of the nineteenth century. During this first period—when Plains Indians were executing effigies solely for their own use—wood remained the sculptors' favorite material for carving human and animal forms.

Period 2: Sculptural Developments under Stimulus from a White Man's Market, 1830–1875.

A very creative period in Plains Indian effigy pipe sculpture followed the establishment of Fort Snelling on the Upper Mississippi, the start of steamboat service to that frontier military post in 1823, and the founding of Cantonment, later Fort Leavenworth, on the Missouri near the mouth of the Platte in 1827. Fort Snelling soon became a market for effigy pipes made by Eastern Sioux sculptors, and Fort Leavenworth a market for the works of Pawnee sculptors. Buyers included traders, Indian agents, military men, and artists and scientists who explored the still little-known upper reaches of those two great rivers.

Among the collectors of the 1830s were Duke Paul of Württemberg, among the Pawnee in 1830; George Catlin on both rivers in 1832–36; Dr. Nathan Sturges Jarvis, physician at Fort Snelling in 1833–36; and Joseph Nicollet, the French scientist who explored the Upper Mississippi in 1839. All of these men collected the pipes, and George Catlin recognized correctly that the finest and most ingenious effigy pipes of the 1830s were executed by the Pawnee Indians on the Platte and the Santee Sioux of the Upper Mississippi. His judgment that the Pawnee were the more innovative carvers at that time may be questioned, for there is evidence that there were also very creative carvers of miniature figures on pipes among the Sioux at that time. Both were very clever in using the bowls and shanks of short-prowed tobacco pipes of catlinite as areas for significant social commentary in ways that were not attempted by Plains Indian sculptors of earlier times.

Duke Paul in 1830 collected a very finely carved Pawnee pipe that illustrated the tribal legend of a boy who acquired bear power (figure 17). No less ingeniously conceived is a pipe Catlin collected from the Pawnee showing a seated Indian on the shank facing a large white man's head on the bowl and which he learned was intended to show that the Indian was not afraid to look the white man in the face (figure 74). Other versions of both of these themes are known, some of which may have been copied by sculptors of neighboring tribes. Catlin also stated that the same Pawnee sculptor who created the pipe in figure 74 also executed one showing two men seated opposite each other with a keg of liquor held between them in their outstretched hands as if they were struggling for possession of this precious item (Ewers 1979, pl. 8, fig. f).

A Santee Sioux master carver of the 1830s also commented effectively on the liquor trade in two effigy pipes, one showing a man with a small keg on his lap, the other a medal chief offering a drink to one of his followers (colorplate 10 and figures 83 and 84), both of which demonstrated this unnamed carver's mastery of the art of working catlinite. During the 1830s, the Sioux chief Running

Cloud was carving Janus-heads on pipe bowls. (One of his works may appear in figure 61.)

As this period progressed, white men continued to be a favorite subject of both Pawnee and Sioux carvers. A Pawnee sculptor executed a humorous open-mouthed white man (figure 76) and another Pawnee showed a white man's head overlooking a nude woman (figure 85). Eastern Sioux sculptors reached a new high in the realistic rendering of the human head near the end of this period by carving portraits of two white friends of the Indians, Dr. Jared Waldo Daniels and Rev. Moses Adams (figures 66, 67, and colorplate 8).

Surely this 1830–1876 period should be remembered especially for the number and variety of interesting person pipes created by Pawnee and Sioux sculptors. The carving of the human figure reached a high level of artistic quality during those years. Even so, some fine animal effigy pipes also were made then. Especially noteworthy are the ingenious horse head pipe from the 1830s in colorplate 6, and the remarkably detailed full figure of a buffalo in colorplate 5, collected near the end of this period. Both are of Sioux origin.

The buffalo effigy pipe in figure 28, with full figures of a cow and her calf standing on the prow and shank, appears to be the last datable example of Pawnee effigy pipe carving to be seen in museum collections. Collected in 1876, the form of the pipe (with tall straight-sided bowl) indicates that it must have been carved during the preceding quarter century. It would appear that those Pawnee sculptors who were so successful in executing novel themes in pipe carving during the 1830s did not pass along their talents to succeeding generations of their tribe. Pawnee effigy pipemaking developed remarkably, and also appears to have died out during this period.

White observers and collectors made significant contributions to our better understanding of the appearance and functions of wood carvings among Plains Indians during these years. Both Catlin and Prince Maximilian, as well as Karl Bodmer, revealed the practice of the Mandan Indians in making plain their concept of the evil spirit, who played an important role in their major annual religious drama of the Okipa (see figures 176 and 177).

Among the finest examples of Plains Indian wood carving to be found in museum collections today are a number from this period that I have selected as color illustrations in this book. They include a painted canine effigy pipestem from the Santee Sioux, collected by Dr. Jarvis in the middle 1830s (colorplate 11); a weasel effigy war club from the Oto collected in 1876 (colorplate 19); and a snipe-head whistle said to have been made by a Sioux about 1865 (colorplate 24). Three wood carvings captured by the U.S. Army

in engagements with hostile Indians during the 1860s are of out-standing quality. One is a turtle effigy doctor's spoon captured from the western Sioux in 1863 (colorplate 22); another is a handsomely carved bird head bowl also from the western Sioux, in 1864; and the third is a striking human effigy pipe stem from Tall Bull's Chey-enne village, captured in 1867 (colorplate 13).

Period 3. Survivals and Innovations among Reservation Indians, 1877–1933.

The last quarter of the nineteenth century witnessed the final extermination of the buffalo on the Great Plains, the end of hostili-ties with the U.S. Army and of intertribal warfare, and the confine-ment of Plains Indians on reservations, dependant on government rations for their subsistence. Even so this was not a negative period in the history of Plains Indian sculpture—there were both survivals from buffalo days and there were some innovations.

During the early reservation years, the grass dance was dif-fused widely on the Northern Plains reservations. Veterans of the intertribal wars continued into the early decades of the present cen-tury to perform their victory dances, to brandish their horse and enemy effigies, and to recount the coups they had counted in ac-tion against their enemies in earlier years. The one Indian who is closely associated with the carving of horse-dance sticks, No-Two-Horns, a veteran of the Custer Battle in 1876, continued to carve and to sell a number of these carvings during this period. He was still mentioned as an active wood carver in 1934.

The years before and after the turn of this century were also ones of intensive field research and collecting activity on the reser-vations of the Great Plains on the part of anthropologists from the major museums of eastern United States and Canada, who sought to gain as much information as possible about traditional Plains In-dian life and customs from older Indians who had experienced the life of buffalo days and had lively memories of it. Even though sculpture does not appear to have been a major subject of inquiry by any of those scholars, they did obtain some knowledge of it. By that time, also, Indians who had been converted to Christianity were not reluctant to tell of traditional religious practices or to sell medicine objects they no longer believed in.

If those were busy times for collecting symbols of the past, they were also not without innovations—especially in the field of sculpture. During those early reservation years, the Teton or West-ern Sioux carved numerous wooden pipestems with representations of turtles and land mammals on them. They also created many cowhorn spoons with bird or animal effigy handles after the buffalo were gone. Meanwhile, Plains Indians of western Oklahoma devel-oped the wooden mirror frame with an arched-neck horse head

FIGURE 205. Man and snake effigy candlestick; one of the most elaborate catlinite souvenirs carved by Santee Sioux Indians for sale to visitors to Pipestone, Minnesota, around the turn of the twentieth century; 11″ high.
Stovall Museum of Science and History, University of Oklahoma, cat. no. 9-3-83.

carved on it, as well as effigy drum supports. A number of carvings of this period appear to have been made from one-inch pine lumber, probably obtained from military posts or Indian agencies.

During the last quarter of the nineteenth century, a unique Indian art colony developed in the neighborhood of Flandreau, South Dakota, within a dozen miles of the famed red pipestone quarry in southwestern Minnesota. Its members were some of the Santee Sioux Indians who had been removed to the Missouri Valley near Fort Thompson after the Indian uprising in Minnesota in 1862. In 1869 a small number of those Indians requested and received permission to return eastward to the vicinity of Flandreau and to take up homesteads. They were Christianized Indians, determined to make their own way, and to support themselves without governmental assistance. At first this was not possible, but through persistent efforts most learned to support themselves by combining agricultural work during the growing season with the creation of pipes and other items of pipestone during the long winter months for sale to non-Indians.

Merchants near the new town of Pipestone, very near the quarry, offered encouragement to Indian sculptors. Consistently interested and supportive was Charles Bennett, who laid out the settlement of Pipestone City in 1876 and was a prominent civic leader and pharmacist. In 1883 Bennett's drug store also housed a "museum of pipestone curiosities . . . containing some of the finest work in pipestone ever seen in the world." (*Pipestone County Star,* June 28, 1883.) At that time the Star Book Store in Pipestone was offering pipestone artifacts for sale, and by 1891 James Austin of that town was offering to fill mail orders for articles of pipestone. During the mid-1890s, the Roe Trading Post was established offering a great variety of Indian-made pipestone objects for sale.

Catlinite pipes were a major product of the Indian workers in pipestone of the Flandreau community, as well as a number of Yankton Sioux sculptors who visited the quarry regularly in summer to obtain their basic material. Edwin Barber probably had the products of both Indian groups in mind when he wrote in 1883 that Indians were using "over seventy-five different patterns in pipe manufacture, of which the calumet is the only form for which they evidence any degree of veneration in their ceremonies." (Barber 1883a, p. 750.) Doubtless that figure included a number of designs in which no life forms appeared.

Even so this must have been another very creative period for Indian sculpture in catlinite. Among the new designs that appeared during the last quarter of the nineteenth century were the running horse (figure 40), the horse and rider (figure 41 and colorplate 7), the dog head alone or in combination with other animals (figure 93), the snake twined around the shank and prow—the snake and frog (figure 53), the snake approaching a man clinging to

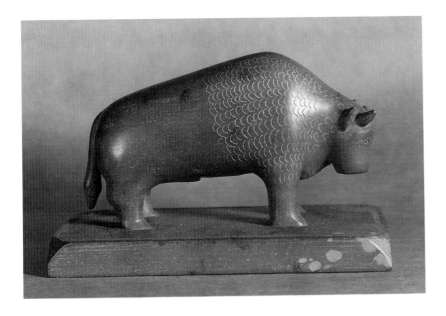

FIGURE 206. Buffalo standing on pedestal; Santee Sioux; 5″ long; Charles H. Bennett Collection, before 1919.
Minnesota Historical Society, cat. no. 2867/E298.

the front of the bowl (figure 81), and several variations of the flat-sided, arched-neck horse head pipe, only three of which are illustrated in figures 34–36. Horses, dogs, snakes, and eagle claws were life forms frequently employed by Sioux sculptors in carving catlinite pipes during the final quarter of the century, as were also fish effigy pipestems. All of these themes appear in the collection of pipes assembled by Bishop Whipple, presumably composed of carvings given to this beloved religious leader by his Indian friends during the last quarter of the century (*Straight Tongue* 1980, pp. 49, 55–57).

To fill a popular demand for less expensive pipestone souvenirs, as well as to make use of small pieces of catlinite left over from pipemaking, the Indians made a variety of other objects for sale to tourists, such as fish effigy letter openers, miniature shoes and horseshoes, effigy napkin rings, cutout maple leaves, small crosses, and so forth. Some of these were provided with elaborate surface decoration in the form of incised leaves or flowers. Pipestone souvenirs are illustrated in *Straight Tongue* 1980, pp. 85–87.

A larger pipestone souvenir of those years appears in the form of a candlestick 11½ inches high, on which is carved a twined snake with its head approaching the head of a man clinging to the candlestick near its top (figure 205). Doubtless this theme was derived from the humorous pipe representing that same theme, such as is illustrated in figure 81 of this book.

A new development in catlinite carving during this period was the representation of animals standing on pedestals—quite frankly as works of art to be admired by the beholder. There were five of these in the fine collection of pipestone artifacts presented to the Minnesota Historical Society in 1919 by Charles Bennett. There were two dogs, a rabbit, and two buffalo. The largest of these is the standing buffalo shown in figure 206. In style this buffalo

FIGURE 207. Boys carving decorative plaques in the woodworking shop at Fort Shaw Indian School, Montana, in the mid-1890s.

National Anthropological Archives, Smithsonian Institution.

does not closely resemble that of any buffalo effigy pipes I can recall. Its sculptor took pains to carve realistic horns and ears in the round, yet the shape of its head is quite generalized, and its eyes and the long hairs that cover the forepart of its body are simply indicated by lightly incised lines. Although the date of this piece is not given, Bennett said that its maker was the "only Dakota Indian who does this kind of work (very rare)."

The most noteworthy new developments in wood sculpture during this half century took place in the northwestern portion of the Great Plains within sight of the Rocky Mountains. In the first example, the sculptors were children in boarding school. Plains Indian children had been recruited for education at Hampton Institute in Virginia as early as 1878, but their classroom experience in art tended to be in the graphic arts rather than sculpture.

The first Indian school encouragement of wood carving that I have found took place at the site of old Fort Shaw, a military post some twenty-six miles west of Great Falls, Montana, which was established in 1867 to protect travelers on the Mullan Wagon Road and settlers in the Sun Valley from Blackfeet raiders. By 1892 Fort Shaw had outlived its military usefulness, and was turned over to Department of the Interior for conversion to an Indian school. By the mid-1890s this new school cared for more than 200 Indian students from the tribes who lived on reservations in Montana east of the Rockies.

As part of their training in the useful arts, both boys and girls were instructed in woodworking, and part of that instruction included the carving of decorative plaques from ten-inch-square

214

FIGURE 208. Decorative plaques by twelve-year-old Blackfeet students at Fort Shaw Indian School in the mid-1890s. At left, by Chester Pepion; at right, by William Williamson. Both are 9¾" square.

Smithsonian Institution, cat. nos. 379,950c and 3790,950d.

pieces of one-inch pine boards, using metal gouges and stamps to create botanical designs on the top surfaces of the boards. There was no precedent in Plains Indian art for such designs in wood, so we may safely assume that the designs produced were suggested by their instructor and probably copied from ones furnished by him also. Figure 207 shows a class of young boys in the woodworking shop at the Fort Shaw Indian School in the middle 1890s at work on some of these decorative plaques. Two of their finished works are pictured in figure 208. They are part of a larger series of these plaques preserved in the collections of the Smithsonian Institution.

There seems to be no indication that any of the boys or girls who learned to create decorative wooden plaques in the Fort Shaw School during the 1890s went on to become sculptors or to create any of the larger wood relief carvings employing human and animal forms that a number of Blackfeet Indians executed during the twentieth century—unless it was John Clarke.

John L. Clarke, three-fourths Blackfeet Indian, was a grandson of Major Malcolm Clarke, a West Point graduate who went west to participate in the fur trade on the Upper Missouri, and who married a Blackfeet woman. John was born in Highwood, near Great Falls, Montana, in 1881. He was stricken with scarlet fever at the age of two, which left him permanently mute and deaf. He attended Fort Shaw Indian School for a time before he went east to study. A list of Indians from the Blackfeet Reservation who had attended off-reservation schools, compiled in 1910, named "John V. C. Clarke, School—Grand Forks, N.D., Occupation—Wood carver."

Clarke was determined to compensate for his physical handicap by achieving recognition for his talent as a wood carver. He received encouragement from Montana's best-known painter and sculptor, Charles Russell. I have seen in the C. M. Russell Gallery in Great Falls, a letter Russell wrote to John Clarke in 1918 advising him on the sale of his carvings, and suggesting that it would be advantageous to him to use his Indian name. In later years Clarke did sign some of his works "CUTAPUIS"—his Blackfeet name, meaning The-Man-Who-Talks-Not.

A successful hunter and very close observer of wild life, Clarke preferred to carve the larger wild animals of the Glacier National Park region, just west of the Blackfeet Reservation. His reputation was built on his meticulously accurate representations of these animals in very life-like poses in miniature wood carvings. He built a studio at East Glacier, near the southeastern entrance to Glacier National Park, and continued to carve miniature animals for sale until near his death on November 20, 1970. Clarke pursued an active career as a sculptor for more than sixty years.

John Clarke worked with me one winter during the early 1940s at the Museum of the Plains Indian on the Blackfeet Reservation, when he modeled and cast in plaster a series of figures illustrating the successive processes employed by an Indian woman of earlier times in dressing a buffalo hide. I last saw him in the lobby of the big hotel at East Glacier during the summer of 1969. He was seated in a chair in front of a mounted mountain goat exhibited in a glass case, and he was carefully drawing that animal. I knew that Clarke must have carved scores of mountain goats—perhaps even hundreds—during his long career. But there he was—ever the perfectionist—keeping his hand in drawing that familiar animal from the model.

One of Clarke's most striking animal sculptures is the 27-inch-high carved and painted mountain goat standing on a simulated rock base, executed in 1925 and pictured in figure 209. Clarke's carving of a mountain goat is said to have provided the model for the logo of the Great Northern Railway.

By the 1920s Clarke's reputation as an artist in wood was recognized in distant sections of this country. His Rocky Mountain animals were exhibited in the Philadelphia Academy of Fine Arts, the Chicago Art Institute, and the Biltmore Salon in Los Angeles. A review of an exhibition of his works at the last-named location appeared in *The Art Digest* of December 1, 1926. It read in part: "He carves from solid chunks of cottonwood bears and deer which seem to live and have personality. Many a carver has given us realistic textures, but only occasionally does one underlay them with such knowledge of his subject and such life."

Figure 210. Walking grizzly bear, by John Clarke, Blackfeet, ca. 1925; wood on base; 6¼″ long.
Smithsonian Institution, cat. no. 416,411.

One of Clarke's most popular animal carvings was a walking bear, which he rendered many times for discriminating collectors. What may be his first rendering of that subject, purchased from him by one of his hunting companions, Louis W. Hill, president of the Great Northern Railway, was presented to the Smithsonian Institution by Hill's son, Louis W. Hill, Jr. It is pictured in figure 210. Other prominent Americans who collected John Clarke's works included President Warren G. Harding, John D. Rockefeller, Jr., and fellow Montana artist Charles Russell. Competent critics did not look upon Clarke's miniature animals as Indian curiosities. They knew and respected them as works of art.

Period 4. Since 1934: Sculpture under Tribal and Governmental Encouragement of the Arts

During the early years of the Great Depression that followed the stock market crash of 1929, there was little demand for the works of Indian artists. Yet under the terms of the New Deal for Indians inaugurated by congressional passage of the Wheeler-Howard Act of 1934, Indian tribes were empowered to draw up their own constitutions and to assume a considerable degree of management of their own affairs. The new constitutions usually included language calling for the encouragement of traditional tribal arts and crafts.

The federal government had already instituted a program to enable artists—a segment of the population especially hard hit by the depression—to continue their creative work. But during the early days of the Public Works of Art Project, city-based artists benefitted most while the Indians on remote reservations received little help. A first step toward finding assistance for Indian artists

was taken by Mrs. Charles Collier, daughter-in-law of President Roosevelt's dynamic Commissioner of Indian Affairs, John Collier, when she enlisted the aid of Indian agents, Indian traders, and prominent collectors of Indian art in compiling a directory of Indian artists. Doubtless her directory provided a much more comprehensive listing of Plains Indian painters, for it revealed the names of fewer than a score of active carvers of stone and/or wood among the tribes on the Great Plains in that year of 1934. Even so, she listed three of the best-known and most active Indian sculptors of the northern plains in 1934. They were John Clarke on the Blackfeet Reservation, No-Two-Horns on Standing Rock, and John Saul on Crow Creek Reservation (Collier 1934).

Mrs. Collier's directory gave the names of only five workers in catlinite in the Flandreau Community: Taylor Flute, John Lovejoy, Henry Taylor, Joe Wabasha, and Taylor Weston. This hardly could have been a complete list of Indians in that vicinity who were working catlinite at that time. Even so, their number increased after the historic quarry site was designated the Pipestone National Monument and placed under the jurisdiction of the National Park Service in 1937. My wife and I first visited that area in September of that year. We saw Indians living in tipis while quarrying catlinite for their own use. Under the new administration, Indians were permitted to remove stone from the ancient quarry. Meanwhile, pipestone artifacts were offered for sale to visitors by shopkeepers in the nearby town of Pipestone.

As plans were implemented for educational programs to explain the history and use of this historic site to the public, the National Park Service built an Interpretative Center near the quarry, which included both a museum and a shop in which authentic Indian-made pipes and other objects of catlinite were sold. A cooperative named the Pipestone Indian Shrine Association was formed by Indians active in creating pipestone objects for sale through the shop. A network of marked trails enabled visitors to view the quarries close-up, and in the open air nearby highly skilled Indian pipemakers demonstrated old and modern methods of making pipes from blocks of catlinite taken from the quarry.

Left to their own choice of objects to be made for sale at the Pipestone National Monument and by mail to dealers and collectors, members of this Pipestone Indian Shrine Association have tended to be quite conservative in their creations, most especially in the matter of effigy pipes. As of old, only a small proportion of the pipes made for sale have effigies carved on them. And by far the most popular effigy pipe has been one bearing a lone buffalo standing on the shank, although styles of carving this animal have differed with individual sculptors.

One of the most able carvers of this period has been Harry Dupree. A buffalo effigy pipe probably created by him during the 1930s appears in figure 211. The center of attention remains the precisely carved buffalo standing on the shank facing a stump, even though the carver took considerable pains to conceal the bowl of the pipe within a tree trunk with a realistic, barklike surface finish—and embellished both the prow and shank with surface decorations.

George Bryan, the most active effigy pipe carver in the area when I visited it in 1971, told me that he remembered Harry Dupree's works especially because of that artist's ability to carve "thin figures." Among the works he attributed to Dupree are two elaborately carved pipes in the Roe Trading Post Collection from Pipestone, now in the Glenbow Museum in Calgary. One of these, portraying a kneeling man on the prow facing both a stump and buffalo, is shown in figure 212. The other is still more elaborate, with a feather-bonneted Indian on horseback chasing a running buffalo atop the pipe. Dupree's ability to carve thin arms, legs, and other features from catlinite without breaking it, reminds us of the works of that unnamed Santee master carver of nearly a century and a half ago who executed the medal chief offering liquor to a follower atop the shank of a pipe, pictured in figure 84 of this book. Probably he was also admired by his fellow Santee sculptors for that same ability to render very "thin figures."

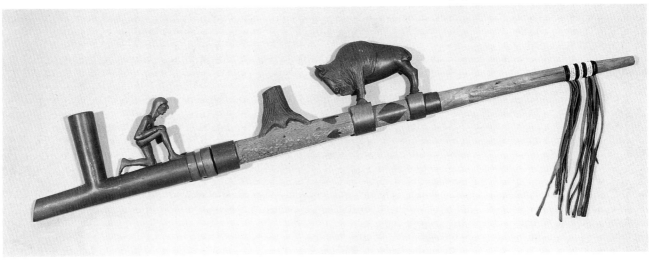

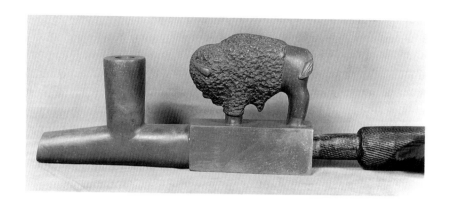

FIGURE 213. Buffalo calf effigy pipe, by George Bryan, Chippewa, of Pipestone, Minnesota; presented to President Eisenhower in 1958; catlinite; 9¼″ long.
Dwight D. Eisenhower Library and Museum, Abilene, Texas

George Bryan, who signed his works with his Indian name of Standing Eagle, pursued his carving career over a period of more than forty years, from the 1930s. He was a Chippewa Indian by birth, whose father was a carver of wooden love-medicine dolls. George married a daughter of Moses Crow, an active Flandreau worker in catlinite, and has continued to live near the famous pipestone quarry. He told me that he began to carve the buffalo calf pipe, for which he has become best known, during the 1930s and has made a countless number of pipes of this design over the years. I have seen these pipes for sale in shops in Santa Fe, and preserved in museum collections in California, Colorado, Manitoba, and elsewhere, and have learned of one in a private collection in France. There must be many of his pipes still in private hands.

At the Pipestone National Monument in 1971 I bought one of these pipes, which is virtually identical to the one George Bryan carved and which was presented to President Dwight D. Eisenhower in 1958. A photograph of that pipe, preserved in the Eisenhower Library in Abilene, Kansas, appears in figure 213. Bryan said another of these pipes was presented to President John F. Kennedy. He did not seem to be aware that the practice of giving Indian-carved effigy pipes to American presidents went back more than a century and a half (see the Andrew Jackson pipe in figure 75).

George Bryan's buffalo calf pipe is a highly stylized, simplified representation of that animal, standing rather stiffly atop the shank of a catlinite calumet. The animal has no hump and bears the shorn poodle look of a buffalo, although the long hairs extend farther back on the body than they do in nature. The eyes are simply round indentations; the tail wags to the left and is carved in relief upon the rump.

Bryan showed me the tools he used to carve effigy pipes. They included a hacksaw to rough out the figure from the block of catlinite, a sharp pen knife and a metal awl made from the tine of a pitchfork set into a wrapped handle to do the carving, and a brace and bit to bore the stem and bowl holes. He said it took eight hours for him to carve the head alone on one of his buffalo pipes. In 1971

his buffalo pipes sold for only $35 each at the Pipestone National Monument shop. Had he not also been employed as a demonstrator by the National Park Service, his pipemaking would not have provided a living for himself and his family at that time. As he approached his seventieth year, George Bryan discontinued making buffalo pipes. However, his son Bill, who signs his works with the name of Big Eagle, continues to carve a smaller version of the long-popular buffalo pipe.

Evidence suggests that many more buffalo effigy pipes have been carved by Plains Indians within the last half century than were carved before the buffalo was exterminated on the Great Plains. Figure 214 illustrates another style of buffalo pipe made in 1969 by Joe Medicine Blanket, a Brule Sioux on Rosebud Reservation. He continued to carve pipes from the limestone quarried locally on Black Pipe Creek, and he gave them a shiny black surface finish by rubbing them with fat, holding them over a buckbrush fire, then polishing them, as did Brule pipemakers more than a century ago. Joe Medicine Blanket was considered the most able and versatile effigy pipemaker on his reservation. He also carved bear, ram's head, and bird effigy pipes. The buffalo pipe illustrated here was given to me in 1969 by the late Clyde Dollar. It was attached to a long stem of sumac wood on which were carved two buffalo in low relief and in profile. They were painted black so that they would stand out from the otherwise unpainted stem.

On Crow Creek Reservation, the Yanktonai Sioux wood carver John Saul was active from about 1920 until his death in 1971. An Episcopal clergyman, Rev. David W. Clark, and his wife organized the Crow Creek Crafts Cooperative on that reservation in 1924, which provided a market for Saul's carvings, as well as other and varied items created by Indians. Saul became known for his ingeniously carved applehead dolls. My wife purchased one of them for our daughters at the shop on Crow Creek Reservation in 1937. Figure 215 shows a six-inch-tall bust created by John Saul in 1965. The wrinkled-faced head was carved from an apple core, and the red cloth neckerchief and felt hat added to the realism of this clever figure. We have seen John Saul's version of a traditional Sioux Tree-Dweller spirit lying snugly in its wooden "home" in figure 116.

The Sioux Indian Museum in Rapid City, South Dakota, was the first of three museums developed by the Educational Division of the Bureau of Indian Affairs in cooperation with local or state governments to serve the dual purpose of interpreting traditional Plains Indian culture to visitors and providing markets for authentic contemporary Plains Indian arts and crafts. The Sioux Indian Museum opened in 1938 in a building provided by the town of Rapid City; it has continued to serve as an important market for Sioux Indian artists and craftspersons.

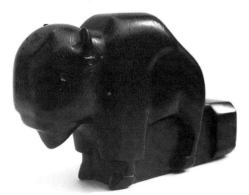

FIGURE 214. Buffalo effigy pipe, by Joe Medicine Blanket, Brule Sioux, 1966; blackened limestone; 5¼" long.
John and Margaret Ewers.

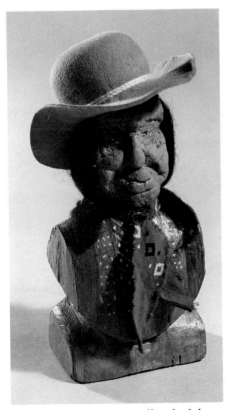

FIGURE 215. Apple face effigy, by John Saul, Yanktonai Sioux, 1965; dried apple, wood, hair, cloth; 6" high.
Sioux Indian Museum, Rapid City, South Dakota, cat. no. R-69.94.15. Photograph U.S. Department of the Interior, Indian Arts and Crafts Board.

The Museum of the Plains Indian, largest of the three museums, was opened on the Blackfeet Reservation at Browning, Montana, in June 1941, to interpret the culture and serve the Indian tribes of the northwestern Great Plains. A Northern Plains Indian Arts and Crafts Cooperative with headquarters in the museum was organized soon thereafter. During the three and a half years I served as that museum's first curator, few sculptured works were offered for sale in the shop. John Clarke, the only Blackfeet sculptor named in Mrs. Collier's directory of 1934, had been commissioned in 1940 to execute two wood relief panels in Philippine mahogany, interpreting aspects of the traditional buffalo hunt, which were installed over the entrance doorways to the museum. He was employed at the museum for one winter during my curatorship to create figures for use in museum exhibits, but he preferred to offer his most salable carvings at his own studio near the East Glacier entrance to Glacier National Park. Clarke consigned to the museum a few of his larger, more complex, and expensive works for which, unfortunately, there was little demand during those depression years.

Even so, Clarke's example encouraged other Blackfeet Indians to try their hands at sculpture. The post-World War II development

FIGURE 216. *The Last Supper*, by Albert Racine, Blackfeet, 1935; carved wooden altar front in United Methodist Church, Browning, Montana; 30″ high.
Photograph Glacier Studio, Browning.

Figure 217. Bull Rider, by Lawrence Mad Plume, Blackfeet, 1969; painted wood; 11″ high.
Museum of the Plains Indian and Crafts Center, cat. no. 72.4.1. Photograph U.S. Department of the Interior, Indian Arts and Crafts Board.

of the Blackfeet Reservation as a lively center for woodcarving can be attributed in considerable part to his successful precedent.

As early as 1935, Rev. Allen C. Wilcox persuaded Albert Racine, a young Blackfeet Indian, to execute a wood relief panel interpreting The Last Supper to be placed on the front of the altar of the United Methodist Church in Browning. This, thought to be Racine's first effort at woodcarving, appears in figure 216. Following service abroad during World War II, Racine returned to the reservation, and influenced by John Clarke's example, opened his own studio near another entrance to Glacier National Park, at St. Mary. There he offered his own humorous drawings and serious paintings, as well as carvings, for sale. He continued to execute wood relief panels, some of which interpreted aspects of traditional Blackfeet life in buffalo days. He did some three-dimensional wood carving as well. In the Lyndon B. Johnson Library in Austin, Texas, I have seen exhibited a wooden gavel, the head of which is carved in the likeness of the head of a war-bonneted Indian. It was carved by Albert Racine and presented to the President by the Blackfeet Tribal Council in 1964.

While some of the younger generation of Blackfeet sculptors continue to interpret selected aspects of tribal life in buffalo days, others have chosen more contemporary themes. An example of the latter, Lawrence Mad Plume's *Bull Rider*, a polychrome wood carving executed in 1969, is illustrated in figure 217. It reflects the intense interest in rodeo on the part of many young Blackfeet, some of whom have met with considerable success on the rodeo circuit. Other recent and contemporary Blackfeet who have studied art at

FIGURE 218. Flute with bird effigy stop, by Bela Cozad, Kiowa, probably 1940s; cedar wood, buckskin ties.

L. D. and Ruth Bax Collection, Morrison, Colorado.

the Institute of American Indian Arts in Santa Fe, or in other non-reservation schools, have preferred to experiment with more abstract subjects.

The third combination museum and craft shop in the Great Plains region was established by the Education Division of the Bureau of Indian Affairs in cooperation with the state of Oklahoma in Anadarko, Oklahoma. As its name, Southern Plains Indian Museum, implies, it was intended to interpret the culture and to market the arts 'and crafts of the tribes of the Southern Plains. I remember its early days well, for I planned its exhibits in 1948 and left its first curator, Royal B. Hassrick, three empty spaces in the exhibition gallery to be filled with miniature dioramas to show aspects of life among the nomadic tribes of the area in buffalo days—to be installed when he could find an artist or artists to create them. The following year, Allen C. Houser, a multitalented Fort Sill Apache Indian, accepted the challenge and in so doing became probably the first Indian artist to create a diorama—including the miniature figures and accessories in the three-dimensional foreground and the painted background. For good measure, Houser also painted a striking mural for the lobby of that museum.

At that time there were many more graphic artists than sculptors among the Indians of western Oklahoma; carving was limited largely to small items such as decorated flutes and mirror frames. During the 1940s, Bela Cozad was a highly-regarded flutemaker among the Kiowa Indians. Figure 218 shows one of his flutes, with its bird effigy stop carved in the traditional Kiowa preference for elaborating the stop with a bird form. We have seen other and earlier variants of Kiowa bird effigy flute stops in figure 157.

By 1970 the Arts and Crafts Board of the Department of the Interior had assumed responsibility for the three Indian museums on the Great Plains and had begun to offer temporary exhibitions of selected examples of contemporary Plains Indian art by named

individuals. Each exhibition was accompanied by a four- or six-page, profusely illustrated leaflet. At first the works of well-established artists were featured, but soon these temporary shows came to include works by younger traditional and experimental artists as well. Some of the sculptors were self-taught, others had the advantage of instruction in art schools.

These exhibitions revealed a multiplicity of influences upon contemporary Plains Indian sculpture. A few sculptors followed the lead of those non-Indian artists of recent years who created non-figurative works. Others were more strongly influenced by such older masters of western sculpture as Frederic Remington and Charles Russell, and such successful contemporary non-Indian sculptors as Bob Scriver, executing traditional cowboy and Indian themes realistically. And like those non-Indian sculptors, they modeled in clay and cast their works in bronze so as to provide multiple reproductions of the same subjects.

During this recent period, the Northern Plains have provided the greatest number of Indian sculptors. Nevertheless, the two most-honored Plains Indian sculptors of the last half century have come from western Oklahoma—Allan C. Houser and W. Richard West. Of nearly the same age, both were born before World War I, received good educations during the New Deal years, achieved recognition as graphic artists before they gained it for their sculpture, and have had marked success as teachers of younger generations of Indian artists.

Allan Houser was hailed by the Indian Arts and Crafts Board as "the Nation's leading Indian sculptor" when it presented a one-man show of his works at the Southern Plains Indian Museum in 1971. A member of the small Fort Sill Apache tribe, composed of followers of the renowned chief Geronimo who were permitted to return only as far west as the vicinity of Fort Sill, Oklahoma, after their captivity farther east, Houser was born in the little town of Apache in 1914. While an art student at The Studio in the U.S. Indian School in Santa Fe in 1936–37, he showed so much talent for graphic art that he was invited to join a select group of more experienced Indian artists in painting murals on the walls of the new Department of the Interior Building in Washington the following year.

Houser's ability to create impressive sculpture was revealed in the 7½-foot-tall marble statue made as a memorial to the students of Haskell Institute, Lawrence, Kansas, who lost their lives in World War II. Titled *Comrade in Mourning*, it depicts the finely carved head of an Indian woman surmounting a massive body completely wrapped in a long robe. At the front above the base is placed an inverted war bonnet. See figure 219.

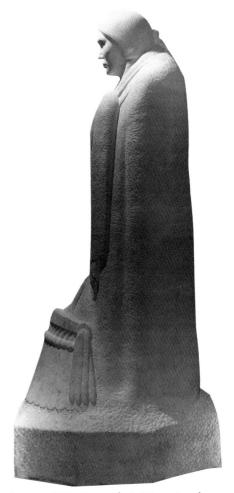

FIGURE 219. *Comrade in Mourning*, by Allan Houser, Fort Sill Apache, 1948; Carrara marble statue in honor of Indian students who lost their lives in World War II; 7½' high.
Haskell Indian Junior College, Lawrence, Kansas.

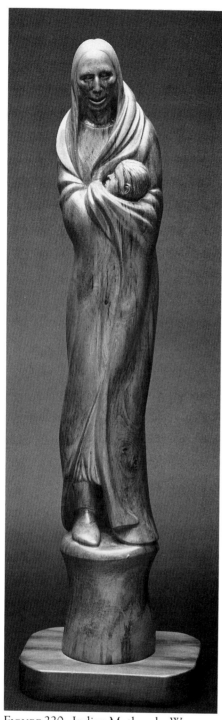

Since then Houser's artistic talents have found expression most frequently in the medium of sculpture. He has experimented very successfully with various media—stone, wood, bronze, and welded steel. Despite the strikingly modern style of his works, his themes have remained Indian. Allan Houser has won numerous awards for his contributions to Indian art both in this country and abroad. As a teacher at the Institute of American Indian Arts in Santa Fe for two decades after 1963, he guided and influenced the development of many young Indian sculptors.

W. Richard West, who frequently signed his works simply "Dick West," was born in Darlington, Oklahoma, in 1912. Raised by his conservative uncles, he has always shown a deep interest in the details of the traditional culture of his tribe, so that ethnologists find his paintings of Cheyenne ceremonies, myths, and games as appealing as do art lovers. West was the first full-blood Indian to graduate from the University of Oklahoma. He served as chairman of the Art Department at Bacone College and was on the faculty at Haskell. West received the coveted sustained artistic achievement Waite Phillips Award from the Philbrook Art Center in Tulsa in 1963.

Many of West's sculptured works are striking elongated and sinuous standing figures with sharply defined facial features. These characteristics are well exemplified by the standing madonna pictured in figure 220, a version of which was awarded first prize in sculpture at the Philbrook Art Center's 22nd Annual American Indian Artists Exhibition in 1967.

FIGURE 220. Indian Mother, by W. Richard West, Cheyenne, 1967; wood; 24" high.

Courtesy W. Richard West.

Epilogue

We have learned that there have been several periods of creativity in the history of Plains Indian sculpture, and that individual artists have played important roles as innovators, both in terms of style and the selection of subject matter. Indeed, one of the most satisfying aspects of my pursuit of this study in the collections of many museums in this country and abroad has been the finding of works by some of the most innovative and talented sculptors in several different museums. Let me cite three noteworthy examples considered earlier in this book: the finely carved men seated on platforms atop the shanks or prows of catlinite pipes executed by an Eastern Sioux master carver of the 1830s, illustrated in colorplate 10 and figures 83 and 84; also the running horse catlinite effigy pipes created a half-century later by an unnamed sculptor, who probably was a Yankton Sioux, shown in figure 40; and the snake effigy pipes carved in blackstone by the Blood Indian sculptor Eagle Ribs, who was active during the 1890s, pictured in figure 54.

In the Appendix, I have listed ninety named Plains Indian sculptors. Although the earliest of these, a Kiowa-Apache (Kaskia) named The Calf, was seen carving an alligator (or lizard) on a wooden mirror frame by members of the Long Expedition on the Southern Plains as early as 1820, no examples of his work are known to have been collected. The earliest carving that may possibly be the creation of a *known* Plains Indian sculptor is the Janus-headed catlinite pipe in the Brooklyn Museum, which may have been executed by the Santee Sioux chief Running Cloud before 1837 (see figure 61). The earliest example that can be identified unquestionably as the work of a named individual, is a catlinite pipe bearing the head of a white man on the bowl and the figure of a buffalo on the shank (see figure 26). It was carved by One-Legged-Jim, a Mdewakanton Sioux, in 1853 and is preserved in the Minnesota State Historical Society.

Although one Sioux sculptor signed his name incised on the bottom of an effigy pipestem as early as 1876, few Plains Indian sculptors signed their works before the 1930s. More than 80 percent of the named Plains Indian sculptors I have listed have been active since 1930.

227

Today, younger Plains Indian sculptors are fortunate to have two such outstanding artists as Allan Houser and Dick West for models. At the same time, in these days of home television, opportunities for specialized education of young men and women who demonstrate artistic interests and talents, and handsomely illustrated books picturing the finest examples of the art of all ages and cultures, Indian artists are exposed to many non-Indian influences. Some critics worry lest they become so attracted to international art styles that their art may lose its Indianness. There is also danger that traditional Indian qualities may be lost in following the demands of the western art market for realistic interpretations of old time cowboy and Indian life after the manner of Remington and Russell.

Yet even as I write, the morning's mail brings a letter from South Dakota enclosing photographs of some miniature carvings in catlinite by a young Sioux Indian whose name and works were not known to me. They are the creations of a person untrained in art, who shows promise. He is going back to carving miniature human and animal figures on the prows and shanks of red stone pipes, much as his Sioux ancestors did a century and a half ago.

I am not predicting that as more Plains Indian sculptors become acquainted with the history of their art, we may enter a period art historians might term a neoclassical one, but I do hope that this book will help contemporary and future Plains Indians to realize that their people possess a sculptural tradition of which they should be proud. The strength of that tradition, as well as the bustling creative activity of young Plains Indian sculptors today, bode well for the future of this art.

Appendix

Named Plains Indian Sculptors Active During the Nineteenth Century

Name	Tribe	Dates	Medium	Reference
The Calf	Kiowa-Apache (Kaskia)	Active 1820	Wood	Alligator effigy mirror frame (p. 197)
Running Cloud	Santee Sioux	Active 1837	Stone	Janus-headed person pipe (p. 83–84, fig. 61)
One-Legged-Jim	Mdewakantan Sioux	Died 1857	Stone	Man's head + standing buffalo (p. 59/fig. 26)
Stone Man	Wahpeton Sioux	Died 1842	Wood	Bowls and pipestems (S. Riggs 1918, p. 527)
Good Thunder	Mdewakanton Sioux	ca. 1820–1901	Wood & Stone	Snake and dog head cane, ca. 1875 (p. 201, fig. 198)
James Goodteacher	Yankton Sioux?	Born 1842	Stone	Fish effigy pipestem, dated 1876 (p. 109, fig. 98)
No-Two-Horns	Hunkpapa Sioux	1852–1942	Wood	Horse dance sticks (p. 142–43)
Green-Grass-Bull	Piegan Blackfeet	ca. 1862–1951	Stone	Portrait pipe, complex effigy pipe (pp. 81–82, fig. 60; p. 89, fig. 69)
Philip Weston	Santee Sioux	Active 1883	Stone	"best (pipe sculptor) among Flandreau Indians of the present day" (Barber 1883, p. 421)
Johnny Yellow Wolf	Brule Sioux	Active ca. 1890	Wood	Elk effigy whistle (p. 160)
John B. Cloud	Santee Sioux	Active 1893	Stone	Fish Effigy Pipe shown 1893 Chicago World's Fair
Zack Flute	Santee Sioux	Active 1893	Stone	Horsehead pipe shown Chicago World's Fair 1893
William Jones	Santee Sioux	Active 1893	Stone	Claw pipe shown Chicago World's Fair 1893
Crazy Bear	Hunkpapa Sioux	Active ca. 1890–1925	Horn	Effigy cowhorn spoons (Info. Beatrice Medicine)
Eagle Ribs	Blood Blackfeet	Active 1893	Stone	Snake effigy pipes (p. 77, fig. 54)
Big Pawnee	Omaha	Active ante 1896	Wood	Flutemaker (J. O. Dorsey 1896, p. 282)
Ben Wesman	Santee Sioux	Active 1897	Stone	Fish effigy letter opener (Dockstader 1972, p. 108)
Daniel Weston	Santee Sioux	Active 1897	Stone	Eagle claw pipes (Dockstader 1972, p. 108)
Chester Pepion	Piegan Blackfeet	Active 1890s	Wood	Wood relief floral plaque (p. 215, fig. 208a)
Willie Williamson	Piegan Blackfeet	Active 1890s	Wood	Wood relief floral plaque (p. 215, fig. 208b)

Named Plains Indian Sculptors Active During Twentieth Century

Tribe	Division	Name	Dates	Medium	Reference
Apache	Ft. Sill	Allan Houser	Born 1914	Bronze, Stone	One-Man show, S. Plains Indian Museum, 1971; War Memorial Haskell (p. 225, fig. 219)
Assiniboin		Harvey Rattey	Active 1977	Bronze	Reno's Retreat. Shown Museum Plains Indian, 1982
Arapaho	Southern	Walter Finley	Active 1934	Wood	Listed by Mrs. Charles Collier, 1934, p. 67
Blackfeet	Siksika	Wolf Collar	Active 1900ff	Stone	Human head etc. (Brasser 1974, pp. 70–73)
Blackfeet	Piegan	John Clarke (He-Who-Talks-Not)	1881–1971	Wood	Wild animals Glacier Nat'l Park region, pp. 216–17, figs. 209, 210) One Man show, Museum Plains Indian, 1970
Blackfeet	Piegan	John Bear Medicine	Born 1896	Wood	Dolls; One-Man show, Museum Plains Indian, 1971
Blackfeet	Piegan	Mae Williamson	Active 1941	Wood	Toy horses (Ewers 1955, pl. 12a)
Blackfeet	Piegan	George Bull Child	Active 1950s	Wood	Dolls for small children (p. 192, fig. 181)
Blackfeet	Piegan	Albert Racine	1907–1984	Wood	Carved altar (p. 223, fig. 216) One-Man show, Museum Plains Indian, 1974
Blackfeet	Piegan	Mike Swims Under	Born 1914	Wood	Wood relief panel show, Museum Plains Indian, 1970
Blackfeet	Piegan	Donald B. Billedeux	Born 1917	Wood	One-Man show, Museum Plains Indian, 1969
Blackfeet	Piegan	Webb Pepion	Born 1919	Wood	One-Man show, Museum Plains Indian, 1977
Blackfeet	Piegan	William Weatherwax	Born 1923	Wood	Buffalo shown, Museum Plains Indian, 1970
Blackfeet	Blood	Gerald Tailfeathers	1925–1975	Clay	Examples in Glenbow Museum, Calgary
Blackfeet	Piegan	Garry Schildt	Born 1938	Bronze	Museum Plains Indian shows, 1971, 1974
Blackfeet	Piegan	Lawrence Mad Plume	Born 1936	Wood	Bull Rider (p. 223, fig. 217)
Blackfeet	Piegan	King Kuka	Born 1946	Stone	One-Man show, Museum Plains Indian, 1973
Blackfeet	Piegan	Gordon Monroe	Born 1946	Stone	One-Man show, Museum Plains Indian, 1973
Blackfeet	Piegan	Ernie P. Pepion	Active 1983	Cast Aluminum	One-Man show, Museum Plains Indian, 1983
Caddo		Jim Inkanish	Active 1934	Wood	Listed by Mrs. Charles Collier, 1934, p. 67
Cheyenne	Southern	Dick West	Born 1912	Wood	Cheyenne Mother (p. 226, fig. 220)
Cheyenne	Northern	Grover Wolf Voice	Active 1973	Wood	Effigy stop flutes sold at N. Cheyenne Arts and Crafts Assn. Shop, 1973
Cheyenne/ Sioux/ Arapaho		Charles Pratt	Born 1937	Bronze	One-Man show, S. Plains Indian Museum, 1978
Cheyenne/ Arapaho		Johnny Burgess	Active 1979	Wood	White Bear Kachina, shown S. Plains Indian Museum, 1982
Chippewa-Cree		White Sky	Active ante 1931	Wood	Human on post (Mantokan) (p. 157, fig. 152)

Tribe	Division	Name	Dates	Medium	Reference
Chippewa-Cree		Julian Peltier	Active 1934	Wood	Listed by Mrs. Charles Collier, 1934, p. 51
Chippewa married to Santee Sioux		George Bryan (Standing Eagle)	Active 1930s to early '80s	Stone	Buffalo calf and claw pipes (p. 219, fig. 213)
Chippewa-Cree		Mrs. Joe Gopher	Active 1950s	Wood	Clothed wooden dolls (pp. 193–94)
Comanche		Doc Tate Nevaquaya	Active 1972	Wood	Effigy stop flutes (Info. from Gillette Griswold)
Comanche		Rance Hood	Born 1941	Stone	Buffalo, shown S. Plains Indian Museum, 1982
Comanche		Bartell Little Chief	Born 1941	Terra Cotta	One-Man show, S. Plains Indian Museum, 1971
Delaware/Kiowa		Parker Boyiddle	Active 1979	Bronze	Horse Spirit shown S. Plains Indian Museum, 1982
Creek/Pawnee		Acee Blue Eagle	1907–1959	Wood	Examples in Smithsonian Collections
Kiowa		Moses Cozad	Active 1930s	Wood	Listed by Mrs. Charles Collier, 1934, p. 67
Kiowa		Bert Geikaumah	Active 1930s	Wood	Bird stop flutes, listed by Mrs. Collier, 1934, p. 67
Kiowa		Bela Cozad	Active 1940s	Wood	Bird stop flutes (p. 224, fig. 218)
Kiowa		George Silverhorn	1911–1969	Wood	Carved peyote equipment box in S. Plains Indian Museum #66.29
Kiowa		Roland N. Whitehorse	Born 1921	Bronze	Black Legging Warrior, shown S. Plains Indian Museum, 1982
Osage		Romain Shackelford	Active 1970	Bronze	Walks at Night, S. Plains Indian Museum, 1982
Oto		Charles W. Dailey	Born 1868	Wood	Arched-neck horse head mirror frame (Photo from Mrs. Martha Blaine)
Ponca		Peter Le Claire	Born 1883	Wood	Canes and a wood sprite (Howard 1965, p. 51)
Nez Perce/Chippewa/Assiniboin		Douglas Hyde	Born 1946	Stone	One-Man shows, Museum Plains Indian, 1971, 1974
Shoshone		Lewis (Bud) Boller	Born 1928	Bronze	One-Man show, Museum Plains Indian, 1974
Sioux	Santee	John Lightening	Born ca. 1849	Stone	Pipestone ornaments (Sociological Study of Flandreau Indians, 1902, p. 17)
Sioux	Mdewakanton	Joseph C. Taylor (Indian Joe)	1860–1933	Stone	"Pipestone souvenirs" (Obit in *Pipestone County Star*, Feb. 14, 1933)
Sioux	Teton	Daniel Buffalo	1878–ca. 1970	Wood	Bird head flute in Museum Plains Indian #1785

Tribe	Division	Name	Dates	Medium	Reference
Sioux	Yanktonai	John Saul	1878–1971	Wood	Tree-Dweller (p. 128, fig. 116; Bust, p. 221, fig. 215) Listed by Mrs. Charles Collier, 1984, p. 54 One-Man show, Sioux Indian Museum, 1977
Sioux	Brule	Ignatius Walking Eagle	Active ante-1915	Wood	Bird Head Flute in St. Francis Mission Museum
Sioux	Brule	Kills Enemy	Active 1915	Wood	Human effigy flute stop (p. 166, fig. 161)
Sioux	Santee	"Blind Joe"	Active 1927	Stone	Human head, also buffalo pipe (Info. Drew Bax)
Sioux	Mdewa-kanton	Henry Taylor	Active 1934	Stone	Listed by Mrs. Collier, 1934, p. 55
Sioux	Santee	Taylor Flute	Active 1934	Stone	Listed by Mrs. Collier, 1934, p. 55
Sioux	Santee	John Lovejoy	Active 1934	Stone	Listed by Mrs. Collier, 1934, p. 55
Sioux	Santee	Joe Wabasha	Active 1934	Stone	Listed by Mrs. Collier, 1934, p. 55 Snake pipes (Info. from George Bryan)
Sioux	Santee	Taylor Weston	Active 1934	Stone	Listed by Mrs. Collier, 1934, p. 55
Sioux	Santee	Charles Robeson	Active 1930s	Stone	Claw pipes (info. from George Bryan)
Sioux	Santee	Harry Dupree	Active 1930s	Stone	Horseman chasing buffalo pipe in Glenbow Museum (info. George Bryan from study photograph) (p. 219, figs. 211, 212)
Sioux	Sisseton	Iron Ring	Ante 1932	Wood	Human head effigy bowl (p. 172, fig. 167)
Sioux	Mdewa-kanton	Ephriam P. Taylor (Looking Eagle)	Died 1966	Stone	Buffalo and claw pipes (photos Pipestone Nat'l Mon.)
Sioux	Mdewa-kanton	Myron Taylor	Active 1971	Stone	Bear effigy pipe sold at Pipestone in 1971
Sioux	Brule	Joe Medicine Blanket	Active 1960s	Stone	Buffalo effigy pipe (p. 221, fig. 214)
Sioux	Oglala	Nick-Fast-Horse	Active 1970s	Wood	Dancer dolls (p. 193, fig. 184)
Sioux/ Chippewa		Bill Bryan (Big Eagle)	Active 1970s	Stone	Buffalo pipes (seen at Pipestone Nat'l Monument)
Sioux	Oglala	Luther Good Voice Flute	Active 1972	Wood	Bird head flutes (info Dr. James Hanson)
Sioux	Brule	Richard Fool Bull	Died 1976	Wood	Bird head flutes (cover illus. S. Dakota Museum, vol. 1. no. 2. 1973)
Sioux	Brule	Annamae Pusetonwequa	Active 1974	Stone	Human faces in stone (Exhibited St. Francis Mission Museum, 1974)
Sioux	Yanktonai	Lillian Ironbull Martinez	Born 1915	Wood	Bird head whistle, one-man show, Sioux Indian Museum, 1979
Sioux	Lower Brule	Alfred Young Ziegler	Born 1919	Bronze	One-man show, Sioux Indian Museum, 1976
Sioux	Oglala	Buck Bettelyoun	Born 1925	Wood	One-man show, Sioux Indian Museum, 1978
Sioux	Oglala	Cecil Apple	Born 1952	Wood, Stone	One-man show, Sioux Indian Museum, 1978

Bibliography

Ahlborn, Richard E., ed. 1980. Man made mobile. Early saddles of western North America. *Smithsonian Studies in History and Technology* 49. Washington, D.C.

Arese, Count Francesco. 1934. *A trip to the prairies and in the interior of North America 1837–1838*. New York.

Atwater, Caleb. 1850. *The Indians of the Northwest, their maners [sic] customs etc.* Columbus, Ohio.

Barber, Edwin A. 1882a. *Catalog of the collection of tobacco pipes deposited by Edwin A. Barber*. The Pennsylvania Museum and School of Industrial Art. Memorial Hall, Fremont Park, Philadelphia.

———. 1882b. Mound pipes. *The American Naturalist* 16(4):265–81.

———. 1883a. Catlinite. *The American Naturalist* 17(7).

———. 1883b. The Pipe of Peace. *The Continent* 3(14): 418–22.

Bass, William N., David R. Evans, and Richard L. Jantz. 1971. The Leavenworth Site cemetery: Archaeology and physical anthropology. *Publications in Anthropology* 2. University of Kansas.

Belden, George P. 1871. *Belden, The White Chief*. Cincinnati.

Black Elk, Benjamin. 1962. Black Elk's notes on Teton Sioux culture. *Museum News* 23(3). W. H. Over Museum. Vermillion, S.D.

Blakeslee, Donald J., and Warren W. Caldwell. 1979. The Nebraska phase: An appraisal. J. and L. Reprint Company, Lincoln, Neb.

Boas, Franz. 1908. Decorative designs on Alaskan needle cases. *Proceedings of the United States National Museum* 34:321–44.

Boller, Henry A. 1966. *Henry A. Boller Missouri River trader*. Ed. Ray H. Mattison. Bismarck, N.D.

Bolton, Herbert E., 1915. *Athanase de Mézières and the Louisiana-Texas frontier, 1768–1780*. 2. Cleveland.

Botone, Ida. 1932. Origin of the Kiowa flute. *The Oklahoma Indian School Magazine* 1(7):22.

Bowers, A. W. 1950. *Mandan Social and Ceremonial Organization*. Chicago.

———. 1965. Hidatsa social and ceremonial organization. *Bureau of American Ethnology Bulletin* 194.

Boyd, Maurice. 1981. *Kiowa voices*. I. Ceremonial dance, ritual and song. Fort Worth, Texas.

Bragge, William. 1880. *Bibliotheca Nicotiana: A Catalogue of Books about Tobacco, together with a Catalogue of Objects connected with the Use of Tobacco in all its Forms*. Birmingham, England.

Brower, J. V. 1904. *Mandan. Memoirs of explorations in the basin of the Mississippi*. 8. St. Paul.

Brown, Joseph Epes. 1953. *The sacred pipe. Black Elk's account of the seven rites of the Oglala Sioux*. Norman, Okla.

Carter, John G. 1938. The Northern Arapaho flat pipe and the ceremony of covering the pipe. *Bureau of American Ethnology Bulletin* 119 (2):73–101.

Casagrande, Louis B., and Phillip Bourns. 1983. *Side trips. The photography of Sumner W. Matteson, 1898–1908*. Milwaukee.

Catlin, George. 1841. *Letters and notes on the manners, customs, and conditions of the North American Indians*. 2. London.

———. 1967. *O-kee-pa: A religious ceremony and other customs of the Mandans*. Centennial ed. Ed. John C. Ewers. New Haven.

Chapman, Carl H., and Eleanor F. 1964. Indians and archeology of Missouri. *Missouri Handbook* 6. Columbia.

Clark, Earl. 1984. Cave Alava uncovered. Exciting dig reveals prehistoric culture of Washington Coast. *American West* 23 (3):22–31.

Coe, Ralph T. 1977. *Sacred circles. Two thousand years of North American Indian art*. Nelson Gallery of Art. Kansas City, Mo.

Collier, Mrs. Charles. 1934. *Survey of Indian arts and crafts April, 1934*. U.S. Bureau of Indian Affairs. Mimeographed.

Commissoner of Indian Affairs. 1880 and 1885. Annual reports. Washington, D.C.

Conn, Richard. 1979. *Native American art in the Denver Art Museum*. Denver Art Museum.

———. 1982. *Circles of the world. Traditional art of the Plains Indians*. Denver Art Museum.

Cooper, John M. 1956. The Gros Ventres of Montana. Part II. Religion and ritual. *The Catholic University of America, Anthropological Series* 16. Washington, D.C.

Cooper, Paul. 1939. The Archeological exploration of 1938 by the Nebraska State Historical Society. Report of Explorations. *Nebraska History* 20 (2):94–151.

Curtis, Edward S. 1908. The Teton Sioux. *The North American Indian* 3:1–118, 137–82.

———. 1909. Mandan, Arikara, Atsina. *The North American Indian* 5.

———. 1928. Cree. *The North American Indian* 18.

Deloria, Ella C. 1929. The Sun Dance of the Oglala Sioux. *Journal of American Folklore* V:35–413.

Deloria, Ella C., and Jay Brandon. 1961. The origin of the courting-flute, a legend in the Santee dialect. *Museum News* 22 (6):5–7. W. H. Over Museum. Vermillion, S.D.

Denig, Edwin Thompson. 1961. *Five Indian Tribes of the Upper Missouri*. Ed. John C. Ewers. Norman, Oklahoma.

Densmore, Frances. 1918. Teton Sioux music. *Bureau of American Ethnology Bulletin* 61.

———. 1923. Mandan and Hidatsa music. *Bureau of American Ethnology Bulletin* 80.

———. 1948. A collection of specimens from the Teton Dakota. *Indian notes and monographs* XI (3). Museum of the American Indian, Heye Foundation. New York.

DeSmet, Pierre Jean. 1905. *Life, letters, and travels of Father Pierre Jean DeSmet*. Ed. H. M. Chittenden and A. T. Richardson. 4. New York.

Diedrich, Mark F. 1981. Christian Taopi: Farmer chief of the Mdewakanton Dakota. *The Minnesota Archeologist* 40(2):66–77.

Dockstader, Frederic. 1961. *Indian art in America*. Greenwich, Conn.

———. 1972. Those catlinite pipes. *Indian Notes* 8(4) 108–9. Museum of the American Indian, Heye Foundation. New York.

———. 1973. *Indian art of the Americas*. New York.

Dodge, Richard Irving. 1882. *Our wild Indians: Thirty-three years' personal experience among the Red Men of the Great West*. Hartford, Conn.

Dorsey, George A. 1903. The Arapaho Sun Dance: The ceremony of the offering lodge. *Field Museum Publications* 75. Anthropological Series 4.

———. 1904. Traditions of the Skidi Pawnee. *Memoirs of the American Folkore Society* 8:88–94.

———. 1905. The Cheyenne. Part I. Ceremonial organization. *Field Columbian Museum Publication* 99. Anthropological Series 9 (1).

Dorsey, James O. 1890. A study of Siouan cults. *Bureau of American Ethnology, 11th Annual Report*: 361–422.

———. 1896. Omaha dwellings, furniture, and implements. *Bureau of American Ethnology, 13th Annual Report*.

Douglas, Frederic H., and Rene d'Harnoncourt. 1941. *Indian art of the United States*. Museum of Modern Art. New York.

Driver, Harold E. 1961. *Indians of North America*. Chicago.

Drysdale, Vera Louise, and Joseph Epes Brown. 1982. *The gift of the sacred pipe*. Norman, Okla.

Dunbar, John B. 1880. The Pawnee Indians. *Magazine of American History* 4 (4).

Dusenberry, Verne. 1962. *The Montana Cree*. Upsala, Sweden.

Ellis, K., and C. Steen. 1974. An Indian delegation in France, 1725. *Journal of the Illinois State Historical Society* 67 (4) 385–405.

Ewers, John C. 1939. *Plains Indian painting. A description of an aboriginal art*. Palo Alto, Calif.

———. 1955. The horse in Blackfoot Indian culture, with comparative materials from other western tribes. *Bureau of American Ethnology Bulletin* 159.

———. 1958a. *The Blackfeet, raiders on the Northwestern Plains*. Norman, Okla.

———. 1958b. Love medicine. *The Beaver* (Autumn):40–41.

———. 1963. Blackfoot Indian pipes and pipemaking. *Bureau of American Ethnology Bulletin* 186 (64):29–60.

———. 1968. *Indian life on the Upper Missouri*. Norman, Okla.

———. 1977. Notes on the weasel in historic Plains Indian culture. *Plains Anthropologist* 22 (78)1:253–62.

———. 1978. Three effigy pipes by an Eastern Dakota master carver. *American Indian Art Magazine* 3(4):51–55, 74.

———. 1979. *Indian art in pipestone: George Catlin's portfolio in the British Museum*. Washington, D.C.

———. 1979a. Images of the white man in 19th century Plains Indian art. In Justine M. Cordwell, ed. *The visual arts, plastic and graphic*, pp. 411–29. The Hague.

———. 1980. Saddles of the Plains Indians. In Richard E. Ahlborn, ed. Man made mobile: Early saddles of western North America. *Smithsonian Studies in History and Technology* 39:72–84.

———. 1981. Pipes for the Presidents. *American Indian Art Magazine* 6 (3):66–70.

———. 1982. The awesome bear in Plains Indian art. *American Indian Art Magazine* 7(3):36–45.

Eyeman, Frances. 1966. A grizzly bear carving from the Missouri Valley. *University of Pennsylvania Museum Expedition* 8(3) 33–40.

Feder, Norman. 1964. *Art of the eastern Plains Indians: The Nathan Sturges Jarvis Collection*. The Brooklyn Museum. New York.

———. 1971. *American Indian Art*. New York.

———. 1972. *Two hundred years of North American Indian art*. New York.

Feest, Christian F. 1968. *Indianer Nordamerikas*. Museum für Volkerkunde. Vienna.

Fletcher, Alice C., and Francis La Flesche. 1911. The Omaha Tribe. *Bureau of American Ethnology, 27th Annual Report*.

Frink, Maurice, and Casey Barthelmess. 1965. Photographer on an army mule. Norman, Okla.

Frison, George C. 1978. *Prehistoric hunters of the High Plains*. New York.

Gilliam, Laura L., and William Lichtenwanger. 1961. *The Dayton C. Miller Flute Collection*. Music Division. Reference Department, Library of Congress.

Gilman, Carolyn. 1982. *Where two worlds meet: The Great Lakes fur trade*. Minnesota Historical Society. St. Paul.

Goetzmann, William, and William J. Orr. 1984. *Karl Bodmer's America*. Lincoln, Neb.

Gottschell, Amos H. 1921. *General remarks regarding the collection*. Harrisburg, Pa.

Graham, Andrew. 1969. *Andrew Graham's observations on Hudson's Bay, 1767–91*. The Hudson's Bay Record Society. London.

Grant, Campbell. 1982. *The bighorn sheep—pre-eminent motif in the rock art of western North America*, pp. 11–25. El Toro, Calif.

Grinnell, George Bird. 1923. *The Cheyenne Indians, their history and ways of life.* 2. New Haven.

Hail, Barbara A. 1980. Hau, Kola! The Plains Indian Collection of Haffenreffer Museum of Anthropology. *Studies in Anthropology and Material Culture* 3. The Haffenreffer Museum of Anthropology, Brown University.

Hamilton, Henry W. 1967. Tobacco pipes of the Missouri Indians. *Missouri Archeological Society, Memoir* 5.

Harmon, Daniel W. 1911. *A journal of voyages in the interior of North America.* Ed. D. Haskell. Toronto.

Harrington, M. R. 1920a. An archaic Iowa tomahawk. *Indian Notes and Monographs* 10(6):55–58. Museum of the American Indian, Heye Foundation. New York.

———. 1920b. A sacred warclub of the Oto. *Indian Notes* 10 (1) 25–27. Museum of the American Indian, Heye Foundation. New York.

Hartmann, Horst. 1973. *Die Plains-und Prärieindianer Nordamerikas.* Museum für Volkerkunde. Berlin.

Hassrick, Royal B. 1964. *The Sioux, life and customs of a warrior society.* Norman, Okla.

Haupt, Herman. 1897. North American Indians. Ethnology of the Dakota-Sioux and Ojibway-Chippeway Indians. Mss. in Newberry Library. Chicago.

Hedger, E. 1969. Saskatchewan bison effigies. *Näpào* 1(1):13–16.

Hemphill, Herbert W. Jr., ed. 1976. *Folk sculpture USA.* The Brooklyn Museum. New York.

Hennepin, Louis. 1903. *A new discovery of a vast country in America.* Ed. Reuben Gold Thwaites. 2. Chicago.

Henry, Alexander. 1809. *Travels and adventures in Canada and the Indian territories.* New York.

Heye, George C. 1925. Andrew Jackson's indian pipes. *Indian Notes* 2:116–18. Museum of the American Indian, Heye Foundation. New York.

Hilger, Sister M. Inez. 1952. Arapaho child life and its cultural background. *Bureau of American Ethnology Bulletin* 148.

Hill. A. T. 1927. Mr. A. T. Hill's own story. *Nebraska History Magazine* 10 (3) 162–67.

Hodge, Frederick W., ed. 1910. Handbook of American Indians north of Mexico. *Bureau of American Ethnology, Bulletin* 30. 2 parts.

Holmes, William H. 1910. Sculpture and carving. Handbook of American Indians north of Mexico. Ed. F. W. Hodge. *Bureau of American Ethnology Bulletin* 30. Part 2:490–92.

Hough, Walter. 1895. *Catalogue for the ethnological exhibit from the United States National Museum. Columbian Historical Exposition Madrid.* Washington, D.C.

Howard, James H. 1950. An Omaha Dancing Ornament. *Museum News* 12, no. 1. W. H. Over Museum. Vermillion, S.D.

———. 1965a. The Plains-Ojibwa or Bungi. *Anthropological Papers* 1. W. H. Over Museum, Vermillion, S.D.

———. 1965b. The Ponca Tribe. *Bureau of American Ethnology Bulletin* 195.

James, Edwin. 1823. *Account of an expedition from Pittsburgh to the Rocky Mountains performed in the years 1819 and 1820.* 2 and atlas. Philadelphia.

James, Edwin, ed. 1830. *A narrative of the captivity and adventure of John Tanner during thirty years residence among the Indians of the interior of North America.* New York.

Jenness, Diamond. 1932. The Indians of Canada. *Bulletin* 65. Canada Dept. of Mines. Ottawa.

Keating, William. 1824. *Narrative of an expedition to the source of the St. Peter's River, Lake Winnepeek, Lake of the Woods, etc. performed in the year 1823.* 2. Philadelphia.

Kellogg, Louise Phelps, ed. 1908. The British regime in Wisconsin. *Wisconsin Historical Society Collections* 18.

King, J. C. H. 1977. *Smoking pipes of the North American Indians.* British Museum Publications Limited. London.

Kinietz, W. Vernon. 1965. *The Indians of the Western Great Lakes, 1615–1760.* Ann Arbor, Mich.

Kroeber, Alfred L. 1902–7. The Arapaho. *American Museum of Natural History Bulletin* 18. New York.

La Flesche, Francis. 1921. *The Osage Tribe. Bureau of American Ethnology, 36th Annual Report.*

La Pointe, James. 1976. *Legends of the Dakota.* San Francisco.

Leakey, L. S. B. 1954. Graphic and plastic arts. In Charles Singer, A. J. Holmtard, and A. R. Hall, eds., *A history of technology:* I:144–53. New York and London.

Lehmer, Donald J. 1971. Introduction to Middle Missouri Archeology. *Anthropological Papers* 1. National Park Service.

Lehmer, Donald J., W. Raymond Wood, and C. L. Dill. 1978. *The Knife River phase.* Dana College. Blair, Neb.

Lowie, Robert H. 1913. Crow military societies. *American Museum of Natural History, Anthropological Papers* 11:143–217.

———. 1913. Societies of the Hidatsa and Mandan Indians. *American Museum of Natural History, Anthropological Papers* 11:221–93; 323–54.

———. 1916. Societies of the Kiowa. *American Museum of Natural History, Anthropological Papers* 11:837–51.

———. 1918. Myths and Traditions of the Crow Indians. *American Museum of Natural History, Anthropological Papers* 25:1–308.

———. 1954. Indians of the Plains. *American Museum of Natural History, Anthropological Handbook* 1.

Lynd, James William. 1864. The religion of the Dakotas. *Minnesota Historical Collection* 2.

McClintock, Walter. 1910. *The Old North Trail.* London.

———. 1937. Dances of the Blackfoot Indians. *Southwest Museum Leaflet* 7. Los Angeles.

MacGregor, J. G. 1966. *Peter Fidler: Canada's forgotten surveyor, 1769–1822.* Toronto.

McGuire, Joseph D. 1899. Pipes and smoking customs of the American Indians based on material in the U.S. National Museum. *U.S. National Museum Annual Report:* 351–645. Washington, D.C.

MacLean, John. 1924. Canada's native sculptors. *The Beaver* 4 (7):248–49.

Marquis, Thomas B. 1931. *Wooden Leg. A warrior who fought Custer*. Minneapolis.

Mathews, Zena Pearstone. 1984. *Symbol and substance in American Indian art*. The Metropolitan Museum of Art. New York.

Matthews, Washington. 1877. Ethnography and philology of the Hidatsa Indians. *U.S. Geological and Geographical Survey, Miscellaneous Collections* 7:1–239. Washington, D.C.

Maurer, Evan M. 1977. *The Native American heritage. A survey of North American Indian art*. The Art Institute of Chicago.

Maximilian, Prince of Wied. 1906. Travels in the Interior of North America 1832–1834. In *Early Western Travels, 1748–1846*:22–25. Ed. Reuben Gold Thwaites. Cleveland.

Mayer, Frank B. 1851. Album of drawings. Rare Book Room, New York Public Library.

Methvin, J. J. 1899. *Andele, or the Mexican-Kiowa captive*. Louisville.

Minneapolis Institute of the Arts. 1972. *American Indian art: Form and tradition*. Walker Art Center.

Mooney, James. 1896. The Ghost-Dance religion and the Sioux outbreak of 1890. *Bureau of American Ethnology, Annual Report* 14 (2).
———. 1898. Calendar history of the Kiowa Indians. *Bureau of American Ethnology, Annual Report* 17 (2).

Morgan, Lewis Henry. 1959. *The Indian Journals, 1859–62*. Ed. Leslie A. White. Ann Arbor, Mich.

Morris, Frances. 1914. *The Metropolitan Museum of Art Catalog of the Musical Instruments of Oceania and America*. New York.

Mott, Mildred. 1938. The relation of historic Indian tribes to archaeological manifestations in Iowa. *Iowa Journal of History and Politics* 36 (3) 227–313.

Murie, James. 1981. Ceremonies of the Pawnee. Ed. Douglas R. Parks. *Smithsonian Contributions to Anthropology* 27.2. vols.

Murray, Robert A. 1962. A brief survey of the pipes and smoking customs of the Indians of the Northern Plains. *Minnesota Archeologist* 24 (1):4–41.
———. 1963. Some notes on pipe-making stone and place-names in and near the plains. *Minnesota Archeologist* 25 (4):156–59.
———. 1965. *A History of Pipestone National Monument, Minnesota*. Pipestone, Minn.
———. 1968. *Pipes on the plains*. Pipestone Indian Shrine Association. Pipestone, Minn.

Nasatir, Abraham. 1952. *Before Lewis and Clark*. 2. St. Louis.

Neihardt, John G. 1961. *Black Elk speaks*. Lincoln, Neb.

Neill, E. D. 1862. Dakota land and Dakota life. *Minnesota Historical Society Collections* 1:254–94.

Nicollet, Joseph N. 1976. *Joseph N. Nicollet on the plains and prairies*. Ed. Emund C. and Martha Coleman Bray. Minnesota Historical Press. St. Paul.

Nuttall, Thomas. 1905. Thomas Nuttall journal. In *Early Western Travels*. Ed. Reuben Gold Thwaites. 13. Cleveland.

Nye, Wilbur. 1962. *Bad medicine and good: tales of the Kiowas*. Norman, Okla.

Orr, William J., and Joseph C. Porter. 1983. A journey through the Nebraska region in 1833 and 1834: From the diaries of Prince Maximilian of Wied. *Nebraska History* 64 (3):325–453.

Palliser, John. 1969. *Solitary Rambles*. Rutland, Vt.

Parkman, Francis. 1925. *The Oregon Trail*. Boston.

Parsons, Elsie Clews. 1929. Kiowa tales. *Memoirs of the American Folk-Lore Society* 22.

Peeso, F. F. 1912. The Cree Indians. *The Museum Journal* 3:50–56. University of Pennsylvania Museum. Philadelphia.

Petersen, Karen D. 1964. Cheyenne Soldier Societies. *Plains Anthropologist* 9 (25):146–72.

Philbrook Art Center. 1980. *Native American Art at Philbrook*. Lincoln, Neb.

Pond, G. H., 1867. Dakota Superstitions. *Minnesota Historical Society Collections* 2(3).

Pond, Samuel. 1908. The Dakotas or Sioux in Minnesota as they were in 1834. *Collections of the Minnesota Historical Society* 12:319–501.

Powell, Peter. 1969. *Sweet Medicine* 2. Norman, Okla.

Powers, William K. 1980. The art of courtship among the Oglala. *American Indian Art* 5 (2):40–47.

Prufer, Olaf H. 1964. The Hopewell Complex of Ohio. In Joseph R. Caldwell and Robert L. Hall, ed. Hopewellian Studies. *Scientific Papers* 12:37–83. Illinois State Museum. Springfield.

Quimby, George Irving. 1966. *Indian culture and European trade goods*. Madison, Wis.

Radisson, Pierre. 1885. *Raddison's voyages*. Boston.

Ray, Arthur J. 1974. *Indians in the fur trade*. Toronto.

Riggs, Stephen R. 1869. *Tahkoo-Wa-kon, or the gospel among the Dakota*. Boston.
———. 1880. Theogeny of the Sioux. *American Antiquarian and Oriental Journal* 2:265–70.
———. 1918. Dakota portraits. *Minnesota History Bulletin* 2 (8). St. Paul.

Ritzenthaler, Robert E. 1976. Woodland Sculpture. *American Indian Art Magazine* (4):34–41.

Roe Collection, from Pipestone, Minnesota, notes on. n.d. In Glenbow-Alberta Institute. Calgary, Alberta.

St. Francis Indian Mission. 1973. *Father Eugene Buechel, S. J. Memorial Museum*. St. Francis, S.D.

Schmitz, Marie L. 1980. From Mississippi mounds to western plains. *Gateway Heritage* 1(1):22–27. Missouri Historical Society. St. Louis.

Schoolcraft, Henry Rowe. 1851–57. *Historical and statistical information respecting the history, condition and prospects of the Indian tribes of the United States*. 6. Philadelphia.

Schulze-Thulin, Axel. 1976. *Indianer der Prärien und Plains*. Linden Museum. Stuttgart, Germany.

Scott, Hugh L. 1911. Notes on the Kado, or Sun Dance of the Kiowa. *American Anthropologist* 13 (3):345–79.

Shimkin, D. B. 1953. The Wind River Shoshone Sun Dance. *Bureau of American Ethnology Bulletin* 151.

Skinner, Alanson. 1919. A sketch of Eastern Dakota ethnology. *American Anthropologist* 21 (2):164–74.

———. 1921. Material culture of the Menomini. *Indian Notes and Monographs* 20. Museum of the American Indian, Heye Foundation. New York.

———. 1925. Tree-Dweller bundle of the Wapeton Dakota. *Indian Notes* 2(1):66–73. Museum of the American Indian, Heye Foundation. New York.

———. 1926. Ethnology of the Iowa Indians. *Milwaukee Public Museum Bulletin* 5: 181–353.

Smith, Carlyle S. 1977. The Talking Crow Site. *University of Kansas Publications in Anthropology* 9. Lawrence.

Sociological study of Flandreau Indians. 1902. U.S. Department of the Interior, Indian Field Service. (30 typed pages.)

Squier, E. G. and E. H. Davis. 1848. Ancient monuments of the Mississippi Valley: Comprising the Results of Extensive Original Surveys and Explorations. *Smithsonian Contributions to Knowledge* 1.

Stallcop, Emmet A. 1972. A religious effigy of the Cree of Rocky Boy Reservation. *Plains Anthropologist* 17 (55).

Stephenson, Robert L. 1971. The Potts Village Site (39C019) Oahe Reservoir North Central South Dakota. *The Missouri Archeologist* 33.

Straight Tongue. Minnesota Indian Art from the Bishop Whipple Collections. 1981. The Science Museum of Minnesota. St. Paul.

Swanton, John R. 1942. Source material on the history and ethnology of the Caddo Indians. *Bureau of American Ethnology Bulletin* 132.

Sweeney, Robert O. n.d. Drawings of Sioux artifacts and activities. Minnesota Historical Society. St. Paul. (Manuscript materials.)

Tabeau, Pierre-Antoine. 1939. *Tabeau's narrative of Loisel's expedition to the Upper Missouri*. Norman, Okla.

Thayer, Burton W. 1944. A Santee Dakota figurine. *The Minnesota Archaeologist* X (2):78–81.

Thomas, Sidney J. 1941. A Sioux medicine bundle. *American Anthropologist* 43 (4):605–9.

Thompson, David. 1962. *David Thompson's narrative, 1784–1812*. Ed. Richard Glover. The Champlain Society. Toronto.

Thompson, Judy. 1977. *The North American Indian Collection. A catalogue*. Berne Historical Museum. Switzerland.

Tooker, Elizabeth. 1964. An ethnography of the Huron Indians, 1615–1649. *Bureau of American Ethnology Bulletin* 190.

Truettner, William H. 1979. *The natural man observed: A study of Catlin's Indian Gallery*. Washington, D.C.

Walker, J. R. 1906. Sioux games. *The Journal of American Folk-Lore* 19 (72):29–36.

Wedel, Mildred Mott. 1959. Oneota sites on the Upper Iowa River. *The Missouri Archaeologist* 21 (2–4).

Wedel, Waldo R. 1961. *Prehistoric man on the Great Plains*. Norman, Okla.

Weltfish, Gene. 1937. Caddoan texts, Pawnee South Band Dialect. *Publications of American Ethnological Society* 17.

———. 1965. *The Lost Universe*. New York.

West, George A. 1934. Tobacco pipes and smoking customs of the American Indians. *Milwaukee Public Museum Bulletin* 17.

West, Ian M. 1978. Plains Indian horse sticks. *American Indian Art* 3 (2) 58–67.

———. 1979. Tributes to a horse nation: Plains Indian horse effigies. *South Dakota History* 9 (4):291–302. South Dakota Historical Society.

White, C.A.M.D. 1869. A trip to the red pipestone quarry. *The American Naturalist* 2 (12) 644–53.

Wildschut, William, and John C. Ewers. 1960. Crow Indian medicine bundles. *Contributions from the Museum of the American Indian* 17.

Will, George A., and H. J. Spinden. 1906. The Mandans. A study of their culture, archaeology, and language. *Papers of the Peabody Museum of American Archaeology and Ethnology* 3(4). Harvard University.

Wilson, Daniel. 1857. Narcotic usages and superstitions of the Old and New World. *Canadian Journal of Industry, Science, and Art* 2: 233–64; 324–44.

Wilson, Gilbert L. 1928. Hidatsa eagle trapping. *American Museum of Natural History, Anthropological Papers* 30 (4).

Wissler, Clark. 1905. The whirlwind and the elk in the mythology of the Dakota. *Journal of American Folk-Lore* 18: 257–68.

——— 1907. Some protective designs of the Dakota. *American Museum of Natural History, Anthropological Papers* 1: 21–53.

———. 1912. Ceremonial bundles of the Blackfoot Indians. *American Museum of Natural History, Anthropological Papers* 7(2).

———. 1922. *The American Indian*. New York.

———. 1938. *Indian cavalcade*. New York.

Wood, Raymond. 1974. Northern Plains village cultures: Internal stability and external relationships. *Journal of Anthropological Research* 30 (1):1–16.

Woolworth, Alan R. 1954. Some unusual artifacts from the Central and Northern Plains. *North Dakota History* 26(2): 93–100.

Woolworth, Alan R., comp. 1983. The red pipestone quarry of Minnesota: Archaeological and historical reports. *The Minnesota Archaeologist* 42.

Zierhut, Norman W. 1968. The Kalmbach bison effigy. *Archaeological Society of Alberta Newsletter* 17:1–4.

Acknowledgments

Rarely has an author been dependent upon the assistance of so many institutions and individuals during research and preparation of a book as I have been for this one. I wish to express my deep appreciation to all of them. A grant from the Viking Fund made possible my first research in museums abroad—in Paris and Stuttgart—in 1968. Subsequent research in this country and abroad, prior to my retirement from the Smithsonian Institution in 1979, was funded by the Smithsonian Research Foundation, which also provided a grant for the color illustrations in this volume. I am grateful to my colleagues in the Department of Anthropology at the Smithsonian for consultation on this study, most especially to Paula Fleming, Cesare R. Marino, William Sturtevant, and Waldo R. Wedel. Victor Krantz, Smithsonian photographer, and the illustrators Marcia Bakry and George R. Lewis contributed importantly to the visual effectiveness of this book.

I am grateful to the many public and private museums and libraries and to members of their staffs who permitted and helped me to examine pertinent artifacts, pictures, and documents in their collections. They include the American Museum of Natural History, New York: Stanley A. Freed and Phillip C. Gifford, Jr.; Amon Carter Museum of Western Art, Fort Worth: Mitchell A. Wilder and Ron Tyler; The William M. Bass Collection, University of Tennessee, Knoxville: William M. Bass; The R. D. and Ruth Bax Collection, Morrison, Colorado: R. D. Bax; The British Museum, London: the trustees of the British Museum and Elizabeth Carmichael, William Fagg, Jonathon King; Browning United Methodist Church, Browning, Montana: Rev. James R. Bentley, D. J. Schmidt; The Brooklyn Museum, Brooklyn, New York: Michael Kan; Plains Indian Museum, Buffalo Bill Historical Center, Cody, Wyoming: Peter Hassrick, George Horse Capture; Carnegie Museum of Natural History, Carnegie Institute, Pittsburgh: Don W. Dragoo, James B. Richardson III; The David Clark Collection, Hampton, Connecticut: Mrs. David Clark, Elizabeth Clark Rosenthal; John L. Clarke Western Art Gallery, East Glacier Park, Montana: Mrs. Joyce Clarke Turley; Charles M. Russell Museum, Great Falls, Montana: Jerry Goroski, Ray W. Steele; Colorado Springs Fine Arts Center, Colorado; Colorado State Museum, Denver: Maurice Frink; Custer Battlefield National Monument, Montana: Mardell Plainfeather; Denver Art Museum: Otto Bach, Norman Feder, Richard Conn; Denver Museum of Natural History: Arminta Neal; Department of Archives and History, State of Alabama, Montgomery: Milo B. Howard; Alfred Dunhill Ltd., The Pipe Collection, London: Margot Beal; Dwight D. Eisenhower Library, Abilene, Kansas: William K. Jones; Father Eugene Buechel, S.J., Memorial Museum, St. Francis, South Dakota: Harold Moore; Field Museum of Natural History, Chicago: Donald Collier, Philip H. Lewis, George Quimby, James W. Van Stone; Norman Flayderman Collection, New Milford, Connecticut: Norman Flayderman; The Gilcrease Museum, Tulsa: Mary Elizabeth Good, Jeannie Snodgrass King, Fred A. Myers; Glenbow Museum, Calgary, Alberta, Canada: Hugh A. Dempsey, Douglas Light; Grand Rapids Public Museum: Nancy S. Powell; The Haffenreffer Museum, Brown University: Barbara Hail; Hampton University Museum: Mary Lou Hultgren, Jeanne Zeitler; The Henry Hamilton Collection, Marshall, Missouri: Henry and Jean Tyree Hamilton; Haskell Indian Junior College, Lawrence, Kansas: Milton S. Overby; Hastings Museum, House of Yesterday, Hastings, Nebraska; The Heard Museum, Phoenix: Robert G. Breunig, Ann Maxwell; Horniman Museum and Library, London: D. M. Boston; Indian Arts and Crafts Board, U.S. Department of the Interior, Washington, D.C.: Robert Hart, Myles Libhart; Museo di Antropologia e Etnologia, Florence, Italy; Iowa State Historical Department, Des Moines: William M. Johnson; Joslyn Art Museum, Omaha: Marsha Gallager, David C. Hunt, Eugene Kingman, Henry F. Robert; Kansas State Historical Society, Topeka: Thomas P. Barr, Thomas A. Witty, Jr.; The Library of Congress, Geography and Map Division: Ralph E. Ehrenberg; Linden-Museum Stuttgart, Statliches Museum für Völkerkunde, Stuttgart, West Germany: Axel Schulze-Thulin; Logan Museum of Anthropology, Beloit College: Andrew W. Whiteford; Los Angeles County Museum; The Lyndon Baines Johnson Library, Austin: Patricia Burchfield; Thomas B. Magee Collection, Browning, Montana: Don Magee; McCord Museum, McGill University Museums: Harriet Campbell; Manitoba Museum of Man and Nature, Winnipeg: James Stanton; Maxwell Museum of Anthropology, University of New Mexico: John J. Brody, Marian Rodee; The Metropolitan Museum of Art, Musical Instruments Collection, New York; M. H. De Young Memorial Museum, San Francisco: Thomas K. Seligman; Milwaukee Public Museum: Thomas Kehoe, Nancy Lurie, Robert Ritzenthaler; Minnesota Historical Society, St. Paul: Russell Fridley, Marcia G. Anderson, Bonnie Wilson, Hilary Toren, Lolita Lundquist; Missouri Historical Society, St. Louis: Raymond F. Pisney,

Marie L. Schmitz; Montana Historical Society, Helena: Patty Dean, Susan R. Near; Museo Civico di Scienze Naturali, Bergamo, Italy: Mario Guerra, Antonio Valle; Musee d'Histoire de Berne, Bernisches Historisches Museum, Switzerland: Ruth Pizzanato; Museo Nazionale Prehistorico ed Ethnografico "L. Pigorini," Rome; Museum für Völkerkunde, Berlin, West Germany: Horst Hartmann; Museum für Völkerkunde, Vienna: Christian F. Feest; Museum of Anthropology, University of Cambridge: L. P. Morley; Museum of Anthropology, University of Missouri-Columbia: Carl H. Chapman, Raymond W. Wood; Museum of Indian Heritage, Indianapolis: Pat Lawton, Vicki Cummings; Museum of the American Indian, Heye Foundation, New York: Roland W. Force, Carmelo Guadagno, U. Vincent Wilcox; Museum of the Fur Trade, Chadron, Nebraska: Charles E. Hanson, Jr., James Hanson; Museum of the Plains Indian, Browning, Montana: Ramon Gonyea, Loretta Pepion; The National Archives, Indian Office Records: Robert M. Kvasnicka, Still Pictures Section, Josephine Cobb; National Museum of Man, National Museums of Canada, Ottawa: Ted J. Brasser; Nationalmuseet, Copenhagen: Helge Larson; Nebraska State Historical Society, Lincoln: Marvin Kivett; William Rockhill Nelson Gallery of Art, Kansas City, Missouri: Ralph T. Coe; The Newberry Library, Chicago: David R. Miller; New York Public Library, The Arendts Collection, The Rare Book Room; State Historical Society of North Dakota, Bismarck: Robert C. Hollow, Norman Paulson, James Sperry; Ohio State Museum, Columbus: Ray Baby; Oklahoma State Historical Society, Oklahoma City: Martha Blaine, R. W. Jones; Oregon Historical Society, Portland: Dale Archibald; W. H. Over Museum, University of South Dakota, Vermilion: James E. Gillihan, Julia R. Vodicka; The Panhandle Plains Historical Society, Canyon, Texas: C. Boone McClure; Peabody Museum of Archaeology and Ethnology, Harvard University: Hilel Berger, John O. Brew, Katherine Edsall, C. C. Lamberg-Karlovsky, Stephen Williams; Peabody Museum of Natural History, Yale University: Cornelius Osgood, Leopold Pospisil; Pettigrew Museum, Sioux Falls, South Dakota; Philbrook Art Center, Tulsa: Ben Stone; Pioneer Museum, Douglas, Wyoming: William Ogg; Karen Petersen Collection, St. Paul: Karen Petersen; Pipestone County Historical Society, Pipestone, Minnesota: Winifred Bartlett; Pipestone National Monument: Roy W. Reeves III, Harvey Reynolds; Pitt-Rivers Museum, Oxford University: Geoffrey Turner, F. J. Cousins; Putnam Museum, Davenport, Iowa: Janice Hall; Robert H. Lowie Museum of Anthropology, University of California, Berkeley: Frank A. Norik; Robinson State Museum, Pierre, South Dakota: David B. Hartley; Rochester Museum & Science Center, Rochester, New York: Charles F. Hayes III; Royal Ontario Museum, Toronto: E. S. Rogers, Kathleen Wood; Royal Scottish Museum, Edinburgh: Dale Idiens; Saint Joseph Museum, Saint Joseph, Missouri: Bonnie K. Watkins; Saint Mary's School, Faribault, Minnesota; The Science Museum of Minnesota, Saint Paul: Louis B. Casagrande; Sibley House Museum, Minnesota Daughters of the American Revolution, Mendota: Cynthia A. Doffing; Sioux City Public Museum, Sioux City, Iowa; Sioux Indian Museum, Rapid City, South Dakota; The Southwest Museum, Highland Park, Los Angeles; The J. B. Speed Art Museum, Louisville; Stovall Museum of Science and History, University of Oklahoma, Norman: J. K. Greer; The Colin Taylor Collection, Hastings, Sussex, England: Colin Taylor; Texas Memorial Museum, University of Texas, Austin: Lynn Denton, William W. Newcomb, Jr.; The University Museum, University of Pennsylvania, Philadelphia: Frances Eyeman, John Witthoft; Washington State Museum, University of Washington, Seattle: Bill Holm; Western Heritage Center, Billings, Montana; West Point Museum, United States Military Academy: Renee Klish, Richard E. Kuehne; Wildlife and Fur Trade Museum, Medora, North Dakota; State Historical Society of Wisconsin, Madison: Joan E. Freeman; Yellowstone County Historical Museum, Billings, Montana.

I am also grateful to a number of individuals who have provided information based on their knowledge of particular aspects of Plains Indian sculpture. They include the Blackfeet sculptors John Clarke, Green-Grass-Bull, and Albert Racine; the Chippewa sculptor George Bryan; the Cheyenne sculptor W. Richard West; and the Kiowa sculptor Roland White Horse. Anthropologists who provided detailed information based on their own research experiences include Loretta Fowler (for the Arapaho), Bea Medicine (for the Teton Sioux), Joan Taylor (on Plains Indian collections in English museums), Gene Weltfish (for the Pawnee), and Alan Woolworth (on obscure references to Indian sculpture in local newspapers and other sources in Minnesota). Additional information on Cheyenne sculpture was furnished by Father Peter Powell, and on Sioux sculpture by Mrs. David Clark, widow of a missionary on Crow Creek Reservation; Dennis Lessard, Chandler Institute, Mission, South Dakota; Paul A. Ewald; and Clyde Dollar. Emmet A. Stallcop of Havre, Montana, provided the photograph of the Chippewa-Cree *Mantokan* illustrated in figure 152. I am indebted to J. Richard Haefer, of the University of Indiana, a musicologist specializing in American Indian musical instruments, for advice on the nomenclature of the Plains Indian flute.

Finally, I should like to thank Felix Lowe, director, and the staff of the Smithsonian Institution Press—especially Hope Pantell, editor, and Christopher Jones, designer, for helping to make *Plains Indian Sculpture* both a readable and a beautiful book.